THE RELIGION OF REALITY

Inquiry into the Self, Art, and Transcendence

DIDIER MALEUVRE

THE CATHOLIC UNIVERSITY OF AMERICA PRESS
Washington, D.C.

LIBRARY OF CONGRESS CATALOGING-IN-PUBLICATION DATA
Maleuvre, Didier.
The religion of reality : inquiry into the self, art, and transcendence /
Didier Maleuvre.
p. cm.
Includes bibliographical references and index.
ISBN-13: 978-0-8132-1454-2 (cloth : alk. paper)
ISBN-10: 0-8132-1454-8 (cloth : alk. paper)
1. Aesthetics—Religious aspects. 2. Religion and art. 3. Self—
Religious aspects. 4. Philosophy and religion. I. Title.
BL65.A4M25 2005
111'.85—dc22

2005021903

To Jude, Pierre, and Ludo

Contents

THE RELIGION OF REALITY

Introduction

———— ❧ ————

All philosophy can do is to destroy idols. And that means, not making any new ones—in the "absence of an idol."

Wittgenstein

THIS BOOK DEALS with the two forces in modern culture that command the centrality and force of religion: the self, on the one hand, and art, on the other.

It is largely assumed that the intellect became modern when it replaced scriptural truths and revelation with the guidance of reason, science, and empirical knowledge. On this account the modern age is said have "disenchanted" the world, according to Max Weber's famous phrase, by which is meant that the modern mind does not believe in objects, processes, or phenomena that transcend or escape physical, logical, or rational necessity. A bolt of thunder is no angry deity but a sudden release of electrostatic energy due to measurable changes in the atmospheric pressure. Likewise with wills o' the wisp, medical ailments and their cure, or strange noises in the attic: to be modern is to connect these phenomena with factual objective causes, rather than to allege the workings of extranatural unknowable intentions. The modern intellect works by the light of science. It draws a picture of the world not by unverifiable beliefs, but by calculated hypothesis and empirical verification. This is the sense in which the modern world underwent its disenchantment,

a process that has sectioned religious belief off from the center of natural and social life. Religion is no longer the way of the world but only an optional way of looking at the world. Indeed, to some, the divine is only a department of human knowledge, such as psychology or philosophy, rather than the absolute authority and great *explanans* over all moral, scientific, or political investigation. "Once Gods walked among humans," wrote the German romantic poet Hölderlin (1770–1843), "but, friends, we have come too late! The Gods are . . . above our heads, up there in another world."

But is it so certain that we moderns walk without gods? The question does not mean to dispute the process by which scientific rationalization has purged the world of mystery and, more important still, has flushed the very idea of the mysterious from knowledge and understanding. Instead, the question suggests that, having cashiered the gods, we may have enthroned other gods, other powerful centralities and inscrutabilities over our world. The first half of this study argues that religious feeling persists in the secular Western mind, and that it has taken refuge in the unlikeliest of camps, indeed the supposed debunker of religious creed: the philosophic defense of reason. Briefly put, the new deity is the self-contained, autonomous, separate self. The Enlightenment (Descartes, Locke, Rousseau, Kant), romanticism, and more recently existentialist philosophy devised a subjectivity that aspires to the sort of unconditioned, absolute existence which, in the tradition ranging from Aristotle to Spinoza, defined the deity: an intelligent force that is uncaused, unmoved, independent, free, and ultimately unfathomable. The first half of this study, titled "The Cult of Self," traces the story of this philosophic idolizing of self in modern thought from the Cartesian cogito onward. The second half, titled "The Religion of Art," is an inquiry into the artistic paths that lead away from this solipsist confinement.

&❖&

Part I is a selective survey of modern thought from its early roots (Neoplatonic Renaissance thinkers, Descartes) to the romantic philosophers (Rousseau, Kant, Hegel, Kierkegaard, Nietzsche) and recent philosophy (Heidegger, existentialism, postmodernism, and American pragmatism). I argue that the mainstay of the philosophical tradition since the late Renaissance has been less an analytic than an *aesthetic* endeavor. Its stated goal was a logical description of the self; in actuality, it reshaped subjectivity and achieved a formidable modeling of man *as we want him to be*: less, that is, in the light of reason than

under the lens of self-magnification. This is the key meaning of the turn to subjectivism in modern thought. Not just that consciousness, the subject, the private mental order became the key of any inquiry into the nature of things; but also that consciousness, because it is free and sovereign, is justified in picturing the nature of reality as it wishes it to be. Hence the suggestion that the modern mind-set has produced an aesthetic, rather than an analytic, of who we are and where we stand.

Subjectivism defines the philosophic belief or existential attitude that places the human subject at the choice and mysterious center of the known universe. It is mysterious because, as Descartes surmised and Kant formulated, the subject of consciousness cannot peer into its own depths. In the attempt, it splits itself in half, into a known and a knower, a thing beheld and a beholder. And though we may of course know and see things about the thing beheld, the beholder necessarily remains out of the picture. The source of consciousness cannot become an object of consciousness without, in the process, sidestepping itself. For this reason, there is a part of consciousness that remains beyond knowledge; it is a part never conditioned or restricted by facts, ideas, or objects. Though subjectivity is in me, it is not reducible to my identity and all the things I take myself to be: for who I really am is not the product of self-knowledge, but the beam of attention that sustains all mental activity, including self-knowledge. The facts about me do not objectify me since they are known by me, that is, by an agency external to its biographical facts. In Hegel's words, "consciousness transcends its own self."[1]

Subjectivity thus sits above itself, like a hidden god. This self-abstraction of course does not suggest that the late Renaissance and Enlightenment thinkers who emancipated reason supposed the self to possess a transcendental substance. What it indicates is that modern subjectivity took on attributes reminiscent of those by which the Scholastics described the Godhead. Among those features, for instance, is the Aristotelian account of God as the unmoved mover of all things, the unconditioned source that conditions every existing thing in the universe. Subtracting deep consciousness from the ambit of knowable things is a manner of declaring it unconditioned—irreducible to any attribute but contrariwise giver of all attributes. Since it is the knowing and not the known, it can never be definitely conditioned by any property. Moreover,

1. G. W. F. Hegel, "Preface," *The Phenomenology of Mind*, trans. J. B. Baillie (New York: Dover Publications, 2003), 14.

this unmoving center is a center, a mover, because—and this touches upon the second main tenet of subjectivism—human knowledge is believed to animate the whole range of things known. Subjectivity is a center in that every object is perceived never in itself, but in relation to the human beholder who thereby stands at the hub of all the spokes connecting him to every thing that is. There is not an object in the universe that does not somehow look toward the human agent. One could say that the act of knowing things moves them in our direction, forces them to face our subjective center. For everything known is known by, and from the standpoint of, the human subject. Thus subjectivity is the unconditioned center that conditions the rest of existence. This is the meaning of, for instance, Kant's self-declared second Copernican revolution whose aim was to vindicate the cosmographic map of a universe rotating around a human sun.

<div align="center">⚭</div>

The first half of this study, "The Cult of Self," argues that this exaltation of the self since the late Renaissance leads to a kind of idolatry.

Broadly speaking, two attitudes define the idolatrous character. The first is expediency and consists in enlisting the divine into human service. The second is cynicism and consists in believing in gods one has created for one's convenience, deities whose human-made origin is known but papered over. Consider the parable of the Golden Calf in the Old Testament. Despairing of Moses' return, the chosen people turn to Aaron, his brother, and ask for new gods: "Come, make us gods that shall go before us," the crowd says (Exodus 32:1). "Make us gods"—the phrase itself is a recipe for unbelief. For how can one believe in the absolute transcendence and authority of anything custom-made for us? Does it not seem as though the idolater really worships himself, his own values, fears, cravings, aspirations, and comfort to which he subordinates the deity? Indeed, convenience is at the source of the idolatrous cult. The idolater believes mostly in his mortal self and builds an altar to it. He subjugates the infinite to the finite, the whole to the part. Perhaps to highlight the deficiency of idolatry, Spinoza defined true religion as honoring God without ever wishing that He loved us in return. For such a wish attributes human emotion and partial intention to the Absolute and thus spoils its absoluteness. Idolatry lies in this wish for human-directed deities, a wish that can never be entirely happy since it undermines the authority and absoluteness to which it prays.

To say that the self in modern life is a cult, a masquerade of religion, is

therefore to suggest that this exaltation is artificial, that it calculatedly has the self as its chief beneficiary; and that it is cynical, since the self knows itself to be the source of the cult to which it professes unconditional faith. An object of belief that is created cannot logically be unconditional, since it has a beginning. To believe in the absolute value of the subjective standpoint but to admit, by subjectivity's own logic, that this absolute standpoint too is of our subjective device—this simply sinks any claim to absoluteness.

Of course, from an empirical standpoint, the self seems autonomous and necessary. It is necessary in that one cannot conceive a human life that does not include a modicum of physical separation and self-awareness. At the animal level, the self dwells in a distinct physical organism that relies on its environment for life but moves volitionally and in relative independence of its surroundings. Owing to this basic individuation, this organism cannot help perceiving objects from a unique standpoint which, in the case of humans, is self-aware and therefore carries a unique sense of individual experience. To be human entails, in howsoever feeble a way, being able to account descriptively for who one is. In sum, being human commits each person to exist as his or her own person, in one destiny, bound by one birth and death, the resident owner of a changing yet continuous internal monologue. A thoroughly integrated society to which members are individually unaware of belonging is a society no more but an aggregate like the tentacles of an octopus or a clump of trees.

Subjectivism is the philosophy that takes the internal monologue to be the essence of the human form of life and therefore the starting point of any investigation into it. Not only does animal existence plays only a secondary role in individuation, but physical life itself is significant only when taken up in the inner voice of consciousness. Indeed, we conscious beings may be said to have physical existence inasmuch as we know it. So, at any rate, seems to be the upshot of Descartes's famous "I think therefore I am" which, inter alia, subordinates being to thinking. I can be sure that I (and therefore the world) exist not because existence is primary, but because clear reason forces that conclusion. Note, then, that existence is no longer an external fact but a distilled deduction. It is, as it were, absorbed into mind stuff. Thus Descartes raised the inner light of consciousness, the internal monologue, over all physical, social, empirical externalities.

To taper the human essence down exclusively to the inner light of consciousness leaves too much out of the picture to seem, at first blush, of much

practical worth (What, after all, is an absolute self that nevertheless needs to eat, drink, breathe, and draw from outside and others the very meat for its existence?). In reality, however, the intellectual abstraction of self served very concrete practical purposes. Idealistic though it was, it nevertheless ministered to very earthly material purposes. Philosophic subjectivism invented a self that was a social and political entity excellently suited to an entrepreneurial age in need of individual agents emancipated from the old feudal and ancestral ties, one capable of conducting business and brokering contracts within institutions and laws that existed to serve the entrepreneur. To reverse the classical and feudal balance of power between institutions and the average person, a compelling doctrine had to come into place that guaranteed the sanctity of the individual. And this sanctification somehow had to presume a radical division of world and person by which the latter might be declared to exist independently of the former and possess self-given properties unimpeachable by external circumstances. Subjectivism supplied, or at any rate gave philosophic sanction to, this new emancipated human agent, the person.

The person is the pillar of modern times—it is the fulcrum of our moral, political, social, economic, and religious universe. It crystallizes our sense of what is crucial about human existence and how to live it. Interestingly, however, this exalted entity, the person, has its origins not in philosophy or ethics or Roman law, but on the stage. The word *persona* designated a character in ancient Greek and Roman theater, and stems from the verb *per-sonare*, "to sound through," in reference to the clay or wooden masks through which actors spoke their parts.[2] The person issues from the world of magic and make-believe. It was originally an artifice, an aesthetic illusion—quite a contrast indeed with the subsequent philosophic and legalistic consolidation of the person which, especially since the Renaissance, built the autonomous individual as an ultimate reality, a bedrock, the truest first thing about us.

The aim of this study is, in the first half, to survey the story of how the mask that was personhood has come to stand for the face—how indeed we have come to believe so staunchly and adoringly in what, to others, was a momentary illusion. More constructively, the second half considers ways of envisioning

2. This etymology has been discussed, for instance, by T. Adorno and M. Horkheimer, in the chapter "The Individual," in *Soziologische Exkurse* (Frankfurt, Germany: Europäische Verlanganstalt, 1969), and by Hannah Arendt, in *The Life of the Mind* (New York: Harvest Books, 1981), 227.

the human experience beyond personhood. The first half lays out the modern installments in the tale of an idolatrous creation, while the second sets forth the story of a religious recovery. Idolatry and religion are used here in antinomy to distinguish two contrasting dispositions. Idolatry seeks particulars and figureheads; it focuses on the limited, on what can be held and caressed by thought. Idolatry thus naturally harkens to images, masks, gods that tangibly resemble us, speak our language, and confirm, rather than stretch, our understanding. Idolatry feeds the personal and the individual. Religion, by contrast, seeks the universal, of which the anthropomorphic person can be only an aspect. Even while religious faith requires an active commitment of one's inner life and conscience, even while an act or profession of belief demands personal forethought and deliberation, this commitment in the end recommends giving over the grossly individual. This is the gift required of the person—that it ceases being the center. Doubting Thomas's error was to want proof before belief, hence to put man ahead of God, a God cut to the size of human reason/understanding. Thomas could not surrender his human-based perspective. This means not that religion endorses irrationality, but that it asks us to see that the individual with his sense, psychology, understanding, incidental interests and concerns—that all these are not the ultimate keyholes through which to see the universe. The wisdom in the great religious traditions and—to vindicate in advance the second half of this study—*art*, is that the mask must come off and reveal the ultimate reality, of which the self is just one of the personas.

Besides being the age-old labor of religion, liberation from the empirical person is written also in the labor of reason. When Socrates states that to philosophize is to learn how to die, or when Plato talks about purifying the mind to face the sun of truth, philosophy already points to the necessity of discarding the grossly personal. It says that the noble task of the intellect is to show things not as we want them to be, but such as they are—a vision that requires victory over personality. This Socratic wisdom braided itself into the Christian (Augustinian and Thomistic) tradition that inspired at least ten centuries of Western thought on the virtue of emptying oneself before the truth, God, the divine.

Depersonalization, however, can be a trap. Witness the passion for impersonality at work in late-nineteenth-century and twentieth-century philosophy. The latter rose in reaction against the Enlightenment and romantic faith in a disengaged self-powered subjectivity. Twentieth-century philosophers used

reason to purify reason of anything even tangentially mysterious, inner, or subjective. Whether we look at G. E. Moore, or L. Wittgenstein, or the Vienna School's linguistic analysis, or A. J. Ayer's and Gilbert Ryle's logical empiricism on the analytic side of the philosophical divide; or whether, on the continental side, we consider Martin Heidegger's attack on anthropocentrist metaphysics, or Freudian psychology, or the rise of sociological and anthropological determinism, or structuralist and postmodernist visions of the subject's dissolution in myriad networks of meaning and language, it seems that twentieth-century philosophers have done nothing but hunt the self-possessed Cartesian ego into extinction.

An aggregate of theoretical assumptions spanning two centuries of philosophy, the Cartesian ego is roughly the idea, underpinning the Enlightenment, that the mind is by nature self-sufficient and independent from external reality, to which it is tangentially connected; that individual consciousness is inborn and private; and that the mind carries its own spiritual and intellectual beacon, an island of certainty, clarity, and spirit in a storm of transience and illusion.

This is the self-serving piety that twentieth-century philosophy wished out of the way. Where self-knowing clarity once ruled, we are now the flotsam of unconscious currents and historic tides beyond our power to fathom or resist. Instead of portraying intellectual self-possession, modernism pictured a subject that, as per the word, is *subjected* to, and therefore the product of, social conditioning. Where reason once legislated, we find linguistic and logical structures that seemingly do the thinking for us. The Self is dead; long live the Structure. Thus the nineteenth and twentieth centuries launched an intellectual backlash that embraced a scientifically flavored *amor fati* that fettered man to a sense of helpless dependence on forces beyond his control. To be sure, the historical example of totalitarianism, fascism, and mass depersonalization give us warning about what awaits us when humans are stripped of individual autonomy—when, that is, the theory of determinism phases into political action. On the whole, however, these lessons have given little pause to the twentieth-century philosophic campaign against the Byronic excesses of metaphysical individualism.

Given the mass of antisubjectivist philosophies, it may seem that further demystification will smack of superfluity. And given the horrendous acts of dehumanization incurred by man in the killing fields of twentieth-century his-

tory, it also appears that calling for desubjectifying man will seem irresponsible.

That this present study is not superfluous stems from the intuition that the anti-Cartesian deconstruction of the self took the wrong road, that of *materializing* man. It mistakenly assumed that to destroy the centrality of man equates with denying his spiritual life, the part of his experience not readily translatable into formal or technical language. On the whole, it sought to abolish subjectivity either by reducing it to physical or behavioral mechanisms or else by sinking it into the thick glue of history and society—declaring, in the main, that there is no more to persons than the stuffing of impersonal programs known variously as Language, Power, or Ideology. The drift of the twentieth-century critique of subjectivity has thus been to substitute a "we-definition" for the previous "I-definition" of human experience. The trouble is that this move fails to transcend anthropocentric bias: it is multiplied or massified, but not overturned. For Language, Power, and Ideology are in the end products of a subjectivity writ large, indeed that covers the breadth and length of reality.

Overcoming anthropocentric bias, however, is a difficult business, perhaps an interminable labor. We have for our model philosopher Charles Taylor's afterthought at the end of his masterly work of dispelling the myth of human importance: "The case against disengaged subjectivity," he writes, "always has to be made anew."[3] Debunking the autonomous subjects of philosophers is work always to be done. We understand this endlessness to be in part a matter of structural necessity. Subjectivism can be overcome or disproven only by a mental process (obviously no tree or speck of sand is ever going to settle by theorem the existence or nonexistence of the autonomous self). By virtue of exercising reason, a philosopher bearing proof of the nullity of subjectivity therefore shows sign of clear subjectivity—one capable of free and autonomous reflection. The attempt to question subjectivity thus tends to confirm its centrality since it is by means of subjectivity that subjectivity casts doubt on itself. Assault on the citadel only thickens its walls.

The other reasons that make toppling the idol of subjectivity such a Sisyphean task are more empirical. We should assume that the social and economic

3. C. Taylor, *The Sources of the Self: The Making of the Modern Identity* (Cambridge, Mass.: Harvard University Press, 1992), 514.

forces that propelled the philosophic exaltation of individualism at the dawn of modernity are still alive and well. In spite of heady postmodernist theories of a subject dislocated by global commerce and technology (visions of *Homo cosmopolitus* adrift in the cool bacchanalia of television and computers and jet travel and cyberspace and speed and fantasy life), there is good reason to assume that the forces of trade and industry still have us where they need us, in the mold of atomized individuality, the customer, the freelancer, the employee—in short, the single agent rewarded for pulling his economic weight but marginalized in his communal longings.

There is today a widespread modeling of the self-image that induces the individual to feel and think as follows: "I am here, entirely on my own; all the others are out there, outside me; each of them goes his way, just like me, with an inner self which is his true self, his pure 'I,' and an outward costume, his relations to other people."[4]

Few are likely to dispute this picture. It is indeed who we are. Under the tutorship of psychoanalysis, or science or psycholinguistics, we may scoff at the rosy notion of a perfectly self-transparent ego. But this intellectual cutting-down-to-size, however, has little effect on the day-to-day life of individuals who on the whole carry on living as self-willed individuals, as persons with innate rights and entitlements, as firm believers that a life personally determined is preferable to one smothered in anonymity. Advertising, self-empowerment workshops, political liberalism, education, psychological counseling, "feel good" spirituality—they all in the end minister to one master, the disengaged self and maker of destiny. The philosopher may ponder the relevance of subjectivity, but the man on the street goes about his business with vigorous Cartesian confidence. The process of individualizing human destiny shows no sign of losing steam. Of course, the immersive appeal of communal life still runs deep. The individual also wants to feel that his life fits in a warmly inclusive scheme of things. But such activities designed to serve this need for a metaphysical home are generally kept for leisure time. They have been untwined from the strand of serious public life. Social training does not let our spiritual aspirations interfere with the business of keeping the self shipshape and singly competing against all others. The "I," whether conceived as basic productive unit, as citizen, or as consumer, is generally geared to think of life as his life, his

4. N. Elias, *The Society of Individuals* (New York: Continuum, 2001), 27–28.

exclusive business, his self-given tenure to which all other facts and values are more or less subordinate.

Can philosophy help? Let us say that philosophy can point the way but, for reasons already explained, cannot really go the distance. Every reasoned argument to overcome self-centered subjectivity is spoken from the standpoint of self-possessed reason. Philosophy cannot escape the contradiction that to speak against the ego is an egolike thing to do. Genuine self-emptying should begin by giving up the attempt. This type of surrender, however, is not within the ambit of philosophy. Philosophic work is discursive, willful, independent. It is ego-bound even when, in its most exalted moments, it glimpses a realm of being beyond subjectivity. Liberation from self-clinging selfhood is the province of devotional labor, charitable work, spiritual love, religious practice, silent meditation—activities that silence or humble or dispossess the self, that force it to attend to a compelling external reality more demanding or absolute than the inner voice. This is why—in accordance with the conviction that *doing* is a greater externalizing force than *saying*—the second half of this study turns to artists, that is, to doers rather than sayers, in search of examples of the life truly given to reality, to the practice and labor of love of attending to what is.

<center>⚜</center>

The challenge lies in finding a mode of being human that avoids excessive idealist self-assertion at one end and a dull materialist or deterministic denial of selfhood at the other. "What we have never had," Iris Murdoch claims, "is a satisfactory Liberal theory of personality, a theory of man as free and separate and related to a rich and complicated world from which, as a moral being, he has much to learn."[5] The idea here is that philosophy has fallen under the temptation of dualism, depicting man either as free and autonomous or as sunk into biological historical mulch. Neither option, it seems, meets the demand of drawing a realistic, *livable* picture of human experience where the self is both separate and embedded, independent and dependent. We know where either extremity leads. Radical independence leads to solipsism and existential grandstanding, to an emptied universe where only the subject exists but, having nothing to exist next to, fades into an all-and-nothing twilight.

5. I. Murdoch, "Against Dryness," *Existentialists and Mystics: Writings on Philosophy and Literature*, ed. Peter Conradi (New York: Penguin Books, 1997), 290.

At the other extreme, radical dependence leads to denial of free will, determinism, behaviorism, the liquidation of the first-person singular—the sort of thing that looks half-plausible sub specie aeternitatis but poorly matches the individual's everyday experience of making choices, planning his future, or reordering his affinities in light of his character, the sort of life he dreams of and wishes to lead. Moreover, neither the advocates of freedom nor those of determinism can satisfactorily defend their theory on its own terms. Anyone who would defend determinism on purely deterministic and naturalistic terms would have to say, in the end, that "he stands for determinism because he has been made to"—which, of course, does not prove determinism. As for the voluntarist, his defense of free will would ultimately have to take the circular form of "the theory of freedom is true because I will it"—notably less than a knockdown argument.

The issue therefore is to go beyond the fruitless alternatives of freedom and determinism or autonomy and heteronomy. There are indeed other ways of picturing existence than either standing up to the world or being swallowed by it, either vanquishing or being vanquished. Both attitudes seem to be the wide swings of an emotional pendulum which, incapable of holding the middle, veers off into either vainglorious self-claiming or macerating self-eradication. The root of this cyclotimic swinging is an unnecessarily dualistic understanding of self and world. Dualism leads to feelings of estrangement which, in the case of subjectivism, inspires rueful existential self-affirmation and, in the case of material determinism, the masochistic fantasy of melting into the object. The object, however, is actually not the enemy of the subject. Nor is it its estranged twin. It does not stand over there, apart from consciousness. To be aware of the world does not take us out of it. However ethereal its inner projections, consciousness lives and dies in a house of matter, the brain. The self is born, grows, and carries on in the thick of life. Consciousness may be a perspective or light cast on the world; nonetheless, such a perspective issues from the physical world to which it remains elementally entangled so long as it thinks. Consciousness is therefore a modality of matter. Whatever basic property or tendency is proper to the latter must of necessity be shared by the former. To wonder about the nature of consciousness leads therefore to ask about nature proper.

Now, it seems that, for all its infinite forms, nature follows one sure tendency: to keep being, to weave life into life, to hold together rather than to fly apart. Being is indefatigably interested in affirming itself. A thing of be-

ing, consciousness must like all living things participate in the work of being. Indeed, consciousness must be that by which matter carries on its in-drawing process through other means. Thinking is, as it were, another instrument of the world's self-embrace, of its tireless interest in being rather than not being.

Of course, though consciousness is a modality of the physical world, it is not blindly sunk in matter. For if it obeyed matter in every respect, it could never contemplate false, fictional, or hypothetical ideas that have no existing content—no more than, for instance, a stone or a tree can ever swerve into hypothetical states of being. Either a stone is or is not. Consciousness, by contrast, can trespass into the nonexistent without ceasing to be; it can entertain states of being that paradoxically do not exist, such as future plans, memories of things gone by, or fictional worlds, or again wrong ideas. This swerve is, to thinkers like Hegel or Jean-Paul Sartre, cause for describing consciousness as a kind of loosening of the fabric of being. On their view, consciousness breaks up the organic continuity of life with a gap of negativity, or nothingness, across the distance of which life looks back at itself, represents itself, indeed at times even misrepresents itself or falls out of step with itself (such as when, through us, life claimed that the Earth was flat).

This gap of negativity in the otherwise full immanent fabric of being in no way authorizes us to suppose ourselves transcendental entities independent of nature. The proof is still forthcoming of a consciousness that would supernaturally exist outside brain, body, or machine, that is, outside matter. So if consciousness is indeed a loosening of being, this gap in the weave is, rather than a radical negation of being, a process of being. Now, as argued above, being seems to lean toward only one purpose: to be. We have for proof the overwhelming logical necessity of the fact that being has always been and will never cease. (It is inconceivable that being ever began since it would have had to issue from a preexisting world that therefore was alive, and therefore part of being. And likewise it cannot end for the simple reason that the universe has nowhere to go where it isn't already.) Inasmuch as being always thrives to be, that it is always fully itself and never abides interruption, it follows that the gap of negativity of consciousness, which seemed so impressively absolute to a philosopher like Sartre, is in fact another stitch in the infinitely woven fabric of being. The tiny crack of consciousness must consequently be a modality by which being enhances its work and finds a way of being ever more itself. Con-

sciousness is not a break in being but a step by which being manages to be ever more itself and pulls itself closer together.

The next step is to identify the mode of consciousness that comes nearest to its natural substance, the activity most germane to the being to which its every atom belongs. Of course, every act of consciousness is, so far as it goes, an act of life. This is most obvious in our everyday labor of doing and surviving and reproducing. Everything, from the hunter-gatherer's day's work to the writing of sonnets or the phrasing of a quantum mechanics problem, expresses a conscious organism's will to life, to endeavor in its own existence. Whether we call this endeavor "conatus," as Spinoza did, or "the pursuit of happiness" as the Enlightenment preferred, it seems that our every conscious activity aims at not only maintaining the organism alive, but ensuring its possessor the most beneficial allotment of life. (One could say that Sartre's idea of the "nothingness" or "nonnaturalness" of consciousness too is paradoxically a way to affirm the being of consciousness, to achieve a greater and more unfettered expression of being human.) Consciousness cannot go against being, anymore than a leaf cannot help turning toward light. This necessity applies also to acts of suicide which Schopenhauer was probably right to regard as not the renunciation of the will to life, but a lunge for life through other means.

Consciousness, however, is more than a device identifying what paths or actions will most enhance the organism's participation in being. It is also aware of performing those actions. Can we imagine a kind of conscious activity that, as all conscious activities, are acts of participation in being but whose energy moreover focuses on being aware of, and thus intensifying, this awareness? Acts of consciousness whose aim is to celebrate the life-participating force of consciousness? A baker uses his consciousness to make bread though his self-awareness may be elsewhere. A surgeon expertly mends the flesh without necessarily attending to the light of consciousness by which he works—that is, without using his consciousness not just to manipulate, but to realize its kinship with the flesh. All instrumental actions are affirmations of life. But obviously not all need be aware of the fact; that is, not every action directs consciousness to celebrating its life-participating flow. So the question is, Is there a mode of being conscious devoted to the celebration of life-seeking consciousness? An activity of consciousness wherein the aim is not only to pursue life through external means (e.g., baking bread, reattaching a ligament), but to intensify the awareness of life, or the fact that consciousness is a mode of life?

This would be an activity in which the means would also be the end, where consciousness would seek not just to maintain the body in life, but to draw consciousness nearer to being for the sole purpose of being close to being, embracing being, knowing oneself alive.

The second half of this study, "The Religion of Reality," argues that such an activity is found in art. By art, we understand here the endeavor that seeks maximum awareness of being, that is, the utmost exercise of the awareness of being. From this activity issue objects, forms, colors, sounds that state, in singing tones, the participation of consciousness in being and the plentiful presence of being in consciousness. Art is a way of being awake and this being awake creates beautiful objects. *Beauty* is a word for describing that creature or object that most consciously and positively partakes of being. That thing or activity is art whose making is suffused by the awareness of being and the knowledge that awareness of being is a mode of being. Through art, consciousness revels in being alive. The artistic process seeks not to use consciousness to maintain life (as when baking bread or fixing ligaments or engaging in other instrumental actions where life is fought for). In fact, art does not *use* consciousness at all but *is in* consciousness, stays with it, attends to its vitality. It is life knowing and beholding itself. In art the consciousness of being and the being of consciousness coincide. Less aphoristically, awareness of being is the means and the purpose of art. It is life shining consciousness upon itself.

For this reason it is often said that art is useless; that it does not feed, shelter, cure diseases, builds cities and roads, or increases knowledge; that its connection to the hurly-burly of survival is otiose and distant; and that it is therefore an activity of the mind at rest, of the mind such as it settles when not fending for the organism. In part, this opinion cannot be true for the reason that consciousness, like a vein carrying blood or sap, never stops being a process in and for life. Thus artistic consciousness too belongs in the mechanism of life on a par with others even if, like rest or play, it does not appear to contend and compete directly in the bustle of life forms. Through art, life seeks a form of self-union through means other than organic sustenance. These means, however, are no less essential to life, or else art would not exist or would fail to exist in some societies—a failure so far denied by anthropological evidence. The universal existence of art proves that, as essential to life as food and light, is the consciousness that dwells on remarking the being of things.

Now the foregoing is of course a very sweeping, deeply abstract proposi-

tion much in need of practical show-how. Such demonstration provides the meat and labor of Part II of this study which, by studying artworks and the testimonies of their makers, defends the view that, against an age-old prejudice that lumps art with artifice and make-believe, artworks are really acts of bonding to reality. Art is oriented toward reality, not fantasy. For however fanciful, art's plunge into the rabbit hole leads eventually to a refreshed contact with tangible life. Of course, art is a conceptual activity insomuch as its building blocks are symbolic forms, ideas, elements of language and meaning. For all that, however, the intellectuality of art differs from the other products of reason. Art seeks concrete embodiment in specific forms; it does not succumb to the mind's tendency toward generality and abstraction. Knowledge, not art, lives in the realm of illusions and pictures. For knowledge is synthetic and generalizing, and therefore draws away from particulars that it condenses into unifying schemes, mental pictures, concepts. Not so art, which, in the opposite direction, casts ideas into uniquely limited objects. This is why artistic pictures of imaginary persons or things often give off a more vibrant, deep, and plausible flavor than *theoretical* disquisitions on the same entities, be they philosophical, scientific, or political. Science and philosophy talk about things in a language that drains them of pigment; whereas art talks about imaginary beings in ways that make them more tangibly present. Thus is it no surprise to find more incarnation in one of Anna Karenina's most listless moments than in the whole of Descartes's *Meditations*; or to find Kant's "Consciousness," Heidegger's "Dasein," Freud's id-ego-superego, or Marx's proletarian to be somewhat pale and tottering things next to, say, Vermeer's tiny *Girl with Pearl Earring*. This is less a disparagement of conceptual knowledge than a statement regarding its limitation. By dealing with generalities, knowledge gains in scope and prediction but loses in texture and grain. Knowledge is an aesthetic in the sense that it contemplates from far away; and distance turns whatever appears into an image.

Art—this has the appearance of paradox—reaches beyond the image. Artistic imagination leads the mind to the sensual, the perceptual, and the specific. From a commonsense perspective, artistic works are images only; but the artistic intention is not illusionistic. In general, art does not urge us to believe the illusion—this is where it parts ways with entertainment, fantasy, oratory, advertising, and propaganda. These latter make use of images to lull us into the sleep of forgetting and compliance. The advertising image weaves an all-

encompassing tapestry of unreality into which we are meant to trip from illusion to illusion, driven by the carrot of promised satisfaction and the dancing projections of our desire. This is all fantasy life in the service of another fiction, namely, the symbolic exchange system of money. The advertising image, in itself, has no substance; it is all gleam and surface seeking to capture the attention, not so that it dwells there, but to bounce it off to the publicized product or lifestyle. The work of art, by contrast, is an image that insists on its concrete life. It does not serve hidden masters and purposes. Art in fact becomes propaganda, and therefore clips its own wings, when it embarrasses itself by acting as mouthpiece or mere window. Then it betrays its mission to attend to what exists and becomes mere illustration. This is not to say that art should be devoid of conceptual content or that when it points to a person, an event, or a cause beyond itself it necessarily ceases to be art. But when art advertises beyond itself, the values it defends must be those practiced by artworks: art preaches only by example. To take a famous example, Picasso's painting *Guernica* evokes the wartime massacre of a Spanish village. It is art sending out a cry of moral and political protest. But the painting is not merely an instrument of that protest. The brutal destruction of life at Guernica also squashes art. Whatever kills, maims, diminishes, or hampers life does the same to art. The painting does not just say "This is what happened in a corner of northern Spain," but "This is what is happening to us, to consciousness, to art." Art is empathic; it does not demonstrate or agitate from outside. Instead it takes on the qualities of the represented. An artifact works as art if and when it speaks from the standpoint of that which is shown. This sets it apart from sentimental rhetoric and grandstanding.

But does not art glorify its patrons, the princes of this world, the ruling ideologies? For instance, doesn't Raphael's portrait of Pope Julius II elevate the man in spite of, it is said, a notably querulous papal tenure? Of course, it does. But because it is a great work of art, it elevates the man in spite of the office. Whereas lesser art would have propped up the man by means of his fame, the great work of art uncovers the human life inside the regalia. Its defense of the patron on the social and political stage is conditional on having found a positive reality to inhabit, a face behind the mask, a reality behind the illusion. Sometimes, when the artist can find no reality in the face, as in Holbein's portrait of Henry VIII, he will dwell on the tangible radiance of his clothes and somehow a reality will be rescued and witnessed, though it may in the end eclipse the man.

The point is that it is not enough for a work of art to sponsor the right idea or ruling ideology in order to succeed. Indeed, it succeeds in sponsoring an ideology only if it succeeds as art first. But such artistic success actually limits the range of ideologies it can defend. For clearly an activity of heightened generous consciousness, of careful and tender attention to the given, cannot go to celebrate that power or action that scorns or brutalizes life. The spiritual values that create and sustain a work of art are rarely those by which the likes of Julius II or Henry VIII set their life.

<div align="center">※</div>

Art's attention to the varying thingness of reality gives it a far less theoretical cast than the other products of mind. This shows up best in its making. Whereas works of reason require only logical coherence among conceptual categories, art making pits human intention against realization. It brings imagination to the test of concrete matter. Thinking is almost infinitely plastic, but not so concrete things. We need to consider what art is in terms of how it is made, its nature in the light of what artists do. And what artists do is work with their hands on solid material, the stuff of colors, clay, marble, rock, wood, plastic, sound, and words and rhythm. Theirs is no theoretical labor. It is not enough to have great ideas to make art; one must bring them to the test of practical application. A good pair of boots, not just a head high in the cloud, is needed to walk the path of art. In the end, the artist must be possessed with unwavering attention to the minutest reality. Abstract schemes he may indulge; but in the end even the most cerebral artist must submit his ideas to the test of fact. Ideas may exist in the mind only; artworks dwell in the three-dimensional world. This condition is the source of art's kinship with reality. It licenses this study's suggestion that art is less fabricational, fabulistic, unfettered, contriving, in a word, less *aesthetic*, than the works of pure reason.[6] The latter kick themselves free of matter by way of beginning; they are answerable mostly to man-made rules of sense and logic. They are therefore plastic or "aesthetic." Works of art have form and size and weight and balance to reckon with. They submit to laws other than those of reason. Though plastic, they are limited by matter. They cannot blithely speak of transcendence, unconditioned existence, or pure mental life. "The Real is the rational" has no mean-

6. Here the word "aesthetic" is used with postmodern, rather than modern, overtones: to designate less food for the senses than man's freewheeling Pygmalion-like shaping of the given.

ing to a work of art. Its mission is to bring the mind to dwell in reality. It is less vision than actualization.

It is a sort of miracle when art theory sheds light on a work of art because theory applied to art is like inhaling applied to exhaling. Their directions are opposite. Whereas art is mind's Orphic descent into the concrete, theory is Icarus's flight into the ether. Each direction is prey to its own defect. Orpheus can become consumed by his descent into blind matter where he is struck dumb, while Icarus sometimes gets intoxicated by the ether. In his drunkenness he speaks too mellifluously, oblivious of the air that gives him lift, and falls. The ideal critic would be a hybrid of Orpheus and Icarus: like the former, he can sink deep into the thick of things and yet, like the latter, keep the will to survey, to see things from above, from the light of the sun. Only one type of personality seems to combine these two drives: the artist who speaks about his art.

Here I need defend Part II's choice of having given pride of place to the words of artists. Artists on art are often less charming and fluent than critics; they frequently mumble when we want them to explicate; they mystify, aphorize, or chant when they should be clarifying. They frustrate our hunger for systems, principles, axioms. We know them to be architects, so why must they speak like bricklayers? This has often led the critic to dismiss the artist as a spoilsport. Really, says the critic, we do not need an artist to guide our understanding of art. Artists, like parents, stand too near their offspring to make good appraisers. A mother may know every freckle on her son's nose, but what is that freckle in the giant tapestry of historic and social pressures that mold the boy's identity through his upbringing, the language he speaks, the contemporaries he lives among, the ideas he consumes? The same goes for art. Our appreciation of an art piece is purblind and anecdotal unless enlightened by broad contextual knowledge—what fits it into the pyramid of history, the artistic tradition, the system of forms and ideas in which it is notched. The artist knows in detail but knowledge really is made up of the general, scraps arranged in constellation, networks, systems. So if we want to know, we need to step back. And surely the artist is of little help. He is as averse to stepping back as a mother is loath to generalize about her boy.

Now, shall we say that, because they are unable to draw back, the artist does not *know* his work and the mother does not *know* her son? Of course not. Only perhaps the artist knows not *about* his work, nor the mother *about* her

son. Their knowledge is too deep, too of a piece with their life, their sense of what supremely matters, too suffused with love and presence, for objective distance to wedge into the matter. A mother who holds forth too learnedly or psychologically about her child, like the artist who pontificates over his work, is suspect of listening to herself speak, of preferring her discourse to its object, of relishing her intellectual fluency at the expense of her love. Not that we expect love to be, like Cordelia's in *King Lear*, always speechless. It is just that articulacy savors of mastery, and mastery of cutting too high above the dense, asymmetrical, complex, irreducible ways of life.

What we learn from listening to artists on art is rarely historical generalities. It is generally not *about* art. It is *from* art. Even when it takes the form of axioms, their word is grounded in the specific. Art is love of the particular. Likewise their discourse inherits all that is awkward, unwieldy, muddled, and tongue-tied about the particular. It is easier to talk about trees than one tree, easier also to describe humanity in general than one person. But language is whittled to a finer and brighter edge against the touchstone of concrete reality; it takes on the chiseled contour of experience. Artists on art offer dispatches from the line where subjectivity has tussled and engaged and won and lost against the concrete life. This is what makes their reports so confused, often so inconsistent. But their confusion is really a token of their truth, their tongue-tiedness a proof of their depth, their unsystematicness the evidence that they have honored their commitment to the particular. To study the words of artists is, in a sense, to come closest to seeing knowledge grappling with its opposite, that is, the particular. And this seems, in the end, to be where the discourse on art comes closest to art itself.

<p style="text-align:center">⚜</p>

Now, having dashed through a breathless overview, we come before the forest. Therein we go step by step.

PART I

THE CULT OF SELF

CHAPTER 2

Seeds of Emancipation

It is our own self we have to isolate and take back into possession.

Montaigne

WHAT IS THE MEANING OF LIFE? How must I live? What is the significance of my death?

The life of the mind became *modern* on the day these questions began to be asked, first, in the first-person singular and, second, outside self-validating religious dogma. This, however, means that the modern intellect came to life circa 400 B.C. in Athens. For as soon as commonwealths became affluent enough to support men whose pleasure in life was to discuss ideas and write down their thoughts, it seems that individualists also came into being. Thought is the content and medium of the intellectual life, and genuine thought is always independent. To repeat an idea is not to think. True thought occurs when a person understands and appropriates an idea. "He who learns but does not think is lost" (Confucius).[1] Genuine understanding occurs in the first person. Individual thought is, as Jacques Barzun remarks, a tautology.[2] It is no surprise that claims about the singularity and exception of the individual standpoint

1. Confucius, *The Analects*, trans. Arthur Waley (New York: Vintage Books, 1989), 2.15.
2. J. Barzun, *The House of Intellect* (New York: Perennial Classics, 2002).

date as far back as intellectual activity. This is because the labor of intellect is by nature an individual pursuit and expressions of individualism are bound up in the nature of thinking and understanding.

Hence the reason why the history of individual emancipation is indistinguishable from the history of philosophy. "Better that the mass of mankind should disagree with me and contradict me than that I, a single individual, should be out of harmony with myself and contradict myself," Socrates says.[3] This is less boasting than a defense of reason. Inconsistency in thinking, saying what one does not believe, contradicting oneself—these are tied to a galling sense of self-betrayal. To this extent, reason is personal business.

Everyone will agree, however, that to extend the meaning of modernity as far back as Socrates fails to catch the specific flavor of "modern." The emancipation of subjectivity waited in latency for some twenty centuries before breaking into the open. What held it in check was the indisputable conviction that reason always led to an objective state of things valid for all time and all places and all people. Though personally experienced and directed, reason was thought to open to the impersonal, the truth, the given, the divine absolute. It required a helmsman but its compass always pointed to the same end which brought the individual in touch with the universal: truth in ancient philosophy, God in Christian Neoplatonism. Thus Augustine. His confession dignifies the private individual experience. The personal, however, is not an end in itself but a step, a rung on a ladder that climbs up to a truer, clearer, more absolute state of things. And the self wears out its usefulness the closer it nears divine truth, which is impersonal. Medieval and Scholastic philosophy trod a typically Augustinian path. It liked to think itself in the service, rather than the master, of truth. Logic is discipline and the self its wayward pupil, always in need of stewardship in, always in want of divine guidance. Thus mental exercise, ratiocination, the monologue of mind lead not to a more sovereign consciousness, but to a self boundlessly susceptible to divine truth.

The life of the mind became modern when the work of reason took greater interest in its exercise than in its objects; when philosophy divorced itself from science and knowledge—with which, throughout the Middle Ages, it had been indistinguishable—and by slow degree took on the characteristics of an existential art. Descartes (1595–1650) is said to be the father of modern

3. Plato, *Gorgias*, trans. Walter Hamilton (New York: Penguin Books, 1960), 76.

thought because he was the first on record to think like an existential artist. Unlike the Scholastic philosopher, the modern thinker is not concerned with tradition but, like the artist, with originality. The artist innovates; so does Descartes, by making tabula rasa of all former schools of thought and philosophies. To the philosopher as existential artist, the "I" is not God's creation, hence an object, but a subject, endowed with self-direction, self-transparency, and the will to know. "I think therefore I am": this, Descartes maintained, is the only certainty, the exclusive source of truth we have. From this basis only can we securely build knowledge and, by and by, reconstruct the world. Reality is therefore not a given but a deduction in need of building, a proof waiting to be made, a by-product of reason, hence, to this extent, second to the self.

Characterizing the modern thinker as an "artist" entails the notion that, having identified with his aptitude for clear thought, the self vassalizes reality to an act of thought ("Cogito ergo sum" means in essence "There is existence because I can think it clearly"). All perceptions and certainties descend from an act of mental self-possession. This act is individual, private, and original. Whence the elevation of originality in our cultural pantheon: the former urges that all intellectual inquiry starts from the earliest nucleus of knowledge and subjectivity, that is, the cogito; while the latter recommends that every step thereafter honor the autonomous mind. It is not enough for the mind to entertain thoughts; it needs to *originate* them. And the mind has no higher mission than to be self-mastered at all time, that is, original, faithful to its inborn autonomy, and sui generis. Indeed, the self has begun to think itself the equal of reality: less the handmaiden of truth than its creator.

Now, from a sociological viewpoint, it was in the world of arts and letters, rather than in that of philosophy, that the idea of a self-determined self came into prominence. Before it seeped into philosophical language, the idea to pair self and originality, and to sanctify their union before society, came from the side of artists. It is they who, during the Renaissance, arose out of anonymity and service, broke from the guilds, and concocted the strange notions that one's work and activity are vehicles of character and personal expression; that artworks are tied to their makers instead of to their patrons or beneficiaries or institutions; and lastly that the creative person has spiritual rights over the dictates of patronage and religion. To our eyes, there seems to be nothing out of the ordinary about Michelangelo's wrangling with the Papal Office or the Medicis; in early-sixteenth-century Italy, however, it was still a bit of an odd-

ity. That an artist felt entitled to defend his vision against social interference meant that the individual harbored ideas and forms proper to him only, and not yet found in society; that this originality was worth defending and paying for; that an artist did more than execute works of pleasing beauty but gave birth to an original piece of creation next to which popes and princes were second. This indeed ranked the individual higher than offices and the social order.

To be sure, society had been primed for this upset victory. Beginning with Italy, the fifteenth century saw the decline of guilds and incorporated craftsmen, supplanted by the rise of the freelancer, the man of talent who, far from a nameless worker, gathers a school around his reputation and becomes a sort of trademark. Evidence that the visionary artist came to set the cultural compass is made by Giorgio Vasari's *Lives of the Artists* (1550). It is an account of the lives and works of the great artists of the Italian Renaissance like Ghiberti, Donatello, Piero Della Francesca, Fra Angelico, Botticelli, Giorgione, Raphael, da Vinci, and Titian. In principle, the idea of writing about the lives of famous personalities was nothing new. Medieval libraries abounded in tales and histories of saints. But there is an important difference. However extraordinary, the life of the saint was exemplary: it *matched* a preexisting ideal of the good life; the life of the artist, by contrast, is exemplary by *creating* a model of human perfectibility. The lives of saints and Vasari's *Lives* equally mean to hold up outstanding individuals to public emulation. The difference lies in that we imitate a saint by acting like him, whereas we imitate an artist by rejecting the idea of taking after anyone. Of course, we should emulate the artist's hard work, discipline, and piety. Most of all, however, we should imitate his courage in blazing his own trail, which means not imitating his accomplishments. In effect, the age of Vasari holds up a new human model for edification that subtly undermined the age-old social validity of models. Of course, this is not yet the all-modern emancipation from the ways of old; nonetheless, a seed is being planted.

"I am unlike anybody I know" Petrarch declares in the fourteenth century. This feeling may have always lain secretly in the heart of men and women. It is not incompatible with the ancient Delphic inscription "Know thyself," and tenets of Stoic philosophy as far back as Seneca and Marcus Aurelius. To be a self is to be privy to thoughts and emotions to which no one else has access. To this extent, each feels different from anyone else. The novelty of Petrarch's

time, the Renaissance, is that this feeling now wanted acting upon. It gained cultural validity and recommended an artistic approach to one's own life: Do not just obey life but give expression to what is truly yours. Thus Petrarch's next recommendation: "Everyone should write in his own style." The personal, in other words, demands liberating because it is in itself worthy. Such liberation implies novelty in social affairs, since each person is on principle unlike anyone who has existed before; and it brings plurality into culture since no two subjectivities ever understand or express their reality in the same way. *Via moderna, ars nova, dolce stil nuovo* are among the crop of terms that, in Renaissance Italy and soon throughout Western Europe, signaled a new positive sanction of originality and personality, not just in the arts where the concept originated, but in philosophic and existential matters.

Whether this new brand of personalism repudiated the gothic doctrine of equality and transparency of souls before God was not readily discussed; more certain is that it instilled a more plastic, dynamic idea of human life. It smuggled in the novel idea that, like a work of art, one's person and destiny could be *made*, that it did not answer to some predetermined pattern, final and eternal, set during the Creation but, contrariwise, that man enjoyed license in defining who he is or wants to be. This is the humanist creed defended with more or less degree of philosophic prescience by the great Renaissance writers Erasmus, Rabelais, Montaigne, and Shakespeare. This self-accountability inspired a newfound dignity in man. The fifteenth-century humanist Pico della Mirandola authored a treatise, *On the Dignity of Man* (1486), whose title alone constitutes a manifesto and whose argument defended the inherent validity of the human perspective. What elevates us, Pico argued, is our ability to shape and improve upon our lives, our free will, our creative engagement with nature. Man is not an object but a process, a force in motion whose impetus is the creative will. "Who then will wonder at this chameleon, Man, who was said by Asclepius of Athens to be able to transform by his own nature owing to his mutability, and who is symbolized in the mysteries as Prometheus?" No eternal essence but self-transformation is our nature; and self-transformation leads us ever more upward toward appreciation and comprehension of the universe. So, at any rate, was the humanist faith, so called because it propounded a worldview centered on man's perception and well-being and not, as was peculiar to the classical and medieval ages, on the eternal and the afterlife. This new belief liberated a vast pent-up store of self-confidence that transformed

societies, politics, thought, and religion and gave Western European culture its particular stamp.

The theme of human mutability, so closely akin to that of self-invention, furnishes the subject of one of the great Renaissance works, *The Essays* of Montaigne (1533–1592). From cursory notice, it seems Montaigne's book lays out a typical humanist defense; in truth it is more revolutionary than that. For, not man, but *this* man is the subject of Montaigne's work. It bears less on human existence than on the incomparable singular existence of *this* man, the author. What *The Essays* purport to find exemplary about Montaigne is not that he exemplifies the recommended human excellence du jour; considerably more remarkable is his harboring a view of life, a personality, a philosophy specific to *his* personal experience. If the book is exemplary at all, it is in encouraging us to break the hold of examples. "If all complain that I talk too much about myself, I complain that they never even think about their own selves."[4] Under the new humanist dispensation, failure to be human means not a failure of extension toward the ideal type, but failure of concentration toward one's inner being.

We should have wives, children, property and, above all, good health . . . if we can: but we should not become so attached to them that our happiness depends on them. We should set aside a room, just for ourselves, at the back of the shop, keeping it entirely free and establishing there our true liberty, our principal solitude and asylum. Within it our normal conversation should be of ourselves, with ourselves, so privy that no commerce or communication with the outside world should find a place there; there we should talk and laugh as though we had no wife, no children, no possessions, no followers, no menservants. . . . (270)

In part, this concentration on the autonomous self is old-fashioned Stoicism. The world is the home of transience, suffering, and death. The more thoroughly we achieve mental detachment from it, the greater our serenity and happiness. The tone, however, is not fateful resignation. There is jubilation and voluntarism to Montaigne's unworldliness. Man's autonomy is an invitation for creative self-exploration. It is, in fact, an exercise of self-invention, of which Montaigne's own *Essays* is a demonstration. It is a portrait of the human being as artist, self-fashioner, creator of himself. And since creation implies process

4. Montaigne, "On Repenting," in *The Complete Essays*, trans. M. A. Screech (New York: Penguin Books, 1987), 908.

and evolution, then the identity he holds up to our attention is ever chang-
ing, protean, indefinite, swaying with the ebb and flow of subjectivity. Being
human is *essayed*, not demonstrated; it is a journey inventing its destination;
it is contingency, artistry, becoming—qualities that the medieval mind-set re-
garded as the earmarks of sin and fallenness.

> I am unable to stabilize my subject: it staggers confusedly along with a natural drunk-
> enness. I grasp it as it is now, at this moment, when I am lingering over it. I am not
> portraying being but becoming. (E., 907)

Homo hominis mysterium. Man is a mystery to man. The bright side of this
is personal liberation. A kind of inscrutability and transcendence attaches it-
self to every person. The underside is the existential vertigo that seizes the hu-
manist mind when it turns inward. For once man's intelligence is the reference
point of all exploration, we face a kind of uncertainty when looking at things
(Are we seeing them right?) and downright dizziness when focusing inward
(Who is this seer that is also seen?). Does a lever not need a resting point?
Doesn't a balance want a stable attachment? Likewise doesn't knowledge need
a fulcrum steadier than itself in order to proceed? Here humanism, the knowl-
edge of man by man, stumbles upon the dizzying spiral of subjectivity. The
knower and the known modify each other at every turn. For when the known
is also the knower, the awareness of being known changes its nature, which in
turns requires readjustment on the knower's part. The process is in principle
endless. We therefore belong to, as Montaigne foresaw, becoming and not be-
ing. "This above all—to thine own self be true" is Polonius's very Montaign-
esque advice. And to be sure, Hamlet's passion is to be sincere. His quandary,
however, is that he cannot stay his self-image long enough to become it; he
would like to be true to himself but his self is a vortex of self-consciousness. He
is Hamlet but then again he is not, since he knows he is Hamlet and therefore
distinct from whom he takes himself or is taken to be. Thus humanism ushers
in a mood of anxiety.

To relieve this mood, yet without sacrificing the nascent faith in the auton-
omous self, will be the accomplishment of the first full-fledged systematic and
philosophic defense of self-sovereign subjectivity by René Descartes (1596–
1650).

CHAPTER 3

Severing the Ties That Bind

───────※───────

Stand as if a man were author of himself and knew no
other kin.

Shakespeare, *Coriolanus*

PURITY IS THE SPIRIT of the Cartesian method. Certainty is the goal.
From birth onward, man is thrown in a welter of facts, forces, impressions. If
he is to get a foothold in this world, he must find some stability. But since he
cannot be sure of anything outside himself, since worldly things always seem
to veer out of his control, then he will draw inward into his own self and stake
out what is his and what is not his, the essential from the superfluous, the
inborn from the acquired. This is the metaphysical act of independence by
which Descartes initiates his method.

According to him, no idea or single piece of knowledge or perception, not
one experience, memory, indeed anything gained by empirical and adventi-
tious contact with reality, is immune to uncertainty and error. Nothing ex-
ternal to reason, Descartes claims, "is exempt from disagreement, and con-
sequently certain."[1] If my senses can make a large distant object like the Sun
seem small, then there is no reason to hold perceptual data reliable in general.

1. R. Descartes, *Discourse on Method and the Meditations*, trans. F. E. Sutcliffe (New York:
Penguin Books, 1968), 32.

One rotten apple is enough to spoil the whole basket. This is why Descartes suggests "tipping the whole lot of the basket."[2] What is left when all the apples are thrown out? The basket, of course—that is, the mind aware of having emptied itself out. I have emptied my mind, therefore I am something rather than nothing. Or, as Descartes puts it, I doubt everything therefore I am. For while it is not necessary that the world exists, it is necessary that I exist to question its existence. And since I cannot doubt that I am doubting, it must be that, to begin with, I at least exist.

This syllogism allows Descartes to subordinate the whole of being to a mental act—since only through this reasoning can the certainty of there being some existence be made. Reality henceforth issues from an inward turn of reason that stands to all things as the Sun to our solar system. Philosophy thus begins to regard clarification as a process of centering the world onto mind.

In a sense, Descartes picks up the self where Dante leaves it at the twilight of the Middle Ages. "Expect no longer words or signs from me," says Virgil in parting with Dante. "Now if your will is upright, wholesome and free, it would be wrong not to be ruled by its good sense. And so I crown and mitre you lord of yourself."[3] Of course, this is no Reformation manifesto. It does suggest, however, that on the issue of one's spiritual identity, the soul is best left to its own devices, that its guiding power dwells within. Self-reliance, lordship over one's self, a willful outlook—these are the features of a spiritual revolution with which surely Dante would have had no truck, yet which swept over Europe and changed forever the moral landscape: the Reformation. And these new values—self-guidance, distrust of authority, individual self-understanding—are just what Descartes's *Meditations* stamps with the seal of logic.

For Descartes, consciousness is its own inner light. It possesses an inborn guidance system independent of empirical experience, of learning, of books and men. This guidance system is self-establishing. I think therefore I am: this, Descartes contends, is the original certainty from which we may begin to reconstruct the world; and it is a certainty that is first achieved by pretending that the world does not exist, by, as he says, dumping all the apples out of the cart.

2. R. Descartes, "Objections and Replies," *Meditations on First Philosophy*, ed. and trans. John Cottingham (Cambridge, U.K.: Cambridge University Press, 1996), 63.
3. Dante, *Purgatory, Divine Comedy*, trans. Mark Musa (New York: Penguin Books, 1995), Canto 27.

Of course, it is not inconsistent with the mind's representing function to question everything outside this representation. I know things by the concepts and mental images I have of them. Does not common sense compel me to wonder whether these images are real and whether I apprehend their objects properly? It seems that skepticism is, incipiently at any rate, consistent with sound reason. Nevertheless, it is irrational. Let us first note the technical implausibility of the universal doubt. Can all beliefs, fact, certainties, items of knowledge be cast out of the mind? Is it possible, as Descartes urges, to "reject all beliefs together in one go, as if they were all uncertain and false"?[4] It is doubtful. For at least one belief must stay to warrant chucking out all other beliefs—and that is the belief that one has beliefs. The knowledge of beliefs necessarily sustains the project of throwing them all into doubt. Moreover, only a consciousness mindful of the distinction between mind and contents of mind, or basket and apples, can wish to empty itself. It must have some experience of how ideas and thoughts are come by, and it must hang on to this adventitious piece of knowledge, in order to jettison all other pieces of knowledge. That the mind is a basket is experiential data gained by intercourse with the world. For the radical doubt to be complete, the Cartesian ego would have to forget it is a container. But this awareness is just what energizes and structures its self-emptying. So there is at least one apple that stays when all the other apples are dumped. It is, one might say, the memory that it was once full. For a basket that is not on principle a container is a basket no more. Indeed, it is not even empty.

Now, for the reasonableness of casting the whole world into doubt. The premise of such a move is, to quote Descartes, that "nothing can be considered true except only this, that there is nothing certain in the world."[5] This is a puzzling claim. For if truly everything in the world is uncertain and chimerical, it follows that the idea of truth has no room to arise—at least not from within the world. In a world of total illusion Descartes could never doubt whether he is wrong. Everything would simply be what it is, neither right nor wrong, because there would be no basis on which to suspect a sham. Hence the proposition that nothing is certain has no cause to arise in a world where indeed everything is uncertain. Certainty precedes uncertainty. Universal doubt is therefore not a good place to start. The certainty of the cogito is therefore not

4. R. Descartes, "Objections and Replies," 63.
5. R. Descartes, *Meditations on First Philosophy*, 102.

deduced from the doubt, as Descartes seems to play it in the *Meditations*, but is in fact its dogmatic premise. At first blush Descartes's method seems anthropological and logical, deducing the self from its circumstances; in truth, his opening move is aprioristic and theological. Descartes does not demonstrate the self as starting point; rather, he assumes it as an article of faith.

To be fair, Descartes implied as much in stating that certainty is not a feature of the world but of the mind. The statement entails, however, that the mind—certainty's source—is otherworldly. And this Descartes finally acknowledges when disclosing, in the "Third Meditation," that certainty can only have arisen from God: "if I did not know that God existed, I would never have a true and certain knowledge of anything whatever, but only vague and shifting opinions."[6] Remember, however, that certainty logically has to precede the hunch that not all is certain in the world. Truth is the standpoint from which any perception may be suspected false. But certainty, as it happens, is not a concept that the self could have concocted since the self is obviously of this world. It follows that, to shine certainty upon the world, man must partake of an extraterrestrial essence that—this is crucial—antedates all experience. And this means no less than that the knowledge of God logically and chronologically precedes all other contents in the mind. How we come about, or more exactly, how we *are* this knowledge, is of course inscrutable. Man simply harbors the numinous light of God.

Certainly, there is nothing wrong with this admission except its place in the *Meditations*. For whereas Descartes appears to initiate a human-centered philosophy, building the world from the standpoint of the rational self, his method actually assumes a divine, otherworldly intelligence deep inside the self. In the end, it seems that Descartes's method simply consists in demonstrating, or at any rate producing the logical necessity of, the self's divinity.

This demonstration is innocuous enough so long as we imagine Descartes to stretch a long Scholastic tradition. Rationalizations of *imitatio dei*, defenses of the divine nature of man, are legion in medieval philosophy. But Descartes thought of himself as an innovator. Breaking with tradition, forgetting old books, "resolving to study no other science than that which I could find within myself" make up his philosophic bedrock.[7] Man's divinity, in his view, does not consist in being God's chosen creature, nor in the scriptural tenet that we

6. R. Descartes, *Meditations on First Philosophy*, 148.
7. R. Descartes, *Discourse on Method*, 33.

are fashioned in His image. Descartes wants to establish, not inherit, the divinity of man. Rather than accepting God, and accepting that man is in God, Descartes reconstructively shows God to be *in* man. This is the upshot of deriving God from the cogito, and not the reverse. We are God-like not because we are His children but because we think as He does; because the source of consciousness is as inscrutable in us as it is in Him; because the mystery is *in* us, not in the universe; because transcendence lies not upward in the heavens but inward, down the ever-deepening spiral of consciousness; because, lastly, we can extract ourselves out of the entire universe and still exist in pure consciousness.

In fact, the Cartesian construal of the essence of consciousness—that of being a self-establishing, self-evident clarity—bears interesting affinities with the classical definition of divine substance. The earmark of divine substance, according to thinkers like Aristotle, Maimonides, or Spinoza, is that of being *causa sui*, of cause of itself. In Spinoza's words, "I understand that to be cause of itself whose essence involves existence and whose nature cannot be conceived unless existing."[8] Of course, Descartes would never claim the self to be factually self-given—not, at any rate, in the same sense we can only think of God (i.e., the totality of being) as empirically self-generating. Like any other sound mind, Descartes knows the self to be also an empirically finite entity that is born, grows, and dies and cannot be everywhere at once or free from external causes. This said, however, the logic by which Descartes works out the necessary existence of the thinking ego, of the light of consciousness within, does hold similarities with the divine *causa sui*. God is that essence that involves existence, that is, a being that cannot be conceived as nonexisting. Contrariwise, if a thing can be imagined as nonexisting (e.g., my house, whose existence is contingent and liable to termination), then its essence does not involve existence. Now, Descartes deduces the essence of the ego under a logic of necessary existence: to wit, that it is impossible for one's own self not to be so long as the question arises. In every moment of its existence (which admittedly is finite) the self necessarily is, and therefore is its own essence. While it exists, therefore, the self imitates the self-grounding necessary ontology of the divine itself—surely quite a lustrous achievement.

Naturally the analogy between God and human mind is no piece of nov-

8. B. de Spinoza, *Ethics*, trans. G. H. R. Parkinson (New York: Oxford University Press, 2000), 1, definition 1.

elty one could safely proclaim within earshot of the Sorbonne in the seventeenth century. Nevertheless, the *Meditations* actually go far not only in drawing the ego into arguments formerly attached to divine existence, but also in absorbing divine existence into the human intellect. Cartesian scholar Jean-Luc Marion explains in detail how Descartes's apparent rehearsal of Anselm's ontological argument actually turns the latter on its head. For whereas medieval Anselm infers the existence of God from His very unthinkability, the existence of divinity in humanist Descartes derives from the concept of divinity. That the divine essence may become a concept drops, according to Marion, the first seed of the subsequent replacement of God by mind, that is, the thunderously called "Death of God."[9]

Though understandably shy of declaring it outright in this published treatises, Descartes allowed himself a more celebratory tone in some of his correspondence where the deification of man is correlated to his autonomy of thought. Thus does he speak, for example, in a letter to Queen Christina of Sweden:

Now freewill [a variant of the autonomy of consciousness] is in itself the noblest thing we can have because it makes us in a certain manner equal to God and exempts us from being his subjects; and so its rightful use is the greatest of all the goods we possess, and further there is nothing that is more our own or that matters more to us.[10]

Nothing is more human than the autonomy of consciousness. We cannot help being distinct from what we know by the sheer fact that we know it. Consciousness separates us from what we are conscious of. Whence the idea that we are free so long as we are aware—so long, that is, as we can represent ourselves looking at other people and things and choices and events. Even if the universe weaves us into the fabric of things, its dominion stops at the mind. For, as Kant would say a century and a half later, so long as I can conceive of things I am free of them. In the end, I may be compelled by circumstances to make this or that decision, but I cannot be compelled not to conceive of those circumstances as alternative paths. To this extent, the mind freely experiences the world. Truly it is godlike in that it imitates God's distance from the given.

9. J.-L. Marion, *Cartesian Questions: Method and Metaphysics*, foreword by Daniel Garber (Chicago: University of Chicago Press, 1999), 145.

10. R. Descartes, *Descartes: Philosophical Letters*, trans. Anthony Kenny (New York: Oxford University Press, 1970), 228.

No longer, then, should we honor God by blind obedience but by emulating His freedom.

This is less impious overreaching than zeal for purity: the aim to purge the self from external definitions and prescriptions, to cast off the fetters that bind subjectivity to anything nonsubjective. Indeed, one may even argue that this emancipatory passion is partly inspired by the Christian religion. A creed that preaches renunciation of worldly matters and measures the health of a soul by its detachment will eventually produce a soul eager to transcend received truths and to forge truths of reason's own making. This is why the Cartesian emancipation of self is perhaps not an aberrant twist, but a bloom of Christianity's logic of detachment.

In what sense is philosophic individualism a passionate belief rather than, as the early Enlightenment liked to think, a deduction of clear-headed reason? Simply because it offers not an analytic of the self's construction, but a statement of its inevitability. To be a self is too basic for reason to lay hold of. Descartes does not articulate what it is to be a self; he does not "deconstruct" selfhood, if by that term we mean showing its various parts and mechanism. For Descartes, the self is made of no part. In fact, it is not made; it *is*. Thinking cannot help presuming itself. A clear and distinct idea, such as "I exist because I am now thinking and wondering," is not explained; it is an idea that comes with its own understanding. Why it comes with its own understanding is in turn not explainable. It comes out of the self-evident light of consciousnessness itself that ultimately is sure of itself without explaining why. The very light of consciousness ends up blinding itself. It is an obscure light: by it we see clearly but we do not know what sustains the clarity. It is a kind of hard nucleus of reality. At the heart of subjectivity sits a deity that confounds reason and speech. How not, given these terms, feel awe toward our own selves? Thus is born a new brand of religious inarticulacy, only this time it is not directed at heavenly mystery but inward. The sacred has moved inward. It is in us, it is us. "Two things," Kant opines,

fill the mind with ever-increasing wonder and awe, the more often and the more intensely the mind of thought is drawn to them: the starry heavens above and the moral law within me.[11]

11. I. Kant, *Critique of Practical Reason*, trans. T. K. Abbott (New York: Prometheus Books, 1996).

Here an emblem of archaic awe (the starry sky) is set on a par with the infinity of self-reflection (what Kant means by "moral law" here is thought's unconditional freedom from the given). The mind is our modern infinity. No sooner has the scientific ethos begun to deplete the world of mystique, no sooner have we begun escorting God out of His work than divine mystery slips in again through the back door. This reentrance undoubtedly testifies to the centrality of our need for something *not* to understand—a need perhaps more powerful than the desire to know.

A regrettable law of human life is that what is given to the self is taken away from reality. This is why, on the whole, the elevation of the self in the modern West parallels a gradual process of depletion and deprecation of reality. By intensifying the depth and solidity of the self, the modern gaze on the nonself becomes ever more distant and petrifying. Concretly, this signals the rise of the scientific worldview that, though putatively objectivistic, nonetheless regards life from the seat of the rational subject. We are made of spirit, while the universe is clockwork.

This, more than anything else, divorces the modern spirit from the classical tradition. For Plato and Aristotle also, our dignity lay in being subjects—in our ability to think clearly and independently. Ultimately, however, intellectual self-reliance in classical philosophy was only the first step in a mental journey whose destination was attunement with reality. The Platonic mind cleans up its house in view of apprehending the supreme reality of the world, that is, the Good that exists independently of the mind. Likewise, Aristotle urges us to look inward and know ourselves better in order to improve our view on the true order of things. Classical introspection is a form of training, not an end in itself. Just as the marathon runner trains his body to win the race, the thinking person cultivates his mind to gain admittance into being. In the end, the mind's dignity consists in its ultimate self-emptying whereby, having arranged its inner room for maximum exposure to the sun of truth, it lets the light pour in.

Not so under the Enlightenment. Here the arrangement of the mind's furniture does not aim at accommodating a guest but at controlling his whereabouts. Aristotle's integrated theory of truth drove no essential distinction between the substance of thought and the substance of things. To perceive the real state of things somehow implied osmosis between mental matter and concrete matter. Descartes's dualistic model, by contrast, requires that any cor-

respondence between mind and matter be strictly a symbolic bridge. The connection is not isomorphic but representational. Hence the mind is not a mirror but a stage; its dramatis personae are symbols and cuneiforms of the mind's own invention. Intellectual modernity inaugurates an inner playhouse. Indeed, if anything defines the modernist outlook, surely it is the general opinion that classical *mimetism* was a blooper and modern *constructivism* an indisputable improvement. To say that the mind sees things right is to risk the shrug of the student in Philosophy 101. This constructionist, at times thoroughly idealist, theory of truth owes its popularity more to a matter of moral sensibility than practical application. Indeed, the moderns who scorn at the correspondence theory of truth are the same people who travel on airplanes whose design and functioning in fact rely very tightly on the assumption that the mind is capable of, if nothing else, getting the natural facts of aerodynamics and propulsion right. If the philosopher did not believe such correspondence between plane and objective laws of nature (hence between mind and thing), it is likely that he would walk to the conference where he is to defend his constructionist, nonrepresentational theory of truth. But since he doesn't, it appears that the beliefs we entertain in the everyday walk of life are split off from our intellectual beliefs. This split points to our more overall modern failure of reconciling determinism and freedom. On the one hand, our reliance on technology shows that we subscribe to the notion of a high level of deterministic recurrence in the natural world, one that our mind is capable of decoding probably. On the other hand, we cling to the notion of consciousness as independent and human intelligence as ultimately free, a belief that refuses to accept the humbling notion of the mind compelled to conform to facts, that is, determined by the world. For if the mind reads the world right, it means that it is ultimately not free—not free to see the world as it will, but subjugated to facts. And this offends our self-image of being emancipated creatures—slave to no fact and beholden only to the freedom of consciousness. The problem, of course, is that such freedom does not explain why planes fly.

The general trend in the theory of knowledge from the Enlightenment to the Industrial Age is constructivist or voluntaristic: it understands knowledge as running one-directionally and instrumentally from mind to things. The Platonic embrace of mind and cosmos, the identification of knowledge with love, the notion that one attains true gnosis not by intellectual scrutiny alone but also by readiness of the heart—all this begins to look like a lot of orien-

tal vapors. To the modern mind, truth is a function of reason, not the other way round. If there is a general tendency to philosophic thought, it is surely the one representing reason as producing, rather than making toward, truth. Descartes and Locke are, epistemologically speaking, empiricists: the mind is, as Locke (1690) puts it, "White Paper" that by and by comes to be furnished by "Experience of external sensible Objects."[12] Passive as it seems, however, the Lockean mind does not merely read the imprint. It is free to rearrange the perceptual data into its own idiosyncratic syntax.[13] Taking orders from outside, it is nevertheless a plenipotentiary in its own province. Twenty years after Locke, Bishop Berkeley annexes more of reality to this province with a clever reversal: given that the mind's job is to perceive, is it not logically correct to suggest that reality consists in being perceived? "The table I write on I say exists . . . meaning thereby that if I was in my study I might perceive it, or that some other spirit actually does perceive it" (1710).[14] *Esse es percipi*: to be is to be perceived. This phenomenological reversal sets the general drift of modern philosophy. It installs consciousness at the center, and a center, by definition, never moves. Things come to it and flow out of it. Thus reality revolves around the self and, indeed, in the boldest affirmations of phenomenological idealism, issues from the self.

The belief, operative in Plato, Aristotle, or Augustine, used to be that to see reality or truth called for a spiritual preparation of attention and respect. The modern construal, by contrast, gradually goes to the perceived as one visits a supply site of raw material. One only need to think of romantic philosophy, of Kant, Schelling, Hegel, or Nietzsche, to know that the early modern seeding of subjectivism has yielded an ample crop, indeed that it feeds the spirit of our age. The job of subjectivity is not to delve into the cosmos or, as Heidegger put it, to return to the "Clearing of Being," but to chop the forest down for our convenience. Subject and object are really two poles that never shall meet. The former lies deep down inscrutable depths; the latter, says Kant, is a *noumenon*, a thing beyond our knowledge and perception.

12. J. Locke, *An Essay Concerning Human Understanding*, book 2, chap. 1, §2.

13. J. Locke, *An Essay Concerning Human Understanding*, book 3, chap. 2, § 8: "Every man has so inviolable a Liberty, to make Words stand for what Ideas he pleases, that no one hath the Power to make others have the same Ideas in their Minds, that he has, when they use the same Words, that he does."

14. G. Berkeley, *A Treatise Concerning the Principles of Human Knowledge*, part 1, § 3.

Of course, some philosophies like Hegelianism tried to stretch the polarities of subject-object into a dynamic weave where one strand is always acting and reacting on the other: a cosmos instead of epistemological ping-pong. Perhaps Hegel wished to recapture the magic of the classical world—those invisible skeins that once connected the mind to the worldly matrix, the alchemical interfusion of spirit and matter that is the daily bread of religion. But religious interfusion recommends surrender of the self, a yielding denied by Hegel's stipulation that the reunion of subject and object be a product of mind. In the end, "The Real is the Rational." The union of subject and object tilts toward the subject. Indeed, Hegelian subjectivism cannot help seeing it as a product of consciousness—a fact that significantly curtails the ecological balance in the marriage.

<div align="center">⚜</div>

These philosophical exercises do not live only in libraries. They rule over our self-understanding. Ask the person on the street about what defines a person or what it is to think. Barring certain infusions of Freudianism, new age spirituality, or soul psychology, he is on the whole likely to prove Cartesian: to wit, that to think sets the mind *back* from the world—a little fortress of thinking in the great forest of things. Such permanence probably stems from agreement with historical conditions. Subjectivism is buoyed by social, economic, and religious trends that confirm, and find ready use of, disengaged, self-supported, and mobile human agency. Without the rise of an entrepreneurial and mercantile middle class, without the Reformation, subjectivism might have drifted the way of antiquities. On this account, we may expect the Enlightenment self to endure as long as the power engine of economic individualism stays with us. To be sure, the example of twentieth-century totalitarianism, the stifling of individual impulses in bureaucratized society, and dire images of a human anthill life warn us about how fragile this supposedly indomitable self really is. However, that these various pictures come to us as nightmares exhibits our continuing existential attachment to this early modern invention of the human isolate.

The Romantic Solipsist

Human kind cannot bear very much reality.

T. S. Eliot

THE SOCIAL FABRIC had to undergo some loosening before the Cartesian ego could leave the province of philosophical theorems and enter social life. So long as the guiding spirit of society remained hierarchical and coercive, the early Enlightenment disengagement of the self remained only a hypothesis—the inspiring picture of a man alone in his stove-heated room mulling over the possible nonexistence of the world, but *only* a picture. It took the slow-motion shock wave of bourgeois industry, the shakeup of Protestantism in northern Europe, the decline of the aristocracy from a warrior class to sumptuous leeches, the breakup of agrarian village life by a new merchant economy—in sum, a whole new society was needed to embolden the self to claim possession of itself.

Romanticism came along to popularize, poeticize, and most of all democratize the early Enlightenment picture of the hidebound self. It peeled away the stodgy clerical vestments from the cogito and revealed the everyday knight errant underneath. Personal autonomy assumed something of a religious glow for the romantic mind. Its opposite—dependence on received truth and opinion—seemed of the same ilk as social serfdom and traditionalism. Romanticism brought subjectivism to the everyday person, the reader of poems and

novels, the theatergoer, the broadsheet reader. It did for subjectivism what Lucretius's epic poem did for dry Democritus: it *poeticized* a worldview and, in the case of romanticism, drew out the political branches of an otherwise recondite philosophy of mind. It wrote the story of the self, chronicling its surprising twists and turns, its leaps forward and setbacks, its restless movements of discovery—what Hegel called its "phenomenology." It wrote the *novel* of how a self becomes what it is. It made it legitimate for the average person to begin to express what it *feels* like to be oneself apart from all others. A model is Jean-Jacques Rousseau's *Confessions* (1782). The confessional genre of course recalls venerable precedents, like Augustine's *Confessions* or Bunyan's *Memoirs* or even Montaigne's self-portrait in his *Essays*. But whereas Augustine and Bunyan wished to show the conversion of self toward an absolute order (God, the Church), and whereas Montaigne never lost sight of depicting "l'humaine condition," bringing out the thread that connects his own life to the template life of wisdom, defiance fuels Rousseau's confessional. His modus operandi is not reconciliation but distinction. Indeed, the *Confessions* begins on a boast:

I have begun on a work which is without precedent, whose accomplishment will have no imitator. I propose to set before my fellow-mortals a man in all the truth of nature; and this man shall me myself. . . . I am not made like any one I have been acquainted with, perhaps like no one in existence; if not better, I at least claim originality.[1]

Certainly, the world before Rousseau (1712–1778) had known loners, objectors, hermits, and nonconformists. But Rousseau more than openly shouts his uniqueness; he also defends his right to be nonexemplary. Either Rousseau's *Confessions* is without precedent or the point of writing it is moot. It seeks not to bring together, but to break apart. It does not call for understanding but instead for wonderment. He does not hold a mirror up to the reader but a dark screen through which, half in admiration and half in dismay, the reader may tremble at the alien. *If I am not better than you, I at least claim originality*: this reordering of morals would have seemed aberrant even to free spirits like Montaigne or Shakespeare. We imagine this sentence issuing from the mouth of Iago but not from a moralist. Yet this is just the transvaluation made possible by the Enlightenment. My morals and deeds, Rousseau admits, may be shabby at times, but at least I did it my way. It is not a matter of whether he is

1. J.-J. Rousseau, *Confessions*, trans. Angela Scholar (New York: Oxford Classics, 2000), 5.

better or worse than others; it is that he is incomparable to others. And this incomparability, we understand, bestows on the person a kind of halo.

Rousseau did not keep these musings to autobiography. A man of his age, he was liable to think the particular case through the universal, that is, in a scientific manner. The result was his important treatises, *Discourse on Inequality among Men* (1754) and *Essay on the Origin of Language* (1781). In these essays, the philosophe scrabbles back into the primeval forest to retrieve Primitive Man who, though a savage, is nevertheless a relatively content fellow, not in the least diminished by the absence of civilization, but self-possessed and beholden to none, an intelligence sui generis, humanity in the singular. Man is innately a person and innately free. The root of identity is not communal, but individual. On the face of ethnographic evidence, Rousseau might not dispute Aristotle's idea that man is a social animal; but he would contend that sociality comes on top of the core of singular selfhood. Freedom comes first. Or else why would we always wish to be free? How would we ever experience the social yoke as burdensome if somehow our nature were not to be free of it?

This new myth, from which so many social goods proceed (from the Declaration of the Universal Rights of Man to abolitionism, the reform of cruel labor practices, the women's suffrage movement, etc.) sharply divides individual and community and sets their separate interests at loggerheads. Humanity is shared by all (you and I have it in equal measure), but humanity exists singly and independently in each person (hence my humanity exists autonomously from yours). This primitivist doctrine downplays the interpersonal source of humanity. It makes it easy to lose sight of all a person owes to other people in shaping himself. The typically modern hero is a loner, a Don Quixote, a ranks-breaker, a hermit. Their archetype is Robinson Crusoe, the man to whom utter seclusion from society causes feelings of homesickness but barely a dent in the sense of who he is. Indeed, he discovers within himself an inexhaustible font of civilization, industry, religion, and entertainment—all the goods formerly assumed to be the blessings of human company.

As logic goes, the idea that a person is a person apart from society makes no sense. An individual cannot stand apart from other things without knowing what he stands apart from, that is, without including the constitutive experience of, precisely, stepping apart. Indivisibility assumes the existence of what one can or cannot be divided by. Emotionally, however, the primacy of the individual monad has enjoyed great currency in social and political thought, in-

deed far more than its Hegelian counterthesis that a person gains freedom and individuality only within the state, only when "he becomes a member of a corporation, a society, etc."[2] But the framers of the *liberal* democratic state, as the title suggests, were believers in the innate freedom of man. They were Rousseau's, not Hegel's, men. Hope and diffidence seem to preside in equal measure over the birth of, for instance, the American Republic: hope that America would produce a political body as plastic, minimal, and self-checking as had ever been thought of; and diffidence because, even with all precautions deliberately taken, the state was a necessary evil, not the flower of civilization. Enlightenment and romantic lawmakers legislated in the mood of Locke ("Man in the State of Nature is free") and Rousseau's *Social Contract*: "Man," Rousseau says, "is born free and is everywhere in chains."[3] From such statements it can only follow that even the ideal society is only ever but a necessary evil. All political theory can do is mitigate the pain, which, in the last analysis, is the painful reality that other beings exist (we recall here that the first emotion felt by man coming across another man is, in Rousseau's tale, *fear*).[4]

From this belief in man's extrasocial identity came of course the notion of society as *contract*. "Le contrat social" instills the idea that man possesses rights and entitlements on the impugnable preexistence of which he can negociate on the terms of cohabitation with society. People join freely in association and this means that they preexist the community.

Rousseau's idea that society manages a fallen state of mankind sentences humanity to perennial chafing and discontent. This is the invidious lining of this otherwise empowering political philosophy. At first blush, it endows me with the inalienable essence of being a free-born individual; on closer inspection, however, it fosters resignation. Since true individuality lies in a mythic past before man's encounter with others, the social person must resign himself to making the best of a situation that is at variance with his true nature and that may never bring him happiness. Oddly, then, the Rousseauist dispensation invents the essential individual but jointly tells him to sit quiet because his time is past. This is resignation as social policy. Inasmuch as we will never be free of society (since we are, on the strength of overwhelming universal

2. G. W. F. Hegel, *Philosophy of Right*, trans. T. M. Knox (Oxford, U.K.: Clarendon Press, 1942), § 185.

3. J. Locke, *Two Treatises of Government*.(1690), and J.-J. Rousseau, *Social Contract* (1762).

4. Rousseau, *Treatise on the Origin of Language* (1781).

evidence, what Aristotle described as a "political animal"),[5] we condemn our-selves to being in conflict with our own nature, hence to unhappiness. Things are bad because they can never be good again.

The idea that the company of other people is bad medecine and that in-terpersonal experience is traumatic variously colors modern epigones such as Freudian psychoanalysis, Sartrean existentialism, or Ayn Randish libertarian-ism. Implicit in all is the assumption that other people are a threat, a wound, a hindrance to personal bliss. Psychoanalysis gives this phobia the sanction of normality. Thus in the Oedipal complex it is normal and healthy for the infant to regard one of the first human beings he encounters, his father, as a great calamity, a narcissistic fall, the prelude to all future ills: the one who drained life out of pleasure. Society is a morose spoilsport and civilization, as Freud had it, a breeding ground of discontent. There, at any rate, are the romantic roots of psychoanalysis that fed on the misanthropic loam of gen-erations, from Chateaubriand's René to Thoreau's woodsy reclusion to Zara-thustra's mountaintop. Such misanthropy parallels the waning of *social* uto-pias in the modern liberal imagination—despite such admittedly formidable convulsions as Marxism whose demise today seems to confirm the idea that, shall salvation come, it will not sweep the whole of us, but one man at a time, each for himself.

Against the communal background of the good life in classical political philosophy (Plato, Aristotle, Aquinas), the happy man after romanticism is one who cuts his losses early and retires from the madding crowd. Barring complete solitude, the model citizen seeks to consolidate autonomy, the Vol-tairean garden at the back of the house, the walled-in patch of one's own opin-ion and finances. The Jeffersonian citizen is already not the urbanite, the man of the salons and brilliant conversation pictured in Diderot or Samuel John-son. The swelling of city-dwelling populace in the nineteenth century bol-stered the disillusion that cities would ever become the beacons of civilization once dreamed of. Balzac's Paris is a hydra that devours human lives in quick turnaround; in Dickens the city is a festering sore; in Baudelaire a daemonic spell; in Melville a wasteland of anomie. The romantics prefer the country-side, lakes, mountains. Whatever fascination the city initially holds in Austen,

5. Aristotle, *Politics*, trans. T. A. Sinclair (New York: Penguin Books, 1992), book 1, chap. 2 (1253a2).

Flaubert, Eliot, or Tolstoy, it only brings disenchantment in the end. How curious that, to fashion the ideal citizen, it is now advisable to flee from the daily associations of citizenry. Modern founders gave up creating the new Athens. To breed the future class of civic leaders and captains of industry, nineteenth-century America removed its colleges away from the urban centers and set up shop in the boondocks. The model citizen is cityless; his dealing with others is contractual and rescindable; his social identity is an appendix to his personal identity. Happiness consists less in an expansive blossoming of self, and more in a tremor of self-contraction, a hardening of the membrane that separates self and world: that is, happiness lies in the private sphere.

Of course, there are social reasons for this fierce, passionate claiming of individuality. The explosion of overcrowded urban centers, of large-scale manufacture, of mass labor; the draining of rural communities; the tossing and uprooting of populations; the rise of migrancy, of short-term work—these features of the Industrial Revolution produced a social entity hitherto unknown: the mass.[6] In the traditional community, each person had his place. The ruler, the courtier, the serf, the fool, the blacksmith, the drunkard, the poet, the vicar, the scold, the rake, the bawd, the pilgrim, the village witch—these are persons who, however menial their station, enjoy the community's recognition. They are never faceless even when, like Hester Prynne of the *Scarlet Letter*, they are shunned.

The anonymity in the new industrial Babels blurred the social mirror. The great city blended the shadings of community into the common gray. It is probably true that, as Marx saw, a person then became synonymous with his labor power, hence with an identity in principle faceless and fungible. Mass existence undid the individual from the inside out and forced him to identify with his market value. The new man is quantity and little quality. And this explains why the community, which is the realm of qualities, vanished, and along with it a distinctive ideal of personhood.

Romanticism of the libertarian type arose to stave off this benighted tide, to elevate the individual in spite of all, to perch him on a mountaintop. It wished to wrest the self from the clutch of conformity and set it in heroic solitude. From this new vantage point, not just the "they" of the masses but the

6. The book to read is E. Canetti, *Crowds and Power*, trans. Carol Stewart (New York: Viking Press, 1963).

"you" of daily association began to seem invasive and dangerous. The self must beat back the tide of communal identity if he is to be hale and true. This raised misanthropy to the status of heroic feature whose bearers are to be found everywhere in the nineteenth century, from (in a random sample) Byron, Blake, Chateaubriand, Gautier, Delacroix, Schopenhauer, Beethoven, Flaubert, Nietzsche, Huysmans, and Wilde. This pose enjoyed great success in spite of its implausibility, the heart of which is that individuality obviously stems from interpersonal experience. The reality of being a person is to be an "I" living among other "I's." Reading Descartes, Locke, or Rousseau gives one the impression that a self-made "I" encounters an objective "Them," and thereupon negotiates the social bond. This is erroneous. There can be no "I" that is not simultaneously a "You." Human identity occurs not in a society objectively and generically conceived, but among a group of "You-beings": beings to whom one speaks and by whom one is spoken to; beings whom, by virtue of addressing them, we acknowledge as other "I's." This is the metaphysical cradle of personhood and it is live experience.

The discourse on modern society is, roughly speaking, fatally oblivious to the "You" as a key building block of personal and social identity. From Locke, to Rousseau, and then to Marx (to take only salient points), human identity is described in terms either of the subjective (the "I" or the "We") or the objective ("Him," "Her," or "Them"). Political philosophy has quite properly neglected the "You-dimension" of social being. And without this "You," both individual and society are hollow forms, abstract ghosts. Literary expression in the nineteenth century is full of subjective voices roaming in unreal mental worlds of their own making, inmates of their own monologue, trying to regain contact with reality and others: a literature of skepticism.

For it fell on the postromantic generation, on the likes of Baudelaire, Poe, Maupassant, and Hoffmann, to understand the boredom and claustrophobia of ego-bound reality; to realize that whenever reality is indexed to the ego, the ego constructs a prison. Everywhere the self looks, it only finds itself. No genuine respite, however, loomed in sight because this generation taught itself to look with horror on the slightest encroachment of freedom. Despair, then, seemed the only option.

Especially in Baudelaire is evident the sense that the romantic honeymoon between the ego and itself is over, that the self's inner resources are exhausted, leaving the egocentric life a dungeon of disappointment and self-resentment. In

spite of this, however, Baudelaire's secular stoicism recoils at self-transcendence. Hence the only escape is, precisely, escapism, that is, the *illusion* of release.

One should always be drunk . . . Not to feel the horrible burden of time weighing on your shoulders. You should be drunk without respite. Drunk with what? With wine, with poetry, or with virtue, as you please. But get drunk.[7]

The poet yearns to throw off self-possessed subjectivity; it has become a yoke, a hideous prison. But instead of exiting the prison, he wishes it to implode. His self-forgetting swallows reality instead of leading to it. It is subjectivity lunging into its own vortex. It brings only a sham of release and Baudelaire's most lucid poems are spleenatically aware of it.

Of course, it would be unfair to charge subjectivist philosophy for all the ills endured by modern consciousness: anomie, alienation, loneliness, despair, resignation, and so forth. Other social factors contributed to this disappointment with democratic society and technical progress. Industrialization and the rise of large urban centers forced the individual into economic and existential self-reliance. The factory worker works alone, sells his labor force as a single unit. It is not, like farm work or village life, collaborative effort. Rousseau's solitary walker or Baudelaire's *flâneur* are the intellectual counterparts of the economic self-reliant unit that every individual becomes in industrial society. They are of course free to go wherever they please but they must go alone and eventually, as the freedom of being alone wears off and the walls of selfhood grow taller, boredom and anxiety set in.

Balzac's novel *The Wild Ass's Skin* gives a vivid demonic image of this new condition. Its hero Raphael receives a talisman, a pelt with the magic power to fulfill his every wish. Only the skin shrinks a little with each new wish and so, we discover, does the hero's life expectancy. Prisoner of the rawhide, Raphael is thus prisoner of his own life. He can literally see the outlines of his selfhood and they are closing in. The individual is his own hostage. Romanticism, Balzac seems to suggest, is a Faustian pact. Within the skin that is your life, your self, your uniqueness, you may do as you please, dream as you please, fashion your self as you please, believe in what you please. Only there is one thing you may not do, and that is to step outside of your own skin. The ego is stronger than freedom. For nothing, no force or principle, transcends it. Selfhood is thus the new face of slavery. Get yourself a lifetime-guaranteed autonomous

7. C. Baudelaire, "Get Drunk," in *Prose Poems* (1869).

self, say the vendors of individualism. But individualism is actually lonely and fearful and disconnected. In the end Raphael wishes he weren't himself but this, precisely, is the one wish denied him.

The philosophic venture that since the late Renaissance individualized human existence left artists to struggle with the problem of skepticism, that is, the view that reliable knowledge is beyond our grasp. Briefly the problem of skepticism can be stated thus: How, given that I know strictly the world as represented in my mind, can I be sure that it exists as I see it and, furthermore, that it exists at all? Skepticism takes on special drama when directed at other people. For if subjectivity comes from private evidence, if I have learned what it is like to be a self chiefly from my inward personal experience, then how can I be sure that other people too are selves? This doubt has shadowed modern philosophy ever since, with Descartes, it balanced the whole of reality, indeed the fact of Being itself, on an act of private cogitation, "I think therefore I am." The skeptical doubt is unavoidable so long as the principle of our acquaintance with other human beings is assumed to start from the basis of a self-constituted autonomous ego—an ego whose relationship to the world and other beings rests on *knowing* them rather than living among them.

<div align="center">⚜</div>

The epistemological and moral distress of skepticism is illustrated in the tale "The Sandman" (1817) by the German romantic writer E. T. A. Hoffmann (1776–1822). Philosopher Stanley Cavell has convincingly argued that a central theme of romanticism is the gulf between subject and object carved into the heart of being first by Cartesian rationalism, then by German idealist philosophy.[8] Hoffmann's fantastic tale shows that the chasm between subject and object also runs between the self and other selves. Epistemological skepticism therefore has significant bearings on morals. For where the self is cut off from the world by its own autonomous awareness, intersubjectivity becomes merely an appendage, not a cornerstone, of human experience. This is a case where skepticism leads to the denial of fellowship, community, and love.

8. S. Cavell, *In Quest of the Ordinary: Lines of Skepticism and Romanticism* (Chicago: University of Chicago Press, 1988). Also see R. Eldridge, *The Persistence of Romanticism* (New York: Cambridge University Press, 2001). Profitable background readings on German idealism and skepticism include J. Barzun, *Romanticism and the Modern Ego* (Boston: Little, Brown, 1946); L. A. Willoughby, *The Romantic Movement in Germany*, 2nd ed. (New York: Russell & Russell, 1966); and H. G. Schenk, *The Mind of the European Romantics* (Garden City, N.Y.: Doubleday, 1969).

The question as to whether other minds exist will confirm the popular re-
pute of philosophy as a pastime of idlers. To the person of common sense, it
is madness to suspect other people may not be selves—for instance, that they
might be human-shaped machines or imaginary figments. But modern philos-
ophy is a story that began when a thinker locked himself up in a stove-heated
room where he sought to reconstruct reality from pure rational deduction.
The existence of everything is subject to doubt except the fact that I think,
says Descartes. The upshot is that thinking is independent of whether there
is a world. From the standpoint of isolated rationality, of the ego thinking in-
dependently, it is not absurd to question, if not whether other people exist, at
least how I know that they are people.

If I chance to look out of a window on to men passing in the street, I do not fail to say,
on seeing them, that I see men. . . . And yet, what do I see from this window, other
than hats and cloaks, which can cover ghosts or dummies who move only by means
of springs?[9]

The doubt stems from the rationalist reduction of reality to subjective experi-
ence. Descartes does not say, "I see men therefore there are men," but instead
"I see men therefore I do not fail to *say* that I see men." Only by an act of rea-
son, by inner deduction, he avers, can I be certain that the moving silhouettes
I see before me are in fact human beings. This deduction will strike the sensi-
tive person as deliberate to a fault. It suggests that, in a rather paranoid fash-
ion, other people's humanity is a quality about which the "I" needs to be con-
vinced. It thus assumes a fundamental separation between my humanity, the
essence of which I experience immediately and intuitively, and theirs, which
is consequent upon my ratiocination. Mine is self-given whereas theirs needs
elaborating. What, however, happens to other human beings once their exis-
tence is made to hang on an act of judgment? If you are a human being because
I have adjudicated that you are, your humanity is no more substantial than my
decision that you are.

The practical question is whether I can live comfortably in the supposi-
tion that the humanity of my spouse, my children, or my friends depends on
my private deduction. Does not this decision in fact isolate me from the ones
I love—pluck me out of their midst and remove me to a solitary retreat? It

9. R. Descartes, *Meditations on First Philosophy*, 110.

divides humanity in two: on one side, there is the sort of being—me—who has intuitive apprehension of its own selfhood; and, on the other side, are all other beings whose humanity is a by-product of my deduction. I am no longer a denizen of the human world but its silent observer—one may even add, its ruler. For it is only by the grace of the ego's judgment that other people ascend to subjecthood. And that of course is a dangerously flimsy, potentially tyrannical or sociopathological basis on which to rest the humanity of others.

Perhaps it is *reasonable* to wonder whether the figure outside my window is a human being. But reason alone is powerless to supply complete evidence because there obtains no logical necessity as to why, from the intuition that I am a self, I should see that you are one too. I may be psychologically warranted to do so; the laws of probability advocate it; everyday assumptions plumb for it. But just on this account, I am never immune to doubt. Reason is unsure by practice. It reaches necessities but does so by suspending assumptions. On the reason-based matter as to whether the people outside my window are humans, I can always doubt, suspend my judgment, wait for further proof, look into the matter anew.

Here we touch upon a moral matter. Can the existence of other people really depend on my judgment? Imagine submitting this reasoning to the test of social intercourse. What would it be like to *voice* the Cartesian calculation to another person? What should you make of my verifying, double-checking, and ascertaining that you are human? It would rightly be perceived as a piece of slapstick—or, if I persist, the mental gropings of a sociopath. In truth Cartesian judgment about *your* existence is one I cannot submit without insulting or humiliating you. It has to remain unspoken. And a proof concerning the existence of human beings that cannot be put to them has got to be false. If my doubts are warranted on every occasion, then they can be made public on every occasion. That they cannot seems to limit the role of judgment in establishing the humanity of other people.

The error lies in making the existence of other people into an epistemological issue. This error we cannot help making so long as we begin philosophizing from the assumption that human experience is of two kinds: one peculiar to one's own self; the other, derivative of this primal entity, peculiar to others. Tackling the skeptical problem of other people's existence, John Stuart Mill (1806–1873) met with the same problem. He was a thinker aware that Cartesian rationalist philosophy left the "I" on a plane of existence silently separate

from other people and reality. An important task was to bridge this barren chasm and lift the ego out of self-imposed exile.

What evidence do I have that human-shaped creatures are selves? Mill asks. His answer is that I know that others have consciousness by *analogy* to my own case. Analogy recommends that others have thoughts and feelings because they exhibit outward signs that I also display when faced with similar circumstances. To take an example: A friend unfairly berates me. Painful thoughts assail my mind. I become agitated, tears well up to my eyes. This three-step sequence lays out an action (suffering abuse), my mental experience (feeling hurt), and lastly my reaction (crying). Now, Mill says, in situations when I observe other people, the middle link is missing. A bully harasses a child and the child eventually cries. Naturally I have no empirical grasp of the child's inner state. But from my own experience I know distress to be a state intermediary between abuse and tears. I therefore supply the non-observable intermediate link. "Experience obliged me to conclude that there must be an intermediate link," Mill says.[10] For reason advises him to infer the middle "link to be of the same nature as in the case of which I have experience." Hence the axiom: "We know the existence of other beings by generalization from the knowledge of our own."

Now, the argument runs smoothly but it is flawed. It simply does not produce the promised evidence. Mill does not prove that there are minds like his own but only that there exist patterns and mechanisms of behavior that meet his expectations and match his behavior. Nothing, however, guarantees that these patterns aren't mechanical pantomime. A state-of-the-art robot could be programmed to decode abuse and then trigger a crying algorithm in response. Mill's argument from analogy is therefore inclusive deduction; at most it raises expectations of regularity. There is a good chance that the crying child is a human being, but it is only a chance. There may come a day when the child proves to be made of silicon chips. A choice will then arise: on the argument by analogy, I either must conclude that robots are human beings (since the three-step sequence is as seamless and coherent in the little robot as in my case). Or I must retool my theory altogether. For instance, I may decide that I know a creature is a human being when he behaves predictably like me *and* when I have assurance he is of woman born—a definition I will have to

10. J. S. Mill, *An Examination of Sir William Hamilton's Philosophy* (London: Longmans, 1889), chap.12, 243.

revise after the advent of in-vitro incubation. On that future day, I will have to add "biologically human" to the list of human-making conditions. However, should prosthetic medicine evolve to the point of totally outfitting the human body with mechanical parts, I will have to tweak my definition once again to say that a human being is that creature who behaves predictably like me, is of woman born or organic, or originally organic and only subsequently mechanized. In truth the list of restrictive criteria is as open-ended as the future of biological engineering. We may end up with a Byzantine weave of quotas (heart must be 5 percent organic at least, brain must be 10 percent free of bioengineered synaptic accelerators, etc.) that will be arbitrary and reversible. Meanwhile our certainty about the existence of other minds will be no less vexing. Nor does a sense of humanity bound by quotas seem much enticing from the moral standpoint.

Mill's proof by generalization moreover does not allow for this most human of behavior: the incomprehensible, idiosyncratic, absurd reaction. What if the bullied child reacts by laughing instead of crying? Must I conclude that, because he fails to react as I would, he is nonhuman or not quite human ("crazy")? But then on what grounds do I appoint myself the template of human behavior? In truth, generalizing from my own case makes no epistemological or moral sense. Epistemologically, I have no evidence whatsoever that my behavior is fit to measure that of humanity at large. At most I can say that it is *my* behavior, *my* reaction, *my* personal inclination. If I am going to set myself up as the human archetype, I had better be ready to prove how my behavior is exemplary. But this of course cripples my purpose. For then I have to show how *my* behavior conforms to that of others whereas I set out to prove other people's humanity by showing how *their* behavior conforms to mine. To prove someone's humanity by imitating him is a nonstarter.

The moral mistake of generalizing from my own case is obvious. Moral intelligence consists in shifting the center of human life from the self to the other person. It requires suspending one's inclinations, preferences, and interests to perceive other beings in their own light. But Mill suggests modeling other people to my own case, indeed reducing humankind to my psychological stencil. This seems hardly like seeing the humanity in others and much more like narcissistically projecting my image onto them.

Mill's failure stems from the rationalist assumption that isolates the experience of self from the experience of other selves. Under this assumption, the "I"

is a ready-made entity preexisting social experience, immersion in the group, life among the community. Society is simply a contingent attribute of the individual self, an additive that complements the primary "I." This view has since come under thoughtful criticism, for example, from G. W. F. Hegel, who argued that no "I" emerges outside of a dialectic that contrasts its social individuality with the individuality of others;[11] from Martin Heidegger, for whom the self is never given alone but finds itself enmeshed in interpersonal projects and circumstances, in the so-called *Mitsein* or "Being-with";[12] from Ludwig Wittgenstein, who shows that the very structure of private self-understanding is really not private at all but shot through with social systems of language and significance;[13] from Martin Buber, for whom the "I" derives from a primal relation of reciprocity with the "You";[14] or lastly from Thomas Nagel, who demonstrates that the very saying of "I" entails grasping oneself as a "you," "he," or "she" of other speakers, that is, as an objective member of a social world.[15] These, however, are later philosophic developments that released the self from the solipsistic padded cell in which idealist and rationalist philosophy had unwittingly confined it.

Our interest here is to witness a vivid experience of the sensitive solipsist inhabiting the padded cell. Outside the mind, other people seem to be but passing silhouettes in need of humanizing, puppets that wait on the self's judgment to become human. Is it any surprise if, in the drift of an idle moment, the ego begins to wonder whether other people really are people? This doubt breeds suspicions, nightmares, fantasies of aloneness and exclusivity, of living in a world the reality of which is subject to confirmation. These nightmares were long in the making but finally crept into the open during the romantic period, roughly a century and a half after Descartes balanced the whole of human experience on the tapering tip of self-awareness. That it took so long for solipsism to break out into nightmare comes down to two factors. The first is

11. G. W. F. Hegel, *The Phenomenology of Mind* (1807), trans. J. B. Baillie (New York: Dover Publications, 2003).

12. M. Heidegger, *Being and Time* (1927), trans. J. Macquairrie and Edward Robinson (New York: Harper & Row, 1962).

13. The so-called Private Language Argument in sections 243–51 of L. Wittgenstein's *Philosophical Investigations*, trans. G. E. M. Anscombe (Malden, Mass.: Blackwell, 1953).

14. M. Buber, *I and Thou*, trans. R. G. Smith (New York: Scribner's, 1958).

15. T. Nagel, *The View from Nowhere* (New York: Oxford University Press, 1986).

religion, whose influence generally subordinates ego-centered feeling to the greater reality of a nonhuman absolute. The second is the realist consensus that undergirds philosophy before Kant: to wit, the idea that the mind is a receiver doing a generally faithful job of grasping things as they paint themselves on our senses.

The tide begins to change when, in the wake of the Kant's *Critique of Pure Reason* and German idealism, the mind is understood to take much more creative leeway with reality than hitherto imagined. The German idealists in the league of Kant, Herder, Fichte, Schiller, and Schelling now regard the mind as more emitter than receiver. Certainly, consciousness takes its cue from reality, but what appears to us, in the end, is reality rebuilt, retooled, refashioned, reinvented. One response to this new construal is a mood of anthropocentric exhilaration. This is the Byronic, ego-intoxicated, optimistic face of romanticism exemplified in the writings of Herder and Fichte. "The destiny of man is the measure and the goal of all our strivings and efforts," proclaims Moses Medelssohn of the so-called Berlin Enlightenment.[16] "Our concern is not with anything that lies outside you, but only with yourself," Fichte concurs.[17] This is the sort of statement that prompted a thinker like George Santayana to dismiss German romanticism as highbrow plain "egotism."

Another romantic response, however, soon feels the confinement in this inflated entity, self-consciousness, that keeps us apart from reality, henceforth declared an off-limits "noumenon" by Kant. It is the romanticism of Wordsworth and Coleridge, of Hölderlin and Schelling, of Lamartine and Nerval, that aches to fill the gap between mind and world. It is rich in expressions of yearning for what philosopher Charles Taylor calls "epiphanic moments," for holistic reunion, for leapfrogging out of language and into the water of oblivion, unselfconsciousness, childhood, religion, naïve belief.[18] Here the romantic mind dreams of slipping from "the shades of the prison-house" to behold once more "the visionary gleam" of primal nature, of reality regained (Wordsworth). At times, this doubt spawns nightmares of self-entombment,

16. M. Mendelssohn, "What Is Enlightenment?," in *Eighteenth-Century Answers and Twentieth-Century Questions*, ed. James Schmidt (Berkeley and Los Angeles: University of California Press, 1996).

17. J. G. Fichte, *The Science of Knowledge*, trans. P. Heath and J. Lachs (New York: Cambridge University Press, 2003), 6.

18. C. Taylor, *Sources of the Self* (Cambridge, Mass.: Harvard University Press, 1992).

bouts of skeptical madness, the forlorn cries we hear in the tales of Hoffmann, in Poe, or in Shelley's *Frankenstein* (1831). In Hoffmann's "The Sandman," for example, a young man finds that the existence of others is subject to proof, a proof about which he bizarrely needs convincing. In *Frankenstein*, a monstrous human being finds himself having to convince others that he is human. The Hoffmann character asks, "Are others human like me?," while Mary Shelley's wonders "Am I human like the others?" Both are spawns of a philosophy that overstated the case of autonomous self-made subjectivity.

But to "The Sandman." This tale is a centerpiece of the German romantic gothic genre and, ever since Freud devoted an essay to it, a staple of theoretical inquiry into the fantastic. According to Freud, the tale exemplifies a central aspect of his psychoanalytic theory according to which what seems strangest or most frightening to us is, far more than anything new, an element buried in our psyche that was once repressed and now is newly set loose.[19] The following reading of Hoffmann's tale takes no issue with this general assumption. In fact it radicalizes it. For what is strangest or most frightful or most *unheimlich* (literally "unhomely," i.e., uncanny) to the self in this tale is not a repressed aspect of the self, as Freud argues, but the self as such, or, at any rate, the self of subjectivist and rationalist philosophy.

The story's main protagonist (the one whose self is in question here) is Nathaniel, a student. His words begin the novella, characteristically on a statement of human separation: "I have not written for such a long time. But . . . you are all in my thoughts everyday and every hour."[20] Assuming the opening paragraph to set the tone, two themes emerge: the first is separation, anomie, aloneness; the second is the substitution of people by mental images—a trade-off that Nathaniel by no means feels to be second best or lessening. For he continues: "In happy dreams my darling Clara's figure appears before me and smiles at me with her bright eyes as sweetly as she used to do whenever I came into the room" (*S*, 85). The thought of Clara, he breezily states, has no less brightness than the actual Clara. Substitution by the mental image has not dimmed reality. Dreaming is a happy state that wants nothing of the original.

19. Sigmund Freud, "Das Unheimliche" (1919), in *Studienausgabe*, ed. Alexander Mitscherlich, Angela Richards, and James Strachey, Vol. 4: *Psychologische Schriften* (Frankfurt, Germany: Fischer, 1989), 241–74 (and other editions).

20. E. T. A. Hoffmann, "The Sandman," in *Tales of Hoffmann*, trans. R. J. Hollingdale (New York: Penguin Books, 1982), 85.

Could this be a man so used to seeing with his mind's eye that he has lost his thirst for reality? A man whose relationship to others consists in not being among them, but in observing them?

This is the tale in quick strokes. One day Nathaniel is visited by a dealer in optical instruments, a man named Coppola, who incidentally reminds him of a childhood bogeyman called the Sandman. To hurry their children off to bed, Nathaniel's parents used to threaten that, lest they be in bed soon, the Sandman would come and take their eyes away. Young, impressionable Nathaniel held the Sandman in holy terror. He also associated him with an odd, occasional visitor to his father's house, a clockmaker by the name of Coppolius. Considerable alarm, therefore, fills Nathaniel when, now a student at the university, he is called upon by the lens maker Coppola. "Lovely eyes, lovely eyes," says Coppola, touting his spectacles. To get rid of the peddler, Nathaniel hurriedly buys a telescope. Later, he gazes through his new instrument and notices a beautiful girl in the window opposite. It is love at first telescopic sight. He begins a courtship and spends hours talking to the persistently silent beauty. To Nathaniel, she is the paragon of love. No deeper connection has he ever struck with another human being. Then, one ill-starred evening, he discovers that she is not human at all but a wax-covered automaton! Nathaniel sinks into despair, he reels on the brink of breakdown. However, under the nursing of his childhood sweetheart Clara, he slowly recovers. One bright day the couple and friends go for an outing. They climb a belfry tower. Nathaniel takes out his telescope. He aims at Clara standing beside him. What he sees then, whether he sees her far or near, whether he sees her or an image, the reader is not told. But it unsettles Nathaniel so deeply that he goes mad on the spot and leaps to his death shouting "lovely eyes, lovely eyes."

And so dies another romantic casualty, "lying on the pavement," Hoffman writes in conclusion, "with his head shattered" (*S*, 124).

That Nathaniel's head shatters by way of conclusion is no idle detail. It is plain realism. For the demon, the Sandman, I wish to argue, is in fact the hero's head—or, more properly speaking, its significant filling, the mind. Not, however, in the crude sense that Nathaniel has hallucinated the whole episode. On the contrary, the Sandman is all too real. The Sandman is not *in* Nathaniel's mind; it is the fact of Nathaniel's mind, his head.

The Sandman obsession is a childhood fixation. He is, Nathaniel acknowledges, "some quite private association rooted deep in my life" (*S*, 86). Now

privacy of course describes the domestic realm, but its philosophic redolence is also Cartesian, the inner private mental world of the self. "This is mere child-ishness" (*S*, 86), he admits at the outset, and here we must stress that *childish-ness* is a word used to describe not children, but failed grownups, adults specif-ically resistant to the worldly stance of maturity. Childhood offers a realm of mental privacy, fantasy, imagination, the license to indulge a private language independent of shared standards. And this mental privacy, in fact, is what Na-thaniel admits clinging to; most importantly, it is also the root of the Sandman fantasy. Here is how Nathaniel's mother would send her children to bed:

"Now, children, to bed, to bed! The sandman is coming." On these occasions I really did hear something come clumping up the stairs with slow, heavy tread, and knew it must be the sandman. Once these muffled footsteps seemed to me especially fright-ening, and I asked my mother as she led us out: "Mama, who *is* this sandman who always drives us away from Papa? What does he look like?"

"There is no sandman, my dear child," my mother replied. "When I say the sand-man is coming, all that means is that you are sleepy and cannot keep your eyes open, as though someone had sprinkled sand into them."

My mother's answer did not content me. (*S*, 86–87)

First let us note Nathaniel's powerful imagination that, as Hume once put it, liberally spreads itself among facts. Nathaniel really does hear the thud of footsteps drawing near. Does the child put too much store by the power of language? For him in any case, his mother's words have the power to make a sentence come real. Of course, the mother is quick to rouse the child from this misconception, from—one might say—his overly subjectivist disposition. My child, she says, what is meant by the Sandman is that it is time for you to go to bed. Thus the good mother teaches the meaning of a word to her child by showing the real-world, practical, social context in which it is spoken. The child, however, refuses to take note.

Much of the tale turns on this scene of failed learning—that is, on the child's refusal of the socialness of words and ideas.

Here is why. The mother, we notice, does not teach what the word means in itself. She does not give synonyms, for instance, nor does she describe it by evoking the mental states and moods aroused by the word. Her method is neither philological nor psychological. Instead it is situational. She teaches the meaning of "sandman" by describing how the word is used, the circum-stances in which it is spoken, the human context of its occurrence. She acts on

a concept of human understanding that, as Wittgenstein put it, is a "game . . . learned purely practically, without learning any explicit rules."[21] We learn language along with human behavior, through concrete practice, not by theoretical regress and meditation.

Nathaniel's manner, however, is typically contemplative. This is why, displeased ("not content," he says) with his mother's instruction, he stares inward for the meaning of words. To him, language lies not in social ways of speaking and behaving but in the mysterious mental event that brings images to the mind's eye. In short, Nathaniel's idea of language is representational and private. His mother shows him that language is conversational, intersubjective, and context-bound, but Nathaniel clings to the childishness of private mental universes and believes that the meaning of a word derives from his unique consciousness of meaning. To him, for instance, the word *red* certainly does not derive significance from actual situations of learning, such as, for instance, when my mother told me to wear my nice red sweater instead of the blue one, or when I heard on the radio that the Reds were coming, or when a friend teased me about being red in the face. In fact, the word *red* never arises in a vacuum but in a braid of concurring meanings and occurrences, such as "lovely-red-rose" or "icky-red-blood." The meaning of *red* is just the variety of ways in which it is spoken by actual people, *not* the contextless coincidence of the concept "red" with a mental swatch of the said color stored somewhere in the mind. No meaning is self-given and autonomous.

Failing this lesson, Nathaniel rejects the communicative, conversational, intersubjective fabric of language in favor of an autonomous, self-given, imaginative, and representational picture of understanding. Somewhere in the tradition that stretches from Augustine to de Saussure, Nathaniel assumes that a word is made meaningful by the private mental event or "inner picture" that holds it in place.

Given his linguistic idealism, the word *sandman* also has meaning according to the corresponding image of "sandman" floating before Nathaniel's inner eye. I know that whatever the sandman means, Nathaniel assumes it must take the form of a matching image, a corresponding idea of "sandmanness," in his head. "Mama, who *is* this sandman who always drives us away from Papa?

21. L. Wittgenstein, *On Certainty*, ed. G. E. M. Anscombe and G. H. Von Wright (New York: HarperCollins, 1996), §95.

What does he look like?" were his questions (*S*, 86). It is not that the question in itself is nonsensical (there *are* ways of pinning adjectives on the Sandman, tall or short, handsome or humpbacked, etc.); it is just that nothing could have satisfied Nathaniel's question. He wanted a nominal entity, an exact definition, a self-constituted word whose meaning stands apart from how, where, in what circumstances, and to whom it is spoken. Naturally the mother is bound to disappoint this need. It is like asking her to produce her idea of red, to display the redness she harbors inside herself. This cannot be done. And even if it were, through painstaking accumulation of adjectives and synonyms, Nathaniel still could not be sure that he was seeing what she depicted just as, in the grip of referential zeal, one cannot be sure that one's own idea of red is the same as the next person's. This impossibility in fact grinds communication to a stop (given that, for everything that anyone says, I would be susceptible to wondering whether *they* mean what *I* mean, whether, for instance, their inner mental picture for the word *bliss* is not what my mental taxonomy has pegged for "satisfaction," or again that what they mean by "red" is not what I call "purple").

That communication among people, however, takes place in everyday life shows that language in fact does not operate that way. We check the meaning of a word not by looking inward at the matching mental picture it conjures up, but by grasping its operative currency in a given social context, what Wittgenstein calls a "form of life." In other words, we learn how to be human not by reflection, but by participation.

Wrapped up in a Cartesian cocoon of private understanding, Nathaniel's question was therefore mostly rhetorical. He had little interest in what his mother meant by saying "sandman." Instead he was looking for endorsement of his private conviction. This in hindsight casts a new light on his prefatory acknowledgment that the Sandman is the matter of "some quite private associations rooted deep in [his] mind." It is not that the Sandman only exists inside Nathaniel's head; rather the Sandman is the name of a wrong-headed notion of how the mind, language, and intelligence work. The Sandman is the "childishness" of a person who will not wake up to the interpersonal, socially grown-up nature of language. *Indeed the Sandman is the romantic nightmare of solipsism.*

The tale follows from an education gone awry, from a failure of learning how to speak. "My mother's answer did not content me; and in my childish

mind . . . I continued to hear him coming up the stairs" (*S*, 87). Says a friend to Nathaniel: "all the ghastly and terrible things you spoke of took place only within you" (*S*, 95). This sounds like Nathaniel's is merely a case of madness. In truth it is a case of *philosophical* madness, not a fever in the mind, but a feverish misconception about the mind. Madness is more often thought of as an affliction that comes *to* the mind. Hoffmann asks us to consider madness here as the mind itself.

> There does exist a dark power which fastens on to us and lead us off along a dangerous and ruinous path which we would otherwise not have trodden; but if so, this power must have assumed within us the form of ourself, indeed must have become ourself, for otherwise we would not listen to it. (*S*, 96)

Madness, we are told, could not enter the mind unless it found a germane ground in it. Common sense could always ward off the dark power of madness; the reason it cannot is that reason in fact is akin to madness. As Hoffmann puts it, the madness is not *in* the self; rather it *is* the self. The Sandman appearances, as the tale puts it, "are phantoms of our own ego" (*S*, 97), which invites two readings. One is that the Sandman is a creature spawned by subjectivity; the other is that the Sandman is subjectivity. The former holds that the mind sees what it intends to see; the latter concludes that the self therefore beholds only itself.

"The Sandman" therefore stages a nightmare of self-confinement—the dreadful realization that the ego never glimpses beyond its own subjectivity. A cautionary tale, it suggests that there is no way back to the outside world once we assume meaning to flow from an inner personal source. For if a word's significance is set by the intensity of an inner mental image, then communication is a mere afterglow. Whatever we say is a paltry translation of what we mean. This in turn casts a poor light on interpersonal connection henceforth seen as an unfortunate descent into the secondhand, the makeshift, the compromise and corruption of original meaning. In this scheme, our fellow beings seem to be conspirators against the purity of self and one's inner meaning rather than, as the mother wished to convey, the bloodstream of language. The individual intent on purity therefore ought to stay silent. And this in fact is a tale of failed adulthood, of a childish man who had rather stay a child, an infant (Latin *infans*, "speechless," "without language"), a pure autonomous self, than grow up to the corrupting intersubjective speech of adulthood.

In fact, the tale openly voices an advocacy of Pristine Idiocy (i.e., of the romantic defense and protection of the idiosyncratic inner self against social corruption):

Have you ever experienced anything which completely filled your heart and mind and drove everything else out of them? . . . Which transfigured your gaze, as if it were seeking out forms and shapes invisible to other eyes, and dissolved your speech into glowing sighing. Your friends asked: "What is the matter, honoured friend? What is wrong?" And you wanted to express your inner vision in all its colours and light and shade and wearied yourself to find words with which even to begin. . . . Every word, everything capable of being spoken, seemed to you colourless and cold and dead. You sought and sought, and stammered and stuttered. . . . (*S*, 99–100)

Expression vitiates the internal speechless language of the soul. Communication is babble. Thoughts lose their meaning on being spoken. The true-to-self individual is silent. But he is therefore a prisoner. Ego is the shape of his cell. At the height of subjective self-exaltation, romanticism swings into claustrophobia: there is no running away from oneself. This is why the Sandman keeps shadowing Nathaniel into adult life.

Remoteness of reality is a feature of the Sandman. Recall that, in the guise of childhood bogeyman, the Sandman picks out the eyes of children. Making them blind, he deprives them of a sensual connection with the world. Now a young adult's neurosis, the Sandman appears as Coppola peddling telescopes and glasses, perhaps to replace the stolen eyes. "I got lovely *occe*, lovely *occe*!" he says. "Coppola . . . brought out lorgnettes and pairs of spectacles and laid them on to the table. 'Here, here: glasses, glasses, to put on your nose; they're my *occe*, my lovely *occe*!'" (*S*, 109). The Sandman calls his optical wares "eyes." Blurred, then, is the distinction between looking and secondhand looking, between seeing and seeing through.

Hastily Nathaniel buys a pocket telescope and thus acquires a pair of eyes, *lovely occe*, to see with. The Sandman takes people's eyes away, replaces them, and makes you forget the prosthetic switch. Now Nathaniel is poised to mistake remote telescopic vision for embodied vision. Why a telescope? Because, if the sword stands for might and the scales for justice, then by right telescope is the solipsist's emblem. A telescope allows one to see without breaching distance. The observer sees without becoming present to the object. This why telescopic vision only ever sees objects and never subjects. A subject is more than a thing seen, but he by whom one agrees to be seen in return; he

to whom one discloses oneself in the process of knowing him; he with whom one shares a textured continuum of mutual exposure, recognition, and vulnerability. A telescope wipes all this away. It allows one to look at other people with impunity. It makes it possible to peer and peep. But looking at people one-directionally is really to see them as though they were things. *They* are confined to a body whereas *I* can leap out of mine; *they* are enmeshed in space while *I* fly over it; *I* can go up to them but *they* can't come near me. These are the dreams of which solipsism is made: to know the world as though from outside the world; to penetrate reality without being penetrated in return; to know things shrunk to visual objects, a world without presence. Indeed, it is the world of Descartes—a philosopher and scientist known to have produced treatises in optics and mathematical techniques of vision. The Cartesian cogito is born by bracketing out the external world (i.e., I exist by virtue of the act of knowing it rather than by virtue of evidence that I share an empirical connection with reality). It therefore entertains a telescopic relation to reality. The world is not the enveloping fabric of being, instead it is an image flickering at the other end of my telescope-like cognition. But the question arises regarding what happens to other people when they appear at the far end of my tele-vision. "The Sandman" stages a lively answer.

On first looking through the telescope, Nathaniel beholds Olympia, the beauty in the window across the street.

He had never in his life before handled a glass which brought objects to the eyes so sharply and clearly defined. Involuntarily he looked into Spalanzani's room: Olympia was, as usual, sitting before the little table, her arms lying upon it and her hands folded. Only now did Nathaniel behold Olympia's face. The eyes alone seemed to him strangely fixed and dead, yet as the image in the glass grew sharper and sharper it seemed as though beams of moonlight began to rise within them; it was as if they were at that moment acquiring the power of sight, and their glance grew ever warmer and more lively. Nathaniel stood before the window as if rooted to the spot, lost in contemplation of Olympia's heavenly beauty. (*S*, 110)

This is not just a case of love at first sight. It is love *by* sight, and accordingly yields only images. Nathaniel falls in love with a remote object. And this basically nullifies love. Indeed, only the grammar of "I love you" takes the form of subject-verb-object. In reality, loving you means that you are not the object of my love; rather my love awakens to your being a subject. Whereas Nathaniel peeps: he sees without being seen; he captures without being captured; he

pierces through to Olympia without being pierced in return. He is the consummate dilettante lover who marvels at his own infatuation, the Faustian stroke of the magic wand by which the mind galvanizes its surroundings. Olympia's eyes, Hoffmann says, "were at that moment acquiring the power of sight." The subjectivity he sees is really his own for she exists only *in* his knowing that he is looking at her. Whereas there are no images in true love, Olympia exists only in his image; she is a miniature creature in the orb of a telescopic abstraction. Thus solipsized, it matters little whether she is a real girl or, as it later transpires, an automaton.

Of importance is that the objective reduction of another self cannot fail to occur once the existence of other people is made to be an object of knowledge, that is, once epistemology replaces love in the human experience. There is no need for me to emphasize how Nathaniel's "invention" of Olympia coincidentally stages the scene in Descartes's study where the philosopher "look[s] out the window at the men crossing the street," wonders whether robots could be concealed under the hats and clothing, and decides in the light of his private judgment that they are human beings after all. The ego appoints itself giver of the humanity of others. In the same vein Olympia is human because Nathaniel wants to see her that way; she is made human by his judging that she is so. Literally. Thus literature makes philosophic ideas concrete.

Nathaniel hangs on to his telescope throughout the tale. This is why the telescope returns at the end of his life—because mentally he never outgrows the telescopic vision of solipsism. Just as he was unable to accept the publicness of language (i.e., the fact that it gets meaning from being multiply spoken), so he cannot accept the publicness of his subjectivity. Being seen, taking his place among others, being present—these are beyond his psychic resource. Nathaniel keeps to the paralytic recoil from reality that typifies a childhood stage.

Children take refuge in dreams and images because the inner world is the only realm they can control. In the real world, they are physically defenseless before the giants who seem to inhabit it. Imagination is needed to boost their stature because the world dwarfs it. Now, part of growing up consists in dismantling this early ego-colored map of the world. An adult who escapes into fantasy is suspect not because he possesses a rich imagination, but because of his psychological timidity. Not that adults make no use of imagination. Only they use it for diametrically opposed purposes. Thus the mature artist deploys his imagination to see through social assumptions; the scientist indulges day-

dreaming to leap beyond conceptual boundaries; the philosopher seizes on the flash of illumination to unveil reality anew; the loving person, the ethicist, the psychologist, or the friend imagines himself into the life of other beings to understand them better. These are instances where imagination leads into, not away from, reality.

Romanticism pendulums between these two poles of imagination. The childish Byronic genius of romanticism trumpets man's isolation, his imaginative power to transfigure the world. The mature genius, on the contrary, yearns to surmount this self-imposed exile and assents to the world with openness and attention—with, in Wordsworth's phrase, "wise passiveness." Between these two stands yet a third disposition, formalized by the fantastic tale. The fantastic mode perceives the stuffiness of selfhood but feels greater horror at leaving it. Its overriding fear is *disappointment*: it understands the need of overcoming subjective imaginings but dreads facing a disenchanted world, a world in dull tones, unlivened by spirit. Is that all there is? Is there no more to reality than just reality? Hoffmann dramatizes this recoil from disappointment in the story of Nathaniel's infatuation with Olympia, on the one hand, and his longtime affection for the real flesh-and-blood Clara, on the other. The fantasy of Olympia is clearly avoidance of Clara. Olympia is mystery, dark magic, spirit; whereas all there is to Clara is the fact of Clara. Nathaniel cannot accept that reality is all there is, and that it exists apart from us. Call it the dodging love—where love means awakening to the separateness of reality.

Indulging this avoidance, Nathaniel fails to see that Olympia is only the artifact of his telescopic vision. "O lovely, heavenly woman!" he croons. "O heart in which my whole being is reflected" (*S*, 114). Of course Olympia reflects his whole being because there is no more to her than his imagination. His love, like his language, is a monologue—which means it is neither love nor language. Indeed, Hoffmann's subtle aim may be to dramatize the foolish tragedy of the romantic poet, that is, the poet who perceives the world as in need of shaping rather than being seen.

From the profoundest depths of his writing-desk Nathaniel fetched up everything that he had ever written: poems, fantasies, visions, novels, tales, daily augmented by random sonnets, stanzas, *canzoni*, and he read them all to Olympia without wearying for hours on end. And he had never had before so marvellous an auditor. . . . She sat motionless, her gaze fixed on the eyes of her beloved with a look that grew ever more animated and more passionate. (*S*, 117)

The Greeks had a figure for the personality fatally unable to glimpse beyond himself. Narcissus was the name of this shortsightedness. Eventually, like Narcissus, the youth in Hoffmann's tale comes head to head with his own solipsism. Olympia is an automaton. Faced with the reality of his solipsism, Nathaniel sinks into mental chaos. This breakdown is susceptible to two readings. One is that Nathaniel grasps the horrifying extent of his solipsism; the other is that is his mind shatters against reality. In the former case he shrinks from the excessive power of his mind; in the latter he recoils at reality's nonconformity to his fantasies. Whichever the case, Nathaniel recovers enough to see his error and, it seems, to die from it.

Now in convalescence, Nathaniel enjoys the fine view from the top of a bell tower in the company of his sweetheart Clara and friends. Reaching into his pocket, Nathaniel finds the old telescope. Nathaniel oddly turns his telescope, not to gaze into the distance, but at Clara at his side. "Lovely *occe*! Lovely *occe*!" he suddenly calls out and in the moment's madness, leaps to his death. What did he see through the telescope? Reality at a remove? The impossibility of escaping one's vision? The realization that perception comes incurably short of the perceived? That the mind stands guard at the gateway of reality? That connection with another real human being is impossible so long as subjectivity proceeds from the autonomous self alone? The answer lies in Nathaniel's splattered remains. But of this we are sure: the ground of reality is tougher than his head.

<div align="center">⟡</div>

Is this a cautionary ending? Do we all break our heads against reality? Hoffmann appends a moral epilogue to his tale. Nathaniel's madness, we are told, is a madness to which we are all liable. It affects anyone with a mind.

> The minds of many esteemed gentlemen were still not set at rest: the episode of the automaton had struck deep roots into their souls, and there stealthily arose in fact a detectable mistrust of the human form. To be quite convinced they were not in love with a wooden doll, many enamoured young men demanded that their young ladies should sing and dance . . . , that they should not merely listen but sometimes speak too, and in such a way that what they said gave evidence of some real thinking and feeling behind it. Many love-bonds grew more firmly tied under this regime; others on the contrary gently dissolved. "You really cannot tell which way it will go," they said. (*S*, 121–22)

"Mistrust of the human form" is a fine name for the disease of doubting the existence of other selves. Mistrust of the human form is mistrust of humanity;

it is also failure to face the hard labor of walking the social maze. The skeptic wants proof; he chooses certainty over trust. Can the social bond survive this despotic demand for certainty? Can it outlive the end of trust? "You really cannot tell which way it will go," Hoffmann coyly says. Some love bonds grew stronger from applied skepticism; others crumbled. "Show me that you're human" can thus be a key *or* an antidote to love. It can be a key because love is after all the affirmation of one's humanity by another being; and it can be an antidote when we imagine being in a position to extort this proof from another person. The lover who demands that the beloved prove her humanness severs the bond of humanity. For humanity is not an object inherent in you or me; it is the fact of our mutual engagement. Humanity lives between two persons; just for this reason it cannot be incumbent on just either one to produce it.

<div align="center">⚜</div>

A further lesson for the critic. "You really cannot tell which way it will go" is a caveat against drawing too neat a lesson from the tale. If humanity is beyond demonstration, so must it stand beyond Hoffman's demonstration that it is beyond demonstration. If anyone could nail the case of humanity, he perhaps would transcend it. Being human places one among others. It is occurrence, not definition. To define it would be like leaving it. You really cannot tell which way it will go because you are traveling with it.

CHAPTER 5

A Church of One

"The individual" is the category through which, in a religious respect,
this age, all history, the human race as a whole, must pass.

Kierkegaard

RELIGION IS COMPATIBLE with nearly every philosophic disposition except solipsism. For the essence of religious belief is the insight that an order of reality outside the mind absolutely exists. God, Brahman, Tao, the Universal Being, the Oversoul, Truth, Love: whichever the object of worship, religion entails a deeply felt conviction that reality exists in its own right; that it has an authority, dignity, and value independent of our interests and feelings; and that man finds quiescence in orienting himself to this immensity that exceeds him. A religious person who believes only in himself is, plainly put, an oxymoron.

Not least among the magic strokes of the Individualistic Age is to have made this oxymoron acceptable, even to the religious. Religion under the reign of individualism should die—in this, Nietzsche was right: an age that sets only man at the center of life has no room for awe. That religion survives in our time—indeed, that it thrives in cultures otherwise given to the cult of self—shows that religious institutions have proven extremely adaptable, in this instance, by adjusting to spiritual circumstances wholly adverse to religious feeling.

At the heart of religion is love, that is, loving acceptance of a being beyond oneself. A mother does not ask why she loves her child; she need not thicken her piety with reasoning. No mother doubts that her baby exists; that its existence commands care and acceptance; and that her whole being is the instrument of this loving acceptance. The same, it seems, obtains for the religious person. Like the mother, the believer is overwhelmed by the reality of the world. In normal circumstances, this feeling is accompanied by apprehension of self-loss, fear, anxiety, or cowering self-regard. But not with love; love turns the psychology of fear on its head. Instead of dreading obliteration, the loving person welcomes being displaced from the subjective center of reality. There is no true love without some self-sacrifice. For love loosens the narcissistic stronghold and concedes to a force greater than self-centeredness.

The genius of the religious revolution known as the Reformation consisted in seizing upon the inward turn of subjectivity in Western culture—its emphasis on the autonomous self—and making it work for religion. What, the likes of Descartes and Kant asked, is greater, more mysterious, deeper, more absolute than the everyday self? Their answer was the deep self, the light of consciousness, unconditioned and uncreated. The Reformation turned our need for mystery and reverence inward, away from the heavens—burying divinity deep in a haze of sanctity inside the self. Do not seek God in the heavens or the church, in plaster saints or miracle-mongers; do not seek Him in externals, the Reformation said. Seek Him in your own heart, the light within, your own understanding, the Word as you understand it, the Scriptures as you interpret them, the inner voice that cannot lie. The Reformation wrapped the self in a nimbus of irrational respect. It devised a way to channel love—which is acceptance of the other—toward the other within, that is, the source of consciousness. In truth, modern philosophy seems, inasmuch as its chief heralds breathed the air of Protestantism (Descartes, Locke, Hume, Rousseau, Kant), a rationalistic validation of the Reformation to produce a self, as Kant put it, filled "with ever-increasing wonder" for the infinity within.

A modern philosopher who cross-justified the spirit of the Reformation and philosophic individualism is Sören Kierkegaard (1813–1855). True to the subjectivist ethos, Kierkegaard is not interested in the standard Socratic aim of philosophy that consists in justifying beliefs; his purpose is rather to tell the tale of what it feels like to entertain a belief. Among philosophers, Kierkegaard particularly detested Hegel. To him, Hegel was a hypocrite: he claimed to fol-

low step by step the experiential subjective development of consciousness, but in actuality he rolled it all out from sub specie aeternitatis. A dialectic progress that is surveyed is no genuine dialectic. To be true, it must be lived through; indeed, the truth of subjectivism is experience.

And experience is what, in fact, Kierkegaard gives his reader. Thus his existential-theological meditation *Fear and Trembling*. In it, Kierkegaard imagines Abraham as he journeys to Mount Moriah to sacrifice his son Isaac. The reader is invited to follow the patriarch's steps, to think his thoughts, to share his wranglings of conscience, his trembling progress. Like many theologians, Kierkegaard wonders why a God of goodness should demand such an appalling deed. Why would God ask Abraham to violate the bounds of human love, filial attachment, and moral goodness to fulfill his religious duty? Kierkegaard gives an original answer: God is infinitely beyond human understanding; therefore true faith must require breaking with the ways of man. Faith is a mysterious connection between the soul and the divine. It cannot be explained in terms of reason, science, knowledge, morality, laws, indeed by none of the customary social ways. It is, in Kierkegaard's term, a "suspension of the ethical." By contrast he who bases his faith on reason operates within the confines of human-centered intelligence. That person is not in contact with the divine. If, Kierkegaard argues, I have good reasons to believe in God, I am no longer a believer but a schemer. In truth, God is inscrutable, infinitely greater than human understanding. Hence the truly holy man, if he is to partake of God, must become unintelligible to reason and human norms. By agreeing to kill his son, Abraham is an abomination to the ethical norms of human society. But just this breakdown between society and individual, Kierkegaard holds, is the sign of the divine. It is this unintelligibility of Abraham to himself and society that makes Abraham an exemplum of religious faith. The starker his break with the ways of men, the closer he walks in God.

Because it isolates the believer, faith is therefore a climax of private subjectivity—so bottomlessly subjective that, like madness, it breaks with the rules of intelligibility and social fellowship. No longer is religion a bind that ties people together. Rather, it shatters mutual understanding. No people of God do we find in Kierkegaard, but instead the loner, the visionary, the patriarch who makes no sense to his own flock.

Thus Kierkegaard synthesizes the Cartesian first-person privilege together with religious experience. In the process, he internalizes God—a turn that

probably would have bewildered Descartes himself. Remember that, in Descartes's "Third Meditation," God is finally called up to rescue the ego from solipsism. Having established the primacy of the first person, Descartes quickly finds himself spiraling inward: Does the world really exist? Can I be sure that knowledge matches reality? God comes to save the ego from self-engulfment: Descartes can rest in the conviction that, were he the only thing in the world, he would therefore be perfect, since he would be the world; but then he would have omniscience; however, since he obviously does not know everything, he is clearly not God, hence God must dwell outside his mind; and therefore something exists outside the mind, that is, the world.[1] The external certainty of God's existence is, in Descartes, the magnetic force that rescues us from the centrifuge of all-out solipsism.

To Kierkegaard, on the contrary, the mystery of God is not so alien to human consciousness. Indeed, it cleaves closer to the mystery of subjectivity—its depth and inscrutability, the well of noncognitive, prelinguistic, prerational, speechless, innermost selfhood—the part of the self wherein subjectivity is so densely packed and concentrated that no critical distance, certainly not the distance of reason and observation, holds sway. God speaks out of my depths where I am not even myself. From there He can make me do the most unaccountable things—like killing my beloved son.

Now of course in the end God's angel stays Abraham's hand. This reprieve suggests that, for all his terrible might, Jehovah abides by what is humanly sensible. But Kierkegaard is not interested in the outcome of the parable. What matters is that Abraham proved willing to carry out the unconscionable; what matters is that Abraham the man could not know that God would spare his son in the nick of time. So while he prepared the sacrifice, he was in effect willing to commit the unconscionable, to destroy morality, become unintelligible to his own paternal feelings, against the ties of human fellowship. This subjective centering or privatization of faith is true religion. "It is subjectivity that Christianity is concerned with, and it is only in subjectivity that its truth exists, if it exists at all; objectively, Christianity has absolutely no existence," Kierkegaard maintains.[2] Religion does not dwell in institutions, church services, symbols, temples, and hymn books. It is not a feature of the world but of

1. R. Descartes, *Meditations on First Philosophy*, 127.

2. S. Kierkegaard, *Concluding Unscientific Postscript*, trans. D. F. Swensen (Princeton, N.J.: Princeton University Press, 1941), 116.

consciousness. Thus religion cannot open the self to an external reality since religion is the subjective itself. All it can do is entrench the self, indeed isolate it further (as it does to Abraham). Kierkegaard, like Kant before him, falls in awe with the spiral of reflective consciousness. Before its own abyss, subjectivity trembles. The self has, in a sense, become its own place of worship and it is scarcely clear whether the deity now is the infinite outside or the infinite inside.

The Knight of Faith obeys God for no reason. So long as we give ourselves reasons for acting, we remain in the purview of social understanding. If Abraham truly steps outside socially conditioned facts and values, he therefore acts for reasons he cannot articulate. He is unaccountable to himself—an idiot in the ancient Greek sense. But just this idiocy, Kierkegaard would argue, defends his purity and freedom. The believer acts in what Kierkegaard calls "objective uncertainty": in the absence of empirical or moral evidence to back his belief. He simply throws his lot with God and this renunciation of reason makes him heroic—an acrobat foregoing the safety net, a brave subjectivity forging on alone without the crutch of society, ethics, indeed reason itself. Nietzsche, no less allergic to mob mentality, similarly praised the value of an action on its escape from socially or rationally justified causes.

The decisive value of an action lies precisely in what is *unintentional* in it, while everything about it that is intentional, everything about it that can be seen, known, "conscious," belongs to the surface and the skin.[3]

Of course, it is not clear how unintentionality can be "the decisive value of an action." Value is by definition what we prize in a scheme of what matters and what does not on the basis of human uses and purposes. It is therefore intentional. So Nietzsche is simply saying there is value in valuelessness—wherein, as in Kierkegaard, it is not hard to discern the aristocratic dislike for herd mentality, conformism, mass thinking, indeed the grey pusillanimity of a commercial age from which the romantic hero desperately tried to stand out.

Kierkegaard gives a more explicit turn to this reflection in his *Concluding Unscientific Postscript*. There, he reiterates the notion that faith without individual passion—without a personal upheaval of the soul—is as good as dead. Were the proof of God or of the Gospels established as an irrefutable fact of

3. F. Nietzsche, *Beyond Good and Evil*, trans. Walter Kaufman (New York: Random House, 1966), §29.

natural science, religion would still stir our interest; but it would be only a scholarly, or historical, or anthropological pastime.

When the [religious] question is treated in an objective manner it becomes impossible for the subject to face the decision with passion, least of all with an infinitely interested passion if at all. [And] if passion is eliminated, faith no longer exists, and certainty and passion do not go together. (*CUP*, 26–35)

If it is a fact that God exists, He exists whether or not I believe it. But if the existence of God is not a fact but a conviction, then it requires my never-ending dedication and attention, what Kierkegaard calls "the infinite need of a decision" (*CUP*, 35). The reality of God needs our commitment to become truly real. The energy must run from me to God. In empirical reality, by contrast, it runs in the opposite direction. For instance: I wake up with a high fever; this is a fact. To this fact my behavior has to submit. But just for this reason, this contact with reality is, in Kierkegaard's view, only half-interesting. Anything that imposes itself on subjectivity, anything that has the first and last word over us, anything that indubitably *is*, indeed anything that leaves the subject with no recourse but acceptance, that thing or event does not carry the full flavor of reality. This is because reality is, in Kierkegaard's prototypically modernist view, not a matter of *what* but of *how*. Experience of reality is of a piece with reality: the more intense the degree of subjective activity, the greater the degree of reality. In other words, there is no reality but the experience thereof. On this account, acceptance is not an adequate experience. By "adequate experience," Kierkegaard means the productive shaping and processing of facts. Reality does not want our submission but our active, participative affirmation. Only then is it real. And subjectivity becomes identical with fact. Thus:

When the question of truth is raised in an objective manner, reflection is directed objectively to the truth, as an object to which the knower is related. Reflection is not focused upon the relationship, however, but upon the question of whether it is the truth to which the knower is related. If only the object to which he is related is the truth, the subject is accounted to be in the truth. When the question of the truth is raised subjectively, reflection is directed subjectively to the nature of the individual's relationship: if only the mode of this relationship is in the truth, the individual is in the truth, even if he should happen to be thus related to what is not true. Let us take as an example the knowledge of God. . . . (*CUP*, 177–82)

Notice that at this stage religion is summoned only as an example of a broader epistemological theory. Kierkegaard starts with the idea that all truths should

have the passionate lived quality of religious experience; by the end, however, the religious modality of truth is a mere case, not the archetype, of this general subjectivism. All truth is passion. It stands and falls with the intensity of the psychic energy that believes it: "A definition of truth: an objective uncertainty held fast in an appropriation-process of the most passionate inwardness is the truth" (*CUP*, 182). Thus a crank who believes passionately that pigs can fly has a more genuine truth experience than the scientist who, on grounds of generally (albeit impersonally) accepted principles, maintains that pigs are earthbound. The crank is sincere, and therefore praiseworthy; the scientist is blandly honest.

Kierkegaard attempted the impossible by combining subjectivism and religion. Subjective relativism is, roughly put, the notion that all truth is related to the subject who perceives it. Facts exist not outside, but in the act of expressing them. A statement is true to the extent that it is convincing, passionately felt, and powerful enough to reshape our understanding. "Subjectivity is the truth" (*CUP*, 178). Of course, this new notion is immensely flattering. God exists so long as I keep my eyes on him. I am a partner to the divine. But applying subjective relativism to religion nevertheless makes hay of religion. It empties religion of its vital source, reality—that is, the sense that something absolutely larger and more powerful than the self exists. For an ultimate reality that exists only because I give it my attention is reality no more. At the basis of religion is the insight that the subject is a part and not the whole; that the aim of human life is to get the part to mirror the whole. The individual life is not an end in itself and whoever thinks so mistakes an infinitesimal speck of the universe for the universe itself. To be sure, our ability to conceptualize and imagine the infinite reality is a great feat, but it is no cause to think that the mirror is larger than the object—especially since reality is not an object but also the stuff of which the mirror is made. "I exist" says the rational self; "I exist by grace of a world, a nature, a universe of which I am a part and which sustains my existence" says the religious mind. Indeed, religion is the love of fact: that the world exists, that it precedes and outlasts my existence, that it is. "I am that I am" says God. This, should reality speak, would be its word. And it states nothing but that being is: the irrevocable, immensely powerful fact of it to which subjectivity is infinitely second.

Of course, all perception is relative to a standpoint. In this respect, truth indeed is the subjective. But perception is *of* something. The religious spirit

holds fast to this tiny particle "of" that connects us to what we cannot know as a whole. But just because we only see mirrored images of reality does not oblige us to fall in love with the mirror. Worshipping go-betweens and intermediaries is the office of cult—a reason why Kierkegaard, by turning God into the subjective, also turns religion into cult. And the beneficiary of this cult is of course the self—since it is a fixture of cults to pander to their practitioners, to soothe rather than enlighten, to bolster rather than edify. Kierkegaard is rightly said to be the father of existentialism whose essential meaning, Jean-Paul Sartre says, is that "it is impossible for man to transcend human subjectivity."[4] It should be of interest to existentialists, however, that this impossible transcendence of subjectivity by subjectivity originally tested itself out (1) as an article of faith, and (2) to exalt religious faith. Faith in subjectivity becomes modern faith—the religion of modernity. At any rate, Kierkegaard performs the stunning trick of turning religion on its head. For when religion rests on subjectivity's own immanence (i.e., its inability to transcend itself), it may also be said to rest on the nonexistence of religion. Kierkegaard's genius lay in spinning the nonexistence of religion into a religious emotion.

4. J.-P. Sartre, *Existentialism*, trans. Bernard Frechtman (New York: Philosophical Library, 1947), 19.

CHAPTER 6

"And Zarathustra saw that he was alone"

There was in him a vital scorn of all . . .

He stood a stranger in this breathing world . . .

So much he soared beyond, or sunk beneath,

The men with whom he felt condemned to breathe.

Byron, *Childe Harold*, Canto 1.6

KIERKEGAARD'S ABRAHAM has only inner passion to justify him. The strength of his devotion answers for its validity. His chief virtue is sincerity— he heeds an inner calling no one understands and everyone frowns upon, yet he is true to himself. Abraham is really a romantic soul: at odds with society but faithful to his own light, wholehearted, committed to living out his subjectivity.

It is often said, correctly, that romanticism put forth no consistent system of beliefs, no single political vision, no unified system of morals. A romantic can be a monarchist like Chateaubriand, or he can be a Whig like Byron, or he can be both like Hugo; he can be an antiquarian and a futurist; a lover of change and a lover of tradition. In truth he can believe almost anything he wants because romanticism, unlike the Enlightenment, is less defined by a set

of arguments and ideas than by an emotion: how *truly*, not *what*, he believes defines the romantic soul. The emotional purity of a belief trumps its validity. Stendhal's man of "virtu," for instance, is emphatically not one who is possessed with an Aristotelian pedigree of civic qualities. Values are no longer assumed to exist objectively and independently of one's passionate interest but rather the opposite. The intensity with which a cause is argued or followed speaks for its worth.[1] Of course, the goal may be contemptible or nefarious, the enterprise may come to naught, but a romantic always feels a shiver of admiration for the man who blazes his own trail, stays true to his heart's vision, and turns down compromise.

Take an example. A throwback to Aristotelian ethics, the heroine of a Jane Austen novel marries a suitor after he is found to have the right virtues (fairness, honesty, courage, moderation). Love arises from moral pedigree. It is anything but blind. This contrasts sharply with the romantic Catherine of *Wuthering Heights* (1847). She happens to love a man whose chief virtue is to be loved by her. The emotion of love lends virtue to the beloved, however repellent, cruel, and unlikable he may be. To the romantic soul, the Austenian heroine seems a dowdy conformist. The virtues she prizes are stock features of the landed gentry. Although not a hypocrite—since she truthfully admires these values—her destiny is nonetheless to take her appointed place in the world, not to invent it. By contrast, Catherine sails by bearings of her own creation. The outcome may be quite unhappy, as it is for Isabel Archer of Henry James's *Portrait of a Lady*, but at least she indisputably has had a life of her own. And this, in our world of emotional individualism, is the hallmark of a successful life. "To thine own self be true" has come to mean striving not after a difficult truth, but after a defiant self-creation. This transvaluation throws truth out of hinge. No longer understood as an adequate match with reality, truth is expression. That thing is true that is originally spoken, sincerely voiced, and freshly created. This is the aestheticization of truth, the "ideology of the aesthetic," that earmarks the modern mind-set.[2]

To modern understanding, the human mind has a more ambitious purpose than just to mirror facts. Those are there to be shaped, not bowed to; conventions are there to be twisted; things are thereto be questioned; facts are there

1. Thus A. McIntyre describes our descent from Aristotelian value ethics to emotionalism in *After Virtue: A Study in Moral Theory* (London: Duckworth, 1981).

2. T. Eagleton, *Ideology of the Aesthetic* (New York: Blackwell, 1990).

to be overthrown or remodeled. Life is struggle, dynamic, change, progress. In former days, the hero sacrificed his rich inner life to fealty, duty, the call of others (Hamlet). Now he is heroic by sticking to his subjective calling, no matter what may come. Stubbornness, persistence in the face of sense, takes on righteous prestige (cf. Sophocles' Antigones with the Antigones of twentieth-century playwright Jean Anouilh). Consequently the modern hero who surrenders to social obligation, from Balzac's *Eugénie Grandet* to Wharton's *Ethan Frome*, savors of wasted life. Selflessness is a step short of self-betrayal—unless the hero's altruism flies in the face of conventional wisdom or battles formidable odds, in which case its very irrationality is an assertion of laudable individualism (this is the case of Dr. Rieux, the hero of Camus's *The Plague*).

Friedrich Nietzsche (1844–1900), for one, filed *all* acts of selflessness under the rubric of devious self-promotion. The Nietzschean cardinal sin is not self-love, but failure to act on self-love.[3] Self-affirmation is the new virtue. It is the principle of life itself, the organic pulse of generation, expansion, reproduction. Just as a plant reaches up for maximum exposure to sunlight, so a human being, as a biological organism, should organize his values to enhance the consummation of life. Man in Nietzsche's naturalistic view is primarily a physical being, one hardwired for biological self-interest. All the niceties of civilization are ways either to conceal or to make this stark biological reality presentable. So unshakable is this instinct that even the effort at resisting it harbors self-promotion: those Christians who preached love to their Roman masters actually sought to weaken them, Nietzsche says. But their moral crime, in his view, was not to have contrived the demise of their oppressors; it is to have done it under the pretense of brotherly love. Preaching benevolence was a ploy of self-assertion, and therefore positive; but believing this ploy assumes a denial of self that is contrary to nature. And—Nietzsche hammers on—no failure is uglier or more depraved than the failure to assert oneself.

Nietzsche's youthful reading of Schopenhauer looms large in his vitalist philosophy. In Schopenhauer, Nietzsche glimpsed visions of organic life streaming through all things, indomitable, eternal, indefatigable, a life energy that makes the tree grow, the cloud burst, the lion pounce, and humans strive: "that will itself, the will to power, the unexhausted, procreating life-

3. F. Nietzsche, *The Genealogy of Morals* (1807), trans. Walter Kaufman (New York: Vintage Books, 1989).

will."[4] To this cosmic efflorescence Nietzsche mixed in the stuff of biological science, of a materialist outlook which, from La Mettrie's *L'homme machine* (1748) to Victorian phrenology and Darwinian natural selection, was growing ever more assertive in its idea of the human being as an offshoot of the natural world.[5] George Combe's astoundingly popular *Constitution of Man* (1828) maintained that man is a system of physical laws as inflexible and regular as the dropping of an apple from a tree. "We have a nervous system but not a soul," says Nietzsche.[6] The ruling assumption is that anything not verifiable by empirical sample must be declared nonexistent. A nervous system can be dissected; behavior can be measured; the will manifests itself in action: this is the stuff of reality and, as behaviorists would begin to say some fifty years later, there is no cause to assume the existence of a ghost in the machine. Like Ludwig Buechner in his influential treatise *Force and Matter* (1855) and Darwin in his *Origin of Species* (1859), Nietzsche sees the world moving by immanent mechanical laws. Man is no exception to these laws. We are born, live, reproduce, and die as biological entities—our urbanity and industry, our art and customs, cannot conceal the intelligent mammal beneath it all. Any sound philosophy, Nietzsche maintains, must therefore start from the realization that the belly must be fed before the head can think; and that, consequently, the head is liable to think thoughts that are conducive to keeping the body filled and happy. In general terms, the faculty of thought is ancillary to certain vital requirements of survival and well-being. To Nietzsche, this means that the mind is likely to approach reality in terms of human needs, rather than through rigorous objectivity.

What are Nietzsche's arguments for naturalizing the mind? "'Thinking' as

4. F. Nietzsche, *Thus Spoke Zarathustra*, trans. R. J. Hollingdale (New York: Penguin Books, 1961), 137

5. On Nietzsche's biologism, see G. Moore, *Nietzsche, Biology, and Metaphor* (New York: Cambridge University Press, 2002); and W. Müller-Lauter, *Nietzsche: His Philosophy of Contradictions and the Contradictions of His Philosophy*, trans. David Parent (Urbana: University of Illinois Press, 1999), 261. Even those like Heidegger who argue that Nietzsche aims at not applying science, but uncovering its metaphysical underpinnings, in the end admit to Nietzsche's reliance on nineteenth-century scientific biology. See M. Heidegger, "Nietzsche's Alleged Biologism," *Nietzsche*, vol. 3, trans. Joan Stambaugh, David Farrell, and Frank Capuzzi (San Francisco: Harper & Row, 1981).

6. Cited in M. Horkheimer, "The Soul," in *Critique of Instrumental Reason*, trans. Matthew J. O'Connell and others (New York: Continuum, 1994), 57.

epistemologists conceive it, simply does not occur: it is a quite arbitrary fiction."[7] By this Nietzsche means that thinking is no ethereal nimbus indifferent to practical matters. Indeed, like a muscle or a blinking eyelid, thinking is one of the devices by which we cope with the given. Consciousness thus exists primarily not in order to think (thinking is not an end in itself, Nietzsche insists) but in order to ensure survival of the host species:

Our intellect is a consequence of conditions of existence: we would not have it if we did not *need* to have it, and we would not have it . . . if we could live otherwise. (*WP*, 273)

We have senses for only a selection of perceptions—those with which we have to concern ourselves in order to preserve ourselves. Consciousness is present only to the extent that consciousness is useful. (*WP*, 275)

Because consciousness evolves out of practical action, it follows that it is therefore not free and open, but focused and prudential; by design we only think what is useful to the well-being of our organism—what we need to think in order to thrive:

There exists neither "spirit," nor reason, nor thinking, nor consciousness, nor soul, nor will, nor truth. . . . There is [only] a question of . . . a particular species of animal that can prosper only through a certain relative rightness. (*WP*, 266).

This emphasis on performance leads Nietzsche to show little patience with such ontological questions as to whether thinking can have a true grasp of the world. To him an idea is correct not when it matches the world, but when it successfully makes use of it. And that is because the mind is not designed to know things in themselves, but to arrange the world in such a way that it is safe and convenient to live in.

This pragmatic epistemology was actually formulated first by Fichte some eighty years before Nietzsche. "We do act because we know," Fichte says, "we know because we are called upon to act."[8] To Fichte, the practicality of consciousness did not really compromise its transcendence. But Nietzsche does not shrink from materialism. Not only knowledge but also the mind is a by-

7. F. Nietzsche, *The Will to Power*, trans. Walter Kaufman and R. J. Hollingdale (New York: Vintage Books, 1969), 264.

8. In I. Berlin, *The Roots of Romanticism* (Princeton, N.J.: Princeton University Press, 1999), 89.

product of expediency. There is no will to know apart from the Will itself. Consciousness is no window onto the world; it is simply a tool that reflects our needs and intentions.

In sum, Nietzsche naturalizes knowledge. Like the fox's sharp nose or the rabbit's keen ear, our knowledge gathers only what we need to know, what is beneficial for us to know, not "truths" or "disinterested facts" or "pure phenomena" or any of this, on Nietzsche's view, idealist claptrap. Facts are really interpretations that seek a maximum return on our involvement with the world. Hence only that which serves us comes to our attention, which is to say that we do not see the world as such ("truth") but modulated by our organic imperative to thrive:

Truth is the kind of error without which a certain species of life could not live. The value for life is ultimately decisive. . . . It is improbable that our "knowledge" should extend further than is strictly necessary for the preservation of life. (*WP*, 272)

We are too deeply involved in the natural game to be its referee. Or to put it otherwise, we are too much an objective part of the world to cast an objectively disinterested eye on it.

But here comes Nietzsche's stroke of genius: in appearance, Nietzsche reconnects us with reality on the grounds that we are biologically embedded in reality; but for just this reason, he denies our access to reality. *Precisely as creatures of nature*, we are not hardwired to be mindful citizens of the world but solipsistic users of its bounty. Our task, he says, is not to know our place in the world, but to carve it out. Nietzsche's premise is ecological (we are children of reality), but his conclusion recommends scorn for reality, which is just the putty of opportunity. In short, we are objectively, naturally conditioned to be subjectivists.

Little in Nietzsche's biologism therefore fundamentally alters the heroic isolating of reason carried out by the idealist philosophers he is said to revile. The latter subtracted man from nature by investing thinking with a spiritual aura; Nietzsche equally isolates man with his thesis that nature itself designed us to disregard it or to make of it what we will. Nietzsche, no less than Kant, hypostatizes reason. Kant removes reason from the world by claiming that the world is unknowable; Nietzsche carries out a parallel removal by claiming that the world is not there to be known. Idealist philosophy is resigned to the finiteness of knowledge that limits man's access to the world; Nietzschean naturalism is

confident there is nothing to know. In both, the separation between man and world authorizes an instrumental one-directional understanding of human life as action of doer to thing, of user to raw material, of subject to object, or of ruler to the ruled. But whereas Kant's inaccessibility of nature to human knowledge authorizes the sort of respectful awe that grips consciousness before the vastness of all that cannot be known, Nietzsche's roguish dismissal of knowledge spares admiration only for man's creative self. Man is the measure of all things and, besides, there is nothing definite to measure up against. We can always change the measuring rod to fit whatever scheme we need to fulfill.

In Kant's transcendental unity of apperception (roughly the logical deduction that some features of consciousness are necessary), human experience still held to a definite framework. Within this framework it was possible to assert, as Kant did, that a world lay beyond it ("thus perception of this permanent is possible only through a *thing* outside me and not through the mere *representation* of a thing outside me").[9] This is the humble acknowledgment that one is part of something larger than oneself. To be sure, Nietzsche's creative subjectivism does not deny that there is a world outside our cognition, but it does deny that the world is a set entity of inherent features. The only inherent feature is creativity. The world is will, changing forms, and we humans are virtuoso players of the protean stuff. Reality does not demand our admiration but our successful use and shaping of it. This disposition of course leaves little room for wonder at an external given—a wonder that is the axle of moral intelligence. This, by the by, is why there may be a Nietzschean analysis of ethics but never a Nietzschean morality.

This is important to point out because the twentieth-century school of thought and sensibility known as postmodernism takes Nietzsche to be the starting point of a new form of ethics. This assumption, I believe, is erroneous for the following reason. Where reality amounts entirely to the subject's interpretation there is no reason, no imperative, no need to acknowledge centers of interest and meaning stronger than oneself. And this imperative of course is the ball and socket of moral intelligence. The notion that all is text ("there is no beyond-the-text" goes the postmodernist mantra, meaning that the world is woven through and through by our interpretation of it) leads to the conclusion that our relationship to reality is textual, that is, creative, inventive, pro-

9. I. Kant, *Critique of Pure Reason* (1781), trans. Paul Guyer (New York: Cambridge University Press, 1999), B275.

ductive. The postmodern universe is thoroughly subjectivist: since subjectivity is exitless, our relationship with all things and beings is colored by irony, glibness, world-weary illusion, smooth unconcern. The sky, an atom, a person, a city—all are constructions of language, artifacts of convention, figments of social and private fancy. With no world to reckon with, no hard reality to match or approximate, no patient labor of attuning our sentences to an extralinguistic order, the drive of human life is not knowledge and love (as suggested by Plato) but one of possession and self-creation, which is roughly where Nietzsche wants us. The goal of life, he says, is not to know but to expand. It is not the serfdom of external demands but the adventure of self-invention. A good life is free of timidity and pious respect for boundaries. When Nietzsche declares self-overcoming the ethic appropriate for modern man, he does not mean the work of reaching beyond the ego but instead the work of bolstering it, quelling the meek conformist in each of us and releasing the genius of self-fashioning—otherwise known, in the Nietzschean lexicon, as the "will to power."

Now, the "will to power" in Nietzsche's idea, though organically present in all living things, does not unite us. True to the individualist bias of modern sensibility, it in fact atomizes beings. Unleashing the will to power in my self is to push other beings aside. For to want power is to want others to be powerless. To live by the will to power therefore rules out fellow feeling. The "we-feeling," the herd instinct, Nietzsche says, is really a war against life because it demands sacrifice, accepts delays, brooks compromise—that is, it it puts life on hold, throttles the vital flow, demands that we live in cages. And this "we-feeling," Nietzsche argues, has been getting the upper hand of late because the whole of civilization celebrates it, and therefore denies creation, power, life. This, for Nietzsche, means that man has been avoiding being himself; that he has let civilization stifle his naturally egotistic instincts; and that it is therefore time to turn the tide and exalt man's true, pugnacious, winning, and selfish nature, the "I."

The "You" has been consecrated. But not yet the "I."... Higher than love of one's neighbor stands love of the most distant man and of the man of the future.... This phantom that runs along behind you, my brother, is fairer than you; why do you not give it your flesh and bones. But you are afraid and you run to your neighbor. You cannot endure to be alone with yourselves and do not love yourselves enough.[10]

10. F. Nietzsche, *Thus Spoke Zarathustra* (1891), trans. R. J. Hollingdale (New York: Penguin Books, 1961), 86–87.

In other words, Nietzsche would like the autonomous self of philosophy to become a thing less of the intellect and more of real life. In this sense, he asks modern man to pluck up the courage to live out his human-centered philosophy. This demands courage because it pitches him in headlong battle against the democratic spirit—the culture of crowds, factories, and parliaments. How can I be myself when there are so many like me? asks the nineteenth-century seeker of distinction, the dandy, the bohemian, the anarchist, the *flâneur*, the romantic prophet whose common nemesis is the gray average and for whom no worst sin exists than to be average. Democracy swept away the external markers of caste, birth, guild, and divine election, and handed the individual the one-size-fits-all outfit of modern individuality. This is a rather drab and shapeless coat for the thinking man, the man of taste, the person for whom the meaning of democracy is more about the freedom to dissent than the freedom to form associations. Eager to assert his distinctiveness against the fog of equality, the man of distinction rushes into flashy and aberrant display. One such display is Zarathustra, Nietzsche's mountain-top prophet who castigates humankind for not daring to live, and spins a rhapsody of Teutonic knight-errant fantasies, Greek tragedy, Emersonian gusto, and Darwinian biological electivism, all to produce the *übermensch*.

Let us grant Nietzsche this point. Let us say that reality rises and falls with our will to dominate. Hawks have their fine eyesight to survive; we have our fine science. No more than the hawk's eyesight does our science come closer to how things really are. It is simply one of the cognitive modes in which the imperative of survival occurs in the human animal. "It is our needs that interpret the world."[11] This thesis, however, undermines its own credibility. For the thesis that need creates knowledge is also an offshoot of need. Notwithstanding the question why we should believe anyone who says his message has no special purchase on reality but simply ministers to his own interests, it is also clear that we must believe Nietzsche only if we derive a practical gain from his ideas. But what vital benefit do we get from naturalizing knowledge? Do we improve our survival chances by interpreting reality strictly on our own terms? Does the subjectivist have a better fighting chance than, say, the realist?

We have it from experience that the opposite is true, that the closer our

11. F. Nietzsche, *The Will to Power* (1901), trans. W. Kaufman and R. J. Hollingdale (New York: Vintage Books, 1968), 267.

perceptions stand to fact, the more effective and successful our dealings with the world become. The unregenerate subjectivist died eons ago to predatory or hostile forces he failed to take seriously and realistically. Petting the lion, rather than running away from him, is a perilously unrealistic evaluation of the relationship between humans and big cats. This is the sort of subjectivism that gets one killed. Similarly, planting seeds in autumn rather than spring disregards the reality of the seasonal cycle at the cost of famine and death. There is every reason to assume that nature outfitted us to perceive reality as diligently as possible. Those species obliquely and leisurely mindful of reality in all likelihood succumbed long ago. Of course, it repays a species to approach reality with need in mind. It gives a creature that right mix of prospective and prudential attitudes. My *need* to run away from the lion agrees with the ferocious reality of lions. But note here that need is no subjective state. Though emitted by the subject, a need is proof that the subject correctly appreciates reality's stern edicts. Thus to perceive reality in light of our need is precisely to follow reality. In this respect, Nietzsche puts the matter wrongly: our needs do not "interpret" the world. My need to get away from the tiger is no stylistic interpretation of what tigers tend to do with human beings. In this instance, as in most, a need simply submits to the world's rules of conduct. Only a god, a being freed from the physical world, has purely subjective needs—that is, needs independent of empirical coping. For the rest of creation, however, need is the tug of reality.

Everyday experience tells us that there are ways in which our relation to external facts now connects and now misfires. Unfiltered truth is unreachable of course. But it is the direction in which the necessity of biological maintenance sets us. Epistemologically this suggests that living creatures do not merely make up the truths that they find most convenient to live with, but that we are hardwired to heed external circumstances, to be watchful and humbly realistic with our surroundings. Nietzsche's idea of nature as a riot of freelance biological "interpreters," each crafting its self-styled truth as it goes along, may flatter fin-de-siècle aestheticism, and it may also pamper our existential sense of self-importance. Nevertheless, it holds little biological plausibility. The rough-and-tumble school of coping and surviving teaches us at an early age that we improve our handle on the world the more we suppress our recoiling tendency to see what we want to see instead of what is there. This of course does not rule out ingenuity. We are not enslaved to facts. But our inventively clever manipu-

lation of facts remains at bottom a making-do with them. A dam that plays fast and loose with the facts of the valley bed and the laws of hydraulic pressure is not a dam but a disaster in the making.

※

Nietzsche, of course, has a point: a creature in the grip of need has no time to spare for ontological niceties—wondering, for instance, whether it has got reality down right. An amoeba, to use one of Nietzsche's pet examples, does not investigate the world as it really is in order to survive; rather, it modifies, absorbs, shifts, permeates, or, in a word, "interprets" its environment to suit its purpose. For the purposes of safety and time-saving, an organism needs to cut corners and take the world in broad samples: being able to synthesize the multiplicity of affects, stimuli, and states scattered across time into one abstract entity is just one way to cut corners. An organism gains in efficiency, says Nietzsche, the more coarsely it interprets stimuli:

> The relative ignorance in which the regent is kept concerning individual activities and even disturbances within the communality is among the conditions under which rule can be exercised. In short, [the "I"] also gains in *not-knowing*, in seeing things on a broad scale, of simplification and falsification, of perspectivity. (*WP*, 271)

Less thinking is therefore better thinking. A creature agonizingly aware of every shard and angle of reality would be bogged down in details; endless deliberation would have to preface its every movement. Life would grind to a halt. It follows that reality wants us to take it with some interpretive license. A dash of subjectivism is good for performance. Thus Nietzsche establishes the naturalistic, *objective* necessity of subjectivism.

My contention is that the objective necessity of subjectivism in fact nullifies subjectivism. Indeed, Nietzsche may not be a prophet of subjectivism after all but its reformer. For if subjectivism is dictated by biological reality and the nature of things, then so our interpretations. An interpretation that is dictated by circumstance, however, is clearly no interpretation. To interpret assumes a margin of freedom; the narrower this margin, the closer interpretation resembles perception and stimulus. And this narrowing is just what Nietzsche in fact brings about in maintaining that we interpret the world at the world's own behest. Here interpretation is no creative freedom—the figure of the self as artist waltzing smoothly across a glaze of facts. It is brought on by necessity. The amoeba that wrongly interpreted the surrounding infusorians is no longer

around to rue its mistake. Thus only those who make correct interpretations survive. But interpretations that are always correct are, by definition, not interpretations but accurate *perceptions*.

Subjectivism is thus a modality of realism.

※

How does Nietzsche reconcile his mechanistic view of the human animal with his Zarathustrian exaltation of the superindividual? How can we aspire to drink the wine of self-realization if we are coarsely enmeshed in biology? It seems Nietzsche has to loosen the strictures of his naturalism if the *übermensch* is not to be a superape.

The whole of nature in Nietzsche's view is, we recall, a bedlam of interpretations with one goal only: the enhancement of life. Let's admit that there is no truth, no absolute reality, no real knowledge of things, no cogito, and that a violent hunger for life lies behind even our subtlest intellectual exercises. We believe that a thing is so and so because it is fruitful to think so. No fact apart from value. But does this mean that the will to power itself is a value, not a fact? Here Nietzsche's relativistic materialism hits a snag. For if he balks at subsuming the will to power under the umbrella of value, then it means his theory of relativistic interpretism rests on a nonrelative cornerstone. Nietzschean interpretism would then revolve around a premise that, in principle, refutes it—that is, the thesis that there exists an absolute. But the notion that everything is value-ridden except for valuing life itself is a metaphysical proposition. It is metaphysical because it supposes that someone is able to rise above life and behold its ultimate principle. But who is ever in a position to wrap up all of infinite space into the nutshell of a single principle? Who, by Nietzsche's own standards, can rise above the value-ridden interpretative ways of our earthly stay and glimpse "the most elemental fact from which all becoming and effecting arise" (*WP*, 339)? If everything we see, we interpret for our convenience, then who is the one among us who can see beyond the screen of self-interest? It would have to be someone, a metaphysician, a magus, who has risen above life, is able to see it from Nowhere, and declares the will to power its undeniable essence. But if there is a Nietzschean principle, it is that we cannot have a view of the world that does not reflect our interests, values, and preference. So Nietzsche works against his own philosophical assumption in defending a principle so absolute as the will to power. If naturalist interpretism is true, the will to power is then an incidental phenomenon like all else; and

if the will to power is the lynchpin of life, then naturalist interpretism is false. Of importance is that Nietzsche cannot have *both* his relativistic interpretism *and* the will to power.

In the end, Nietzsche's solution is extremely deft:

The way of knowing and of knowledge is itself already part of the conditions of existence: so that the conclusion that there could be no other kind of intellect (for us) than that which perseveres in us is precipitate: this actual condition of existence is perhaps only accidental and perhaps in no way necessary. (*WP*, 273)

In other words, insofar as what we know is limited by how we live, then the idea that we know solely in order to thrive is self-serving: life is necessarily going to tell us that life is all that matters. The will to live is only an absolute within the current form of life. But, so Nietzsche seems to suggest in anticipation of Freud, one could conceive of a universe in which weakness or the will to death would be the overriding force. Biological thriving is only one of the many conceivable ways of being in the larger universe. Why life rather than not? The answer is not metaphysical but practical: because life is the only perspective that this life allows us to see—or, as he puts is elsewhere, we have no idea what *Being* is; all we know is *living* (*WP*, 312).

There is another example of Nietzsche's debunking of the will to power:

We have arranged for ourselves a world in which we can live—by positing bodies, lines, planes, causes and effects, motion and rest, form and content; without these articles of faith nobody would endure life. But that does not prove them. Life is no argument. (*Gay Science*, 177)

Nietzsche naturalizes the will to power itself by saying, against his own teaching, that usefulness for life is no valid argument: a belief that promotes life is good within the restricted compass of our view that living is good; but it is not good in itself because living cannot be proven to be better than nonliving. No one is ever in a position to pass this sort of ruling about life. "Not being able to contradict is proof of an incapacity, not of 'truth,'" Nietzsche rightly says (*WP*, 279). Thus not being able to see beyond the will to power is no argument to support the universality of the will to power. It only proves that not being able to see beyond the will for life is simply where our human type of thinking stops.

Can we be satisfied with this? Can a thinker truly afford to dither on his key thesis, to tell us that the will to power is, but again is not, the principle rul-

ing over life? If there is no absolute truth, then neither is it absolutely true that there is no truth. Nietzsche seems content to leave things in this conceptual limbo, thus showing himself willing to sacrifice his own philosophy to his horror of being definite. In truth, he feels trapped by the will to power because, in the end, it is not enough of a will and too much like necessity. If all things are subject to the will to power, then thriving, triumphing, and overcoming are really not expressions of selfhood but of instinct. And the superman is therefore not he who creates himself, the poet of self-invention, but a puppet that does as his instincts tell him. And Nietzsche is too much the romantic to give up on the self-creating self. So in the end his biological realism succumbs to his romanticism, and reality to subjectivity. He quite properly subjectifies the will to power, endowing life with heroic intent, with the spirit of conquest and restless self-realization that typifies the Nietzschean *übermensch*. "Life itself told me this secret," Zarathustra chants on, "'Behold,' it said, 'I am that *which must overcome itself again and again*'" (*TSZ*, 138). Life is dissatisfaction with itself, with synthesis, accepted terms, balance, and harmony. Life is will and this means—becoming. "And truly, where there is perishing and the falling of leaves, behold, there life sacrifices itself—for the sake of power!" (*TSZ*, 138). The will to power is refusal of what one has got and the compulsion to grab at what one can become. If this compulsion entails self-sacrifice, maiming or forfeiting existence, so be it. Nevertheless, the thesis that "life is overcoming" takes Nietzsche into an anthropomorphic trap. It assumes, first of all, that reality has the power of negation, of taking stock of a situation and wishing it otherwise. And this, in turn, assumes that reality is conscious and purposeful: that it reaches for an aim beyond itself. Life *wants* something, but since life is already all there is, this desire is of necessity insatiable. Thus nature roils in the thrall of incompletion. This picture is really a climax of romantic anthropomorphosis. In actuality, life cannot go beyond itself for the simple reason that it has nowhere to go. It simply is. It does not thrive. Thriving means aiming at a state of affairs. And clearly being need not contemplate any other state of affairs since it already is all that can ever be. To think that being wants something is to imagine that the universe goes somewhere whereas in fact the universe cannot have anywhere to go since it includes all the possibilities of being at once.

Eventually Nietzsche gives up the project of naturalizing subjectivity. The romantic personality is stronger in him than the biological reductionist. His

will to power is a portrait of life as he imagines the *übermensch* to be: fearlessly breaking bondage to the given, free, adventurous. His naturalization of man leads back to the humanization of nature.

This highlights Nietzsche's inability to dispense with the human standpoint—his inability, in fact, to embrace the biological materialism he propounds. Nevertheless, he charted a new way of envisioning the self. Before Nietzsche, it seems that if Darwin was right, then Descartes had to be wrong; and if the Cartesian idea of autonomous consciousness was correct, then it could not be embodied in the way naturalists claimed. After Nietzsche, consciouness is naturalized and nature subjectified. Consciousness is part of nature but nature behaves, in fact, like a self. This allows us to agree with the scientist that man is embedded in the natural continuum, and yet hold on to certain classical and romantic notions about transcendence and freedom. Now we can be both part of nature *and* rise above it, since nature in fact seeks freedom from itself. This trick ensures Nietzsche's lasting place in the philosophic pantheon and the appeal of that alluring but slightly slipshod idea, the Will to Power.

Longing for the World

———— ⚜ ————

IN THE INTELLECTUAL HISTORY of subjectivity, Nietzsche is both a high watermark and a hint of a tidal change. In him we find the brashest exaltation of self; in him also glows the desire to tear down the idol. Zarathustra is both Dionysus and Apollo, the god of dissolution and the god of affirmation. This heroic figure of a subjectivity both triumphant and self-overcoming stirred the hearts and minds of the first generation of Nietzsche's readers—artists who, like André Gide and D. H. Lawrence, sought to burst the Victorian straight-jacket, exalted personal freedom, but also sought liberation from the self in the unconscious, sexuality, primitivism, primal identification with natural forces. It is as though the climaxing individualist in the end sought liberation from the citadel of individualism. To prove that he is free, the superman must show that he is free from being himself. This is suicide as a way of life, the cult of oblivion, speed, abstraction, deconstructed humanity—the futurist Marinetti careening headlong into self-oblivion, the kinetic trance of vorticism, the sur-realist lost in babbling dreamwork.

Altogether these turn-of-the-century fantastications bespeak growing dis-enchantment with the corseted, self-guarding ego bequeathed by the Enlight-enment. No more does our human dignity lie in distancing ourselves from feeling and stimulus. Man should revel in the senses, embrace his surround-ings, and reconnect with his body. It was then that the American philosopher John Dewey (1859–1952) began advocating a new way of experiencing the self

in a holistic fusion of mind and body. Though his rhetoric now conjures up images of beachside gymnastics in long shorts, it does proclaim the urgent message that the time was ripe for some loosening and living it up.

❧

In philosophy, a concerted critique of the Cartesian primacy of selfhood got underway. Rumblings can be heard as far back as G. W. F. Hegel (1770–1831), whose concept of self is so woven with history than it is less an entity than a confluence of social forces, time, circumstances, events. A generation later, Arthur Schopenhauer (1788–1860) dignified those subjective tendencies directed at self-denial. Among his most inspired writing surely is Book 4 of *The World as Will and Representation* where will, self, and self-interest are shown to be transcendable steps on the way to a greater understanding of ultimate reality. The universe is a calling and man answers it best by surrendering his prize possession: himself.

A further attempt to loosen the subjectivist deadlock came with Edmund Husserl (1859–1938) and his famous "phenomenological reduction." The term meant to convey that the nature and existence of objects are actually identical to their appearance. As he puts it, "[O]bjects would be nothing at all for the cognizing subject if they did not 'appear' to him, if he had of them no 'phenomenon.'"[1] This sounds like old-fashioned Berkeleyan idealism, but in reality the phenomenological reduction cuts both ways. Just as a phenomenon is what appears to us, so consciousness is what relates to an appearing object. All acts of consciousness are intentional. Consciousness is in every case *of* some phenomenon. Subject and object thus share a common life. The subject needs a world to find itself and be a subject. Gone is the Cartesian axiom that consciousness grasps itself apart from being conscious of anything else; gone also is Kant's assumption that at some deep level the mind is pure rationality free of psychology.

Husserl's contribution set the tone for the next generation of continental philosophers interested in overcoming the rationalist legacy—chief among them, Martin Heidegger (1889–1976). Heidegger is responsible for creating one of philosophy's most famous characters—figures that, like Plato's Soul, Descartes's Cogito, Hegel's Spirit, or Nietzsche's Zarathustra, typify a certain

1. E. Husserl, "Pure Phenomenology, Its Method and Its Field of Investigation," Inaugural Lecture at Freiburg in Breisgau, 1917.

human ideal at a particular time. "Dasein" is Heidegger's addition to the dramatis personae. The word *Dasein* ("being-there") conveys the idea that the basic feature of human life is that we exist in the world. Dasein is the being-in-the-world of man. In his "Letter on Humanism," Heidegger called humanism the philosophical tendency to set man apart from the rest of creation. Humanism swindled us out of the realization that we are part of the world. Heidegger does not deny that consciousness is unique; only this uniqueness, he claims, does not make us separate. Once we define ourselves primordially in terms of our subjectivity we relate to the world as an object of knowledge. And holding reality at bay has deleterious effects. It makes skeptical problems unavoidable and insoluble; and it unrealistically isolates and finally confines man to his own intellectual limits. Whereas "Dasein," Heidegger says, "is absorbed in the world."[2] Being-in-the-world is not an optional feature of human life. Being intellectually aware of the world assumes that we are part of it. Heidegger's *Being and Nothingness* wants to draw out the consequences of the primacy of presence over intellect in human experience.

In actual life, Heidegger contends, we are far too involved in practical behavior to make time for the sort of contemplative and objectifying vision by which philosophers typically envision man's relation to things. Nothing we perceive is merely an abstract object. Thus the field along which I stroll is not a generic nominal field; rather, it is the field that belongs to my father who is hoping for rain to invigorate his crops so that the harvest will be bountiful, our family prosperous, the country well fed, and my action of turning on the irrigation tap justified. The result is that the field is shot through with humanity. Reality is therefore subjective. True, says Heidegger, but the reverse is also true: the subject, or Dasein, never arises in the abstract, but always enmeshed in circumstances. I am never just a self but a self-that-drives-a-red-car, a self-that-is-male, a self-that-leaves-work-early-because-of-a-nasty-cold, and so on.

Thus Heidegger wants to liquidate the notion of a hermetic self. Just as the world appears through our active engagement with it, we get to be who we are because there is a world in which we find ourselves. Heidegger does not solve the problem of skepticism; he gets around it by arguing that there was never a problem to begin with. Skepticism is a belated reaction, a pose of disconnec-

2. M. Heidegger, *Being and Time*, trans. John Macquarrie and Edward Robison (New York: Harper & Row, 1962), 149.

tion that in fact assumes the existence of what it throws into question. "The real," Henry James says, is "the things we cannot possibly not know."[3] Heidegger would agree. Thus I cannot possibly not know that letting go of the steering wheel while driving on the freeway will have catastrophic effects. My gripping the wheel shows I take the concept of reality with utmost seriousness. The skeptic belies his own doubts by getting up in the morning. Wittgenstein puts the matter thus: "My life shews that I know or am certain that there is a chair over there, or a door, and so on.—I tell a friend e.g. 'Take that chair over there,' 'Shut the door,' etc. etc."[4] Though the skeptic may entertain doubts about the actual existence of the chair, his behavior around the chair proves that he in fact assumes the chair's existence. Certainty of external reality is demonstrated by our ways of acting around things.

Whether in Wittgenstein or Heidegger, then, twentieth-century philosophy seems anxious to rescue reality from centuries of doubt and abstraction. This mission carries epistemological weight but also a moral dimension since the matter of permeability between self and world also concerns the relation between the self and others. Thus Heidegger finds that, just as skepticism is a false problem preempted by our essential being-in-the-world, so skepticism concerning other minds is ruled out by the primordial intersubjective root of selfhood. Nathaniel's doubt was not just overwrought; it was wrong. "An isolated 'I' without Others is far from being proximally given" (*B&T*, 152). Selfhood is not a native "given" of being human; it is not the case that one is born endowed with human self-recognition. Nor is a self acquired in later life by looking inward, by stopping the flow of everyday life and concentrating on one's inner states. "One's *own* Dasein becomes something that it can itself proximally 'come across' only when it looks away from 'Experiences' and the 'centre of its actions' or does not as yet 'see' them at all" (*B&T*, 155). The self is a becoming that is built of concrete actions. We will not find it by focusing on the seeing of what we see, the experiencing of what we experience, or the inner agency of our actions. Rather, it will grow from taking part in the rough-and-tumble of life.

Now, if the self is no self-given entity, then neither is the self of others. Their existence is the background against which all things appear. Take the example of my car. Its mechanical complexity assumes the contribution of many

3. H. James, "Preface," *The American* (New York: Thomas Crowell, 1972), 353.
4. L. Wittgenstein, *On Certainty*, 2.

to its making. I drive it on roads laid down and traveled by other people. The type of car it is reflects my concern for other people—whether I want them to think me affluent, savvy, elegant, or environmentally conscious. Acknowledgment of other people is therefore built into the fact of my having a car. At whichever level I consider it, whether its look, choice, my driving or maintaining or admiring or despising it, the fact of other people arises. It makes my car what it is like to have and to drive it. Other people are thus not entities that a self-given "I" comes across in the world, they are the spirit in which the world appears to me.

Indeed, Heidegger argues, other people are the spirit in which I understand anything at all—including my own self. They are "those from whom, for the most part, one does *not* distinguish oneself—those among whom one is too" (*B&T*, 154). Self-identification is possible owing to there being other selves. "Knowing oneself is grounded in Being-with" (*B&T*, 161). Heidegger does not deny the "view from the inside" (i.e., I can meaningfully insist that I have special intelligence of what it is like to be myself); but first-person privilege arises not sui generis, but in a world already permeated by a plurality of selves. To have a first-person perspective is a by-product of sharing a common human form of life with others. Otherwise my perspective would never be able to perceive itself as *a* perspective among many. It would be, like animal intelligence, absolute and not self-transcending. Human experience belongs not *in* the self, but *between* selves.

This surely is welcome news. Gone is the theological dream of a substantial self-given individual soul; outdated also is the make-your-own-self Cartesian kit. And equally irrelevant are skeptical doubts about the existence of other people whom I can no more doubt than my own self. Overthrowing the classical grammar that made "We" a by-product of the "I," Heidegger argues for establishing an "I" that is a declension of "We."

By "Others" we do not mean everyone else but me—those over against whom the "I" stands out. They are rather those from whom, for the most part, one does *not* distinguish oneself—those among whom one is too. (*B&T*, 154)

The concept here is fellowship. Inherent in each of us is a concernful attitude, a powerful communal instinct that predates personal individuation. Since in fact I learn to be a self from other people, to see them as other people comes as naturally as perceiving my own selfhood.

Of course, lovely as it is, this vision raises a few questions. How, for instance, does the "I" come out of the primordial "we-being"? If others are those from whom I "do not distinguish myself," then how do I emerge at all? Or how do I not mistake others for myself? And does not the act of "not-distinguishing" imply that there is something to distinguish in the first place? Moreover, it seems that if Heidegger posits "a sameness of Being" (*B&T*, 154), altruism is no moral achievement but an instinct, a version of Rousseau's primal sympathy. But then how do we explain selfishness, hostility, and war? Are these, as Rousseau held, corruptions of primitive consciousness by society? If so, we run into another conundrum: How can society, itself a product of our instinctive gregariousness, pervert this gregariousness? Isn't this like saying that our instinct to be together tears us apart? Should these questions be dealt with successfully, a further puzzle remains concerning the origin of morals. Most ethical philosophers agree that morality hinges in great degree on acknowledging other beings as independent and unlike oneself. My recognition of other people is incomplete so long as I fail to distinguish them from me. But then, in Heidegger's idea, moral recognition needs entail loosening the primitive "sameness of Being." And this is not far from arguing that morality and immorality share the same root, that is, a suspension of primordial we-identification. This is an awkward proposition.

"Being-with is in every case a characteristic of one's own Dasein," Heidegger says (*B&T*, 157). Is that a way of toning down his earlier assertion that "Dasein in itself is essentially Being-with" (*B&T*, 156)? In one version, my sociability is built into my humanity; in the other, it is only a feature added to my humanity. Since no real description of this ontogenesis follows, the reader is hard put not to assume that Dasein possesses inborn aptitude for other-mindedness independently of experience and social training. Heidegger claims that the "I" is a "We-being." At the end of the day, however, it seems that this "We-being" is a product of the "I." I was not trained to be a social being; rather, society exists because I, and others like me, are instinctively geared to perceive other people. Thus: "Dasein as Being-with lets the Dasein of Others be encountered in its world" (*B&T*, 157). Surely this is nothing so crude as suggesting that the existence of other people is dependent on a personal act of mind. But the formulation does assume an ontological priority of the self that puts a significant check on Heidegger's emphatic notions of "fellow concern," "care," and "solicitude" ("Besorgen," "Sorge," and "Fürsorge").

The problem is not really that these essential items originate with the self; the issue is whether the basic disposition of fellow feeling leaves me any choice to let "the Dasein of Others be encountered." If no choice avails, then my "solicitude" for others may be said to make the world more harmonious and all around nicer to live in, but it inhibits the moral significance of solicitude. Once awakening to other people's existence is not an achievement, but written in the substance of my being, it becomes no more morally significant than the color of my hair or my date of birth. In his eagerness to make fellow being unavoidable, Heidegger overshoots the mark. Dasein *lets* other people be encountered, as he puts it. Unfortunately this "letting-be" is less than the "making-be" expected of a moral agent. I am not exactly *bound* to let others be. But it does not seem as though I can fail to either since the very Being-with fabric of my consciousness entails acknowledging other people. Heidegger circumvents the skeptical doubt but regrettably sacrifices the moral thrust of personhood in the bargain.

In acknowledgment of this difficulty, Heidegger adds the rider that the human "sameness of Being" is "to be understood *existentially*, not categorially" (*B&T*, 154–55). The italics suggest that human sameness is no biological or spiritual essence. Instead it is something we do, a result of action, perhaps the habit of living around others. But if it is something we do, mustn't this "we" be understood as holding a plurality of selves? To live together means that several separate beings join together "existentially." This in turn assumes that they exist apart from the totality they make up. The problem is that, in the same pages, Heidegger states that the Being-with of a human being is "not based on the occurrence together of several 'subjects'" (*B&T*, 157). Other-mindedness is to some extent independent of circumstance. This is a strange claim because it assumes that "Being-with" is an essence after all, rather than an existential feature. Heidegger begins by saying that the self does not exist apart from being social but then goes on to suggest that being a social creature remains independent of there being factually a society. Does Heidegger then imply, rather fantastically, that "Being-with" is an outlook that the self possesses whether other people exist or not? But then what becomes of the independent force in the existence of others? Should not the *fact* of their existence outweigh the mere idea of it? Heidegger's intellectualism seems to rub the edge off the concrete existence of others.

Being-with is such that the disclosedness of the Dasein-with of Others belongs to it; this means that because Dasein's Being is Being-with, its understanding of Being already implies the understanding of Others. This understanding, like any understanding, is not an acquaintance derived from knowledge about them, but a primordially existential kind of Being, which, more than anything else, makes such knowledge and acquaintance possible. (*B&T*, 161)

To wit: Being with others is an instance of a more general way of Being-with. Hence my grasp of there being fellow selves around me is a facet of my human environmental aptitude to sense that I am a part of the world, *with* it, engaged in it, and not just standing alongside it. People-mindedness is an instance of a more general world-mindedness.

By reducing acquaintance with other humans to being an aspect of Dasein's overall openness to Being, it seems the philosopher neutralizes the existential thrust of encountering other people. The reality of their existence hangs, as it were, on my innate disposition which necessarily is self-given. Resolute as Heidegger's attempt to decenter the human world is, in the end the philosopher makes the world very safe for Dasein. He idealizes it around the self's goodness and openness of disposition. By making seeing others a subcase of Dasein's ability to see the world, Heidegger knocks the strength out of intersubjectivity. Indeed, the passivity inherent in human relationships vanishes. For in actuality another person is not a mere thing I see but a being by *whom* I am seen. "Being-seen" is the peculiar experience of human acquaintanceship that is not accounted for by the Heideggerian idea of openness to the world. In reality other people are entities always liable to take me aback, anticipate my moves, bring an unexpected perspective that challenges my placid attentiveness. In the case of things I can be with them but they cannot be with me. Not so with people. This is why Being-with-other-people cannot be a subcase of my Being-with-the-world: because other people are actively with me. They are not just objects. Intersubjectivity is more than my being open to others. It entails being opened up by others. In other words, the other person needs to precede my kindly disposition toward Being if I am to acknowledge him as a subjectivity in his own right and not as a familiar thing. Being with other people means that they will disappoint, foil, betray, baffle, confuse, preempt or overfulfill my openings. As it stands, Heidegger's model comes short of explaining how my openness to the world helps my seeing other people as *other* minds. Heidegger seems to level the difference between my being able to see

a tree as not-me with my seeing a fellow person as a center of consciousness. Such a leveling anesthesizes the emphatically surprising, mind-boggling, centerless experience of being with other people.

Heidegger's expansive vision grows timid halfway. It pictures the self as inherently relational but the relation tends to run from the self to others. To be sure, it is a humbled self aware that its own subjectivity depends on the admitting of a plurality of selves. Missing, nevertheless, is the urgency ever present in our dealings with each other. Perhaps Heidegger's moral outlook is too benign. It is a balm over the unsettling intrusion that another person visits on me in spite of, or perhaps in contempt of, my concernful stance toward his being. By making the social world safe for his main character Dasein, Heidegger strangely depopulates life. He dulls its asperities, makes the life of others remote by making them too fuzzily available. As much as the philosopher struggles against the magnet of subjectivist idealism, he cannot help reprising some of its assumptions—in this instance the image of a world contemplatively laid out around the self.

Heidegger interestingly contends that perception of otherness is the root of aesthetic perception *and* of moral intelligence. I perceive other people as being their own self-directed entities when I step back from narrowly self-interested practical concerns. Moral recognition is thus bound up with aesthetic stepping back (a reason why animals come short of moral insight is perhaps that they are *too* involved in what they see and do). But moral recognition is complete only when the other person comes shattering through the aesthetic distance. It cannot be that moral intelligence is an aspect of the aesthetic frame of mind. Moral being breaks through contemplation. The man whom Descartes glimpses walking past his window can always knock on the door, step into the room, ruffle his papers, and drag him out into the open air. Being-with-others is not second to innate Being-with. Fellow-being is not second to world-acceptance. Morality is not ancillary to art.

<center>⚜</center>

Heidegger envisions human consciousness to be primordially attuned to reality. A thoroughgoing defense of this claim would take us far afield into Heidegger's philosophy of consciousness. Briefly put, the mind is, to Heidegger, neither (pace realism) a high-fidelity instrument of reception nor (pace idealism) a vigorous creation of the world. Neither option is interestingly human. What earmarks consciousness as human is its disposition to

hold what it sees in a loving light, to honor. Only man is able to gaze upon the world and contemplate it with selfless attention and praise. On the one hand, we are creatures deeply enmeshed in the world. This is what Being-with means. On the other hand, this factual involvement comprises the *conscious* sense of being-in-the-world. Along with our practical mind is a reflective disposition that marvels at the situation for being thus and thus. It awakens us to the ever amazing realization that the world *is*. In this aptitude for wonder dwells the highest virtue of human intelligence: that it is moved to *see* the being of the universe for its own sake, an experience that, from Plato to Heidegger, is kindred to beauty.

A shadow, however, is gathering over this rare human gift of, as it were, touching reality. Heidegger's late writings draw attention to this obscuring force. He calls it "technology" but its synonyms are also materialism, the scientific world picture, instrumental thinking. Science, Heidegger charges, casts a blank utilitarian eye on the universe. Under the scientific glare, everything, including man, is clockwork, mechanistic actions and trigger reactions, hardwired processes, in short, a quantifiable world that calls for control and use. We now regard life, including ourselves, as stuff to be engineered to our convenience. When modern man looks up at the stars he sees dots of thermonuclear fusion hanging on space-time coordinates. The more objectlike we regard life—so holds the scientific mind-set—the finer our adjustment to reality becomes. Man is now a technician and bureaucrat of being—indeed, the idea of being itself becomes a wordless blur. Philosophers mock and reject the notion of Being as the dream of woolly-minded idlers.[5] Once upon a time the universe was alive with deities that watched us and spoke to us, punished us when we misbehaved, led us through the desert when we needed help, even *loved* us when the times became gentler. Nature thus had moral standing—as God, Karma, or World Soul suffused all things. Instead of being manipulators of objects, we stood organically welded to a sensitive universe and our actions let out a cosmic echo.

Our technologically obscured age, however, has wrecked this spiritual bond, says Heidegger.[6] The frenzy of instrumental consciousness has crippled

5. A. J. Ayer, *Language, Truth, Logic*.

6. M. Heidegger, "The Age of the World Picture" and "The Question Concerning Technology," in *The Question Concerning Technology and Other Essays*, trans. William Lovitt (New York: Harper & Row, 1977).

the mind, reducing it to its most crassly practical aspects. Human existence is now a thwarted thing and Heidegger paints it in apocalyptic shadows. In the grip of metaphysical dualism, we carry on as though we were wholly separate entities (subject) set apart from the rest (object); our interaction with reality is dismissive and utilitarian; we look upon nature in the Medusan language of science; we have, in a word, plucked ourselves out of the world, out of our own bodies and lives, and look upon Being as a thing.

The root of the spiritual illness of technology, Heidegger claims, is "humanism"—a term by which he designates the ideology of man's centrality and autonomy in the natural scheme of things. Thus "antihumanism" is no call for a ruthless philosophy but, more placidly, an overall mood of opposition to "subjectivity's unconditioned self-assertion."[7] Metaphysics (by which Heidegger means the boast of man's centrality and exceptionality, Plato's disengagement of subject from object) is the culprit behind the ills of subjectivism, individualism, and nationalism. The first is the myth of man's prideful separation from nature; the second is the myth of man's separation from all fellow beings; and the third is the same niggling egotism as it radiates from tribe, city, or nation. It had brought only alienation and despair to the West.

Hostility to individualism leads Heidegger to regard with impatience concern for the first-person standpoint. In his zeal to overturn the idol of selfhood (insulated, mechanically efficient, remotely calculating, prudishly abstract), Heidegger sometimes thunders like angry Moses. Thus, for instance, his call to cancel the real-life bearer of metaphysical subjectivity, the actual person. He recommends a world "in which not the human being but the human being's historical essence is at stake in its provenance from the truth of being" (*H*, 261). This puts one in mind of those missionaries who, hell-bent on saving the soul, blithely sacrifice the flock. "New humanism," says Heidegger,

means, in case we decide to retain the word, that the essence of the human being is essential for the truth of being, specifically in such a way that what matters is not the human being simply as such. (*H*, 263)

One wonders about a philosophy willing to immolate the actual person for the good of his "essence." Though Heidegger does not mean to deprecate human

7. M. Heidegger, "Letter on 'Humanism,'" in *Pathmarks*, ed. William MacNeil (New York: Cambridge University Press, 1998), 260; henceforth cited as *H*.

beings, nor harbors Nietzsche's scorn for humaneness, his spiritual loftiness sounds like the intellectual titanism that swept over European intellectuals in the interbellum period. Those intellectuals, it is well known, hated the bourgeoisie, its plump petty self-regard and timidity and addiction to comfort, its "me-centered" view of the world, its prudence, naysaying, and depressingly unambitious ideals. Instead they craved a fuller, richer life on the major scale, rife with heroic deeds and sweeping world-historical momentum. Paramount in Heidegger's attraction to the Nazi Party was the promise of spiritual rejuvenation. Against the cold Western intellect, the Third Reich held the power of Soul, of commitment brimful of energy and deep feeling. There, an individual mattered only for his willingness to melt into the crucible of a fiery renascent *Volk*, the Nation Spirit, the Eternal Unconscious drummed up by Nazi mystagogues.[8] Fascism thus dangled the promise of escape from the ashen landscape of bourgeois society. Many an intellectual fell for it—susceptible as intellectuals are to hypnotic grand schemes.

Of course, it did not take Heidegger long to understand that those Nazis were every inch the bourgeois profiteers and soulless technocrats who, no less than the rest of the West, lived "in the oblivion of Being" and worshipped at the idol of instrumental reason, the machinery of efficiency, control of nature, and production.

Heidegger's later writings tried to establish by means of philosophy what politics had so woefully failed to bring about. For thankfully, so Heidegger believes, our state is not past remedy. He offers a spiritual cure. "The human being is not the lord of beings. The human being is the shepherd of being" (*H*, 260). The phrasing is somewhat fanciful but basically says that, pace Protagoras and all subjectivists to come, man is *not* the measure of things; that we are not wizards designing nature from somewhere above it. "Human beings do not decide whether or how beings appear," says Heidegger (*H*, 252). Our intellectual destiny is not to compact the world into small psychological concepts. Instead it is to understand that our consciousness of the world is *in* the world. Thus it should want to behold reality for the sake of celebrating our kinship with it. Seen from a cosmic standpoint, human consciousness is an organic development by which the world adds awareness to itself. It behooves us to attend to this mission in the spirit of the universe that did not create us so we

8. G. Mosse, *Nazi Culture: Intellectual, Cultural and Social Life in the Third Reich* (Madison: University of Wisconsin Press, 1966), 38–41.

may conquer it (the inside of the fruit cannot peel the skin) but so we may fill it with awareness. We are shepherds of being: recipients of the beautifully useless notion that the world is rather than not.

Only when man, in the disclosing coming-to-pass of the insight by which he himself is beheld, renounces human self-will and projects himself toward that insight, away from himself, does he correspond in his essence to the claim of that insight. In thus corresponding man is gathered into his own, that he, within the safeguarded element of world, may, as the mortal, look out toward the divine.[9]

The idea, it seems, is that only when we let go of our arrogant exclusivism and self-motivation, only when we give up our own centrality and regard all beings with deep kinship, only then will untarnished reality dawn again and only then, by stepping into relation with beings, will we see Being. In short, the solution lies in unselfish perception, heightened awareness, humility, and fellowship—that is, the markers of religious experience.

But why is it so hard for Heidegger to put it this way? Perhaps he seeks to explicate the deep mental process of which these virtues are the visible shorthand. His is an attempt at drawing a philosophical description of how religion is reached—indeed the rational path by which reason leads beyond itself. Heidegger valiantly tries to chart the way out of philosophy by means of philosophy. He gestures in the direction of the "nameless" where man comes into "the nearness of being" (*H*, 243). But the nameless is rather swampy terrain for philosophy and this accounts for the faltering aimlessness of Heidegger's late writings: their incantatory stammering is that of a messenger struck dumb by the inadequacy of language.

Heidegger means to take language beyond language, to express without objectifying, to seize without grasping, to know without putting human limits on the known. This is the ambition to think with God's mind—to know the world without making the world an object of knowledge; to see from no distance; to comprehend life without abstracting from it; to be the stuff of what is known; to achieve fusion of consciousness and object. It understandably fails. Describing reason's self-overcoming in the language of reason refutes the goal. Heidegger's later philosophy quivers with yearning for epiphanic union. Accordingly, he sensed that such an embrace requires forfeiting the tight spec-

9. M. Heidegger, "The Turning," in *The Question Concerning Technology and Other Essays*, 47

trum of subjectivity. As a part of reality, subjectivity is too narrow to let in the fact of reality. Here we are reminded that when Socrates comes to defining the Good he wisely demurs. Is it right for a man to talk as if he knows what he does not? he asks. "I'm afraid it's beyond me, and if I try I shall only make a fool of myself and be laughed at. So please let us give up asking for the present what the good is in itself."[10] This is no failure of philosophy but its fruit. Socrates says the Good is "beyond me." Acknowledgment of some "beyondness" outside the mind is not for the mind to define, or else the absolute becomes relative to some local perspective, hence nonabsolute. The Good must only be intuited lest it be a partial, relative good.[11]

Heidegger, for one, does not give up hope of reaching this nonhuman, nonpersonal affinity with Being. His later philosophy is dedicated to the idea that a special gateway runs between language and Being—that, in effect, human language has umbilical affinity with the cosmos. "Language is the house of Being," Heidegger avers.[12] This is a momentous pronouncement indeed since it proposes no less than a solution to skepticism and epistemology. Language, against the teaching philosophic realism, is more than a mere representation of Being; it provides access into its essence. It is difficult to puzzle out what Heidegger has in mind here but the basic idea might be put thus: understanding the world is a feature of the world, and therefore of a piece with it. A complete objective description of reality hence must include our subjective standpoint. Heidegger's language, however, suggests some even more mysterious principle: "[T]he word makes a thing appear as the thing it is, and thus lets it be present" (*OWL*, 65). Or again: "Thinking is not a means to gain knowledge. Thinking cuts furrows into the soil of Being" (*OWL*, 66). Similar intimations of parousia by language abound in Heidegger's reflection. But surely Heidegger is aware that language is of human making. To posit language as "the house of Being" therefore comes awkwardly close to either old-fashioned realism or idealism. The former, if Heidegger somehow means that language, after all, represents the world as it actually is; the latter, if he means

10. Plato, *The Republic* 6.506d.

11. In the same vein, Martin Buber says "[r]eflexion makes God into an object." God is Thou, total presence, and not just a presence. Man addresses God by stepping into his presence. Speaking about God displays the hubris of a part trying to swallow the whole. See *I and Thou*, 116.

12. M. Heidegger, *On the Way to Language*, trans. Peter D. Hertz (New York: Harper & Collins, 1971), 63; henceforth cited as *OWL*.

that the world really amounts to the saying and perceiving thereof. Heidegger is a modernist, which rather rules out the former possibility. But he certainly edges very close to some version of linguistic idealism. "The being of language: the language of being," Heidegger states cryptically (*OWL*, 94) and leaves in limbo the matter whether the colon stands, or not, for the word "is." Which suggests either that he doesn't dare say what he thinks or that he doesn't altogether think what he dares suggest. In either case, the meaning is obscure, as perhaps it should be. The reader is assured, however, that Heidegger has nothing in mind like a crude anthropomorphic reduction of being to human understanding. That language is the house of Being does not mean that being is cut to man's measure. For man too lives in the house of language not as king and master, but as guest.

> We human beings remain committed to and within the being of language, and can never step out of it and look at it from somewhere else. Thus we always see the nature of language only to the extent to which language itself has us in view, has appropriated us to itself. (*OWL*, 134)

Just as we are in being so long as we live, we stand in language so long as we speak. Both Being and language envelop us. This similarity, however, leaves the reader suspecting there may be little more to Heidegger's special bond between language and being than a feeling of envelopment. We are encompassed by nature and by our verbal consciousness of nature. This parallel, however, licenses linguistic solipsism. It seems to fuse the limits of the world to the limits of our verbal universe. Of course, the idea that language is a gateway to Being has hallowed precedents, not the least of which is the biblical tradition where in the beginning rules the Verb. One way to frame this idea is to say that understanding the world is immanent to the world: through us linguistic beings, nature grasps itself, is aware of itself, comes into self-knowledge. Hence language is not alienation from being but one of its many forms. This is one way of understanding Heidegger's vision: "Language belongs to this persisting being, is proper to what moves all things because that is its most distinctive property. What moves all things moves in that it speaks" (*OWL*, 95). Is Heidegger suggesting that expression and communication are the ground of Being? That nature is deep down an act of expression, a reaching for self-understanding? If so, then language is not man's peculiar tool, but one of the ways in which nature speaks to itself. Warranted, on this account, is Heidegger's notion that

language has direct access to Being. "For, strictly speaking, it is language that speaks. Man first speaks when, and only when, he responds to language by listening to its appeal."[13] Our speaking is one of the many forms by which Being seizes itself. Surrendering to language, heeding language, is therefore a way of embracing Being. "Speaking is of itself a listening," he affirms (*OWL*, 123). Heidegger seems to point to the existence of a passive voice in speaking. Language can be not just aggressive representation and analysis, but a way of listening. For instance:

Language, thus delivered into its own freedom, can be concerned solely with itself. This sounds as if we were talking of a selfish solipsism. But language does not insist upon itself alone in the sense of a purely self-seeking, all-oblivious self-admiration. As Saying, the nature of language . . . disregards precisely itself, in order to free that which is shown, to its authentic appearance. (*OWL*, 131)

However stirring, this religious vision of language leaves one fumbling with the practical aspects. We have little but Heidegger's good faith to go on— his faith that language really lets reality be, that it has the power of revealing reality and adjusting the perceiver to the true perception of "What is" (Parmenides). Just how, indeed, does one "respond" to language by "listening" to it? Does he mean poetry—diving into the sparkling pool of words with wholehearted trust and humility, agreeing to be servants of language which, through a sort of incantatory letting-go, waxes over us like the universe itself? Does it involve, as Heidegger seems to favor, a passionate attention to the etymology of words which, the deeper into the past their roots extend, the closer to their origin in Being we reach? Yet, even in the ancient Greek past, words were of human contrivance. They mirrored choices, intentions, and concerns proper to a certain people at a certain time. Granted that language is a relation to Being—and it certainly is—what grounds have we to hold it as a *special* relation to Being, indeed one that cleaves closer to the essence of nature? Is this not like enshrining the tool or the messenger? But since language is evidently of human making, are we not then indulging a devious form of subjectivism? Often indeed it seems that Heidegger is building on little more than a feeling of affinity between language and Being. We are born into the living world. To live, to die—these are modalities of being the children of nature. Thus we are

13. M. Heidegger, *Poetry, Language, Thought,* trans. Albert Hofstadter (New York: Perennial Books, 1985), 216.

enfolded by Being. Similarly we are denizens of language. We can never over-step its limits:

> We human beings remain committed to and within the being of language, and can never step out of it and look at it from somewhere else. Thus we always see the nature of language only to the extent to which language itself has us in view, has appropriated us to itself. That we cannot know the nature of language . . . is not a defect, how-ever, but rather an advantage by which we are favored with a special realm, that realm where we, who are needed and used to speak language, dwell as *mortals*.[14]

Being enfolded by language *feels* like being enfolded by Being. In neither case can we reach beyond the horizon. A thinker can no more think without language than an individual can exist without being alive. In this similar feeling of encompassment lies presumably Heidegger's sense that language replicates the experience of Being, that it is emphatically *like* Being.

There is cause to suspect that this vision unduly overvalues language, in-deed that it deifies it. In which case, it seems that we deify ourselves, or, at any rate, that we commit ourselves to some fatalistic embrace of our own linguistic understanding, indeed of our intelligence and human standpoint. Heidegger is correct in assuming that understanding the world first entails having the precise measure of the means by which we understand it, and that means our-selves. But just because we must navigate the channel in order to reach the sea does not mean that the channel *is* the sea. Or, in this instance, that language *is* really Being. This equation enthrones the human means above the end. It places man and reality on the same level. Of course we reach reality by way of our human scope, but this necessity simply does not equate our understanding to reality. Nor, by the way, is language our only access to reality. Much of our immersion in reality goes by way of preverbal intuitions, feelings, emotions, physical intimations, indeed a kind of vital intelligence that grows no richer from subsequent verbal articulation.

Heidegger's vision looks like a genuine attempt at reaching beyond the human-centered ideology of subjectivism. It puts forward a religious ecolo-gy wherein man and being are nondualistically bound. In the end, however, his philosophy harbors an intellectualist bias that endows language with too much power. To speak about "Language" instead of "Man" does not really re-move human intelligence from the cosmic center. Indeed, it is hard not to

14. M. Heidegger, *On the Way to Language*, 134.

hear echoes of Protagoras's dictum that man is the measure of all things in Heidegger's "[l]anguage is the house of Being." For however language here is decanted of its human speaker, or however much the human speaker is subsidiary to language, one gets the impression that human understanding is given too large a share of the attention—indeed, that the human standpoint still looms larger than the universe around it.

Deep inside Heidegger's meandrous meditation is the religious insight according to which the mind's most noble task is to overcome itself. To this end it must be concerned with itself (this is where philosophy comes in), but the ultimate aim is self-surrender, which means surrendering speech. Heidegger, it seems, makes the mistake of trying to articulate this surrender in philosophic language. That is, he treats the other side of language as a linguistic problem, trying to pull inward what lies outside, or translating into words the mute prayer, the humble gesture, the loving gaze that in the end constitutes true listening. More wisely, Wittgenstein suggested that philosophy was a kind of ladder which, once climbed, needs be kicked away. Wittgenstein thus recognized the limitation of philosophic language and language at large. (He knew how to end a sentence and fall silent for a few years.) Heidegger, on the contrary, clung to the ladder past its usefulness. He self-defeatingly tried to rationalize the end of language. Had he been a poet, he might have succeeded. Heidegger understood that, better than philosophy which cuts too high above the given, art is a language of action, of doing: a language that surrenders to the subject matter, hence a human mode of expression closest to listening. And, of course, by their sheer rhapsody, Heidegger's later writings tried to bridge the gap between poetry and philosophy, between doing and reasoning. But in the end Heidegger was no man of action, nor was he a man of passivity—both qualities possessed by the artist: he who speaks in action, enacts what he believes, surrenders to existence, practices a kind of active kneeling before what is. The philosopher cannot pray without explaining that he does so. The artist can—and the action, as Part II of this volume will show, is the work of art.

Though obscure, Heidegger's vision marks a genuine attempt at loosening the lock of the human prison, liberating the self from ontological exile, renewing the partnership between subjectivity and the world. Heidegger belongs in that stream of modernity that split off from the bold assertion of autonomous selfhood. His intellectual ancestors are poets and thinkers like Holderlin, Coleridge, Baudelaire, but also Wagner, Wyndham Lewis, and the Stravinsky

who wrote *Sacre du printemps*, exalted souls who aspired to a more sympathetic, trancelike union with the raw forces of nature, with reality unadulterated, with the primitive, the sensate, the vibrant, and the authentic. Heidegger strenuously sought to open philosophy to this breath of immediacy—to devise an idiom by which language rationally demonstrates its self-overcoming. We can argue about the success of this venture. What is beyond dispute, however, is that it firmly established the longing for reality in the modernist tradition—a longing at least as strong as the one for human autonomy that it counteracts.

The Idol Fallen and Resurrected

——— ᏸᏗᏸ ———

LET US NOW BRIEFLY SURVEY the twentieth-century philosophic critique of autonomous subjectivity. Twentieth-century philosophy set out to melt down the golden calf of subjectivism, but new idols seeped out of the crucible: Language, History, Discourse, Culture, Text—all various ways of enshrining human agency without naming its tabooed source, that is, man. Twentieth-century continental philosophy, by and large of French and German stamp, aggregates around three major figures from whom it draws its main themes, methods, and inspiration: Marx, Freud, and Nietzsche (the latter has already been discussed).

The first milestone is Karl Marx (1818–1883). Marx was among the first figures after Hegel to set human life in terms of *selves* rather than self. Philosophy hitherto had spoken of man either as an essence or as a private subjectivity. Marx (and, one should note, Hobbes before him) believed that an individual alone is an insignificant concept and that human reality is a "we." The meaning of existence is social and quantitative; it dwells in the amount of pressure a social group is able to bear on society. Marx's vocabulary is that of crowds and social groundswells that sweep up the single individual, global tides admittedly unleashed by man but beyond any single person's control. Salvation lies not in inner conscience, but in the scientific manipulation of the giant-size forces

that pull us to and fro. Marx is a humanist because his moral compass points to justice and dignity in human affairs. But his notion of the human being is a faded and distant thing.

Derived in part from Hegel's grand vision of history's irrepressible march, Marx's economic philosophy imposed the view that history has a direction of its own, that its destination can be roughly charted, and that opposing its momentum is at best futile and at worst dangerous. The Marxist materialist view of human experience is, inter alia, the inspiration behind the ascendancy of the social sciences in the humanities. Under the impasto brush of materialist historicism, it has become acceptable to understand human history in terms of abstract structures endowed with independent force. History makes man, not man makes history. This worldview is the unstated assumption of countless thinkers, from Emile Durkheim, Claude Lévi-Strauss, Michel Foucault, Pierre Bourdieu, Fredrich Jameson, indeed the school of historical structuralism, which, as the name points out, conceives of human experience as the artifact of general social structures.

Sigmund Freud (1856–1939) took this desubjectification of man one step further by scooping self-possession out of the mind. Marx carved away at subjectivity from the outside; Freud finished the job by showing that the inside, formerly a wellspring of light and awareness, was really a primeval underworld of drives and impulses—shadowy semiselves operating secretly in the antechambers of consciousness. There is no risk of course to overstating the influence of Freudian ideas in modern thought. It humbled and demoted man, demystified subjectivity, installed a bottled-up machinery of pressure and release, of drives and vectors and principles where the mysterious psyche had once held court. On the outside man is a product of ideology and cultural training; on the inside he is a product of trained responses, engrained impulses, ancestral drives. Freud's self is indeed a long way from the self of Descartes and Kant.

A precedent for this materialization of man was set, as we saw, by Nietzsche who filtered the biological world picture of Darwin into pungent philosophical language. To Nietzsche, consciousness, religious conscience, spiritual aspirations, the achievements of civilization, morals, and science are all venial appetites in disguise—roughly, strategies to impose one's will on others. Our values and morals are, it appears, little more than fangs and claws, means by which we subjugate others and cover up the crime. Thus pointing out the hun-

gry beast inside the civilized individual, Nietzsche materialized consciousness. Ours is a ravenous species and we had better act like it. Notice, however, that the "critique of man" here is not a spiritual protest against anthropocentrism, but a fulmination against the weeping worldviews of Hebrew prophets, against any moral system that retails in submissiveness and abnegation. For Nietzsche, to be assertively self-centered is the natural function of life, hence of the biological entity that is man. Of importance here in this genealogy of the desubjectification of man is to note that to be self-centered means not being human-centered; it means simply to hearken to the beast in us. Power is less in us than we are in power. This classically Hobbesian picture of human society is bolstered by scientific biology and materialism, and accepted more or less wholesale by the contemporary disciples of Nietzsche, chief among them Michel Foucault. To Foucault, all reality, all human existence, every individual is caught up in the play of power. Everything is ruled by the will to control, assert, dominate, exploit, use. "Isn't power a sort of generalized war which assumes at particular moments the forms of peace and the State? Peace would then be a form of war, and the State a means of waging it."[1] What we believe intellectually, our ideals, our loftiest convictions too, are products of the will to power. They are functions of society's battlefield:

Truth isn't outside power, or lacking in power: contrary to a myth whose history and functions would repay further study, truth isn't the reward of free spirits, the child of protracted solitude, nor the privilege of those who have succeeded in liberating themselves. Truth is a thing of this world: it is produced only by virtue of multiple forms of constraint.[2]

Thus the will to power shapes us inside and out. We should be naive to believe we act freely and independently, that our values are pious, our actions disinterested, and our ideals transcendental. In reality, we are the fools and tools of power.

Nietzschean power, Freud's unconscious, and Marx's materialism meet in the postmodern imagination to create an overarching entity known as "Ideology." Like power, ideology is geared toward control, ruthless imposition of will, rule by the fittest and canniest; like Freud's unconscious, ideology operates deviously, sinks deep into the hidden mechanism of mind, operates unbe-

1. M. Foucault, *Power/Knowledge*, trans. C. Gordon, L. Marshall, J. Mepham, and K. Soper (New York: Pantheon Books, 1980), 123.

2. M. Foucault, *Power/Knowledge*, 131.

knownst to us; and like Marxist historical materialism, ideology is a collective force relentless in its onslaught and development. German idealism further broadened the sweeping mantle of ideology. Let us recall that, against the realists and the empiricists, idealist philosophy held the mind to be self-enclosed. Since it cannot lead to reality, it must rest content with shaping reality after its own interests. Ideology and idealism fused together and created a new entity, variously named "Language," "Text," or "Discourse." This entity is unanswerable to reality, confines man to a thoroughly human-made world yet one over which the individual has no power since it seeps into the very fabric of our self-understanding, of what we take ourselves and the world to be, and weaves an infinite mesh around us, a "Text" which, though, cast by man, ends up trapping man. Text is subjective (i.e., human-made) but nonhuman (no individual consciousness can fathom it, or see its way through it, or escape it, or control it). The human and natural world is thus a creation but of a nonpersonal, agent-independent creator, labyrinthine, godlike Discourse.

Materialist history, psychoanalysis, and structuralism thus join forces to shrink the person to a nodule. Man, Foucault professes at the end of *The Order of Things*, is a comparatively recent cultural figure. And the time is now come for the tide of history to wash him away. No first person do we find in the structuralist Foucault and his followers but patsies engineered, exploited, disciplined, suckered, abused, manipulated, and browbeaten by a ubiquitous force of many names—ideology, history, discourse, power, language—that no one harnesses and everyone endures. "There is no longer anything but language," writes the structuralist.[3] The creature has risen to devour its creator. And so man disappears. "Soul," Foucault says, "is not a substance; it is the element in which are articulated the effects of a certain type of power and the reference of a certain type of knowledge."[4] The private self, the sense of one's life and death—these features of interiority are illusions. There is nothing but the social machinery programming us to behave as it will. And so individuality is in fact a dangerous flimflam. It is another yoke of oppression by means of which society divides us up the better to control us. Hence the palpable mood of jubilation in getting rid of "man." For the sooner we chuck that piece

3. R. Barthes, *The Pleasure of the Text*, trans. Richard Miller (New York: Hill & Wang, 1975), 9.

4. M. Foucault, *Discipline and Punish: The Birth of the Prison*, trans. Alan Sheridan (New York: Vintage Reprints, 1995), 24.

of ideological manipulation, the better off we will be. There is some masochistic streak at work here, a longing to squash the subject, which finds an outlet in the exaltation of madness and schizophrenia and a general psychedelic "dérèglement de tous les sens" as workable solutions to the so-called problem of subjectivity. When, as in Foucault, or George Bataille, or Gilles Deleuze, mental illness, sexual polymorphism, and mystical disorientation are found to be heroic stands against Cartesian self-centeredness, we know the passion for "the end of man" to be overstraining itself.[5]

The assumption here, supported by the Marxist Frankfurt School, is that the Enlightenment palmed off a swindle. It purported to rouse humanity from dogmatic slumber and give us self-direction and reason. In actuality (this is the whistle-blowing in such works as Adorno and Horkheimer's *Dialectic of Enlightenment* or Marcuse's *One-Dimensional Man*), the Enlightenment spawned a lonely, submissive, crudely shrewd, soulless, blandly alienated subject outfitted to perform mechanically at the office or the factory. The Aufklärers (from *Aufklärung*, the German name for the Enlightenment) claimed to free man from bondage to customs and religion; in reality, they cut him off from his broader spiritual and visionary background and tied him to narrow-minded tasks and ambitions. It gave us the Victorian girdle; the straightjacket; the hourly paid workday; the prisons, reformatories, and madhouses; the world of pigeonholes and medical labels, of life-denying mores and hypocrisy and scientific coldness on a total scale. To these oppressive constructs we need add the most cunning of all, the self (better known as the "subject") which is the illusion of personhood by which the powers-that-be have us march to their tune. To be a self is oppression (Deleuze and Guattari);[6] the individual is really a cog in the social factory. It is another yoke of oppression by means of which society divides us up the better to control us.[7] Better, then, to write philosophy and analyze history with minimun reference to this agent of social coercion. Foucault writes the

5. See, for instance, G. Bataille, *Visions of Excess*, trans. Allan Stoekl (Minneapolis: University of Minnesota Press, 1985) and *Erotism: Death and Sexuality*, trans. Mary Dalwood (San Francisco: City Lights Publishers, 1986); and G. Deleuze and F. Guattari, *Anti-Oedipus: Capitalism and Schizophrenia*, trans. Brian Massumi (Minneapolis: University of Minnesota Press, 1983).

6. G. Deleuze and F. Guattari, *Anti-Oedipus*, and *A Thousand Plateaus*, trans. Brian Massumi (Minneapolis: University of Minnesota Press, 1987).

7. T. Adorno and M. Horkheimer, *The Dialectic of Enlightenment*, trans. John Cumming (New York: Continuum, 1976).

kind of history that can account for the constitution of knowledges, discourses, domains of objects, etc., without having to make reference to a subject which is either transcendental in relation to the field of events or runs in its empty sameness throughout the course of history.[8]

It is wrong to read history from the standpoint of man because man is a product of history. Witness another influential voice, that of Pierre Bourdieu:

When I speak of a field my attention fastens on the primacy of this system of objective relations over the particles themselves. And we could say, following the formulas of a famous German physicist, that the individual, like the electron, is an *Ausgeburt des Felds*: he or she is in a sense an emanation of the field.[9]

In brief: we human beings are particles bouncing off and colliding under the magnetic influence of society.

Can this method of depersonalization be more than a rhetorical style? For in the end what or who is this ionized Leviathan at the helm of human history? Surely it is not irrelevant to ask "who," despite the impersonal jargon, because when we speak of "power" or "knowledge" we appeal to notions of agency and intentionality. Bourdieu would agree that the social field shakes its human atoms in a way that is not random. Now, inasmuch as "power" or "knowledge" or "the field" move in determinate ways, it seems as though belief in human agency is merely shifted from the individual to a sort of superself that is all the more autonomous and omnipotent for being impossible to pinpoint. The postmodern thinker enthrones abstractions ("Society," "Power," or "Language") in place of kings and emperors, and of course abstraction is more sophisticated than royal emblems. But who is this new ruler if not a collective human power raised above scrutiny, will triumphing over reality, indeed a hyperbolic ego lording it over the world? As in Nietzsche, human life has been materialized but its self-importance is nevertheless intact—only it has been raised from the individual to the abstract mass. Thus twentieth-century structuralist antihumanism does not really destroy the idol of "man." Indeed, it does not abandon the view that all reality centers around the subject—however materialized this subject be, in Nietzsche's case, or collectivized by critical sociology, or even abstracted into Text by structuralism. The doctrine of sub-

8. M. Foucault, *Power/Knowledge*, 117.

9. P. Bourdieu and L. Wacquant, *An Invitation to Reflexive Sociology* (Chicago: University of Chicago Press, 1992), 106–7.

jectivism holds sway over postmodernism, no matter how abstract or imper-
sonal or seemingly faceless its rhetoric seems.

<center>⚛</center>

A similar backdoor return of subjectivism at the heart of contemporary
philosophy's most antisubjective forays can also be absorbed in the musings
of the Continental School on language, and in particular on those schools of
thought known as poststructuralism and deconstruction. At first blush, those
two philosophies seem to fall squarely within the modernist campaign against
the self-possessed Enlightenment subject. Against the Cartesian self, modern-
ism erected a philosophy of no-self, of subjectlessness, of human intelligence
drawn into a labyrinthine universe where language always has the upper hand.
What we say—what language says through us—is infinitely more than what
we think we say or mean to say. "The writer writes *in* a language and *in* a logic
whose proper system, laws, and life his discourse by definition cannot domi-
nate absolutely," Jacques Derrida says.[10] Any language user is really *used* by lan-
guage, or by the Text, a ubiquitous omnipotent elusive power that legislates
everything we say, think, and perceive, and yet never materializes because it is
not one thing but the endlessly branching and meandering process of mean-
ing. Language signifies by dint of "différance," a word coined by Derrida to
emphasize that meaning or communication is never in a word or a sentence
but in between them, in the differential infinite network of their relations.

Difference is what makes the movement of signification possible only if each element
that is said to be "present," appearing on the stage of presence, is related to something
other than itself but retains the mark of a past element and already lets itself be hol-
lowed out by the mark of its relation to a future element.[11]

Language is not a thing but a differential system whereby the significance of
any sign stands on the absence of other signs; thus language is ghostly, a kind
of spectral bureaucracy where the decree of one office leans on the authority of
another office ad infinitum; and no human presence finally holds the process
in hand because the language speaker is too deeply enmeshed in language, too
reliant on language for his self-understanding as conscious speaker, to really be
in control. Nor is this linguistic texture transparent. In concord with the mod-

10. J. Derrida, *Of Grammatology*, trans. G. C. Spivak (Baltimore: Johns Hopkins University
Press, 1998), 158.
11. J. Derrida, *Speech and Phenomena*, trans. D. Allison (Chicago: Northwestern University
Press, 1973), 142.

ern subjectivist doctrine, poststructuralism and deconstruction are resolute in the absolute split between word and thing, or mind and world. However strenuously we look into reality, we never glimpse beyond the web of words and concepts that hold the world together. Language rests on nothing; it is emphatically not transcriptive or representative of reality but freely symbolic. The world is an invention of the text. "There is no outside-of-the-text" goes the famous deconstructionist mantra. Everything our attention lands upon turns into language. There is no nonsubjective access to reality. Man lives inside his mind.

Now this looks like old-fashioned solipsism except that the modernist taste runs to abstraction. "Text" allows the postmodern philosopher to entertain the basic tenets of idealism with no reference to, for instance, the Kantian individual carrier of human intelligence, that is, the person. Postmodernism is solipsism without a human face—faceless indeed because the myriad-headed anonymous Text dwarfs and overwhelms individual agency, but solipsist nevertheless because Text is quite obviously a human artifact, however much we are woven into it. So in fact postmodernism is the love of self that dares not speak its name. It may not call itself the Ego, or *Geist*, or the Oversoul, or the Superman, but Text, Discourse, and Language are no less masks of humanity, indeed of a humanity that contrived a polymorphous alter ego as vast as reality itself, indeed capable of catching the world in its net, an impersonal self, a textlike self, a self that like grammar is never born and never dies: indeed man making a claim to transcendental eternity, universality, and inscrutability! For the thesis that all is text, language infinite, and reality unknowable, or better yet, that unknowable reality holds no interest to us—this, then, is a breviary of subjectivism: subjectivism without a human face but made all the more pervasive and transcendental for the lack of concrete human agent.

※

The question "Who or what comes after the subject?" is thus probably human self-importance in disguise.[12] Logic itself forces this conclusion since obviously no one can proclaim postsubjectiveness without refuting the point.

12. The question is nevertheless solemnly debated, as witness works like *Who Comes after the Subject?* (New York: Routledge, 1991), *How We Became Posthuman* (Chicago: University of Chicago Press, 1999), *Posthuman Bodies* (Bloomington: Indiana University Press, 1995), and *The Inhuman Condition* (New York: Routledge, 1995). For a history and survey of this "decentered," "subverted" subject, see P. M. Rosenau, *Postmodernism and the Social Sciences* (Princeton, N.J.: Princeton University Press, 1992), 42–60.

The action assumes the continuance of the subjectiveness it otherwise denies. Let's say I declare myself and my fellow beings posthuman (i.e., material products of social engineering). This act of self-naming presumes free conscious agency. Only a subject can moon on about postsubjective existence, which means that the self is not dead but, like Ulysses, biding his time under beggar's rags.[13]

Moreover the postmodernist notion of textualism is a mystique spun of a commonplace: that no language is measurable. Correct as it is, this judgment needs qualifying. Language is immeasurable with respect to the infinity of the moves, permutations, and semantic arrangements available within it; but it is nonetheless finite in that it ends where matter begins. The postmodernist likes to picture consciousness adrift in the boundless Text. But Text of course cannot decide whether today is rain or shine. It does end somewhere. Likewise, a language speaker is constrained and contained by the linguistic rules operative in the idiom. He expresses himself within the range of what the words and concepts make available. But it is merely magic to suppose that language speaks through us, that it is the source of expression rather than one of its poles, that real objects, events, forces do not shape it from the outside. When a police officer asks for my driver's license, I can hardly suppose the situation to be purely verbal, formal, and ultimately undecidable just because his utterance is made up of words over whose meaning he and I have no finite control. Ultimately the true force of language is that it is intentional, however much that intention gets tumbled around in the net of words. And behind the intention is a human being who speaks. There is a peculiar force to being spoken to that does not feel like sentences are just coming out of a machine. To ignore this peculiar force fits a psychopathic personality more closely than sound philosophy.

One way to understand this postmodern taste for abstraction—that is, its conceptual austerity and propensity to break reality down into the gray stenography of parameters and paradigms and structures, in the language of exactitude and determination—is to see that it reacted to another excess, the blowing romantic ego. This reaction has spawned a rather slab-drab aesthetic. One only need set Goethe's *Sorrows of Young Werther* side by side with Rob-

13. See L. Ferry and A. Renaut, *French Philosophy in the Sixties: An Essay on Anti-Humanism* (Amherst: University of Massachusetts Press, 1990).

be-Grillet's *La Jalousie*, or Shakespeare next to Beckett to see that a certain human glow has gone from us. Postwar Europe popularized an emaciated image of selfhood—either cobbled together of abstract theses as in the fiction of Sartre and Maurois or pared down to grammatical games as in Ionesco, Simon, or Perec. The modernist universe of Beckett, Borges, Roussell, Queneau, Calvino, Pynchon, Barth, or Gaddis is that of persons who are the playthings of inscrutable forces, often at the whim of a textual demiurge, or chance, or Olipo topsy-turvydom. When the individual speaks, it is to convey baffled emptiness. "My trouble is, I lack conviction" says the "I" of John Barth's stories, scanning the countryside for something to be or say.[14] This general picture has inspired an aesthetic of impersonality and self-silencing where, as in Blanchot, the writing self glumly obsesses over its vanishing in the bottomless sea of Text. As in Beckett, the subject cannot stop saying that it has nothing to say of its own, that it cannot say anything conclusive, that it is dead.

The plastic arts reflect similar depletion. Mondrianesque abstraction and Corbusian constructions seem to bully the expressive self into a corner. Meanwhile pop art mockingly reveals the plastic advertisement inside the human face. The quiet endurance of the human figure, when it survives among modernists like Picasso or Modigliani, seems, in retrospect, a nostalgic throwback. Not the mysteries of the face but sullen facelessness and reified life are what greet us in the works of Beuys, Duchamp, Judd, or Nauman, confirming Ortega Y Gasset's prognosis about the "dehumanization of art" in our times.[15] Latter-day humanists like Adorno or Steiner understand these faceless depictions as the sigh of the afflicted, the whimper of a subject who, battle-weary, turns to the Leviathan and says, "Look what you are doing to us."[16]

The emaciation of subjectivity has crept into the idiom of literary and art studies. Variously mesmerized by Marxist historical scientism or the tic-tac-toe universe of linguistics, structuralists and deconstructionists instinctively lean toward *theoretical* reduction. Where the old-fashioned critic spoke the sanguine idiom of deeds and values (of courage, cowardice, doubt, trust, dis-

14. J. Barth, *Lost in the Funhouse* (New York: Anchor Books, 1988), 3.

15. J. Ortega y Gasset, *The Dehumanization of Art* (Princeton, N.J.: Princeton University Press, 1968).

16. T. Adorno, *Aesthetic Theory*, trans. Robert Hullot-Kentor (Minneapolis: University of Minnesota Press, 1998), and G. Steiner, *Language and Silence* (New Haven, Conn.: Yale University Press, 1998).

appointment, freedom, joy, envy, hope, sorrow, obstinacy, pity, pride, shame, love, indeed the boundless spectrum of human expression), the postmodern critic slashes straight to the skeleton, the "superstructure" in Marxist jargon, under the eyepiece of which individual experience is flattened down to its generic social and ideological aspects. Elizabeth Bennett or Emma Bovary are exempla, not persons. They are embodiments of general Ideas, of the Female Subject, the Bourgeois, the Protoconsumer. *What* a person is trumps *who* she is. The critic of yore labored to tease out the ineffably nuanced strands of the thinking and emotional life; nowadays, having defected to the scientist camp, he cuts reality in large swashes of blocks and masses and quantifiables. Hostility to the subject has led to a Corbusier-like moral landscape where the self is pinched from the teeming background of an inner and outer life. Our imagination hasn't got the nerve for anything fleshier than Giacomettian starvelings.

<div align="center">⊗</div>

This brings us to the next pillar of postmodern anthropocentrism: the denial of transcendence. If all is text and reality simply the sum of the statements made about it, then the human world is infinite and spreads over all things. It cannot transcend itself. An entity cannot transcend itself either because it is a thing or because it is all things, an object or God. Since human intelligence is obviously perceptive, intentional, and self-aware, it is not an object. This leaves only the possibility of godhood. But since the postmodern aesthetic is deflationary, since the romantic heyday of the godlike self has gone out of fashion, since we moderns modestly declare understanding nothing of such notions as "soul," "transcendence" or "spirit," we inherit the puzzling fate of the mortal god: a god because our subjectivity spreads over all things, yet a god made of corruptible matter. It is thus a god who bemoans the absence of gods. Remember the Nietzschean madman running around the market square announcing that God and all certainty and absolutes are dead.[17] There, already, was the pathos of grandstanding emptiness, of human solitude, of self-clasping existential rapture. No sooner begun than the twilight of the idols spawned the idol of twilight.

Heedless of Wittgenstein's warning against creating a cult to the absence of gods, meditation over the death of God has lately kindled a new taste for

17. F. Nietzsche, *The Gay Science*, trans. Walter Kaufman (New York: Vintage Books, 1974).

"negative theology." The old school of negative theology, founded in the first century A.D. by Philo of Alexandria, held that God was too great for the narrow straits of human language. Hence the Godhead was best spoken of negatively. By saying what God is *not*, the believer reminded himself not to hem in the infinite—indeed, not to let the mind rest on incidentals when it should be contemplating the boundless. This zeal to not confine God eventually led Philo of Alexandria to aver that God is *not*, since it is crudely limiting to ascribe being to Him who contains being. Of note is that, in its original form, negative theology was a form of gnosis, of attending to the deity, of bringing human speech into as close an affinity with an external reality which, though ineffable, was no less formidable for that.

The new face of negative theology, the one propounded by the likes of Derrida, Marion, or Caputo, also holds that God is not; they, however, mean it. The absence of God, the loneliness of man, the silence of the heavens—these are the objects of a new cult of absence, so consonant with the radical rift between word and thing in deconstruction, with the aimless infinity of language eulogized by its practitioners. The old negative theology was driven by respect. It was an exacting, humbling labor of approaching the infinite; it made a religion out of reality. The new negative theology, on the contrary, is a sonorous celebration of language, of the vacuum around human consciousness, of the world's nonexistence. Most likely it is a way of gilding atheism with heroic solemnity. How glorious, how brave it is to be alone, godless, and therefore godlike in apprehension of the infinite reaches of silence around us. Our loneliness is our throne, our smallness is our greatness.

☙❦☙

In summary, modernist subjectivism holds the self incapable of self-transcendence. Text, ideology, and language are too encompassing for us to escape their conditioning: but since text, ideology, and language are really synonyms for mind, the upshot is quite simply human self-centeredness. Posthumanism impersonates the death of subjectivity the better to enshrine it at the center of a twilight void where subjectivity suffuses all things, yet is present in no particular. And this is neurotic avoidance of death, avoidance of the world, avoidance of *love*.

The Prison

————— ✺ —————

To SUMMARIZE, the Enlightenment enthroned autonomous subjectivity; of a more sensual turn of mind, romanticism exalted the concrete feeling individual; and modernism, in reaction to this sensuality, turned subjectivity into an abstract world-making power. All three stages vary in style but not in gist. They have made man into not just the measure but the creator and context as well. There is nowhere the subject is not. The cost goes beyond mere disenchantment of the world. Overstating the subject also takes a toll of its alleged beneficiary, the self. We have lain the world at your feet, say modern philosophy and science to man. We have shushed away the bogeys and bullies that once cramped your life and troubled your sleep. We have shown you that not even the sky is the limit and that unbounded is your dominion over heaven and earth and everything you conceive or imagine. Only there is one thing you cannot do: and that is to go beyond the veil of your own mind. You are the center. But you are caught in the center. "It is impossible for man to transcend human subjectivity," Sartre assures us, but the statement reads just as well as the very prison sentence of subjectivism.[1]

As we have seen, three main assumptions of modern thought stand against the adventure of self-transcendence: one is the idealist-rationalist-pragmatist

1. J.-P. Sartre, *Existentialism*, trans. Bernard Frechtman (New York: Philosophical Library, 1947), 19.

doctrine that shuts the mind in and trims the world down to the subject's perception and use of it; another doctrine is biological materialism that pictures man in the grip of iron instincts inflexibly bent on the selfish preservation and prevalence of the organism; and the third doctrine consists of varying sorts of historical or linguistic or ideological determinism that holds that, for all his efforts, man can never size up, let alone flush out, the social stuffing that holds him together. Stripped of the spiritual resource of self-emptying, the modern self is the inmate of a prison that, though built by him, is no less barred and bolted. The self is king, court, and country, but lonely therefore is his universe. Images of this cloistered lonely consciousness surface in twentieth-century arts, for instance, in the expressionism of painters like Schiele or Munsch or Bacon, where the self is shown painfully trying to worm himself out of a mental cell that will not let go of its inmate, or, for another instance, in Beckett's prose fiction and dramas where, as in *Malone Dies*, *The Unnamable*, or *Endgame*, the self is only a voice encircled by its obsessive litany of separation and loneliness, forbidden to embrace the outside, to surrender, to die. The Beckettian character is bolted down to being an "I" and this is what torments him because he has no affection for or faith in this "I."

Or consider the story of Josef K., the bank clerk in Franz Kafka's *The Trial* (1925), who is arrested one morning on no stated charge. No restriction is made on his physical freedom but immense is his psychological burden: for he soon understands that he must spend all his time, indeed perhaps the rest of his life, defending his case through a labyrinth of legal courts and subcourts and offices. In the end, the Law commits Josef K. only to one thing: that he dedicate himself body and soul to his case. What is wanted of him is less infinite patience (in expectation of a charge and a ruling that he realizes will never come) than infinite commitment to being a subject. Josef K. is to pledge himself absolutely to his external, official, bureaucratic, structural (indeed torturously *structuralist*) identity. In a sense, the Law requires him to become self-obsessed, to devote all his thought and energy to his socially defined being. Kafka's universe is wholly man-made: hardly a glimpse of nature ever breaks through the concrete; not the sun but light bulbs light the scenes; it is a world without a sky and without horizons, entirely bounded by human protocols and structures. Soon Josef K. does become his case. He becomes a subject—a person cut off from others, obsessively self-centered, and yet oddly impersonal since his identity, as in the historical-materialist doctrine, is mostly social stuff-

ing (the Law). "You are Josef K.!" says the grand priest of the Law and these are just the words that make up the existential sentence to which he must bow: to be Josef K. and only Josef K., infinitely, irrevocably, and exclusively.

In the end, men come to take Josef K. to his execution. Now that he has accepted his subjection, the Law has no more use for him. Either he has wholly ingested the Law or the Law has absorbed him. In any case he has become identical to it. He is subject. Nevertheless, he is given an ultimate chance, that of plunging the knife into his own breast. Does the Law want him to do its dirty work? Or is it testing the degree of his subjugation and obedience? Or else, from a more hopeful angle, does the Law relent at the last and give its victim a chance at the dignity of suicide over the ignominy of liquidation? Whichever the case, K. cannot rise to the challenge. "The responsibility for this last failure of his lay with him who had not left him the remnant of strength necessary for the deed. 'Like a dog!' he said; it was as if the shame of it must outlive him."[2]

The mood, message, and meaning—indeed the very light cast by the tale— turns on these two ultimate sentences and they bedevil resolution. At the eleventh hour, it seems, K. whispers a dying word that gauges the depth of his debasement. He sees his utter enslavement, his failure to take destiny into his own hands, to kill himself and by the same token rise above his conditioning. He still has enough dignity to know that his death is shameful and his last omission despicable. For, if his failure to rise above his social conditioning, that is, if his resignation to being only a self as socially defined, becomes apparent to him, then he is no longer this self-limited subject. At the nadir of his unfreedom he sees what the good life ought to have been.

But Kafka sinks this hope. For suicide, we note, is in fact what the Law deviously required Josef K. to commit. K. feels his executioners to expect him to take the knife and plunge it into his own breast. Unable to take death into his own hands, K. therefore fails not himself, but the Law, that is, the oppressively man-made social order that regiments his life. The upshot is that his shame does not stem from a transcendental sense of obligation to an ideal of what human life ought to be, the freedom it should claim; on the contrary, his shame is fueled by obedience to the social order. K. simply experiences the stinging humiliation of not having wholly surrendered to the Law. So he dies evermore in the clutch of his social oppression. There is no ideal, no human

2. F. Kafka, *The Trial*, trans. Willa Muir and Edwin Muir (New York: Schocken Books, 1956), 228.

life, no transcendence outside of the Law, outside of the rationalist-idealist structure writ large. ("There is no outside of the Law" essentially says every stop in K.'s evolution through the involute labyrinth of the Law.) So vast indeed is this labyrinth that it reaches into the afterlife: "it was as if the shame of it must outlive him" (*T*, 228). K. feels he owes himself to the Law even unto death, forever. Indeed, the Law reaches into K.'s death and steals eternity from him. His shining moment of transcendence, when a window lights up in the sky and God seems to reach out from on high—this moment too is dragged into the human-made universe. Joseph K. will always belong to the Law. And because the Law impounds even his death from him, there is no release from the great encirclement. The Law is the here and the beyond, immanence and transcendence. It spreads over man and god, over the mind and that facet of the mind that looks beyond the self. This is why the Law in Kafka's novel assumes awesome infinity and ubiquity and divine majesty (e.g., the chapter "The Cathedral"). By virtue of becoming the only reality there is, the human-made world—the world of rationality with no reference outside itself—commands the authority of God. And the only sacrifice worthy of a god is, beyond the self, actually the self's infinite surrender. This is why, in George Orwell's *1984*, the godlike Big Brother demands not merely the grinding obedience of its subjects, but the unending commitment of their souls. They must not only give themselves over to the social order, to the all-too-human idol; they must also love giving themselves over; they must turn over to society the corner of eternity that dwells in the self (the side that silently faces the entire universe, the thin membrane through which intelligence feels the infinity of being that intelligence cannot grasp). Big Brother demands the complete loving surrender typical of religion. Undeniably the basic feature of religion, beyond its efflorescent liturgies, is about shifting the center of meaningful experience from the ego to the totality of being that infinitely surpasses us. And this is just what makes totalitarianism, that is, the religion of power, so frightfully akin to religion proper—why also it commits its followers to the frenzy of dedication and sacrifice seen in religious feeling.

What is the cult to which we must surrender in *1984*? What is the god to which we are required to bow? It is, diabolically, the ego. Witness the creed that Winston the heretic is beaten into accepting.

You believe that reality is something objective, external, existing in its own right. You also believe that the nature of reality is self-evident. When you delude yourself into

thinking that you see something, you assume that everyone else sees the same thing as you. But I tell you, Winston, that reality is not external. Reality exists in the human mind, and nowhere else.[3]

Indeed, solipsism is the leitmotiv hammered in by the Party: "nothing exists except through human consciousness" (236); "nothing exists outside your mind" (237); "not merely the validity of experience, but the very existence of external reality was tacitly denied" (71); "If both the past and the external world exist only in the mind, and if the mind itself is controllable—what then?" (71). Then, one might answer, the mind is master over reality. This means it is also master over the reality of the mind itself and the latter vaporizes, becomes unreal, an artifact from the mill of social engineering and relentless molding—indeed, the very ideal of unbridled human self-fashioning held out by the postmodernist likes of Richard Rorty or Stanley Fish. There is nothing real but the will to create, to subjugate reality to the will. The world is thoroughly man-made, constructed by the mind down to its smallest particle. In her remarkable study on totalitarianism, Hannah Arendt offers this definition: "the fundamental belief of totalitarianism [is] that everything is possible," by which is meant that man's perception of reality is infinitely malleable, and therefore that reality too is boundlessly plastic.[4]

In *1984*, the creed that power is all, that man is the measure, postures as religion ("we are the priests of power . . . God is power" [235]). Of course, it is no religion. Outwardly it demands self-abnegation; but the worshipped god is actually man answerable only to his appetite to prevail. In truth it is the religion of mind—a false religion because religion is surrender of mind. It is idolatry, the worship of gods fashioned in our own likeness and for our own convenience. Winston's eventual conversion to Big Brother has the look and feel of religion:

He looked up at the portrait of Big Brother. . . . Forty years it had taken him to learn what kind of smile was hidden beneath the dark mustache. O cruel, needless misunderstanding! O stubborn, self-willed exile from the loving breast! Two gin-scented tears trickled down the sides of his nose. But it was all right, everything was all right, the struggle was finished. He had won the victory over himself. He loved Big Brother. (265–66)

3. G. Orwell, *1984* (New York: Harcourt, Brace and Company, 1949), 222.
4. H. Arendt, *The Origins of Totalitarianism* (New York: Harcourt, 1948), 437.

Orwell understood the need for community that burns in the chest of the modern individual. Alone, cut off from traditional ties, a self-standing economic agent or a faceless operator, the single person yearns for reunion and collectivity. He wants to escape existential solitude and be shown the way, taken care of, loved. In the end, he will throw himself under the thumb of authority rather than endure uncertainty much longer. Totalitarian propagandists have been more than happy to indulge this yearning. Surrender to the surging crowd, to the political chant, to the march in lockstep, gives one a thrill akin to religious conversion. What thrill in yielding the frail vessel of mental autonomy to the sea of discourse, of infinite textuality, of collective language games! What joy in being no one, in casting off self-accountability and metaphysical isolation! The ecstasy of impersonality is nevertheless a terrible swindle because here transcendence of self alights no higher than on a social bandwagon: the party, the state, language, discourse—all faces of the same will to power, of mind's absolute dominion over reality, including (this is the point where social solipsism swings into totalitarian terror) *the point where man surrenders mental dominion*. What the Party wants is for man to enjoy yielding to it. In other words, it wants to lay its hands on man's love of God, of the infinite.

Demonic indeed we are, we the makers of Big Brothers, because we have devised means to reach into the heart of men and steal religion, that is, love. Big Brother embodies the horrendous, but not illogical, outcome of subjectivism evolving to the point where the human standpoint is not just a philosophic absolute, but a social absolute as well. It wants man to surrender unconditionally to the idea that there is nothing but man. To love Big Brother means to accept that there is no world but man's. This love mimics the transcendence of religion but grossly highjacks its direction. Religion organizes man's need to transcend intelligence and make contact with the world through other ways than anthropomorphic knowledge. Big Brother is religion turned on its head because it co-opts the surrender of intelligence to serve intelligence; it lays hold of love in order to comfort narcissism.

Love is acceptance of the world. Whereas knowledge is acquisitive and seeks to transmute the world into intellect, love is liberal: it wishes to render unto the world what belongs to it. Love entertains no desire to transcribe reality back into the language of mind. Put philosophically, love perceives where the mind ends with respect to the world. Love therefore goes with the acceptance of death (one's limitedness in time and space). This explains why God,

whichever the theological tradition, is met always through love and death: for to love completely is to accept the infinitely greater force of the outward over the inner, of reality over mind. Love compels subjectivity to accept its end. "To die to the self" is the message of all great religious traditions and it is synonymous with the injunction to love.

Love of course is the opposite of anthropocentrism. It is not a property of the self but its expulsion; it is abolition of personality, destruction of subjective centralism. Love brings a state of artistic and moral grace: artistic because here the mind dedicates itself to letting the world shine, moral because this contemplation shifts the center of life away from egotism.

Filling the subject to the brim with reason, text, language, and ideology, modern subjectivism has pushed love out of the thinking life. The entailment would therefore seem to be that love, *the religion of reality*, stands no chance in our modernist world of construction and deconstruction. But this thankfully is a partial truth. In reality self-transcendence is vibrantly alive at the heart of modern intellectual experience. As we shall see presently, it is the wellspring of one of modernist culture's dearest fixtures: to wit, art.

THE RELIGION OF REALITY

That which is there to be spoken and thought of must be.

Parmenides

CHAPTER 10

The Sense of Reality

———— ✦ ————

The more I think of it I find this conclusion more impressed upon
me,—that the greatest thing a human soul ever does in this world
is to see something, and tell what it saw in a plain way. . . . To see
clearly is poetry, prophecy, and religion—all in one.

Ruskin[1]

To become reality itself.

Cézanne[2]

THE CHAIN OF SOCIAL AND INTELLECTUAL upheavals that broke our
age from the classical and medieval era and that gave our period its modern
stamp, when reduced to its bare principle, consists in this: to guide society,
customs, learning, science, the law, the arts, indeed even religion, from a hu-
man standpoint. Life is a conversation between human beings in view of
human-appointed ends and carried out by human-made means. The eminence
of subjecthood over reality is, by and large, the winning philosophic story of

1. J. Ruskin, *Modern Painters* (New York: Knopf, 1988), vol. 3, part 4, 404.
2. M. Doran, ed., *Conversations with Cézanne* (Berkeley and Los Angeles: University of Cal-
ifornia Press, 2001).

modernity. The citizen of today is raised on the principles of Descartes, Locke, Rousseau, Montesquieu, Kant, William James, and Sartre even if he never hears their names. To the result that, at any rate in the West, to be a person is to subscribe spontaneously to the belief that having a self is synonymous with autonomy, self-governance, and the ultimate authority of one's judgment on matters of feelings, choices, inclinations, moral or religious beliefs, and understanding at large—the belief, in short, that the "I" is the be-all and end-all for the sake of which society lives and evolves.

It is fruitless to bemoan this state of affairs—fruitless because at this stage the suit against individualism would only be filed on behalf of the individual. The last meaningful assault on individualism, the one led under the banner of Marxism, never proposed to transcend the individual altogether; it only suggested that there existed better, more humane social means to fulfill selfhood. All factions agree that individual happiness is the grail of social organization; we disagree merely on the means. The self is, as it were, the horizon of significance we cannot look beyond. No philosophic or social endeavor to reform the self root and branch, to, as it were, deindividualize it, would succeed without inflicting a gross amputation of minds and personalities. It is not to be wished, and if totalitarian societies teach anything, not to be sought either.

This said, however, to admit that people should not be deindividualized by brutality or terror does not rule out wondering whether autonomous selfhood is the end of human life. Are there not goals and purposes higher or worthier than fulfilling one's individuality? The foregoing suggests that the self is the stuff of idolatry, a wishful image of man not so much as he is, but as philosophers and artists and thinkers wished him to become in the modern era. Idolatry is an attitude that consists in mistaking the means for the end, the image for the god. To suggest that the self is an idol is therefore to propose that it is a means to a purpose greater than self-realization. This is not to call for "the death of man," "the end of the subject," or any such watershed. Nor is it to overrule the principle, rightly sacrosanct, that whatever the greater end of mankind is, it remains good only so long as the individual is free to consent to it. Whatever may lead beyond autonomous selfhood must be undertaken by the self alone, lest we deal not in liberation but in tyranny.

The idea under consideration here defends the view that the concept of individual self-achievement includes the freedom to find a meaningful life be-

yond the self; that no self is fully mature that cannot transcend its own centrality; indeed, that self-overcoming is an essential aspect of what we mean by the notions of individual happiness or perfected selfhood. But if the self is thus a stepping-stone, we need ask what it leads to. What perfection greater than personal sovereignty, individual autonomy, and mental self-possession lies in store for us beyond the self?

The answer is attunement with reality, with the total existence of the world.

Having "the sense of reality" designates primarily a disposition and a perspective. The disposition is respectful and attentive, the perspective indigenous and participating. The sense of reality is a skill. Just as a woodchopper has a feeling for timber, just as a diplomat has a feeling for human motivations, and just as a mother has a feeling of what ails or pleases her infant child, so the sense of reality is reached by experiencing and participating fully in the web of dependences and connections that make up the world. It comes from being an entity whose power to reflect upon reality in no degree lessens its participation in and responsiveness to reality.

Reality in modern life has gone into eclipse; the obfuscating object is the self—the idol of all our bustle and fret and concern. The principle of reality has gone the way of its old herald and champion, religion. Religion entails acknowledging that a force, a powerful center of existence, exists outside the self. The ancient wisdom that the world was God's creation enshrined the notion of an absolute reality existing independently of human actions and purposes. The modern sensibility, however, is subjectivist, and accordingly rejects any extrasocial, extrasubjective nature to anything we know of. Thus reality is a dwindling force, once stronger than human consciousness and intelligence but now increasingly harnessed and tamed, and correspondingly less awesome. The cause of this is undoubtedly social. Our technological mastery of physical laws, our scientific ability to curb, channel, and outwit nature—all this has considerably dulled our former respect for what exists. If diseases can be cured, the atom split, rivers dammed, and the sky flown across, then nothing in principle is beyond the reach of human ingenuity. Thus can we faintly imagine but not really share the terrible awe felt by our forebears for mighty reality—with what reverence the ancient Greek farmer, the medieval villager, and the Renaissance seafarer looked to a storm, a plague, a cloud of locusts, a drought, a broken ankle, or any of those unforeseeable "acts of God," so called

because reality then wielded an inscrutable, terrible, and absolute authority to an extent immeasurably greater than today.

The progress of science and technology in the last two centuries has all but killed this reverence. It teaches us to regard reality's convulsions (diseases, earthquakes, aging, etc.) with the eye of prevention and eradication. Nature is strong but stronger still is man's power to manipulate its building blocks. So, if and when we bow to reality, it is only provisionally—with the confident knowledge that someday science and knowledge will bring that resistant corner of reality to heel.

Decline in the sense of reality also stems from the pace and economy of modern life. Baudelaire touched upon an important truth when he declared that modernity is an infatuation with speed, with the fast and the fungible. Modern commerce favors fashion over tradition. Much of our economy rides on tempting us toward new commodities, new solutions, new gadgets, and away from the old, the tried, and, one might add, the unprofitable. Permanence was the value of a more agrarian and aristocratic age. A mercantile age creates a value that optimizes the traffic of goods; this value is novelty. To the modern ear, to say that an idea or object is new is nearly to praise it. This passion for newness, that is, for forgetfulness, has altered the feel for reality that traditionally dwelt in objects, places, and edifices; family heirlooms; the farm or family estate where one grew up and lived in or returned to; the solid furniture made to pass down generations. In today's marketplace objects are commodities designed to deteriorate in the short run; places are rushed through at great speed, or jumbled together by jet travel; and new buildings regularly arise in place of those too old, costly, or cumbersome to maintain. If reality dwells in objects, then indeed our reality has become an ever-changing shapeless heap. The impermanent rules.

Though the social dynamic is averse to it, however, the sense of reality, of the kind given by prolonged and thoughtful attention, still runs deep in the human character. Social commentators often quote Marx's celebrated sentence "All that is solid melts into air, all that is holy is profaned," but forget that the selfsame paragraph ends with the urge that man "face with sober senses . . . the real conditions of life, and his relations with his kind."[3] Indeed, the

3. K. Marx and F. Engels, *The Communist Manifesto* (New York: Oxford University Press, 1992), 6.

times call for our attention. The sense that mental life is a ghostly and inverte-brate thing unless counterbalanced by an outside force as radiant and compel-ling; the intuition that more is asked of us than perfunctory use of the world, the feeling that a deep acknowledgment of reality is as central to the human personality as the need for shelter, food, or safety—this side of us, then, has not gone away. In fact, we well-fed Westerners stand at an incomparably lucky time in human history. Perhaps for the first time, entire populations—and not just the small cosseted class of priests and princes—have the leisure to turn an eye to reality that is free from apprehension, gain seeking, and squirming. We can now heed reality because we want to, not simply because we have to. This switch from freedom to compulsion refines the substance of both perception and the perceived.

First, perception: when heeding reality is a necessity, it is customarily stained by fear and self-interest. Can a farmer really appreciate the *isness* of his field when the life of his family depends on it? Is his vision not narrowed by apprehension? Our appreciation of a being is often overshadowed by our need for him or her. Contrariwise, attention gets purer in proportion to which ne-cessity loosens its hold. The less grasping our interest, the more limpid our un-derstanding. Our looking gains in clarity because it is not targeted or focused; it does not seek out this or that detail for mechanical purposes but contem-plates the interrelated presence of the whole. What we notice in an everyday casual mode invariably reflects our piecemeal interests and projects. It is reality parted by the toothcomb of personality. Only when we stop looking through the focus of what we want or need to know and start seeing for the sake of the seen, only then does reality fully arise. It is less confined, less niggardly, less straitened. It is reality freed from the grip of graft and interest. "So *all* that was going on and we never noticed!" says the character Emily Webb in Thornton Wilder's play *Our Town*. "Do any human beings ever realize life while they live it—every, every minute?—Saints and poets maybe," the writer replies.

It is beyond this book's competence to speak for saints; it nevertheless builds on the conviction that poets and artists are practioners of reality, that they help us, in Wilder's words, "realize life."

<p style="text-align:center">⋇</p>

A general word on reality. The term is a ragbag that admits any and every definition. For our purpose, I propose to use "reality" in the most everyday sense available. This is because our dealings with reality are mostly everyday

and practical. Devotional and aesthetic contemplation decants it of fret and bustle, but reality presses at our door in the mundane ways. We heed the on-coming traffic before marveling at the silver sparkle over the rooftops. Howev-er much the mind is enthralled by the argument of a book, the hand does not forget to turn the pages. Even the solipsist ties his shoes before sallying out to teach his mind-only philosophy. This philistinism in our instincts is no cause for shame. Indeed, it is the secret key of our relationship to reality. Reality, and therefore the consciousness that lives by it, is worldly. We are bound by the laws of embodiment, space, gravity, fragility, mass, and motion. Western man is wont to construe physical submission to reality as humiliating surrender. This is a mistake. For submission to reality is also the pathway toward spiritual grace. We love because we are mortals: finite and therefore unique. We cherish things because time takes them away. We look upward because we live down in the valley. Every act of transcendence is valuable on account of its humble origin. This is why the state of grace is not really known to the gods. The gods, who transcend reality, by the same token cannot genuinely love it—for no love can come from looking down.

Reality is mundane and close-at-hand. It is, in Henry James's phrase, the legions of "the things we cannot possibly not know."[4] Thus it is the countless gestures and attitudes by which a person acts upon externals, the actions and concomitant objects so embedded in our way of being that, as Wittgenstein thought, the verb *to know* seems too mercurial a term for the web of action and reaction that binds us to things. Things anyone can't possibly not know include looking before jumping, seeking relief for a toothache, or finding shel-ter against the cold. I cannot possibly not know that a smile addressed to me elicits some sort of response; that shoes come in pairs; that the Moon is out of hand's reach; that one looks in the direction from which one is spoken to; that hair grows, as do babies or contempt when one's behavior to others is heinous; that food satiates hunger; that water evaporates; that a roof sits at the top of a building. These are elements of the common world which, for better or for worse, we are never mistaken to name reality. Of course, reality never presents itself as a whole; nevertheless, our every living and acting moment assumes its presence. And it is this presence, free-floating yet undeniable, to which artists open our blinkered self-preoccupied subjectivity.

4. H. James, "Preface," *The American*, 353.

How Reality Was Lost

———❦———

THOUGHT ALONE CREATES NOTHING NEW.

This statement is heresy to our intellectual sensibility, to the philosophy that, from Hegel to Sartre, has taught us to regard consciousness as the spirit of freedom itself, as the escape from the drearily empirical, as the creator of the future and the conditional. In fact, however, thought alone cannot move very far. It simply rearranges what is already known to consciousness. By itself thought makes no discoveries because on its own it cannot lead to reality. Such, at any rate, is the upshot of Kant's refutation of empiricism—a cornerstone of our modern sensibility.

Kant split the world in two: phenomena on one side, and noumena on the other. Phenomenon is the world such as it appears to human perception. Noumenon is reality such as it lies unperceived, outside of our cognition and understanding, the thing-in-itself. Kant maintained that we have no way of knowing the noumenon. To know is to relate mind to a thing. Hence it is to alter its purity. To know the noumenon is a contradiction in terms, which means, inter alia, that the real world, the world-in-itself, can never be known. We are therefore in exile from the world. We live in a theater of images cobbled together of secondhand perceptions and inferences, while the real world, the noumenon, plays out a full symphony just beyond our earshot. It is the Platonic Cave revisited.

This idea deserves attention, less for its plausibility, than for the formidable

hold it has exercised over thinkers and poets well into the twentieth century. The notion that the real world, the *res ultima*, was beyond our reach inspired the romantic readers of Kant like Hölderlin, Wordsworth, Coleridge, and Nerval to regard mankind as irrevocably exiled from the world. On the one hand, Kant empowered the mind by making it a demiurge in its own sphere; on the other hand, he also cast a resigned shadow over our ability to know things. In truth, Kant restricted, even *humbled*, the scope of thinking. At first blush his philosophy of apriori categories of apperception (i.e., inborn fixtures of thought, such as space, time, and causation, through which we filter the world) appeared to liberate the mind from crude dependence on the given. It suggested that, far from dutifully copying the data of senses, the mind creatively shapes reality. On reflection, however, it appears that Kant also locked the mind up in a self-made box. Many grand things the mind can do, but it cannot see things for what they are. Great and mighty is knowledge but forlorn is its kingdom.

In truth, Kant restricted the scope of thinking at both ends of the philosophic spectrum. To empiricists, as we have seen, he said that our contact with reality is a highly convoluted business. But he also chastened idealists and those who, from Augustine and Anselm on to Descartes, held that to possess a clear idea of an entity somehow speaks for its existence. In Anselm's ontological proof, our possessing the idea of God in a sense vouchsafed His reality. But being, Kant objected, is not a predicate.[1] To say that a thing necessarily exists is not enough to give it being. For necessity is a feature of the mind and not of the world. The conclusion is that there is no way to move from idea to reality. And thus the mind was chopped off from the world also at the idealist end. Rightly, then, distressed romantics went on to portray the mind in marooned circumstances, equally in doubt of reality as of itself, for Kant lifted it out of the world and left it hanging awkwardly aloft. No thought entails a state of affairs and no thought, even when mindful of circumstances, lets reality in fair and clean.

"You can't get out of the trees by means of the trees," says poet Henri Michaux. The mind can't lead to reality by mental means alone. But then are we really exiles? Are we bereft of reality? Though Kant himself seemed on the whole untroubled by this loss, induced by the First Critique, his Third Critique, the *Critique of Judgment*, stages a retrieval to palliate the exile.

1. I. Kant, *The One Possible Basis for the Demonstration of the Existence of God*, trans. Gordon Treash (Lincoln: University of Nebraska Press, 1994).

The *Critique of Judgment* is Kant's word on aesthetics. In the aesthetic experience, consciousness delights in the experience of being aware. It revels in the satisfaction of receiving and forming perceptions of objects outside the mind. At the root of experiencing beauty, Kant avers, is delight in "the represented connection of the subject with the existence of the object."[2] Besides the practical aspects and benefits of knowing a thing, there also arises the pleasure of being aware of the acquaintance. The mind delights in contemplating its own representation of objects. But this raises a problem. Why should this contemplation cause delight if, as per the First Critique, our knowledge of things is partial and truncated? Shouldn't the aesthetic experience induce bereavement instead? For surely if the mind never *apprehends* but only *represents* objects, then contemplating this process would amount to accepting the ways in which the mind misfires, distorts, alters, makes hash of, and finally bypasses reality. On this account, aesthetic experience would consist in delighting in the mind's mendacity and inaccuracy. And this of course cannot be Kant's last word. This is why he amended the second edition of the *Critique of Judgment* to suggest an outward, world-directed dimension to art's pleasure. In the aesthetic experience, he adds, "it is not merely the object that pleases, but also its existence" (*CJ*, §5, 43). Aesthetic pleasure is not just self-satisfaction; it is not just the mind applauding its own mercurial powers of conceptualizing. Nor, on the other hand, is it the mind enjoying the sensuous facets of a thing. It is a different pleasure altogether, more mysterious and metaphysical. We rejoice, Kant says, in the "existence," the *fact of*, and not just the *form of* an object.

At first this seems counterintuitive. For what is art if not concrete forms that make us discern and appreciate the sensuous aspects of life? By contrast, to comprehend the existence of an object, at least in classical philosophy (Plato, Aristotle, Augustine, Descartes) involves stepping beyond its particulars to behold the general idea or the work of God. There, we comprehend the existence of things not by means of the senses but through the mind. Existence is, to this extent, an abstraction, a metaphysical feature of which the sensual data is just a manifestation. Kant therefore swerves from classical metaphysics when he asserts that aesthetic pleasure is appreciation of a thing's existence. Here the concrete is not a hindrance to overcome, it is the very path to metaphysical insight.

2. I. Kant, *Critique of Judgment*, trans. J. H. Bernard (New York: Hafner Press, 1951), §5, 43.

The Christian story somehow challenged the prim duality that made essence preincarnationally precede and transcend the existent. Jesus' Incarnation, his few gentle remarks on the fields and the crops, and above all his focus on the living person suggested that the palpable life could be a channel to the absolute, and not just its dross or refuse. Everyday life became sacred. Christ's message was not, unlike Abraham's, unconditional devotion and sacrifice to the Godhead at the expense of our dearest human attachments. To the contrary, his message pointed to a divinity near at hand: one's fellow being, the slave, the poor, the children, the downtrodden, the overlooked. The religious person is he and she who attend to the reality of suffering and well-being around them, he and she who minister to the tender, transient, and all-too-fragile reality of corporeal existence. Not the Platonic sun that blinds but the manifold reality that makes one *sensitive* is the focus of spiritual activity. This transvaluation finds its brightest herald in the figure of Saint Francis in the twelth century. His words and actions reflected the faith that tangible life is not the Manichaean opposite of true reality; that love of embodied forms indeed is love of God; that incarnate life is not a fall, but a rising.

To return to Kant. His suggestion that the concrete reality of things leads to insight into their existence is quite consistent with the Christian redemption of everyday life. How, however, does one go from appreciating the corporeal particularities of objects to marveling at their existence? How, in other words, can the physical be a gateway to the metaphysical? While contemplating Vermeer's *Lady Writing a Letter* we attend closely to the plump tenderness of yellow velvet, the downy dapple of light on a drop of garment, the splendor in a bare arm. It rekindles and enhances our knowledge of yellow, satin, fur, skin, and light. We pause and notice the tender tangible sensuality of things at hand. But whence comes the seemingly superfluous notion (or as A. J. Ayer would put it, the nonsensical notion) that, on top of being there, the object *exists*? This seems an especially paradoxical statement to make about a painting where, apart from oil pigments and canvas, there is no satin, fur, and skin to speak of, no real lady seated at her writing desk. How is it, then, given the make-believe of artistic objects, that they disclose blazing existence?

One way to understand this revelation is to abolish the duality between the totality of existence and existing things. The whole exists only through the parts. There is no being outside of existing things. Nevertheless, every object proclaims the work of being, its insistence on existing rather than not. Every

thing manifests the force that there be things, the attractive power that makes things hold together and appear. Each concrete object is thus suffused with being. This realization casts the light in which the artist works. To answer the question why, for instance in Vermeer, the skin or satin emits a glow, rather than just merely catches the light—why the painted things themselves are the source of radiance—this is because the artist is interested in more than representing things (representation is second-best and always flattens and dims things); his keenness is for bringing out the glowing affirmation in each existing thing: to be rather than not, to coalesce rather than scatter, the goodness of being rather than the unfathomably dark emptiness of not being. Life is unending victory. Art, Kant intuited, expresses the joy in this insight. Art lets things be—a seeming paradox because on appearance it toys and tinkers with reality. In truth, it helps reality into the full release of its natural glow, a feat that first of all requires the artist to dim his own bustling instincts to seize and comprehend. Reality arises when we step back. This stepping-back is the only sense in which it can be interestingly said that art is fiction. The fictionality of art consists not in an as-if, but in holding objects at the distance that protects them from our consuming hands.

CHAPTER 12

The Battle over Reality

That mind is at fault which never escapes from itself.

Horace, *Epistles* 1.14.13

EVIDENTLY, HOWEVER, the idea that art strives to let the object be and that our subjective surrender opens access to reality comes under strain.

It seems to shore, rather than mend, the ontological gulf carved up by the *Critique of Pure Reason*. Indeed, how does desisting from possession help our feeling of being in exile from things-in-themselves? In appearance, the *Critique of Judgment* asks us to assent to our exile from things, and in this assent find the piteous joy of resignation. In art we indulge freely what is imposed necessarily by the structure of consciousness: that we are kept out of reality by our awareness of it. But just how does resisting the urge to enter reality lead us into reality? And how does contemplating our distance from things mitigate the pain of separation from them?

There is another objection to the idea that reality proper emerges when we give up trying to grab it. Is not surrender, for instance, a devious twist of the will? For if reality arises from my withdrawal, then reality is to this extent dependent on my withdrawal. Moreover, to delight in our own lack of interest, motive, or encroachment is psychologically self-serving. It is to enjoy the thrill of one's absence, akin to the juvenile fantasy of spying on one's own funeral. Likewise our pursuit of objectivity in knowledge, science, art, and religion, in

the wish to see or love things as they are—perhaps all this is no more than the regressive glee of pretending we are not here, of playing hide-and-seek. This, at any rate, would be the contention of subjectivism which looks with much suspicion on those moments of grace that lift the artist or the saint above everyday self-interested perception—moments that are psychoanalyzed down to instances of devious self-pleasure. Can you not see, the subjectivist says, that we human animals are organisms one-sidedly bent on self-preservation, that we see never for the sake of the thing, but to optimize our survival and make ourselves safe and cozy? "Consciousness is present only to the extent that consciousness is useful," Nietzsche claims.[1] Given this biological imperative, the experience of deep affinity with reality can only be an after-hours feeling we entertain for the world once we have got it safely under our boot. Love of reality is the feeling of well-fed people. Back in the days of survival, of battling against starvation, inclement weather, beasts of prey, plagues, and other myriad scourges, the existence of the world in fact gave us no time to pause and fill our hearts with beauty. There was no time to muse over the sparkling presence of things then, no time to fall in love with reality. This is the deluxe pasttime of idlers (e.g., priests and artists) sponging off the social surplus. So, at any rate, goes the Darwinist-Marxist strand of social anthropology.

True to historical facts though it is, this outlook is unnecessarily reductive. Its assumption is that our physioneurological makeup is geared only to practical advantage-seeking, and that there is no way to override our preservation instinct. The trouble with this argument, however, is that it harbors its own refutation. For might we not justifiably argue that subjectivism (not religious realism) *is* the view of people blissfully sheltered from the struggle for life? Indeed, that it holds little practical worth in the biological sense? Let us picture our primitive ancestors hunting and foraging for food and fighting against merciless surroundings. This tough reality in fact left them no choice but to take it with absolute seriousness. To play fast and loose with the subjective transcription of external reality was to doom one's person, family, or tribe. Either reality was seen correctly or the person died. Biologically speaking, the sense of reality is no luxury but a point of survival. The existence of the world presumably imprinted itself on our consciousness through terror, fear, and ur-

1. F. Nietszche, *The Will to Power*, 275: "Consciousness is present only to the extent that consciousness is useful."

gency. Let us formulate a guess: to reconnect with the fact of reality is to make contact with this terror once more. Our two cultural activities for highlighting the *fact* of existence, art and religion, are thus probably children of fear. For a good reason reality seen through art and religion is said to inspire awe. Letting-reality-be (i.e., the concession that the world exists over and beyond our perception, or use, or handling of it) logically antedates our practical interaction with reality. Must I not be viscerally sure of the world's existence before, say, I go searching for food? Surely it is not the act of searching for food that makes the world real—action can only further our practical acquaintance with it. The hunger in my stomach is no subjective conceit. It is the tug of reality on consciousness, the tie that connects mind to the need for food, and to the reality of food, body, and body-in-the-world. Letting-reality-be is thus to reconnect not with a state of contemplation, but with a state of submission.

This is why artistic beauty as a way of letting-reality-be reaches into the primitive level of our psychic entwinement with the world. Tellingly, Kant's discussion of aesthetic feeling in the *Critique of Judgment* leads to an "analytic of the sublime" and an "analytic of the teleological judgment," or, respectively, awe for the fact of nature and awe for the fact of God: in the end two expressions of one awe for the terribly unavoidable thereness of the world.

Surely Kant wanted to keep the analytic of the beautiful separate from the other two, more savage and mind-crushing, revelations of existence. To him the beautiful was the experience of the mind urbanely, complacently, happily enjoying the inner representation of things abstracted from the mundane bustle of appetite and profit. But sublimity and divinity also break into Kant's aesthetics in such a way that the sublime and the religious follow the beautiful. Disinterested enjoyment of the representation of things leads to noticing their existence (the beautiful); noticing the existence of things leads to the inescapable presence and might of nature (the sublime); and such tremendous presence leads to the sentiment of its mystery, the unthinkable why of it all, the intuition that the universe is one entity but, paradoxically, a "one" for which no other following number can be imagined (the divine). That the beautiful borders on the sublime is implicit in Kant's pointer that "it is not merely the object that pleases, but also its existence" (*CJ*, §5, 43). For existence is not an abstract generality applied to the particular object. To say that my desk here exists is not just to remark that I am *saying* that it exists. It is also to impress that the fact of its existence is an essential feature of the desk; that the

desk breaks into my perception; that it arises from the quotidian background to, as it were, hit me with the fact, the singularity, the very bulk of its presence. Of course, only self-aware rational beings can remark on the existence of things. But it is wrong to assume that this human way of framing the presence of things necessarily isolates us from them, that it abstracts things from their tangible shells. The thought that the desk exists is significant because it matches something the desk is or does. Otherwise the beautiful (i.e., the act of marveling at the existence of a thing) would merely amount to relishing the omnipotence of thought. Indeed, it would be the enjoyment of madness, of the notion that decreeing the existence of an object is enough to actualize it. And this clearly is not Kant's meaning.

Reality is more than just an invention of the human mind, however much it takes a human mind to entertain its notion. The desk touches me with its reality. This shock opens a vacuum. Thoughts fall away, the mind hushes up, the inner monologue gives out; interpretation stops beclouding perception; the mind is drawn outward by surprise. Only when the mind is naked can reality enter. The experience of beauty (the moment when, as Kant suggested, we are not only entertaining the images of things but also touching their existence) must entail surprise. Because so long as the mind is not caught by surprise, it cannot help putting itself first. To stop assuming, it must be taken aback. And this is why beauty is akin to surprise, hence to our sense of being vulnerable to reality. Beauty thus reconnects us to the primal sense of reality which, to the inhabitant of the primitive forest, consisted of alertness and fear—the habit of taking reality dead serious for survival's sake.

Now, this way of talking about beauty in terms of fear, jolt, and trigger-tight attention seems to confirm that, far from being partitioned events, the beautiful swings over into the sublime. Fear, in Kant's idea, sets the overruling sensation in the sublime:

"bold, overhanging, and as it were threatening rocks; clouds piled up in the sky, moving with lightning flashes and thunder peals; volcanoes in all their violence of destruction; hurricanes with their track of devastation; the boundless ocean in a state of tumult; the lofty waterfall of a mighty river, and such like—these exhibit our faculty of resistance as insignificantly small in comparison with their might. (*CJ*, §28, 100)

The sublime thus connects with viscerally felt danger, the instinct to run and take cover, our unthinking submission to the laws of matter and force. In such conditions the notion that things exist isn't the rare flower of the growth of

cogitation; it is bundled together with our most instinctive, life-and-death readiness. To doubt existence is suicidal, indeed antagonistic to biological response. Existence is something we feel in our stomach before it is taken up by reflection. It is the terrible ground of our response to sense perceptions, that is, the absolute certainty that these sense perceptions are no mere images dancing in our mind's eye but obtrusions of very real and *existing* things. A glass of wine spills across the table and I pull away; a loud report goes off and I start; a rickety shelf comes clattering down and I duck. These reactions, in the end, show to the intellect what consciousness already knows in earnest: that we are too embedded in things to deliberate about being a part of them. The reason why the existence of things is mysterious is not because that insight is a lofty, ethereal concoction of meditative consciousness; it is because the insight is the deepest, most entrenched, most antediluvian part of consciousness. It is the ground on the basis of which consciousness is *of* anything even before knowing it. My actions say that I believe blindly and absolutely myself to be of a piece with existence.

This explains why taking existence into quiet consideration is, in some way, to reconnect with the primitive terror (the instinct to face or dodge, run or stand, swerve or stay the course, jump or duck) of embodied life. In the experience of sublimity, the primeval terrors of prehistoric man break upon the chambered philosopher; vast, uncontrollable, hostile nature bullies the *Homo saber.* Thus beauty trembles on the edge of the sublime, for it too is akin to fear and awe, to a feeling of surrendering to the greater authority of what exists. To notice that a thing exists, as the beautiful bids us do, rekindles the primitive epidermal contact with reality, its pushing and obtruding on the mind. When standing before Titian's *Man with the Red Cap* I cannot satisfactorily discourse about the autumnal crimson, the rumpled leathery gray of the glove, the sunset-colored vest, the inner-lit translucent fur stole. Hardly could I be said to be enjoying the painting—nothing so wan and dilettantish. The feeling is akin to that of my mind tumbling out of me. I am all response, yearning, surrender to the given. The full, irresistible intensity of the painting silences me. Whoever said that art was educated pleasure? In truth, it is a return to the primitive, the reptilian, instinctive, and by necessity most *earnest* recess of the mind, the part of the mind that, even before we tell ourselves about it, watchfully and completely *believes* in reality.

Of course, the objection here may be that I am merely mistaking my rap-

ture for the reality of the painting. Harping on my sensation, evoking its emotional undertow, reliving its vibrancy—all this is no argument for proving the externality of beauty, let alone the externality of reality. The skeptic will simply say that what I perceive to be winning me over is not the work of art per se, but my aesthetic receptivity running ahead of my understanding. This impression of inexhaustibility is still subjective, that is, I am narcissistically contemplating the power of feeling over interpretation. And this in fact is quite close to Kant's idea of the sublime: though a child of primal terror, it is in the end the flower of intellectual pleasure. "Astonishment that borders upon terror, the dread and holy awe . . . —this, in the safety in which we know ourselves to be, is not actual fear but only an attempt to feel fear by the aid of the imagination" (*CJ*, §29, 109). In other words, through the sublime, the mind freely stages the representation of its unfreedom, its subjection to fearsome, bewildering, external forces. The sublime, Kant says, is not really rapture, but the thrill of watching oneself in rapture.

This distinction makes all the difference between, say, really screaming with terror and screaming for play at the horror movie. This pleasant distinction gives Kant the leeway to rope in the sublime to the service of the beautiful since, like beauty, sublimity involves the mind delighting in its inner representations.

Of course, this reversal is just what we might expect of a philosopher who, like Kant, fears being taken by surprise—indeed a thinker who rigged up a philosophical system to insulate the self from a reality now removed to the improbable land of "noumena." Kant is most defensive when he deals with external forces, but he lets his guard down in the seeming safety of inner mental events. This is why, on balance, his analytic of the beautiful (which stumbles into the sublime) is more daringly interesting than his analytic of the sublime (which beats a meek retreat behind the lines of the beautiful).

This enlacement of beauty and sublimity rehearses the old philosophic dialectic of subject and object. Does the aesthetic experience lie in the mind or in the thing? Is beauty a feature of perception or a property of objects? Of course, this question is wrongly put. For to suppose that the matter splits into a stark either/or assumes that mind and matter live in two separate and independent realms. If I were to venture a guess, it would be that the aesthetic experience is that in which subject and object achieve delicate balance, akin to the arms of a highwire artist. Beauty is a kind of harmonic encounter between mind and

thing—a state of grace where mind completely opens up to the given without ceasing to be mind. It is the pleasure of reunion. To wish to tip this subtle equilibrium toward either the subjective or the objective probably comes down to psychological indulgence. The person who understands beauty as subjective probably falls in the psychological typology of persons who derive more enjoyment from watching themselves watching than from apprehending other beings. In contrast, he who prefers to see beauty as independently arising will be in the end a type of person who tends to find the painting more powerful than anything said about it. Considering the sway of psychological sensibility over sense, it is fruitless trying to reason logically about either option. All one can do is sketch the practical, moral, spiritual, and intellectual consequences of being either a subjectivist or a realist.

The forthcoming part of this essay makes a case for finding subjectivism a barren corner of the human experience. It is sterile in the way that afflicts all protracted self-protection: the soil runs out of nutrients. Moreover, subjectivism is ungenerous because it obviously leans parasitically on what it denies. Pure ideas alone cannot provide the raw material for thought. Try to build a world solely with Kant's innate ideas: time, space, extension, and causality. The outcome is skeletal, colorless, unworldly. Ideas feed off phenomena. So subjectivism goes to reality for supplies but in the end disparages the supplier (biting the hand that feeds it).

Likewise beauty that extends no further than the eye of the beholder soon exhausts beauty. Here is why. Should beauty be strictly a property of the beholder, aesthetic feeling would be tantamount to self-pleasure, to the mind delighting in its own ingenious exercise. "Beauty" would then be a word used to express a feeling of self-satisfaction with one's mind. To say "This is beautiful" would amount to saying "I feel good about my mind right now" or "I feel clever and discerning at the moment" or "Boy, how perceptive I am today!" But why then speak of beauty at all if indeed the feeling is really attuned to self-satisfaction? The point is this: if beauty is only an inner feeling, why impute it to the object? Indeed, why would a serenely subjectivist mind bother validating its inner states by crediting them to an external source? It should happily behoove a self-satisfied subjectivist to state not "This object is beautiful" but simply "I am beautiful when looking at this object." And this means simply "I feel good when looking at this object." Beauty is thus replaced by pleasure psychology.

A variant of this assumption fuels the aesthetic theory known as the "pathetic fallacy," thus named because it describes the psychological habit of mistaking objects for how we feel about them. On this account John Ruskin named it a fallacy. Erroneous it is, however, also out of self-contradiction. The reason is plain to see. The pathetic fallacy assumes that we need to validate our inner mental states by hooking them to an external point. By saying "This face is beautiful" instead of directly saying "I feel good about this face," the fallacious seems to admit that his inner emotion needs anchoring onto an external object. Is he then unsure of his own subjective affects to need plant them in objective support? Perhaps inner states shorn of external anchorage are simply too liquid to grasp, too pale to behold, too featureless to believe in. And surely art bespeaks the human need to set our ideas in concrete forms, to see life of the mind made into flesh. Art is one of the means by which ideas are given reality. But if we want more reality for our thoughts and feelings, it follows that we hold reality for a virtue—a good of which mental states can be short, in any case something of which the mind can always benefit to have more. The generalized pathetic fallacy that is art (casting our inner states onto outer objects) thus seems to argue for the vitality, strength, and value of concrete reality.

This then raises an issue: if reality is good to have, if it brings a quality to ideas that they alone are unable to emit, the pathetic fallacy is really no supporter of a subjectivist definition of art and beauty. The fact that the mind seeks concrete support argues against the notion that reality exists only in the mind's eye. For should reality exist only under the aegis of subjective creation, it would be illogical to seek reality to vitalize our ideas. From the standpoint of absolute subjectivity, any concrete actualization of thoughts would be a degradation of their crystalline purity (a thesis more or less entertained by Plato). But in fact subjectivity still seeks validation in external artifacts; indeed, subjectivity refuses to be absolute. Despite Hegel's funeral eulogy, the survival of art to this day proves that we believe in reality, that we hold it for a good not native to the mind alone, and of which the mind is in need. We still want our ideas leavened, raised, magnified, intensified, transfigured in external objects. Never mind what the conceptualists claim: the theoretical description of a work of art will never have the vitality, authority, and irreducibility, indeed the sheer bounty and excellence, of its existing counterpart.

Consider the biblical account of Genesis. The worldless God before the Creation is absolute subjectivity: consciousness existing outside of space, time,

and matter. Because these are yet to be, the complete subjectivity of God is boundless and placeless. But the infinitely self-sufficient spirit that is God now sets out to create things. Indeed, He creates reality. "In the beginning God creates the heaven and the earth. . . . And God said, Let there be light: and there was light" (1:1–3). Creation thus proves that absolute subjectivity wishes to externalize itself, perhaps that it wishes to cast itself into objects, action, movement, expansion out of original self-containment. Once created, however, those objects take on a new glow. Although the idea (the Verb) gives birth to things (reality) and everything in reality therefore has its source in the idea, although indeed nothing is found in reality that is not already contained in the idea, something about the created fulfills the creative intent. Thus the Godhead pauses after each new creation and reflects: "And God saw the light, that it was good" (1:4). This afterthought runs rhapsodically through the first chapter of Genesis.

And God called the dry land Earth; and the gathering together of the waters called he Seas: and *God saw that is was good.*" (1:10)

And the earth brought forth grass, and herb yielding seed after his kind, and the tree yielding fruit, whose seed was in itself, after his kind: and *God saw that it was good.* (1:12)

And God set the stars in the firmament of the heaven to give light upon the earth, and to rule over the day and over the night, and to divide the light from the darkness: and *God saw that it was good.* (1:17–8)

And God created great whales, and every living creature that moveth . . . : and *God saw that it was good.* (1:21)

And God made the beast of the earth after his kind, and cattle after their kind, and every thing that creepeth upon the earth after his kind: and *God saw that it was good.* (1:25)

This continues until the last verse and its restatement of the rhetorical motif: "And God saw every thing that he had made, and, *behold, it was very good*" (1:31; italics added).

The writers of Genesis seem to picture God's appreciation to be like that of a craftsman satisfied over a job well done. But God does more than bless His creation. He does not *say* that the light, the stars, the sea, the whales, the cattle are good; instead He *sees* that they are good. The connection is not just theoretical, it is also physical. Of significance is that the artifact has to be created,

it has to stand apart, it has to exist, for us to see that it is good. God's praise advertises satisfaction. Can we say that the fact adds to the bare concept? That the goodness of Being shines brighter when it casts itself into Existence? Of course logic dictates that everything about the light was comprised in God's idea of it, that "in the beginning was the Verb." But the Verb is not just an idea; it is the force that galvanizes the thing. It is that which casts itself into fact, as light needs an object in order to appear. The story of Genesis is a story about the omnipotence of mind over matter, but it is also about the awesome goodness of Existence, of matter. Its narrative is not of the type "Light is good, hence I am going to make lots of it," but rather of the type "I create light, and lo! It is good!" This is the difference between, for instance, conceiving a child and giving birth to a baby—it is the wonder of existence, whose excellence illuminates the mere notion. Creation is a wonder added to conception. The writers of Genesis cannot help imagining a God who marvels at being, that is, who loves actual being. For God is life in its manifold manifestations, spirit *and* matter. And Genesis sings a hymn to the marvel of that which exists. There is goodness in conceiving of something, but there is even more goodness in a thing's actual existence (e.g., Anselm's argument according to which a perfect divine being could not be just a being in theory, but an existing being as well: from which follows that existence is an added good to the idea of existence).

A thing gains immensely from becoming real while a thing only mentally sketched remains lacking. For this reason it cannot be entirely good. Is there then some inherent positivity in existence that transfigures the concept thereof? Aquinas thought so: "In so far as a thing is real, it is good; the very existence of each single thing is good, and so also is whatever it rises to."[2] Reality is good. In fact it is *the* good. As against nonexistence, it bespeaks infinite affirmation, bounty, generosity. Without existence, evil would have nothing to deny or destroy. It is thanks to existence that we may imagine nonexistence. To subtract assumes the presence of a prior sum (evil assumes its opposite), whereas adding assumes nothing beyond its own generosity. Reality is good because it is positive; it is good because nothing less can be imagined.

God sees that His artifact is good in the same sense we say that a thing is beautiful. To see a thing taking its concept by surprise is to be faced with presence. It is a speechless experience of beauty. Beauty lies in a mind joyfully

2. Aquinas, *Summa Theologiae* Ia, 18, 3.

acknowledging this amazing positivity of reality. In this sense, God's original reaction to the world is aesthetic. "And God *saw* every thing that he had made, and, *behold*, it was very good" (my italics). "Aesthetic" here means not just "contemplative," "sensitive," or "perceptive." Instead it means appreciative of what is. The world is good not because it is large or useful or pleasant or bright or promising. It is good because it is there. And aesthetic experience has to do with seeing this "thereness." God seems delighted to be in the presence of something other than Himself. Aesthetic experience has to do with making oneself present to an object: not noticing this or that aspect of the object, nor inferring this or that proposition about the object, nor again primarily accruing knowledge about the object, nor finally seeing it with the eyes only, sensuously. "Seeing the world" means making oneself present to a living thing that somehow outpaces one's ability to understand it, to the extent that only acceptance and renouncing knowledge remain to encounter the world.

"Seeing the world" entails physical contact, lest the world remain merely an intellectual idea. To see the world, one needs feel the crushing corporeal authority of facts over mind (a literary example is Ivan Illitch, the hero of Tolstoy's novella, who learns to see the world when the reality of illness compels him to inhabit his body; a mundane example of the crushing authority of the world is, say, whenever you look left and right before crossing a street).

But "seeing the world" in this practical manner is only half the work. In fact it takes more than attending to the empirical demands of reality to reach the realization of the thereness of reality. To go from the hunch that the world is calling for my response to my aesthetic-religious insight that the world emphatically and marvelously *exists*, my mind must perform a staggering act of self-overleaping. The task is to bring the mind in touch with its opposite, to lead the abstract to the concrete. Because this cannot be done, because the mind touches the tangible only by etherealizing it, yearning sets in. The thinking mind knows that its thinking bars the way. It is itself the obstacle and the desire. Thus the mind learns to desist from reaching into. It learns to accept its limitation. It becomes humble before what exists. This is aesthetic seeing, which is less about perceiving than feeling and accepting the limits of human perception.

※

This account throws in reverse the notion that beauty is subjectively constructed. For if the foregoing holds true, "seeing reality" (i.e., the experience of beauty) entails a mental emptying out; it is thought flummoxed by the sheer

force of phenomenal reality. Indeed, the notion that beauty is only a way of seeing things generally fails to square with experience where, in the presence of a beautiful face or a beautiful work of art, it does not coherently occur to me that I am imagining such excellence. To see beauty is to be drawn outward. It is to feel the tug of some metaphysical hunger. Beauty pleases but it does not quench—which logically it could not do if it were a function of the subject servicing itself. Seeing beauty comes with the absolute conviction that one does not possess the wherewithal of imagination, intelligence, and insight to create such clarity, such understanding, such delineation. To attribute this beauty to me, the beholder, would be boastfully inaccurate. It would run outlandishly counter to the felt experience of seeing with deeper and brighter and wider scope than ever before. This broadening of seeing is not planned by me; rather, it comes to me, takes me by surprise. And since nothing already inside can surprise the mind (i.e., since the mind cannot really tell itself things it does not previously know), this revealing force must come from outside. If beauty were subjectively derived, appreciating a beautiful work would involve a thrill of self-recognition, a feeling like a pat on the back, a confirmation of one's pre-existing thoughts. But this is not how it feels. A genuine work of art does not round off my understanding but expands and stretches it; it breaks it open; it challenges me, denies me placatory solutions and bromides. This is the sense in which the work of art gives me the unwavering deep sense of standing before something that is definitely not me, nor of my own making. This, I then know, is larger, greater, more powerful than all my theoretical imaginings, my interpretive expectations, my jaded acumen, my art-world savvy.

※

Now, this argument that beauty is the deep sense of reality, and that art is concerned with unveiling the objectivity of reality—it stands puny against the subjectivist juggernaut of modern and postmodern art criticism. Apart from Heidegger, whose occult pronouncements on art point to a mysterious umbilicus between the artwork and "Being," the range of modern aesthetics argues for a less mysterious vision. Art is made by human hands and therefore reflects the human mind. It is bound by personality, psychology, history, society, the mental web we spin around ourselves and that is our home. Through art we express ourselves; we dream about the world as we wish it could or ought to be; we lift objects out of their drab, transient, unredeemed state and transfigure them with the magic wand of subjectivity, whether we call it imagination,

feeling, or thought. Thus, for Sartre, for whom art is the consummate act of subjectifying reality:

Esthetic contemplation is an induced dream, and the transition to reality is a genuine awakening. . . . A fascinated consciousness, engulfed in the imaginary, is suddenly emancipated by the abrupt ending of the play or symphony, and regains contact with existence. Nothing more is needed to provoke the nauseous sense of revulsion that characterizes the consciousness of reality. From these observations we can reach the conclusion that the real is never beautiful. Beauty is a value which applies only to the imaginary and which entails the negation of the world.[3]

For Sartre, the real is never beautiful because it simply is; only that which is brightened, crystallized, transfigured by the Midas of thought may claim beauty. A landscape becomes beautiful when seen as a scenic image of itself; a face appears beautiful when we see it as a portrait of the person. In other words, to see beauty is to aestheticize the given. A face is *imagined* to be beautiful. This does not mean that Rudolph Valentino may have been a repulsive troll; it means that only as an image, lifted out of the contingency of being, do we ever find him beautiful.

Others, most notably Dewey, emphasize feeling over imagination in the subjectivity of beauty.[4] Here the beautiful is the strongly felt, that into which the subject is so burningly welded that we may never tell when facing the artwork which part is objectively given and which part is subjectively felt. A beautiful face before me is really my subjectivity in hyperdrive, glandular mayhem, a hot flash. Valentino may trigger it as well as Mickey Mouse. Objectivity is a sensitive plate pounded by a meteor shower of intense emotions.

For yet others, currently much in influence, the defining feature of artistic beauty is not imagination or feeling, but thought. It is also the one branch of subjectivist aestheticism to have spawned an art form of its own, conceptual art—so called because it programmatically claims to bypass the objective dimension altogether and speak directly to the intellect. Conceptual artist Joseph Kosuth envisions a new aesthetics in which a verbal statement about art could stand for a work of art.[5] Here aesthetic (which etymologically has to do

3. J.-P. Sartre, *Psychology of the Imagination*, trans. Hazel Barnes (New York: Philosophical Library, 1948), 281–82.

4. J. Dewey, *Art as Experience* (New York: Perigree, 1980).

5. J. Kosuth, *Art after Philosophy and After: Collected Writings 1966–1990* (Cambridge, Mass.: MIT Press, 1993).

with feeling) becomes a misnomer. A work of art most purely and originally consists in what it says, its intellectual articulation of any number of subjects. A conceptual artwork is like a clever sentence: while not always elegant, its virtue is to pack in as many thoughts as possible. On the basis of its cerebral weight is a work then declared worthwhile and artistic.[6] For the conceptualist, artworks above all want us to "get" their message rather than stare idolatrously at their shape and color. Thus Duchamp's urinal or snow shovel demand less looking at than thinking about. The intention is unlikely to make us marvel at the contoured elegance of urinals but to impress the notion that aesthetic understanding is what makes an object interesting; that however lowly a urinal may be, it will soon gain artistic value from being thought of in aesthetic terms; that not its inherent qualities, but the talk of critics, curators, and aesthetes and the artist's own authority will make it worthwhile. Duchamp's *Fountain* is the attributive or subjectivist theory of art made into an object but paradoxically triumphing over objectivity. For such an object affirms that art is what we say is art and beauty what we say is beautiful. It is the subject riding to victory on the might of the Verb.

An offshoot of the beauty-as-subjectivity school is the social definition of beauty. Basically, it holds that beauty is not so much what a person says is beautiful, but what a great many people at a given time agree to find beautiful. This is the institutional theory of beauty, thus known because it maintains that the beautiful is the by-product of prevailing opinions defended by institutions and conventions and social conditioning.[7] Beauty is the rumor of subjects overwhelmed by their own consensus.

Here, in brief, is the panorama of our artistic sensibility—idealized or emotionalized or intellectualized or institutionalized, it falls in any case under the province of the subject. Those who still angle for a more two-sided approach, a fair half-and-half settlement between subject and object, draw fire to themselves. They are suspected of being "purists" in disguise, remnants of a pre-Jurassic breed of aesthetes who once went around genuflecting before art-

6. This, at any rate, is N. Goodman's thesis in *Languages of Art* (New York: Hackett, 1976); its flaws are amusingly exposed in R. Nozick's *Socratic Puzzles* (Cambridge, Mass.: Harvard University Press, 1999), 273–76.

7. An institutional theory of art most notoriously defended by philosopher G. Dickie in *Art Circle: A Theory of Art* (Chicago: Spectrum Press, 1997) and *Art and Value* (New York: Blackwell, 2001).

works, their eyes agog with visions of an objective beauty out there that their all-too-subjective words fail to convey (Ruskin, Roger Fry, Rilke). Let us try better than shortshrifting their point.

Their thesis is, roughly, that an object recommends itself to aesthetic appreciation on the strength of inherent features that astonish, fascinate, puzzle, mesmerize, or overwhelm the viewer. In other words, the object must be at least minimally noteworthy to warrant aesthetic attachment.[8] But clearly this approach runs into trouble with modernist artworks. For how does it account for snow shovels, urinals, or piles of dirt in the modern art gallery? There, we are forced to side against the objectivist and concede that artistic value is attributive and institutional, indeed that it has little to do with the object proper and everything to do with the subject.

Since no one even remotely sane can remonstrate that an enamel urinal or a pile of dirt evinces the same level of intricacy, thoughtfulness, delicacy, grace, passion, texture, feeling, and suggestiveness as, say, a Fra Angelico or a Sargent, we must agree that, in this instance, artistic value is subjectively constructed. Our mistake would be to jump to the conclusion that just because artistic value is subjective in this instance, it is *necessarily* so in all instances. The example of urinals and dirt piles simply commits us to say that, in *our* age, at the outcome of three hundred subjectivist years, artists and thinkers are prone to producing artworks that proclaim the dominion of thought over matter, that artists confirm and respond to broad cultural and institutional conditions that sanction the subjectivist ethos. A snow shovel in the museum does not prove that subjective attribution makes art; it merely proves that we moderns are of a subjectivist turn of mind, subscribers to the dogma that mind molds facts. We exhibit and celebrate the sort of art that reflects best who we like to think we are.

Of course, a possibility is that the artist wants us to notice and appreciate the overlooked: the shunned urinal, the humdrum shovel, the unremarkable dirt mound. His attention and care are genuinely reality-oriented; he wants our eyes to open to the humbly wondrous aspects of everyday life—to, as it were, the infinite in a speck of sand. And surely there is much to recommend this view. For art undoubtedly cultivates heightened perception. Long before

8. A middle approach nicely defended by A. C. Danto's meditation in *Transfiguration of the Commonplace* (Cambridge, Mass.: Harvard University Press, 1981).

modernist experimentation in found art and concrete art, still-life painters invited us to tarry with the humble, to feel the cosmic shock in an orange peel, an earthen jar, a rumpled piece of tablecloth. A still life need not have photographic realism, but empty it of its quality of attentiveness, and it is flatly academic. Art invites us to the sort of deep seeing that hushes the mental chatterbox so that a teacup, a branch against the purpling sky, a rock, or a stranger's face appear more important and evident to our mind than our very thoughts.

The artist who exhibits a blank canvas or a stack of soap boxes or four and a half minutes of silence curbs the normally utilitarian cast of our ideas. He wants us to stay with the question "What is this?" instead of jumping to ask "What is it for?" This program of ontological rescue also finds expression in the mid-twentieth-century artistic movements known as brutalism, primitivism, minimal art, and concrete art—all forms of nonfigurative or literalist presentations that emphasize the materiality of the object over all else—to the point where nothing but the taciturn hunk remains, a chunk of rock, a piece of jetsam, some bit of caked plaster evincing no intention, design, or purpose. In this light, literalist art seems the latest expression of art's ancient love for reality.

One can have a good deal of sympathy for this program but find its associated artworks falling short of it. In the end, it seems that material or literalist art only pays lip service to the dignity of mere things. To lean a slab of steel or a ladder or some curl of beachwood against a gallery wall brings a piece of everyday life into the art space. Evidently, however, the object does not stand alone. Its status as art assumes some stage setting.[9] The artist does not merely drop the object; exhibiting it means self-consciously gesturing to the object and saying, "Here is objecthood." The practitioner of found art thus engages with matter in a markedly theoretical way. The object is pointed at. Though a dynamic presence, it has the slightly stunned look of a circus animal. Whatever dialogue takes place between mind and *physis* occurs at a distance. Behold the thing itself, says the minimalist, feel the power of its presence.[10] "I am interested in the inscrutability and mysteriousness of the thing," Tony Smith, a leading literalist, announces.[11] Well and good. But one feels this objecthood to

9. On this topic, see M. Fried, "Art and Objecthood," *Artforum* 3, no. 3 (June 1967): 22–23.

10. A leading celebrant of "presence" in modern art is C. Greenberg, *Art and Culture* (Boston: Beacon Press, 1961).

11. In S. Wagstaff, "Talking to Tony Smith," *Artforum* 4, no. 4 (December 1966): 44–47.

arise from the artist's Prospero-like gesture rather than from the object itself. In the end objecthood arises less as a property of reality than from the mind's detachment from it. Reality is not entered, but theorized. It is circumscribed by the power of the Verb. In sum, it is a *spectacle* of reality, indeed the mind celebrating its own power to blandish artistic worth on whatever it wills. It belies a squeamish retreat from the patient labor of submission, of exploration and apprenticeship, of deep prolonged loving seeing, and embracing the laws of fact that shine out of Chardin's pots and plums, or Richter's candles, or Van Gogh's chair—all of which are born out of unflagging dedication to embracing the laws of matter, to accepting that intentions may be rebuked, altered, or corrected by the paint, the stone, the words. Here matter has a say; indeed, it stands on equal footing with the subject. For art is not magic; it does not decree. It is a patient walk through the valley of things; in fact it is, as we shall see, abnegation of intentionality.

But magic, the omnipotence of thought over physics, is what the modern gallery has been given to favor. It leonizes our power of reality shaping. Unsurprisingly the conceptual artist's statement of purpose often takes as much attention as his works themselves. Hardly an ambitious artist can afford to exhibit without a statement of sorts, some piece of theoretical whim-wham to qualify him as "serious," to intellectualize or contextualize his products. More interesting to us than the object itself, it seems, is what the artist means by it. At times the work of art is so wrapped up in the intellectual message that it is scarcely more than a medium—sometimes to successful effect (e.g., Barbara Kruger's poster art). At any rate, we moderns want our artworks to mean something, to say it loud and learnedly, and wear their slogan on their sleeve. Whether it is incisive, subversive, conciliatory, political, challenging, thought-provoking, or condemning; whether it addresses and "problematizes" issues of race, gender, sexuality, politics, or history; or, barring these qualities, whether it is at least self-knowing and inwardly critical—whichever it be, we expect the artist's mind to speak out and the artwork to provide a medium.

The times—*engagés* writers and thinkers as far back as Tolstoy have insisted—are too tragic, too full of suffering, and too awful for artists to toy with sensual impressions. According to H. Belinsky, "Pure art is impossible in our age."[12] We expect art to take sides, to be serious and wordy. Refusal to solem-

12. R. W. Mathewson, *The Positive Hero in Russian Literature* (Stanford, Calif.: Stanford University Press, 1975), 77.

nize or indulgence in retinal stimulation, in the tangibly beautiful, in speech-less rapture—all these activities are not even supposed to be harmless. The pleasure of the quiet art lover denies social reality, retreats into a private indi-vidual paradise that insults the suffering of others and is nonsense anyway. For it pretends there is such a thing as private experience whereas theory dictates that there is no corner of private subjectivity, no cry of hope or despair, no glimmer of transcendence, no patch of blue sky that, in the end, is not minted by society.

<div align="center">⚜</div>

To conclude, our aesthetic sense has become vastly intellectualized—per-haps to distinguish itself from the twaddle of "relishing Gauguin's colorful palette" or "falling into Kandinsky's visual symphonies" or "embracing Ma-tisse's sensuality." Modern highbrow taste favors the stark and the knowing over the sensual, Manet over Monet. Thus the critic hopes to obviate the em-barrassment of liking an artwork that might some day prettify a calendar.

Such intellectualized art appreciation, however, breeds a philistinism of its own. It is the vulgarity of intellectual self-congratulation. A philistine is who-ever appreciates an artwork because it confirms him. Just as in social matters he prefers the limpidity of formulas, so in artistic matters he favors what the artist means over what he does. Meaning is communicative while form is reti-cent. Meanings require either consent or denial; forms require a more grop-ing exploration. To look at artworks for confirmation of preestablished mean-ings, whether emotional or intellectual, is sentimental vanity. It is the opposite of discovery, adventure, risk, and toil—the virtues proffered by beauty. Art-works that strictly appeal to the intellect, artworks so thoroughly conceptual that they want only to be analyzed and understood, ingratiate themselves by flattering laziness. Appealing to ideas simply sends the spectator rummaging through mental contents in storage, material already digested by thought; it is an appeal to the past. This is how intellectualism is sentimental: because it ca-ters to the safe and the already established, because it indulges our instinctive recoil at the new, the outside, the unsynthesized—a recoil that is philistine through and through.

But, but—the conceptualist will opine—can't artworks introduce new ideas? And can't this introduction serve the process of expanding vision, of disrupting mental habits claimed here on art's behalf? In the obvious sense, the answer is yes. But in a deeper sense, the answer is no. Ideas fall under the

ambit of the intellect. And the intellect is inherently conservative and dis-solving. It organizes the chaos of perception into prelabeled categories. In the words of Fernando Pessoa, "I understood that things are real and all different from each other; I understood it with the eyes, never with thinking. To un-derstand it with thinking would be to find them all equal."[13] By nature ideas abridge and condense. They whitewash colors. A fact understood is classified and put away with others of its kind. This classification optimizes our practical use and handling of the world (how inconvenient it would be if I could not lump your house and my house under the general heading of "house"; it means we would have to devise from scratch different ways of speaking about each separate thing). Although useful in this respect, thought regrettably tends to be aggregative and regressive in character. The novelty of an idea is never pure—unlike the novelty of a fact, which can be undiluted. To recognize a new idea is to understand how it ties into old ideas. Whereas a genuinely new fact has the power to wipe out everything in its path. This is why bad facts can create trauma but bad ideas only worry, why good facts can create wonder, but good ideas only pleasure.

The mind alone is unable to create novelty; indeed, it cannot be properly said to create. It can combine elements of thought indefinitely but it cannot give birth to genuinely new material. This is why a mind cut off from the world entrenches itself further and further into labyrinths of thought which, howev-er intricately rich in design, are limited to their building blocks. A strictly the-oretic mind thus tends to look backward in time. Whenever left to its own de-vices, the mind helplessly tends to conservatism, that is, to philistine attitudes. This, perhaps, is why an idea cannot be genuinely beautiful (though it can be elegant and ingenious): because it is always of the past. Accordingly, works that cast their lot with ideas, such as works of conceptual art, forgo beauty— which is tantamount to an athlete eschewing strength, a diplomat skill, or a politician foresight. Their basic nature is safe and conservative however much their aspiration is cutting-edge and revolutionary. Beauty breaks rules but one does not reach beauty simply by breaking rules. Rules that are broken without the exploratory spirit, the self-sacrificing venture into the unknown, only yield a language of cleverness and knowingness that, in the end, differs little from

13. F. Pessoa, "If, After I Die," in *Selected Poems*, trans. R. Zenith (New York: Grove Press, 1999).

the vernacular of advertising and industrial design (it is interesting to see how serious poster artists, like Barbara Kruger, wrangle with this problem).

ℰℭℬ

Thought is synthetic and dissolvent while reality tends to come in a riot of colorful splinters. This is why attention to reality (i.e., the source of beauty) harkens to the crazy-quilt aspect of life. Artists are natural detail-mongers— so, at least, Virginia Woolf averred:

What is meant by "reality"? It would seem to be something very erratic, very undependable—now to be found in a dusty road, now in a scrap of newspaper in the street, now in a daffodil in the sun. It lights up a group in a room and stamps some casual saying. It overwhelms one walking home beneath the stars and makes the silent world more real than the world of speech—and then there it is again in an omnibus in the roar of Piccadilly. Sometimes, too, it seems to dwell in shapes too far away for us to discern what their nature is. . . . Now the writer, as I think, has the chance to live more than other people in the presence of this reality. It is his business to find it and communicate it to the rest of us. So at least I infer from reading Lear or Emma or *La Recherche du Temps Perdu*. For the reading of these books seems to perform a curious crouching operation on the senses; one sees more intensely afterwards; the world seems bared of its covering and given an intenser life.[14]

Artists are those deputies of the intellect who make amends for its abstraction. The mind is a generalizer, the artist a retailer. But since language is the medium of generalization, the artist, the writer, the poet paradoxically has less to do with "the world of speech," to use Woolf's term, than with "the world of silence." Speech condenses what exists. To step into reality requires giving up speech—a tall order when one is a poet, a painter, or a composer.

What, practically speaking, can "giving up speech" mean to the artistic process? Obviously the mind can never drain itself out and let pristine reality in. But the mind is not immanently stuck in mental stuff. It can entertain dispositions and desires with respect to itself. Thus it can choose to cling to habits of self-preservation and sentimental indulgence and simplification, or it can wish to transcend those habits. The mind is not hostage to its own epistemological situation. Subjectivism itself admits mind's freedom from itself. The very thesis of subjectivism suggests that the mind can transcend itself, survey the walls of its prison, and, as it were, declare itself a prisoner. Factually the mind may not operate outside itself (no thought or feeling outside a brain), but the

14. V. Woolf, *A Room of One's Own* (New York: Harcourt Brace Jovanovich, 1929), 113–14.

mind is so outfitted as to recognize it is only one perspective onto the world; that this perspective is set against a background of a multiplicity of other perspectives; and that these perspectives cohabit a world. Just this formulation, in fact, assumes a margin of self-freedom and self-transcendence within us—an aptitude of self-suspension.

"Giving up speech" is synonymous with this self-suspension. It is the mental orientation most clement to beauty: neither subjective self-absorption, nor absorption in the objective (both trademarks of the mad), but the recognition of the mind's limitation. Art is subjective *and* objective. It is realization of the objectivity of subjectivity—by which I mean first that man's subjective perspective is an objective feature of the world, and second that man's peculiar brand of subjectiveness consists in seeking objectivity. Thus, alone among all thinking animals, we seek to look upon our own subjectivity, that is, to see it as a thing in the world. We alone are dissatisfied with being confined to our perspective. And yet honor this perspective we also must because it is a feature of the objective world. It is how the world wants us to be. This is why we can never leave off being subjects—a nonexit clause that should cause no existential glory or despair. For our subjectivity is harbored in the world, nurtured and conditioned and created by it. Subjectivity is our nature; it is in nature, is natural. Art consists in this realization. Thus does it amount to the labor of enduring the discord between mind and reality as well as that of accepting that this discord is a modality of reality.

CHAPTER 13

On Representation

—— ❧ ——

THE IDEA THAT ART REALITY has been hugely depressed by our modern fixation on *representation* wherever and whenever art is the object of serious discussion. The new weight of representation in art appreciation is a by-product of the subjectivist ethos. And it eclipses an aspect of artworks that is indifferent to merely representing.

That the critical focus on representation issues from subjectivism is easy to understand. Where the mind is thought capable only of *representing* and never breaching reality, every human activity or artifact thereby stays within subjective bounds. Moreover, assessing artworks in terms of representation seems commonsensical enough because, in fact, artworks depict, portray, and illustrate, indeed represent images of things. They give pictures of the mind's various ways of apprehending reality. This at any rate justifies focusing on the represented content of artworks, indeed singling out this content as the special entrance into the meaning of a work of art. Hence the common practice of discussing artworks thematically, in terms of *what* they represent (the West, the Orient, biblical women, animals, farmhands, the common lawyer in England, Paris sewers, food, gender and race, dreams, wars, brothels, corpses, illness, monsters, and just about everything under the sun). Representation criticism is furthermore cloaked in moral benevolence. On the assumption that the representing lens, brush, or pen always inflicts crude distortions and truncations on the given, the critic makes it his duty to target the guilty

spots. Masterpieces are praised or castigated for their ideological slant. This has a leveling effect on art works. For when assessed only in terms of representational contents, it matters little whether the object under scrutiny is a masterpiece or a third-rate daub, and whether the responsible party is Rembrandt or a hack. The latter may show more sensitivity or accuracy than the former and accordingly earn praise. Of course, we cannot blame the scholar for showing moral concerns. But it is arguable whether such a worthy mission warrants turning art criticism into a tribunal. To belittle art because men are corrupt is not wise.

Moreover, the crusade for bringing masterpieces to justice harbors a contradiction. The school of representation draws legitimacy from the principle that all cognition *represents* (i.e., distorts) what it beholds, and that no uncontroversial access runs between mind and matter. This epistemological stance, however, is plainly incompatible with the moral drive of representation criticism. How, indeed, can we take an artwork or artist to task for misrepresenting certain beings when all representation falls under the heading of misrepresentation? Of course, there is nothing wrong with wondering, for instance, how instructive the representation of rural folks in nineteenth-century Russia has been, or with inquiring about whose interests it serves to represent men dashing on horseback and women wilting in boudoirs. The claim of fair or unfair representation, however, assumes that there is a way Russian peasants really were, a way men and women exist outside of biased depictions, if the charge of bias against these depictions is to stand. Representation is *of* something existing apart from its picture or else the charge of tendentious depiction must be dropped.

Central to the critical school of representation is that no image is ever unbiased. It shapes and reshapes the given according to political and social purposes. The assumption here is that reality has no substantial force of its own, that it is putty waiting to be lumped, sorted, molded, and socialized in whatever mode suits art's personal or institutional patrons. "Art represents reality" to the critic of today means "Art in the service of ideology decides what reality is." What art is of, what it represents, is assumed to have little or residual influence on its representation. Reality is a ghostly nothing. This is why the bias in one given representation is not exposed by cross-checking it against fact (since there is no such thing); instead it is "problematized" on a lineup of competing representations that, no less biased, get to weigh in the balance. Through it all,

there is no question of clear vision and truth, but of warring factions squabbling over the social pie.

At the basis of representation criticism is the philosophic theorem of pluralistic relativism. It holds that reality has no unifying property but is a swarm of multitudinous subjective perspectives, from the amoeba's viewpoint all the way to human intelligence. The world is simply an infinity of approaches and uses and representations. However, the notion that an object is only the sum of the various angles of perception converging on it—the theorem that *esse es percipi*—does not typify human consciousness. Perhaps a plankton cell or a squirrel may be excused for thinking the sun to exist nowhere outside their sensate enjoyment of it. Not so a human being. Our consciousness is so made as to infer a realm of existence outside the incoming physical stimuli. We are, says subjectivism, imprisoned by our cognition of the world. But by the same token—so reason compels us to see—no notion of imprisonment can we have without the attendant insight *that there is something from which we are imprisoned away*. Or else it makes absolutely no sense to say that we are limited by our human perception of things. Limited we in fact are because we comprehend our own tightness of perception with respect to some vastness beyond. Of course that virginal world is off limits. No contact with reality can we achieve without scaling it down to our measure. But this scope is imperfect in contrast to a greater scale that we cannot help inferring. How else could we have devised the curious notion that our intelligence of things is subjective if not against the backdrop of a broader reality? Our awareness of the partial stems from our insight into the impartial.

(This, we hear, the relativists deny. On their account we become aware of the partial when our view comes in conflict with other people's: on the evidence that others sometimes prove us wrong we must admit that our cognizance is flawed and limited. Insight in the subjectivity and partiality of viewpoint is thus born of the encounter with other subjectivities and partialities. But this dialogic notion of truth misses the point. For the single consciousness could never admit to the standing validity of other viewpoints unless it has prior insight into its own limitedness. If subjectivity were supreme, then so would it be at the individual level. Each person would find himself living in a world seamlessly commensurate with his imagining of it. This, however, is not how it goes. I check my view against others' views because I know my view is not all, because consciousness carries within the insight of its insufficiency

without. Moreover, I engage in conversation not because I want other people to brainwash me, but in hope of refining my view against theirs in relation to a state of things overarching those views. In other words, I cannot expect others to convince me unless they have something to convince me about, and not merely the strength or violence of their persuasiveness. No thirst for clear vision would I seek, in others or the world, no conversation would I admit to, nor challenging opinion would I countenance, unless I first concede the superior standing of reality over mind—unless, that is, my mind is natively directed toward an order other than itself.)

This, then, is our lot. Our part is not the whole. And we know this, oddly, not because we know the whole, but because our part is so made as to know it is only a part, and therefore wanting of the whole. It is our awareness of limitation that galvanizes our thirsting for truth.

The world is full of angles because there has got to be something to look at in the first place. Though perception tampers with the perceived, it is not demiurgic. It cannot create what it sees and whoever says so can only be speaking metaphorically. Now if it is a fact that there is a state of things out there, though we may never know absolutely what it is, though our apprehensions of it will always be misshapen, there has got to be something that it is, because any existing thing logically possesses some properties rather than others. Those properties do change according to the perceiver (it is possible that, to an unutterably scorching entity, the sun may seem a coldish sort of object). However, for the perceiver to apprehend properties, a basic range of apprehensible phenomena must somehow inhere in the object perceived.

All this is simply to say that our intelligence allows us to see that it is partial, but partial it is because there is an object. And if there is an object, there is a way this object is. It makes no sense to say that perception is relative and changing if it is not relative and changing in relation to something. This something is out of our reach but not out of our aspiration. The inkling that we are only a part of the world and own only a version of reality is an appeal to reality, to a state of things that magnetizes our attention, directs our gaze, fires our intelligence, allows us to climb out of animal intelligence and thirst for a generous perspective uncramped by self-interest, faintheartedness, or wishful thinking. Reality, in a word, is the belief that there is goodness in putting aside personality—what Kant calls the pathological dross of intelligence—when going up to the world.

Reality is one of the names given to this human aspiration to shed our narrowly self-obsessed ways of being in the world. It is the intuition that a richer life awaits us when we die to self-regard and vanity. Philosophy, Socrates says, teaches us how to die. To restate: wisdom consists in seeing that death of the ego is not the end of all; that, as it were, the journey goes on even after we have renounced the vessel of selfhood—it goes on not in some uncertain afterlife, but here and now, in a life open and engaging.

<center>※</center>

Now, the above clearly sets a moral, attitudinal definition on the word *reality*. It couples reality to the disposition of earnestly making room for it. This in turn changes what we ought to mean by "representation." A most punctiliously accurate reproduction gets no closer to reality if somehow it lacks serious acknowledgment of reality. Thus a photograph may well duplicate a face or a landscape and yet keep it under a glaze of unreality. This is because reality is truly represented not when it is caught, but when it is seen, acknowledged, entered. And a camera lens of course can entertain no disposition, no commitment, no intention toward what it records. In *The Republic*, Plato condemned artists for making copies of reality which, invariably inferior to the real thing, thus diminish it. This showed his weak appreciation of artistic representation. For artistic representation is much more than a matter of making lifelike copies. In fact, there is no reason to accuse artworks of falling short of the real thing because there is no competition. An artist approaches reality in a spirit not of rivalry, but of testimony. It is not so much that he wants to transpose reality's presence (one of the possible definitions of re-*present*ation); instead he wishes to testify to that presence, illuminate it with recognition, radiate it with *presence*. Presence is relation. One is present *to* something or someone. A good artist does not set up an alternative version of reality; instead he testifies to a human way of entering and inhabiting reality. The reality he depicts is the reality he is part of. A good landscape artist paints from within the landscape. His work tells us what it is like to be present to the landscape. Likewise, a portrait is painted from *within* the relationship between artist and sitter. A portrait by a painter who did not become present to his subject may well exhibit all the virtues of photographic likeness; for all that it will be a flat and stillborn fiction. Likewise a poem does not represent or report on thoughts and emotions; it *is* the thoughts and emotions in bloom. What distinguishes the good from the second rate

in representation is the degree to which the image issues from sympathy and connection—the degree to which in fact it is not objective. A good representation forgets about merely representing. Reality is not an object—neither in art nor in life. It is a degree of participation. A "real" person is not one who eats, drinks, sleeps, speaks, and moves about as against the one who only gives the appearance of these actions on canvas, screen, stage, or the printed page. A person is "real" according to how deeply (cooperatively, creatively, responsively) he is present to his surroundings—how alive, aware, attentive, fitting, flowing, and subtle his ways of meeting the world. How often we are real according to the laws of physics but nevertheless lack reality! At such times we live unawares, lack attention, overlook or ignore what is shown or told to us. The tree in the forest is no realer than the paper-maché counterpart if our attention to it is slack. Life is unreal whenever mechanical, perfunctory, shallow, slapdash, half-hearted; contrariwise, it arises when deep attention and participation are given. Whence it follows not that reality is subjective, but that it arises truly to the sympathetic mind.

The celebrated realism of great portraitists like Rembrandt, Raphael, Bronzino, or Sargent springs from the spirit of participation. Theirs is a wish to contribute and testify to the reality of persons, not peel off their appearance. Clearly technique, stock-in-trade tricks, and formulas alone cannot yield this vibrancy; it is pointless to wonder how the artist did it, if by this we mean that after touching up a bit of vermillion here and a bit of luster there, a face will appear this more lifelike. Of course, from an empirical standpoint, everything about a portrait ultimately comes down to an arrangement of oily clots and pigments. But this captures the matter no better than saying that a person is an aggregate of carbon molecules. We know this to be physiologically the case but it would be boorish, irrelevant, or criminal to let this view guide our interaction with a person. We are *around* molecules but *in the presence of* persons. In a similar vein, we live around facts but in the company of reality. And to paint a person is to face a presence and a reality.

A good artist can always render his sitter's looks. But to make us converse with the represented, indeed to draw us into a presence—this earmarks the great artist. Resemblance is a skill and can be learned. It is the business of cameras and copy machines, mechanical devices that cannot care whether it is a saint, a mule, or a stone that is represented. To the lens, reality is just photosensitive data; it is an object—flattened on contact because a lens cannot look

into, appreciate, or distinguish what it gapes at. To it, reality is a surface of points varying only in size and brightness. They have quantitative value but no worth. This is why it betokens immense intelligence and warmth when a photographer overcomes the natural iciness of the lens. A good photographer understands that he is at odds with his camera. His job is to testify both by means of *and* in spite of a device that cannot see. This may rankle lovers of photography: when a photographic portrait reveals the humanity of its subject, it is for reasons external to the medium, like serendipity (the subject happens to flash a particularly suggestive or revealing look) or psychological prepping (the subject feels comfortable enough to reveal his familiar face). This is why a perfectly amateurish Polaroid taken by a consummate oaf can sometimes bespeak its subject's humanity as much as the works of great master photographers. Photography is a mechanical event. Of course it needs a human being to select a subject, frame it in the viewfinder, and snap the picture. But what takes place between the subject and the lens is a pseudointeraction between one object and another. Subjectivity cannot get between the lens and reality and, if it tries, it shows up as an object. This is why a photograph almost always objectifies whereas a painting objectifies only with the artist's sustained intention (and this objectification goes half-way because where an artist willfully dehumanizes his subject he thereby admits to a preexisting humanity; whereas photography is beyond human concern: a lens can neither acknowledge nor deny nor even *see* what it snaps).

To see reality requires checking the objectifying intellect—indeed, the intellect which, in a workaday mode, represents, abstracts, translates the given into ideas. To behold a tree not as a thing set in space, but as a rising unique presence whose actuality in fact actualizes me, gives me presence, sets me in the world—this requires overcoming everything that is casual, perfunctory, and lazy about everyday perception. Indeed, it requires a kind of spiritual reorientation. The self goes about normal life world as though its preexisting ego comes across incidental objects. We forget that our own existence has actuality owing to all the things with which we come in contact. Objects situate us. The ground reminds us that we stand on it. It gives substance to our feet. The doorway through which I enter the house makes my existence concrete. It sets bounds and direction to what would otherwise be a ghostly existence. I stand in relation to things, beings, contexts, and situations, and these indeed give my person weight and form, purpose and agency. To live is to be in relation.

Art is a way of recovering this relatedness obscured by the business of everyday life. Representation in art means "to become present once more," to acknowledge the relatedness that places us in the world. In his meditation on art, the philosopher Maurice Merleau-Ponty writes: "Visible and mobile, my body is a thing among things; it is caught up in the fabric of the world and its cohesion is that of a thing. . . . The world is made of the same stuff as the body. . . . Vision happens among, or is caught in, things—in that place where . . . there persists the undividedness of the sensing and the sensed."[1] Art is the acknowledgment of an old debt to the world. And indeed what is the tonic radiance in a tree or a mountain painted by Cézanne, for instance, if not the painter's spiritual aptitude to enter into relation with these phenomena? Work becomes artistic when the painter steeps his seeing in deep grateful recognition of the tree; for the tree in fact gives his seeing something to see, gives his body something to steer toward or avoid, and gives his existence a place. That object is real to which I am related with such intensity that it draws me into the open. This is why the sense of reality brings the feeling that one's own person too is becoming more alive.

All art, it is said, is self-portraiture. This is true strictly in the same sense that anything we come across actualizes us. Reality gives us a face by virtue of facing us. To see a person or a thing is to be made actual by them. Everyday oblivious seeing commits a kind of violation on reality because it forgets how totally the self's own reality derives from encounter. There is a dark bluntness, a slitted asperity, a glum leadenness to the eyes of a person spying on a scene. This is because the human face grows blank when it is not present to what it sees (the face of a person watching television). Anyone who treats reality casually is repaid by becoming unreal, dull, faded in proportion. Likewise a second-rate artist who only gawks at things and mines reality for representational material only produces an image. It may be a skillfully accurate image. But it will be distant and mask-like. Its frigidity typifies those artistic works accomplished with too great a regard for, for their technical or formal elegance, works that are stiff and stingy with self-awareness or, contrariwise, strained by conquest, by the desire to grab and capture. Likewise artistic objects used like recording devices look recorded and secondhand themselves.

1. M. Merleau-Ponty, "Eye and Mind," in *Art and Its Significance*, ed. Stephen David Ross (Albany: State University of New York Press, 1994), 284.

For whenever reality is looked upon as a thing, it only inspires another thing. Objects beget objects. To become art, the work must enter into relation. It needs to become a living act of participation. This comes down to basic intellectual honesty. For if one really cares about the facts of reality, one must then include the fact of one's presence among them. This, in the end, is the simple wisdom of art.

On Love, Beauty, and Evil

Neither a lofty degree of intelligence nor imagination nor both together go to the making of genius. Love, love, love, that is the soul of genius.

W. A. Mozart

TO FURTHER THIS PLEA FOR REALITY, let us return to the defining moment in our modern way of picturing reality. Kant, we recall, sent the mind into exile from the world. From his three *Critiques* came a new feeling of subjective separation and ineffable longing that drove romanticism, German idealism, American transcendentalism, and some forms of European existentialism. It also gave ammunition to those philosophies which, like Nietzschism, pragmatism, analytic positivism, structuralism, and deconstruction, felt quite easy with the picture of a mind that creatively reshapes, rather than mirrors, reality.

Subjectivism, however, is one of the paths, and by no means the only one, that neo-Kantian philosophy could have taken. In fact, Kant regarded himself not as a subjectivist, but as a *transcendental idealist*. The title suggests a sort of philosophic balancing act between empiricism and idealism. In Kant's view, objects do empirically exist outside the mind; they *transcend* the mind or exist in reality whether or not the mind takes hold of them. But he is an idealist by declaring this core basis of reality off-limits to human cognition.

Transcendental idealism describes a mind feeling up to its own boundaries, anxiously aware of what lies beyond it. In a sense Kant brought subject and object face to face and resisted smudging the difference. The empiricists before him (Locke, Hume) had made the mind putty under the molding influence of reality; and the high-flying idealists (Berkeley) spirited away concrete existence. Kant wanted to hold mind and reality apart and endure their tension. This dualism is difficult to take. By nature the intellect dislikes halfway solutions. Limbo always feels like punishment because psychologically we incline toward synthesis and clean-cut solutions, especially when the issue involves the great framing schemes of life: either the universe is rational or it is random; either God exists or He does not; either people are self-willed or determined; either reality is subjective or objective. We like split camps and a winner-takes-all resolution. But Kant's *Critique of Pure Reason* vexingly shuttles from one side to the other. For every passage that confirms him as an idealist philosopher, another follows that identifies him as an empiricist.

Kant's genius, then, was to rise above our psychological weakness for synthesis. He upheld the power of the mind without denigrating reality. That reality is clouded over by mental vapors did not mean that it must drop out of consideration. Dubious as his notion of noumenon was, it lent a new shine to reality. Kant opined that a thing out of reach has no less existence than a thing at hand. In fact, he injected mystery into reality: not, however, the mystery that stems from obscurity and mystification but instead the mystery of clarity and simplicity. Things exist outside the mind, he says, though just how they exist in this unperceived state we cannot know. The simpleness of the world is too simple for the mind to behold. To be sure, this blindness of ours savors of old themes, not the least of which is our biblical banishment from pristine Eden and our subsequent roaming in the land of shadows and approximations. In a sense, and quite against his own temperament, Kant gave philosophy a tragic spin, the notion that, as Rilke put it, "we are aware that we are not very happily at home, here, in this our interpreted world." To be human entails loss, the sting of some imperfection, a divide across which aspiration may fly but not contact. This divide, in fact, opened philosophy to the spirit of poetry and religion: the thirst for transcendence, the drive to orient our life toward something pure and far. Reality, Kant says, is out of reach. This announcement stirs an admirable instinct: our impractical propensity for looking toward a realm of beings we can have no hope of conquering.

It is an observable fact of psychology that we tend to prize and elevate the

unreachable. Mount Everest before 1953 was much taller than it stands today. The more distant things are, the more intense and compelling their reality. Perhaps this is superstition. But could it also be that distance is a source of the moral and aesthetic sense? Could it be that the kind of perception that suffers banishment is also closer to true seeing?

Exploring this possibility requires first of all acknowledging that everyday perception is not as clear, keen, or observant as might be assumed. Prolonged association does not deepen but often dampens our perception of familiar objects and people. The practical mind is generally self-seeking. It extracts the information it needs from things and throws away the husk. This means we live in a world simplified to the pattern of our concerns and goals. We dull down the world because heightened awareness is impractical, time-consuming, and serves no vital function. Were I always to sit down with the harmonic deliberation of a stage actor, or to gaze at chairs with the explosive intensity of Van Gogh, there is a good chance that doing the business of my life would sink under the weight of my excessive self-consciousness. Just the simple action of taking a seat might make me forget why I am sitting down. We thus anthropomorphize the world out of necessity, because it is economical and practical to take things for granted, but useless and possibly life-threatening to marvel at them.

Notice that, on this account, subjectivism is not the rare bloom of the intellect. Ants probably "formicalize" their world, lions "felinize" the savannah, and fish likewise "pescify" the waters around them. Indeed subjectivism—the habit of living in a self-centered world—is the easy bent of conscious life. It is the thinking animal in us. Subjectivism is actually the way of matter, not spirit. Think about the effects of a migraine on a landscape. A pain in the brain is enough to sour the whole world. Matter is selfish, blindly self-centered, under the dictate of efficient survival. So busily indifferent to the independent existence of reality we are at heart, so contemptuous of its nature, that even the useful stuff on which our life depends will, once secured, gradually fade out of sight. How often do I pause to really see the breakfast toast I bite into? Or the sweater I put on against the cold? Objects are noticed when they are needed. It is their degree of usefulness to us that brings forth their reality. And once our interest is satisfied, they are dropped back into the swamp of everyday nonperception.

Our wish to correct this tendency is surprising because it is biologically pointless. It serves no vital purpose. It is all the more baffling because noticing

things in their own right requires, as often as not, willfully maintaining distance between us and them. Distance is the great unveiler of existence. Take his dinner away from a man and never will food appear so real. Distance is deprivation, it is want. Now, artists and philosophers are those who, as it were, deprive us of our habitual dinner. Or, in more general terms, art and philosophy are those activities by which we consent to come short of reality so it may arise for its own sake and not, as in practical life, so that we may use it. Kant fulfilled just this unveiling by distance. Before him, reality stood relatively close to human existence. Idealists averred that it was part of us, and empiricists that we were part of it. Neither made for a particularly epiphanic state of mind. Then Kant came along and lifted reality out of our ambit altogether. No longer could we satisfactorily say that we know and perceive reality. He made us aware of how much the mind stands in the way of its own looking. Reality became, as it were, something to aim at and long for and believe in, but not grasp. In short, Kant made reality more real because it now was not an object of knowledge and perception, but a "noumenon," a mysterious full realm, the opposite of a taken-for-granted everyday thing. Indeed, reality became almost a person—by which is meant not that Kant anthropomorphized reality, but quite the contrary: that whatever defies grasping and possessing seems personlike. This is true of God, which religious language often personifies, and it became true in the language of art which, around the romantic period, began addressing reality in the language of romance, as if speaking to a unique and personable entity.

Indeed Kant's noumenon lay the ground for a religious rediscovery of reality. Bare of theological adornment, the core of religion consists in the spiritual displacement of the self from the center to the periphery. We are not rulers but citizens of the world. For the world, however much we strain and sweat, will never submit to our understanding. The latter will only ever be, precisely, just *our* understanding. And if our understanding encircles us, knowledge shall never set us free. There, at any rate, is where Kant's Enlightenment optimism shades into tender romantic gloom. Reality, as the romantics saw it, cannot be explained, prodded, and prised open by reason; it must be believed in—trusted, accepted, acknowledged with kind faith and confidence. "I have found it necessary to deny knowledge, in order to make room for faith," Kant finally states in the *Critique of Pure Reason*. Poets responded to this sea change. Wordsworth and Coleridge, who together studied Kant in Germany, took to addressing reality in the lyrical language formerly typical

of amorous longing. The French poets Lamartine and Vigny followed suit. Goethe, Chateaubriand, and the German poet Jean Paul felt in nature the living presence of the ineffable. Poetic meditation became in effect a practice of pitting the mind against its own limitation, consciousness feeling the outline of an external world beyond apprehension.[1] Though poetic, this confrontation is in fact more philosophic than sentimental—though, as one can rightly claim about romantic poetry, it lent sentiment to philosophy. In the *Pensées*, Pascal pointed out the logical progress of reason toward its own limit: "Reason's last step is to recognize that there is an infinite number of things which surpass it. It is simply feeble if it does not go as far as realizing that."[2] It is indeed reasonable to admit that one does not know everything, otherwise one could never learn anything new. Hence the mind is smaller in scope than the universe of things. This vastness is deduced by reasoning. In other words, it is part of reason's logic to admit to its mental smallness and a sound, clear, honest mind therefore includes its own humbling. Out of this diminishment the romantic poet beheld light. For what defeats understanding and resists penetration must be of a force and majesty superior to the mind. This is how poetic meditation showed a devotional passion speaking to reality in the language of religious love.

A happy consequence of Kantian philosophy was thus to give epistemological respectability to *love*. Spiritual love is cultivation of the distance between at least two beings. A loving person dedicates his energy to maintaining the integrity of what is not him. The lover protects the loved one from his own self, keeping at bay his naturally voracious bent, which is to eat and appropriate. Thus the true lover would rather never have met the beloved than that the beloved had never existed. By declaring reality off-limits, yet without lessening its command over us, Kant raised reality to the rank of an equal. Through him, modern sensibility created not just an epistemology of reality, nor a phenomenology of reality, nor an aesthetic of reality, nor again an ontology of reality; standing among all these achievements is a *religious romance of reality*.

No doubt, it is a sad reflection on the human character that love should arise out of separation—that only fallen creatures are able to love. For if love

1. See M. H. Abrams, *The Mirror and the Lamp: Romantic Theory and the Critical Tradition* (New York: Oxford University Press, 1971); H. Bloom, ed., *Romanticism and Consciousness* (New York: W. W. Norton and Company, 1970); and S. Cavell, *In Quest of the Ordinary: Lines of Skepticism and Romanticism* (Chicago: University of Chicago Press, 1994).

2. B. Pascal, *Pensées*, trans. Honor Levi (New York: Oxford Classics, 1995), 62.

is thirst for reunion, for a completeness which, as Plato conjectures in the *Symposium*, was once split asunder, it is because we have been thrown apart. Of course, this thirst is an unhappy condition, yet one that, so Plato claims, we should not dream of quenching too soon. For the dignity and adventure of being human in fact lies in suffering the divorce between mind and being. Love, Plato says, is "always poor, . . . he is hard and weather-beaten, shoeless and homeless, always sleeping out for want of a bed, on the ground, on doorsteps, and in the streets. He takes after his mother [Poverty] and lives in want."[3] But why should we wish this poverty, this dwelling in homelessness, on ourselves? Because, Plato explains, this thirst orients our soul toward the Good, it makes us lovers of reality which, should it have been never lost and always within reach, would suffer from our obliviousness. "Love is desire for the possession of the good," Diotima says to Socrates (*Symposium* 86). We should read this idea as in part suggesting that the state of not having in itself enhances the good. For desire induces and sharpens attention. In the best cases, that is, when desire resists blunt covetousness and grabbing, it leads to a refined appreciation of what is longed for. Thus a creature immune to desire is by the same token probably unable to worship. Love is the realization that we are separated from being, but through this realization being arises to captivate our attention. It makes us see and honor and praise reality in a way that animals, who are immanent denizens of being, can never experience. Our homelessness is therefore our blessing for it enables us to love the very reality from which our consciousness separates us. Those who philosophically deny this divorce, like the solipsist and the all-out materialist, risk missing out on love: the solipsist because he has no reality to long for, the materialist because he is one with nature. The first is the fantasy of narcissistic self-sufficiency; the second is the fantasy of uterine bliss. Both are unwilling to accept the unhappy news of our separation but both are thereby foreign to love. For love is the reward of a full-fledged person—a creature who consciously accepts being bound by birth and death, the lone occupant of one mind, one consciousness, one destiny.

❦

Plato holds out yet more rewards to those who accept the pains of separation. For they who dare be lovers, they who dare experience lack, are more

3. Plato, *The Symposium*, trans. Walter Hamilton (New York: Penguin Books, 1951), 82.

attuned to the reality of things; they are more perceptive of the outer, they possess a stronger sense of the tangible life. They are, in a word, aesthetically minded. To them is given, as Plato puts it, the gift of perceiving beauty. "Love is of the beautiful," says Plato in *The Symposium*. The statement obviously calls for some analysis. As evoked by Diotima, beauty is to be understood less as a property of things than as a situation. Neither objective nor subjective, neither a feature of attractive things nor a psychological disposition of observers, beauty has to do with the *distance* between subject and object. Yet this too needs qualifying. Obviously anyone with a roving lusty eye can always single out a beautiful face, but, Plato suggests, this experience ranks low on the ladder of beauty. The truly beautiful is given to those capable of holding back desire and cultivating the distance to the admired. As Plato puts it, the wise "will behold beauty, not with the bodily eye, but with the eye of the mind." Instead of plotting to bridge separation, the true lover of beauty accepts and thereby consecrates the distance. A commonplace of art criticism dating back to Aristotle has it that aesthetic experience has to do with psychic distance. Stepping back from an object or phenomenon imparts a kind of dreamy detachment and leisurely pace to experience. Watching supersedes doing. A veil of "as if" hangs over the beautiful object, not because it is unreal, nor necessarily because it is seen from afar, but because it is seen without an eye for consummation. The classic example is perhaps the beholding of a natural landscape. It is seen with the appreciative mind and not with the consuming body. And this disposition, so says Plato, ushers the viewer into a clean relation with reality where the latter is seen, if only for a fleeting glimpse, so that it, not our human aims and purposes, matters. This amounts to perceiving the repose and authority of being: or, as Plato prefers to put it, the Beautiful and the Good.

This insight of Platonic philosophy interestingly parallels a similar idea in the Hebrew Bible. God sees that the world is good in the same sense we say that a thing is beautiful. To see the reality of a thing overtaking its concept is to be faced with presence. Beauty lies in a mind joyfully acknowledging this amazing positiveness of reality. In this sense, God's original reaction to the world is aesthetic. "And God *saw* every thing that he had made, and, *behold*, it was very good" (italics added). "Aesthetic" here means not just "contemplative," "sensitive," or "perceptive." Instead it means appreciative of what is. The world is good not because it is large or useful or pleasant or bright or promising. It is good because it is there or rather, more emphatically, because it is

over there. Aesthetic experience has to do with seeing this. As Plato imagines it, beauty is when the distance between us and an object intensifies its reality. A thing is beautiful when its existence arises for a beholder who entertains no other thought than to notice that it exists. How indeed can I begin to examine a beautiful object unless I first agree that its existence matters? The art world, in particular the museum, is in charge of setting up the mental space wherein the objects will be seen as mattering, worth noticing and appreciating. And hopefully the excellence of the object will reward this initial act of faith by which the observer agrees to approach an object with respectful attention. Of importance is that, before the aesthetic experience can flower, it need start from a kind of ontological realization: that objects exist and that such existence deserves noticing in its own right. "Beauty and reality are identical," says the French philosopher Simone Weil, pointing out the bond between aesthetics and ontology.[4] Beauty is the look taken by reality when it is seen for its own sake. This is the difference between, for instance, seeing a river valley as a possible hydroelectric project and seeing the same valley, beautifully, existing in its own right.

Thus it is beautiful to say "I am depressed" instead of "The day looks somber." Likewise it is beautiful to say "My friend looks radiant today even though I am too troubled or unhappy to see it." Beauty is subjective in the sense that it fills the vacuum left by the subject's withdrawal. Thus the objective is subjectively conditioned, but conditioned by an act of letting-the-other-be, of willing surrender, that is, by an act of love.

In the *Critique of Judgment*, Kant defined the experience of beauty as a kind of delight in "the represented connection of the subject with the existence of the object."[5] Besides the practical aspects and benefits of knowing a thing, there also arises the pleasure of being aware of the acquaintanceship. The mind delights in contemplating its own representation of objects. But this raises a problem. Why should this contemplation cause delight if, as per the *Critique of Pure Reason*, our knowledge of things is partial and truncated? Shouldn't the aesthetic experience induce us to a mood of bereavement instead? For surely if the mind never apprehends but only represents objects, then contemplating this process would amount to accepting the ways in which

4. S. Weil, *Gravity and Grace*, trans. Emma Craufurd (New York: Routledge, 1963), 56–57.
5. I. Kant, *Critique of Judgment*, trans. J. H. Bernard (New York: Hafner Press, 1951), §5, 43.

the mind misfires, distorts, alters, and finally misses reality. On this account, aesthetic experience would consist in delighting in the mind's mendacity and inaccuracy. To avert this odd conclusion, Kant amended the second edition of the *Critique of Judgment*. In the aesthetic experience, he adds, "it is not merely the object that pleases, but also its existence" (*CJ*, §5 43). Aesthetic pleasure is not just the mind applauding its own mercurial powers of conceptualizing. Nor is it the mind wallowing in the sensuous aspects of a thing. It is the altogether different pleasure of rejoicing in the "existence," the *fact* and not just the form of an object.

That we need being reminded of existence suggests that the fact, though obvious, suffers our frequent forgetting, that everyday life is a lapse into oblivion (Martin Heidegger's "the oblivion of Being"). When, after all, was the last time I reflected on the independent existence of a spoon before dipping it into a bowl of ice cream? A still-life painting might, on this account, help me remember that the spoon has existence apart from my use of it, indeed, that my use of it assumes that it exists separately. "Existence" would therefore designate the experience of beholding something when we have no use or practical interest in it. And surely this must be close to Kant's meaning because he goes on to speak of artistic contemplation as disinterested contemplation.[6] By this he means that, for instance, I find a still-life apple beautiful not because I want to eat it (interest of the senses) or because it increases my knowledge of apples (interest of reason), but for the pleasure of letting the appearance of the apple be. It serves none of my practical interests to let the apple be. But then why do I feel the pleasure associated with this free appearance?

This pleasure is probably akin to the Platonic satisfaction of overcoming our instinct to seize and consume and utilize. By overcoming instinct we, as it were, open up the scope of perception. For whenever we see reality from the angle of our interests, we only see the part that connects with us. This is bound to be a cramped, expectant view. And whatever is cramped by an anxious observer cannot be wholly beautiful—or at any rate its beauty is blocked by need. Crucial to perceiving reality in its beauty is a more accepting approach, one where the perceived is not indexed to the interests of the perceiver. Beauty dawns when we leave our will out of the picture; it arises when we stop fussing over what's in it for us.

6. I. Kant, *Critique of Judgment*, 44: "Taste in the beautiful is alone a disinterested and free satisfaction; for no interest, either of sense or of reason, here forces our assent."

(Persons of aesthetic sensibility sometimes wonder why the topic of beauty has fallen into disuse in today's art world, why to talk of beauty around academic art historians often elicits no more than pitying silence. One reason for the decline of beauty is that our culture is run by consumption: it favors action over contemplation. Commercial society urges us to keep up and indulge a great appetite. Our society tends to praise the sort of personality in whom desire and ambition are dominant. Foregoing gratification, by contrast, seems a musty, life-denying quirk. Advertising hammers in the idea that beauty is what we want and, given the right wallet, *can possess.* Renunciation is bad for business. Desire is forward-looking, dynamic, driven. Under this assumption, the labors of letting things be, of quiet disinterested attention, of generous mindfulness are given short shrift. And so, therefore, is beauty. This is perhaps why "desire" has all but rubbed out "beauty" in the language of academic art criticism in the last decades. Has the ivory tower succumbed to the zeitgeist of Madison Avenue? It has, in part. When academics discuss beauty they really often mean physical desirability. They wrongly accept the advertising executive's identification of beauty with lust. Thus, the art critic rightly frowns on beauty for wrongly identifying it with the industrialized baiting of appetite, the libidinous needling of the senses, and not, as I wish to submit, the renunciation of appetite. What we should do is not give up on beauty, but challenge the commercial equation of beauty with sensual satisfaction.)

<p style="text-align:center">❦</p>

A mind unable to overcome the worries of appetite and personal interests cannot really behold beauty—nor incidentally can it achieve love because love consists in bearing the rift between self and world, wish and fact, language and substance. Love embraces distance, it accepts separateness—indeed, the same distance and separateness that are necessary to behold beauty. This does not mean that our moral sentiment or emotions are dead to what we find beautiful. Aesthetic distance is not the sort of gulf that cuts one off from emotive participation. To the contrary. The person who uses aesthetic contemplation to distance himself from reality is an aesthete and a dilettante—a personality type utterly foreign to the true artistic personality who, in the last resort, is the artist, that is, a doer, a participant. The lover of beauty accepts separation from the object not so as to ward off involvement, but so that the object may stand forth with the fullest, most intense reality.

The opposite of the spirit of beauty is also the opposite of the spirit of love. It is the desperate striving to deny the separation between oneself and others, or between oneself and things. Indeed, the opposite of beauty is not ugliness—which, as so much of modern gallery display confirms, art is powerful enough to transfigure. Instead, the opposite of beauty is evil.

(That beauty consists more in an epistemological situation—i.e., acceptance of separation—rather than a matter of form or taste helps explain why uncomely or repulsive objects can be artistically beautiful. A face is ugly to the extent that we wish it otherwise, for it is in fact our objection and interference that makes it ugly. Yet the ugly does not have the purity of beauty, and for a good reason. For in the end ugliness is probably more subjective than beauty. The ugly bears our fingerprints because it is what we push away. Its expulsion bears our mark. Whereas we always seem yet to reach beauty. The ugly is a presence we want altered or removed; beauty is a presence we do no wish to change. This is why beauty cannot be evil. Evil is the act of crushing the reality of things and others, of diminishing or eclipsing life, whereas beauty if that of letting it be, of walking toward it.)

For a good reason the first commission of evil imagined by the Western mind was an act of eating: plucking the fruit off the Tree of Knowledge and consuming it. Eating clearly exemplifies the inability, or unwillingness, to let the object be and suffer the distance through which the object looms so tantalizing and desirable. Of course eating also proclaims health, communion, participation with nature and others (e.g., the Last Supper). But there is a kind of eating that partakes of no sacramental generosity. It is the sort of eating that wishes to reduce all things to oneself: the drive to possess, swallow, assimilate, neutralize, and destroy. The Serpent in the Garden of Eden invites human beings, not to partake, but to monopolize: that is, to bring separation under the monotonous rule of the one.

"Evil has no depth," Hannah Arendt wrote in a letter to Mary McCarthy.[7] Psychologically, depth entails the cultivation of distance and things other than oneself. By contrast, the world of the self-absorbed is boringly flat; it is not vast enough for echoes, not profound enough for perspective. Evil has no distance. It reduces everything to one. But just for this reason, the evil that is denial of separation cannot give rise to beauty—never mind Nero's panegyric

7. Cited in R. Gaita, *A Common Humanity: Thinking about Love and Truth and Justice* (New York: Routledge, 1998), 39.

over burning Rome or Karlheinz Stockhausen's unfortunate remark.[8] Anything that celebrates power, boundless self-affirmation, and disdain of reality is formless by definition. For to have form is to be set against a background, hence to admit of an outside. Harmony is differential. The evil that consists in blotting out reality is consequently monotonous and factory-gray. The temptation of limitlessness leads straight to formlessness. Hungry self-assertion thus tends to yield artistic bloat. An example is Roman statuary or its grotesque epigone, the social realist warrior and worker congealed in swagger; other examples include military marches and patriotic monuments, Berlioz at his worst, any Donald Trump skyscraper at its best, indeed any creative work whose chief purpose is to bellow "I am" and stomp out the surrounding reality, any work that seeks to eclipse, intimidate, or belittle, and thus reduce understanding.

Of course, a personality apt to subordinate all externals and beings to his appetite can hardly be expected to care much about beauty—about, that is, whether he affirms being, fosters life, cultivates the existence of things for their own sake. In fact, one may conceivably rig up an aesthetic theory holding that boundless self-affirmation *is* life affirmation and therefore beautiful. From the thesis that all is subject, that *esse es percipi*, that reality is the thought thereof, that there is consequently more significance in one's thumb than in the whole universe (Hegel)—from such a perspective, then, affirming the subject is like affirming life itself. There, every display of egotism increases the ratio of reality. Contrariwise, any deviation from this self-seeking is misshapen, meek, and plain unbeautiful (e.g., Nietzsche's philippic against altruism and charity on the ground that they are, among other things, unsightly). On this view, evil is not incompatible with beauty at all, for self-exaltation is beautiful. So, at any rate, does it strike Nietzschean apologists in the league of Gide's Immoralist, Wilde's Lord Henry, or Marinetti's Mafarka the Futurist.

This vision, however, harbors a conceptual crack and falls with it. Complete self-affirmation undercuts itself. The reason is simple. The insatiable egotist who philosophically or practically scorns the separation between self and

8. I.e., his fantastically blundering comment that the collapse of the World Trade Center was "the greatest work of art one can imagine." Under the heat of public outrage, he apologetically justified his remark by setting it into the romantic and modernist background of apocalyptic aesthetic—the decadent Wagnerian, Nietzschean, Marinettian confusion of cataclysmic spasms with artistic power.

world does not deny that the world exists. A madman he is not. In fact, he needs the world to stand there, if only so that he can swallow it. If, however, the world is good to swallow, it means it must be good in itself. Hegel's "The Real is Rational" celebrates this much, which is that mind has made a great conquest. And there is no conquest that does not assume the inherent value of what is conquered, which in this instance is reality. In general we want things because they are desirable. And they are desirable in part owing to independent properties. (Of course, value is not inherent in things. They are valuable because we value them. Water is valuable when we are thirsty. But, though thirst confers value on water, the H_2O substance must have thirst-quenching properties that warrant our valuing it. Hot stones will never appear valuable to the thirsty man because they lack those properties. Hence the nature of an object conditions its desirability. Gold was originally deemed precious because it never rusts, fur because it keeps us warm, land because it is nonfungible, etc.)

Now, the subjectivist with an appetite for reality in toto deems reality precious to have. Some inherent good about reality appeals to him. Presumably a world is better than no world, being better than nonbeing. The subjectivist, however, cannot accept being separated—this is why he subsumes reality under the mental concept of it. But the subjectivist is not faithful to his longing for reality because once in possession of the world he denies its goodness. Now he claims the world has no reality at all, that it is a figment of thought, a perception, an idea. In sum, he desires something so he may spirit it away. This is unhappily contradictory.

To understand why, we must grasp the link between goodness and reality. For just as water possesses the inherent virtue of quenching thirst and gold of never oxidizing and the ocean of buoying ships, so reality holds a particular goodness. This seems a strange claim because reality is no discrete entity, no particular thing we can picture ourselves making use of in a specific way. In fact, from a strictly logical standpoint, reality is really a concept, a way of referring to all things in general. So how can a way of speaking in general, which is ostensibly subjective, have an objectively inherent goodness similar to the goodness that, for instance, water presents to thirst? How can reality, which exists everywhere but nowhere in particular, enclose a concrete virtue?

The answer is this: the specific goodness of reality lies in that *it is separate from us.*

Recall how goodness arises in Genesis. Unlike, say, water whose goodness is defined and thus limited by thirst quenching, reality is good as a whole when

accepted as a whole. The writer of Genesis feels no need to explain why the Godhead finds reality to be good. For explanation is not complete acceptance but acceptance with clauses and guarantees. For acceptance to be complete, explanations must at some point give out.[9] So reality is good for no reason— because reasons harness their object back to the individual user who is too small a creature for reality. The goodness of reality is wholly in that it is—and no part of it fails to exist in a higher or a lower degree than any other part. Of course this computer, this room, my hands are far more real to me at this moment than a mountain in China. But this is simply animal intelligence speaking. Human intelligence, that is, self-overcoming intelligence, commits me to admit that, egocentric prejudices aside, the distant mountain exists just as much as my precious hands.

Now, how do we reach this insight? Precisely by looking beyond the muddle of individual experience. In other words, the reality of the world dawns on us when we stop bisecting and parceling it according to our needs and expectations and designs. So long as we consider water as it pertains to us, we only see it in part (good for thirst, bad for unattended toddlers); we see aspects of it, never the fact of it. To behold its fact, we must let it be. We must abstain from the reflex of fancying ourselves the beneficiaries of creation. Only then reality arises.

The goodness of reality, therefore, is the opposite of being "good for something." Reality appears as a whole when the gaze is nonutilitarian. It is because reality is good for nothing that it is good. Reality is the only good that is valuable not from being consumed or consumable, but paradoxically from *not* being consumed, from being let alone. The goodness of reality lies in not drawing benefits from it. (Perhaps this is why only God can marvel at the fullness of reality because only He, who is reality, does not miss any part of it and can therefore let it be.)

Though a product of inference, reality is infinitely more than a concept. Properly understood, its notion actually prescribes that it be not reduced to a human-centered concept. Of course reality *is* subjectively constructed. But it stems from that part of the human mind that humbles itself. Every time we protect reality against our avidness, every time the mountain in China stands on a par with my immediate surroundings, reality appears.

9. So, at any rate, concludes Stanley Cavell in *The Claim of Reason: Wittgenstein, Skepticism, Morality, and Tragedy* (New York: Oxford University Press, 1999).

Now the subjectivist, as we know, will have none of this. Like the grasping miser, like the unweaned infant, he brooks no delay in shaking his desire. To him, to be good is only "to be good for." There can be no question of any goodness that does not benefit the subject. The subjectivist is of the type that finds separation psychically painful and thus he goes charging wherever he sees a gap. In so doing he ruins the essence of reality, which consists in its not being consumed. The subjectivist thus wrecks what he desires. "Each man kills the thing he loves" says Oscar Wilde and the sentence describes well enough the subjectivist temperament which is the consumer ethos applied to philosophy: all exists for and by the individual. To the modern go-getter, postponement of satisfaction was good for a theological age hoodwinked by such fairy tales as the Fall, the Original Sin, our masochistic exile from the Good, the True, and the Perfect. We modern, post-Reformation individuals know better than to saddle ourselves with such psychological calvaries. The world is for the taking, heavenly rewards are to be reaped now, satisfaction is our inborn right. For man is the measure of all things and the world the plastic stuff of our satisfaction.

This is the victory call of modernism. On the plus side, it broke human beings from many self-imposed shackles and gave a more pragmatic turn to social policies in which the goal was the earthly happiness of actual persons, not human submission to a grand cosmic scheme. Submission (or resisting the drive to consume) was once the nerve of the classical character's dignity. We need only think of the punishment of hubris in Athenian tragedies, the knight of chivalrous romance, or Petrarchist poetry. The enjoyment of distance from the desired defines the classical hero. The chivalric ideal is service—abnegation of personal gain so that the beloved may shine the brighter. Contrast this with the modern character. When he or she forgoes personal satisfaction, the whole of life savors of waste as, for instance, in Balzac's Eugénie Grandet or Wharton's Ethan Frome. Our consumerist mentality casts a gloomy eye on those who decline having it their way. *The Great Gatsby* is a tragedy because its hero does not get the girl. *Tristan and Isolt*, by contrast, would be a failure for achieving the sort of success we cannot stop wishing on Jay Gatsby. Our idea of love is consummation, a fulfilled libido, and the material rewards of domesticity. This bias for earthly reward is consistent with a philosophic mind-set that places material human happiness at the hub of cosmic significance. This happiness primarily means, in utilitarian fashion, "unrestrained development of the subject's use and enjoyment of the world."

Though unattainable in practice, this complete domestication of reality to the subject's wishes is achieved in the realm of theory, specifically in the subjectivist theory that, from Hegel to postmodernism, ever more conforms reality to our mental construct.

Of course earthly rewards are part of the human good. Aesthetic bravado aside, no one is likely to choose being Antigones rather than, say, Elizabeth Bennet, Jane Austen's fulfilled heroine. The issue is that the domestication of reality to the subject's wishes brings about problems of its own: one is the narrowing of the universe around a strictly human-centered perspective, which induces the kind of intellectual claustrophobia expressed by, for instance, Baudelaire or Dostoevsky. The popular imagination delivered a striking figure to illustrate the anguish of all-out subjectivism, the philosophy that indexes reality to the subject. Such a figure is the vampire. Although a creature of archaic folktale, the vampire is really a modern character—as much a creature of the nineteenth century as the steam engine or urbanization.[10] In him is unleashed the demonic thirst of subjectivism: he simply cannot reconcile himself to the separate existence of others. He is ruled by his hunger to assimilate, which in this instance takes the form of sucking people dry. He is the grabbing child, the bulimic, the insatiate. Rightly does his figure rise to prominence, with Bram Stocker's *Dracula*, in the industrializing West because his is the spirit of a new economy that rides on unappeasable hunger. He is the impatient consumer in all of us, the one who regards external reality as food, fuel, raw material made for absorption. The opiate of nondifference between self and nonself is what the vampire drains from the veins of his victims. For this reason we must imagine a vampire to get drunk on blood. As he drinks he is no longer alone; then reality exists in him, for him, by him; and dies in him. He has cured himself of the pains of separation by denying others. This, by the by, explains why, according to the folklore, Nosferatu cannot die. He has in fact no reality to die into. Finitude is roughly to acknowledge the separation between self and world (i.e., I die but the world doesn't). The vampire is immortal in just the way a solipsist is immortal: when he dies he does not surrender to the world but the world spirals into the vanishing vortex of his subjectivity. And where there is no world to die to, no one really dies.

10. The nineteenth century is really when the vampire invades popular fiction, starting with John Polidori's *The Vampyre* (1819) and *Varney the Vampyre* (1847), and continuing with John Sheridan's *Carmilla* (1872), and of course Bram Stocker's *Dracula* (1897).

"Evil has no depth," says Arendt. The vampire withers, flattens, sucks the depth and distance out of life. He consumes his victims because nothing is more important to him than that the world should have no self-standing existence. He kills for the sake of denying. Rightly is he said to bewail his fate, to live in a world without light and beauty. Rightly, also, is his love of pretty maidens choked with sorrow and melancholy. This is so because he knows he will never be able to defeat his hunger, to honor the distance, and thus to love; *he* knows he wants to kill the thing he loves. Thus he recoils in self-loathing sorrow (Klaus Kinski in Werner Herzog's *Nosferatu*), grudging hauteur (Christopher Lee's Dracula in the British Hammer Films series), or melancholia (Catherine Deneuve in the film *The Hunger*). This is because he destroys what he most loves *because* he loves it. He yearns for human presence but denies its separate existence. And the more he denies his solitude, the more wretchedly alone he becomes. "Evil swallows most of its own venom and poisons itself" (Montaigne).[11] His is an abysmally unbeautiful world. The beautiful is the dual experience of thirsting for something one does not want to consume. Evil, by contrast, only ingests. Beauty appears where there is distance. But to the evil soul a distant object is no sooner seen than ingested. A truism has it that love and hate are twin emotions. And this is true so far as hate is denial of what love welcomes: distance.

What, however, of the flashes of beauty issuing out of commissions of evil in Genesis or Milton or gothic romanticism, in Goethe's Faust or Coleridge's Ancient Mariner, in Mozart, Shelley, Blake, Byron, Lautréamont, or Conrad? Don't these bright examples negate the idea that evil necessarily lacks beauty? To answer, we need to distinguish two evils. One, described above, consists in denial of difference and boundless egotism; the second entails a tearing away from the Good. Only the latter type is susceptible to beauty. But whatever beauty dwells in the latter really comes from the mournful remembrance of the Good. It is the beauty of loss, of exile, of severance, of walking the path of aloneness and separation. Such is the beauty of the Fall, of Innocence lost and Consciousness gained, of great romantic poetry. The romantic soul, as in Wordsworth's "Intimations of Immortality," probes the pain of distance, beholds the gulf between itself and the immanent life. It embraces the evil of self-awareness and disconnection but, in fact, mourns it. Such also is the dire

11. M. de Montaigne, *The Essays*, trans. M. A. Screech (New York: Penguin Books, 1987), 909.

beauty of Milton's Satan. The apostate angel in *Paradise Lost* is punished for seeking to equal God in glory. "He trusted to have equal'd the most High" (Book 1). His sin is hubris or overreaching, that is, inability to contain his appetite. Before he became God's antagonist, specifically in the New Testament, the *satan* was originally understood to be a messenger or angel of God, one of his faithful servants.[12] Only later did he become His adversary from, as Milton sees it, wanting to be God's twin, His equal, His like. So close to the beloved Godhead does he seek to be that he wants to be it. His desire is literally for the One, for a world without division. Perhaps Satan is unable to bear his separation from God; trying to break this distance, however, he is cast farther still. Though he now reigns supreme in Hell, though he is the God in his own domain, he never loses his fixation on the One. "I give not Heav'n for lost," he declares (Book 2). He lives in everlasting separation, unable to accept distance and always challenging it, in effect always repeating the denial of separation that damned him in the first place.

> To do ought good will never be our task,
> But ever to do ill our sole delight,
> As being the contrary to his high will,
> Whom we resist.
>
> (Book 1)

Satan's eyes are riveted to the good he lost because he could never accept it. As the adversary, his life truly is absurd because he is wholly defined by the goodness that he wishes never existed. He hates his own raison d'être. Worse still, he hates the source of his existence, which is Being. This painful contradiction, his absurdity, his dependence on what he is not, this quixotic rebellion gave him some sort of dark dignity—the kind of preexistentialist defiance that made Shelley hail Satan as the real hero of Milton's *Paradise Lost*.[13] In Satan, alienation from being rises to a total, titanic, ontological climax. He stands for the part of human consciousness unreconciled to being, a rebellion loudly championed by Goethe's Mephistopheles: "Everything that ex-

12. E. Pagels, *The Origin of Satan* (New York: Vintage Books, 1995), 35–62.

13. On Satan and romanticism, see P. Schock, *Romantic Satanism* (New York: Palgrave MacMillan, 2003); M. H. Abrams, "The Satanic and Romantic Hero," in *Norton Anthology of English Literature*, 3rd ed., 2 vols., ed. M. H. Abrams et al. (New York: Norton, 1974), 2:854–61; and M. Praz, "The Metamorphoses of Satan," in *Romantic Agony* (1933; 2nd ed., 1951; reprint, New York: Meridian Books, 1956), 53–91.

ists deserves to disappear so that it would be better if nothing had ever been."

Romanticism gave poetic vigor to the tragic beauty of separation, the beauty that *is* separation. By doing so, however, it highlighted the beauty inherent in artistic expression. Any image worth its artistic salt is aware of what removes it from life. No painting is ever the face or landscape it depicts; no sculpture will ever crawl back into the replete stillness of stone; no poem cannot overcome its own form, so hulking and stiff next to the never-resting stream of conscious life. The artistic image is separation. This is the precise sense in which a work of art is in love with reality. The suffering kindness of Rembrandt's portraits is the knowledge that they will never be their sitters; the echoing pang of Rilke's poetry is its loving exile from the beloved world. Language is testimony, representation, expression—all of which sets the human apart from mere being. This separation is an evil. But it is also the source of art's beauty. Fruitlessly would we bemoan the fate that makes absolute beauty—a beauty made of the seamless synthesis of opposites—inaccessible. Beauty is acceptance of the distance between the self and the beloved being or thing. Without consent to this distance, there is only lust and eating. Adam and Eve could not contemplate the apple's beauty from a distance. They had to eat it. Their punishment was exile from being. But the penalty, though woeful, goes on impressing the lesson once failed: for now it is not just a tree and an apple that Adam and Eve contemplate from a distance that starves them, but the whole of being from which consciousness splits them off. And consciousness, to be sure, is a source of suffering, but it is also the sacramental link that ties man and the world in love and loss. It is the gap out of which beauty blooms.

Live is suffering. For this suffering, religion offers consolation and science seeks remedy. Art, however, neither consoles nor remedies the solitude of being human. The first act of contemplative appreciation on record ("and God saw that it was good") is one of accepting separation. The history of art and philosophy jangles with definitions of beauty—whether it is subjective or objective, a property of objects or a figment of the imagination, a pleasurable emotion or social conventions. It seems these myriad definitions are in fact compatible under the general principle that beauty involves the division between self and world. This duality is not to be blurred away since it is the source of the beautiful. Beauty is neither subject nor object taken independently. It is the act by which the self tarries at the edge where it ends and the world begins. "More beautiful than all those things I desired to know is the modest

mind that admits its own limitations," Augustine says.[14] Beauty does not dwell in the world—this much the subjectivists and the constructionists have got right. But neither does it dwell in the subject alone. Beauty is the mind poised on its outer edge; it is the result of suffering the disconnection between mind and reality. "The object is for me altogether secondary," the painter Claude Monet once said; "what I want to represent is what exists between the motif and me."[15] This is the old spirit of goodness speaking and still declaring that being a self is not enough, that there is something more. This spirit used to go by the name of religion. Today it goes by the name of art.

14. Augustine, *Confessions*, trans. John K. Ryan (New York: Doubleday, 1960), 121.
15. In J. Berger, *The Sense of Sight* (New York: Vintage Books, 1985), 193.

Art and Experience

IT IS COMMONPLACE TO SUGGEST that art became something of a religion in modern culture—that its votaries regarded themselves as the priests of a truer, more refined experience of life. Bereft of the consolations of church and faith, heartbroken by the matter-of-factness of nineteenth-century science and industry, the sensitive soul clutched at art for salvation. Aestheticism, art for art's sake, the cult of beauty, Pre-Raphaelism, decadence, dandyism, and hellenism—these were so many ways of ministering to the belief in artistic transcendence, in beauty's ability to elevate and transfigure life.[1]

Everything considered, however, the movement was altogether ephemeral. Its crystal wings shattered on contact with twentieth-century trench warfare, gulags, and genocides. Transcendence in general fell afoul of a new, virile, no-nonsense cultural climate generally wary of sublimity—the climate infused with Freudianism, Sartrean existentialism, and of course Marxist criticism, Edmund Wilson, F. R. Leavis, Clement Greenberg, and the like. On aestheticism fell the verdict that, whatever religion it possessed, it was really a charade of religiosity, the swooning affectation of high-brow poseurs. Besides, the aesthete got art wrong. He ran to museums out of escapism and loathing for our factory-gray, modern reality.[2] "Human kind cannot bear very much reality,"

1. See A. Malraux, *The Voices of Silence*, trans. Stuart Gilbert (Princeton, N.J.: Princeton University Press, 1968).

2. None, perhaps, other than John Ruskin felt art to be a protest against our particularly modern grubby drab. He bemoans an age "when the iron roads are tearing up the surface of

says T. S. Eliot.[3] But squeamish withdrawal from reality never did art make. Nor, incidentally, does it make for good religion.

An outcome of this affected flirtation between art and religion has been a new determination to keep the two as far apart as possible. The cult of art is now regarded as a dying throb of idealism, a last timid suggestion that perhaps not all gods were dead and that secular culture could retain a glow of the sacred. But the chance was lost and the time is past, and now the art world is generally as wary of religion as modern medicine is of bloodletting. Today's art lover is a down-to-earth social-minded person. What a work of art means to a given historical community, how it acts inside social institutions, how its composition pulls it all together, or again how it mirrors the artist's values and preoccupations and social circumstances, all these are the questions likely to animate so-called serious discussions of art today.

A common assumption underpins these questions. It is that artistic experience really gravitates around the self, that art documents the subjective life and exists to serve human experience in either its individual or collective form. Pronouncements to the contrary, theories intimating a transcendent source and destination for art sound whimsical or illogical to the modern ear. "The whole comedy of art," Nietzsche says, "is not played for our sake, nor can we consider ourselves the true originators of that art realm."[4] This is the sort of statement that makes our pragmatic sensibility tune out. Whom on earth can art be for, from, or about if not the people that create and enjoy it? How can art, a man-made artifact, transcend the human world? This skyward lift, this "movement forward and upward" (Kandinsky), upsets our diet of philosophical ideas[5]—like, for instance, the notion that the mind may not overreach to glimpse a nonhuman state of reality; that the walls of language gird our un-

Europe, as the grapeshot do the sea; when their great net is drawing and twitching the ancient frame and strength together, contracting all its various life, its rocky arms and rural heart, into a narrow, finite, calculating metropolis of manufactures; when there is not a monument throughout the cities of Europe that speaks of old years and mighty people, but it is being swept away to build cafés and gaming houses . . . ; when we ravage without a pause all the loveliness of creation which God in giving pronounced Good." In J. Ruskin, *Modern Painters*, vol. 2, part 3, sect. 1, chap. 1, § 10.

3. T. S. Eliot, "Burnt Norton," in *Four Quartets*.

4. F. Nietzsche, *The Birth of Tragedy*, trans. Francis Golffing (New York: Doubleday, 1956), 41.

5. W. Kandinsky, *Concerning the Spiritual in Art*, trans. M. T. H. Sadler (New York: Dover Publications, 1977), 4.

derstanding with airtight vigilance; that however deep we peer into the heart of things, we always contemplate no more than our own schemes and projections. Truly, art is made by human hands, destined for human eyes and minds, for the purpose of illustrating or elucidating human meanings. This is the dogma at the core of our modern aesthetic understanding and it explains why the religion of art now looks so hopelessly out of date.

It is out of date for the same reason that religion has been deemed unworthy of serious philosophic inquiry: because religion suggests that the purpose of human life is not human-centered; that reason is on occasion able to peek beyond itself; that we have a mind eager to know but also *not* to know, and marvel at life. But this supposes a degree of subjective self-effacement that our philosophic temperament does not countenance. It rejects religious transcendence on the same grounds that it strikes down artistic transcendence, because both violate the prime directive of philosophic subjectivism, to wit, that the mind may not glimpse anything beyond itself. How can the mind harbor ideas, like God or Brahman or Tao, that are beyond saying? How can consciousness know about something that it cannot actually *know*? This is nonsense to modern rationality which, in the manner of Wittgenstein, holds that merely to frame a mystery is de facto to glimpse the answer.

༄

Of course rationality is entitled to banish forms of expression as it pleases; nevertheless, it cannot wish their existence away. The persistence of art is a good example. Flouting Hegel's announcement that rationality (lucid, far-seeing, universal, ministerial) has made art (incidental, erratic, impressionistic) obsolete, it appears that human beings still delight in expressing and voicing intuitions they do not fully comprehend. Art is proof that we still yearn for fascination, for views of the world not centered on self-possessed reason. Current aesthetic sensibility is rather blind to this yearning and prefers to read art forms as acts of personal or social self-representation, vehicles of cultural understanding, vessels of protest or commentary, the crests of social or intellectual or moral tides—all of which assumes that artistic expression lies within the ambit of articulate ideas. The risk is that we may become all head and no heart in our appreciation. We have shaped our language to speak learnedly of what is interesting about artworks but we are mute as to what makes them fascinating.

And artworks of course have not ceased fascinating us. In fact, there is

probably no art without an element of surprise. The unknown is at the basis of art's enduring power to fascinate and overwhelm us, to stir and delight the joy of embracing without deciphering. In the seventeenth century, Francis Bacon put it thus: "[T]here is no excellent beauty that hath not some strangeness in the proportion." Strangeness implies the unexpected. And the unexpected brings about encounter. Art, in this respect, is encounter.

To say that art is encounter suggests that, since it is human-made, we are capable of breaking with ourselves—capable of, as it were, stumbling out of our own compass. Art is really a form of self-estrangement, the estrangement of subjectivity from itself. This is the wisdom of the Orphic tale. Orpheus the songsmith has to walk through death to turn his music into a song of life. He must submit to the ultimate trial of self-estrangement. Only then will his poem sing. Only then will art become a life-giving song and be born. But Orpheus's downfall, as we know, is attachment. The gods warned him not to look back as he led Eurydice out of the Underworld. But faintness of heart makes Orpheus glance over his shoulder. Self-consciously he clings to the status and purpose and object of his art. The spell shatters. His is now a dead song and a dead art.

The Orphic tale serves as a warning against artistic self-consciousness. An artwork that is too strictly controlled is under the dominion of its self-possessed maker. It is a diligent pupil delivering the goods as instructed. This prudence stymies encounter. Like Orpheus, the overly articulate artwork looks back too self-consciously over its effect and audience. Kant evidently hit on an important truth when arguing that a work of art is purposeful activity without a predetermined goal, "a purposiveness without purpose."[6] "In order to represent objective purposiveness in a thing, the concept of *what sort of thing it is to be* must come first," Kant argues (*CJ*, 63). In other words, in order to make a fork, there has to exist some concept of what a fork is for—preexisting formal and technical criteria that an object must meet in order to qualify as a fork. "In this, what the thing ought to be is conceived as already determined" (*CJ*, 63). Not so with the work of art, Kant avers. On the one hand, an artwork bespeaks a purpose since it is not a natural or random aggregate. On the other, it answers to no preexisting concept of what it will or ought to be. "Therefore by means of beauty, regarded as a formal subjective purposive-

6. I. Kant, *Critique of Judgment*, 62.

ness, there is in no way thought a perfection of the object, as a purposiveness alleged to be formal but which is yet objective" (*CJ*, 64). In plain terms, the end result is not given but invented in the process of moving toward it. The work of art does not know where it is going. It takes the artist on a journey for which there is no known conceptual endpoint, no map, no ready-made destination. Otherwise, art is really craft and the artist merely a skilled imitator. But since obviously artists do constantly strike out on unsuspected paths and bring out undreamt-of forms and ideas, it follows that their way of making runs ahead of the act of knowing. Art is, in this sense, a dedicated practice of nonknowledge. In this fashion does it become encounter with *experience*.

By etymology, *experience* suggests daring, strain, and danger. The root word *experiri*, "to try," carries an image of passing (*per*, "through," "beyond," from the Greek verb *peraô*, "to pass through") beyond borders (*ex*). Decentering and venturesome, experience is akin to *periculum*, "peril," "danger," "hazard," and, in the postclassical period, to *perish*, from *perire*, a going-beyond that portends ruin and destruction. In short, "experience" once implied notions of ultimate occurrence, of open-ended trial, surrender, a dash to the limit, a leap into contingency—indeed quite a different fare than the sort of ossified "experiences" one collects in resumes or memoirs. "I call experience a voyage to the end of the possible," the French essayist Georges Bataille writes.[7] True experience escapes control. It pitches the self into happenstance, process, novelty—anywhere in fact where subjectivity loses its grip and meets the world in a spirit of participation.

The rise in prosperity, the scientific control of crops, industrial production, health, and population, the administration of life in urban and professional units, in sum, the regulation of life in the West, as well as the retreat of magic and superstition—all this has certainly made for a life in which the margin of encounter and genuine experience has grievously narrowed. Mastery of our inner and outer circumstances has somewhat squeezed the surprise out of everyday life. This explains why art (in backlash against the taming of life) came to be regarded with such cultish fervor in nineteenth-century European culture. It is then that thinkers and poets began to speak of boredom with the same horror as their forebears dreaded sin or dishonor or calamity or classlessness. The romantic, the aesthete, the dandy fears nothing so much as that nothing will happen and bemoans that life has grown predictable. Per-

7. G. Bataille, *Inner Experience*, 7.

haps no poet felt this modern ill more deeply than Baudelaire. He is the man under whose pen Evil, "le mal," turned to designate, not, as formerly held, a peak or a nadir, but the lack of movement, apathy, listlessness, a flattened will. Resultantly, art loomed as antidote to this numbing predictability of life. Art became transcendence, the escape into experience from the bogusness and safety of everyday society. In art, the insatiable soul sought the sublime awe and intensity formerly occasioned by sacred rituals or natural phenomena, by gods, thunder, crashing mountains, stormy seas. Witness Baudelaire's portrait of the modern painter.[8] Here the flourish of a brushstroke acquires the kind of daredevil heroism, the chivalry of venture, of life on the knife's edge, that befits a soldier, explorer, messiah, or mountaineer battling formidable circumstances—anyway, someone whose journey is spiritually redemptive, colossal, life changing, and enormously courageous. Baudelaire's painter is an acrobat setting out on the tightrope before he has mastered the skill. Indeed, it is then that the artist became heroic, wild, and preferably mad (for where consciousness did not renounce bourgeois safeguards there could be no encounter, no surprise, hence no art): in short, a visionary, which as late as the urbane eighteenth century it would have been ungentlemanly or plain silly for an artist to impersonate.

There are therefore historical circumstances for the exaltation of art in the modern period. Art became the recipient of the hopes and yearnings of those whom science and industry left cold, those for whom the march of progress was a paltry substitute for real transcendence, those who believed that the best in human life does not necessarily fit in theorems. But does this mean that there is no more to the connection between art and transcendence than an insurgency of aesthetes against the dullards of their day? Orpheus, after all, is no child of modernism. And the tie between artistic expression and religious feeling is too ancient and common for anyone to reasonably argue that it is the concoction of nostalgic hotheads adverse to the slab-drab of modern life or the claustrophobia of subjectivism.

Art is a kind of a death in just the sense that Orpheus's story, or Bacon, or Kant suggested: it requires subjectivity to step into uncharted terrain, to strip oneself of assumptions, and wed the mind to its opposite, that is, matter. Kant's idea that art is purposeful activity without a goal restored the Orphic

8. C. Baudelaire, *The Painter of Modern Life and Other Essays*, ed. Jonathan Mayne (New York: Phaidon Press, 1995).

to art. It suggested that, in some essential way, the artist surrenders control, fumbles into the unknown, escapes the confines of instrumental self-serving behavior. "I find, in working, always the disturbing intrusion of elements not a part of my most interested vision, and the inevitable obliteration and replacement of this vision by the work itself as it proceeds" (Edward Hopper).[9] The artist sacrifices what he is and what he knows for the sake of encounter. For without encounter, art is the application of rules, it is craft, industry, recipe following. In a word, it waits on the self—and when we design things to serve our needs and expectations we turn our back on true experience; we huddle in the past, amid the already known, the already thought of. By contrast, an artist must be always ready to change his mind, to let reality shatter his notions. In art reality comes in the form of the materials (e.g., paint, words, marble, sounds) that block and blindside and trip and waylay consciousness into unsuspected paths. (Of course, science, mathematics, and philosophy are also adventitious: how many theoretical insights are sparked by accidental occurrences, a headache or a heartache, impish incursions of physical life like, say, a random apple plopping at Newton's feet? But the apple came to Newton's attention because it hooked up with a preexisting train of thought. Whereas Chardin noticed *his* apples for no reason other than the sake of noticing them.)

An erroneous cliché has it that superior intellects are self-absorbed and distracted. Geniuses are said to be unworldly: writers forget to tie their shoes, painters neglect to salute the ladies, sculptors are rude, musicians mad. These are charming, yet untrue, vignettes. That men and women of powerful concentration are out of touch with practical realities is no indictment of their concentration but of the triviality and *unreality* of practical concerns. What passes for worldliness in society is attachment to the past, stability, permanence, the smugness of accepted ideas. True worldliness, however, should be to keep the mind as free as possible from prejudices and received notions. The artist performs such a feat. He is a person of inexhaustible attention. Whereas others march in mental lockstep, the artist ventures out, as Kant maintained, without a pregiven concept. This absence of plan and prejudice sets him right into the stream of reality.

The common man is unworldly for favoring representations over things.

9. In *Artists on Art from the XIV to the XX Century*, ed. Robert Goldwater and Marco Treves (New York: Pantheon Books, 1945), 471.

His looking is narrowed by abstraction and symbolic protocol. He sees not a woman, but his wife; not a fellow man, but his boss; not the ocean, but shipping lanes. He, in other words, is distracted. Whereas the artist has a tactile affinity for sensible reality. He does not rush from a thing to its significance. Instead he agrees to make himself *stupid* for the sake of reality (Latin *stupere*, "to be astonished"). Only through this act of self-humbling can he behold colors, pigments, words, marble, or sounds not the way others do, as signposts, but in themselves. The artist sets out from a place of no or minimal knowledge. This is the other significance of Kant's insistence that a work of art follow no pre-given concept. Or if it did, the old, the known, the contents of mind would bar fresh experience. It is said, rightly, that science also is keyed to reality, to what is unknown. But science in the end lacks nerves. Like Sancho Panza, it asks questions before jumping; it shuns bewilderment and approaches the unknown armed with theorems and instruments. Whereas the artist sallies into the unknown while *practicing* the unknown. Could Monet have had the impressionist touch all figured out before his brush fumbled onto it? Could Mona Lisa's midautumn smile have preexisted the moment when, from happenstance, dedication, intuition, and searching, it began flickering on canvas? It is not interesting to think so. The artist's adventure is traveling, not prospecting. He sets out on the journey for the sake of journeying. If he knew where he wanted to go, if his destination were a point on a map, then he would not need to reach it. As Kant saw it, art is active attention to the process of venturing, not of arriving, of exploring, not of leering at the spoils.

"I do not know." These are the words of the artist at work, and the human mind is capable of no greater feat than to say them. What happens when we do not know? The mind then is miraculously faced with the absence of ideas. Consciousness is now without a clear content: only the awareness of an empty place that ought to be filled but isn't. It is a mistake to rush to fill in that empty place. For in this momentary vacancy, consciousness is pure, it feels its tingling expansion. The mind is free of the past; then it is available, aware, primed for experience.

But what, one may ask in concluding this preamble, does nonknowing have to do with a religious disposition to reality? Quite simply this: that reality is never more closely touched, duly heeded, and respected than when the mind cultivates nonknowing; when it is free of apriori conceptual schemes; when, that is, it welcomes experience. How often do we ever pause and see that the

world is not just a stage set for our self-important emoting? The artist is precisely he who does justice to reality because his activity consists in heeding beings and things with precise attention. To the creative person no two events or moments are ever the same. Sameness is the blanket thrown by thought over reality to make it usable. Sameness is not a feature of the world but of thought. It stems from mental expedience—lumping things together for better use. Only the countervailing force of humility jogs us out of the arrogance of quantifying and equating and blending; only humility can cure us of the stupidity of quantity. It takes humility to approach reality without prejudgment, to admit that things may be altogether different than what the mind has ruled out of hand. This humility opens the gateway to experience—and the artist, whatever his psychological flaws, is almost universally humble when it comes to the work, the material, the tangible presence of things. The iconography of the towering, world-bending, mercurial artist is a concoction of romantic theoreticians; in practice it spawns only lesser artists and lesser works of art. The great artist is mindful; at work he is irrepressibly gentle and asks permission—like Flaubert making himself servant to his sentences, or Van Gogh apologizing to the landscape, or Rodin begging the stone with his hands. The artist stands in an attitude of response. This is creativity: not to bully matter or sound or meaning into whatever form the mind fancies, but to attend diligently to the concrete accidental development of the work. It is then the artist gains access to experience.

The philosopher John Dewey wrote with great passion on the matter of art and experience, urging us to dispense with our overly scientific knowingness toward art. For art is more body than mind. It is made of matter. It loves to plunge into the sensorial and the concrete. Art, Dewey affirms in *Art as Experience*, is delight in our receptive and perceptive nature, in breathing, moving in time and space. It thumbs its nose at abstraction. It is the acme of our ability to enter experience and indeed, Dewey urges, the regal way to the full life.

Though endearing, this paean to art harbors the weakness built into pragmatism. Experience in Dewey's idea is too facile, gratifying, pliant. It is a wellspring of tonic fun and youth. Deweyan experience is akin to gymnastics: while it lasts one is fully occupied; but one loses track of neither the protocol, nor the goal, nor the bottom line of the experiment that always pays off. It is the forerunner of our consumerist insistence on "fun." This perhaps explains why Dewey instinctively emphasizes the reception and enjoyment of artworks

rather than the exacting process of making them. There, the balance of cost and benefit often leaves the artist in the red: one seldom goes mad or destitute or desperate enjoying artworks; whereas art is often unforgiving with its maker. Genuine experience wants yielding to. Dewey's sunny intellect has no taste for the sort of experience involving disorientation, and sacrifice. Without these, however, experience is really leisure. For only in retrospect is experience acquisitive. When it happens, the self must be ready to lose everything—or else experience is sampled but not actually gone through.

And this is how, finally, art opens to experience in a religious, rather than experimental, sense: because it throws subjectivity beyond itself, because it makes the mind release its grip, because, in short, it opens to the unknown. Indeed, no art is there without sacrifice.

The Will to Weakness

———————◦⟨⟩◦———————

PERHAPS THE FOREGOING is a roundabout way to say that the old hokey "religion of art" had got one thing right about wedding art to religion. The two are expressions of a wish to give up our subjective monopoly over "the ten thousand things" of life. Art suspends the will to cut the world down to our measure. As in religion, art is an admission that the world is there not just to know, but also crucially *not* to know. And finally it is a recognition that human experience remains a pale stunted growth unless, breaking the magic charm of our own centrality, we are rid of the anthropocentric sin.

This heartfelt idea, however, is likely to raise eyebrows: How can art, or even for this matter religion, which are both ostensibly man-made, conceivably attain unmade being? What pathway can art carve out of human language when it is all human language itself? I believe an attempt to resolve this question drives Nietzsche's first and most comprehensive statement on art, *The Birth of Tragedy*.

Nietzsche is among all modernists the one most often credited or reviled for having killed our faith in science, in religion, in morality, and even—beating Freud to it—in the clarity of human intentions. This judgment is as correct in general as it is incorrect in particulars. Nietzsche did scoff at positivist science's claim to capture reality as such, but he also entertained a vitalist conviction of man's immersion in nature, life, biology, and the quiddity of reality. Likewise, though he heralded the death of God, he, more than any modern

philosophers, exalted man's transcending ability, his need to aim high, to overcome the trivial ego, and to climb up to the rarified heights of transcended selfhood. Nietzsche by no means intended to empty human experience of the spiritual—which word conveys the sense of inhabiting a universe greater than our puny ability to manage it, the sense of mystery but also inclusion consequent upon this insight, the realization that the psyche's greatest task is to reach its breaking point, ever upward where it eventually lets go, or, in the oldest words of philosophy, learns how to die.[1]

This spirituality he explored not in the realm of religion proper, but in the realm of art. Nietzsche is perhaps the first in those modern line of intellects like Heidegger, Santayana, Roger Fry, and Dewey who, no sooner the lamp of God snuffed out, glimpsed spiritual radiance everywhere there was art. We shall consider here the case of *The Birth of Tragedy*.

Boldest among this book's many impetuous claims is the idea that art harbors in equal measure the will to create *and* the will to uncreate, that it is form and obliteration of form, making and unmaking, Apollo and Dionysos. Apollo is the spirit of form, of plastic creation. He, Nietzsche tells us, "may be regarded as the marvelous divine image of the *principium individuationis*," the one by whom a being is one entity and no other (*BT*, 22). He is the god of separation and image making, of outline and definition. His countervailing force is Dionysos. This is the god of dissolution, oblivion, and rapture, the great unmaker who, against the Apollonion drive to individuate, wants "to tear asunder the Veil of Maya, to sink back into the original Oneness of nature" (*BT*, 27). The Vedic flavor here is not just for show. Behind the Apollonian, which stands for the sun-splashed Western facade of the Greek psyche, the Dionysiac coils back to the Far Eastern roots of Hellenic civilization, to a wellspring of yearnings and precedents Nietzsche hazily associates with Brahmanic Asia (*BT*, 109). In this ancient substrate of culture, "complete oneness with the essence of the universe" (*BT*, 25) is preferable to distinctive identity and scientific knowledge. In the Dionysiac release, "nature herself, long alienated and subjugated, rises again to celebrate the reconciliation with her prodigal son, man" (*BT*, 23). Thus we are swept into Being once more, and no longer is nature a thing plunked before us, but the cosmic womb reentered. Thus art cures

1. For a demonstration of what the word "spiritual" can still mean to the secular thinking person, see Robert C. Solomon's excellent *Spirituality for the Skeptic: The Thoughtful Love of Life* (New York: Oxford University Press, 2002).

us of the pain of separation—an idea by no means of Nietzschean invention but a staple of romantic poetry and rhapsodized in the greatest of Nietzsche's intellectual forebears, Emerson, for whom the artist's mission was no less than to "carry art up into the kingdom of nature, and destroy its separate and contrasted existence."[2]

The Apollonian and Dionysiac drives equally energize the artistic process: no work of art can there be without the will to round up matter into shape. But no artwork can have any expressive power without breaking its formal reserve. The work of art pulls itself together; outwardly, however, it longs to burst into reality. Although this thirst for reunion is never quite satiated, since no work of art can logically afford not to be, no work of art can omit appealing to the outside, to speak out, to appear, that is, to express its connection to what it is not. This latter feature is what on balance makes Nietzsche more partial to Dionysos. The Dionysiac has all the features to recommend it to the Nietzschean imagination. Present are the romantic explosion and self-overcoming, the smashing of forms and vitalistic embrace of organic powers—in short, the will to live on an expanding scale that is the hallmark of Nietzscheism.

For all that, it would be wrong to write off the Dionysiac as just an excuse for Nietzsche to harp on his repertory. There is something sober and humbling afoot in the work of Dionysos: the will to overcome boundaries, to be sure, but more interestingly *the will to overcome willing* as well, which means to jettison the self as agent and beneficiary of art.

Here is how. Of necessity the Dionysiac spirit initially harbors discontent. Or else it would not thirst for release and expansion. This hunger for expression, however, does not aim at swelling the subjective life. It is rather the renunciation of all that is bumptiously assertive about human endeavor. Why this self-renunciation? Because, being a movement of life, the work of art feels that its own congealed existence is an impediment on the path to life. It is too much diversion and illusion, a bright image that hinders a direct imageless contact with reality. This contact is, in the last analysis, the ultimate artistic destination. In Nietzsche's words, art is no merry picture-show but "a confrontation with stark reality" (*BT*, 17). It is the activity by which "the world of appearances is pushed to its limits, where it denies itself and seeks to escape back into the world of primordial reality" (*BT*, 132). In brief, a work of art

2. R. W. Emerson, "Art," in *The Essential Writings of Ralph Waldo Emerson*, ed. Brooks Atkinson (New York: Modern Library, 2000), 281.

conjures up images in order to do away with them. Truly to enter reality, the work of art needs to drop all pretense and imitation. In effect, it has to jettison its own imagelike character. This of course is an unfulfillable wish, though no less the driving force of great art for that. The paradox, at any rate, seems to be that superior works of art derive their expressive powers from their wish to fall silent.

But does Nietzsche actually make a strong case for his thesis that love of reality is the driving momentum of art? I am not sure he does. His premise is less artistic than psychological. It rests on the assumption that, deep in the psyche, we yearn to reenter primordial union with cosmic oneness. Still, we must ask what so earmarks art that, of all human activities, it serves this oceanic longing in us. How does art enable this religious union with reality?

A defining feature of art, it is said, is expressiveness. Speech moves it. This alone makes art no different from other products of human labor which, whether it be ditch digging, diplomacy, or dentistry, exhibit intention and expression. Art is distinct from other forms of expression in that here expression arises for enjoyment of its own exercise. Now, what does this new feature reveal about the creatures so endowed as to delight in the act of expression itself?

The first is that humans derive pleasure from putting their imprint on the world. From cave painting to video art, art bespeaks pleasure in fashioning our environment, in shaping material life after the hues and arabesques of our inner subjective world. We might call this the Pygmalion theory of art. It is, in my view, not very interesting because in the end it does little to account for the uniqueness of art. In fact, all our activities, however mundane or exalted, bespeak the desire to shape our environment. So a dentist enjoying the drilling of a tooth could claim to engage in art. As would a murderer carrying out homicides with craftsmanlike application. Indeed, at this rate, an occupation only has to be enjoyed in order to become art. This clarifies little the difference, if there be one, between art, on the one hand, and science, craft, or manufacture, on the other.

A brand of modernism and postmodernism is happy to suggest that in fact there is no such difference, that art is on a par with all other forms of human industry in that all aim at stamping our face on things; it even goes further in suggesting that art indeed is the supreme manifestation of our will to shape the world—abetted in this conviction by Nietzsche's later philosophy, the so-

called doctrine of the will to power, which holds that organic life is perpetual self-fashioning. If, however, this is true, the question stands: What sets art apart from ditch digging, dentistry, or computer programming if all activities are at bottom artistic, that is, expressive of the will to shape? The postmodern Pygmalion is likely to answer that self-consciousness really distinguishes art from the rest. Art is willpower delightfully aware of exercising itself.

For reasons discussed below, this doctrine seems to me misguided. It files art under the heading of power—and self-consciousness, on this account, is merely a device by means of which power furthers itself. Artistic delight then is simply the thrill of dominance spiced up with self-satisfaction. Scarcely a greater contrast obtains than between this late voluntaristic aesthetics of Nietzsche's will to power and the early *Birth of Tragedy* where, I wish to argue, art consists to a large measure in an activity of powerlessness—the will to fragility. Against the Pygmalion hand of the will to power, and of reality subjugated to human fashioning, against the view that life is "the desire to incorporate everything" and "a mode of nutrition," *The Birth of Tragedy* holds that the nobler part of subjectivity consists in self-surrender, that the will's highest and most refined wish is to achieve freedom from itself.[3] Recall that art is understood to be emphatically about reality: a "confrontation with stark reality" is how Nietzsche puts it. Now this confrontation certainly does not entail smashing reality with the sledgehammer of volition. For encounter to happen there has got to be a force counterpuntal to the self. Subjectivity has to be countered, checked in its tracks, drawn to the edge where it faces what it is not. This is what Nietzsche conveys in his insight that art is the experience whereby the self rushes to its limits and seeks escape back into primordial reality. Obviously, however, subjectivity can never contemplate such an escape if art consists only in molding and marshalling external stuff into our likeness. The gates of being cannot be jimmied. Else it is not reality one enters but a manufactured reconstruction. To enter reality, one must forego trying. Otherwise the will stands between the self and reality.[4] A sort of self-emptying, a will to fragility, is therefore needed. Now the question is: Just how does art veer away from Pygmalion and practice powerlessness?

3. F. Nietzsche, *The Will to Power*, 347, 341.

4. *The Song of God: Bhagavad Gita*, trans. Swami Prabhavananda and Christopher Isherwood (New York: Mentor Books, 1954), 42: "When a man enters Reality, he leaves his desires behind him."

To answer the question, we must observe the kind of expression cultivated by art. An artwork does more than just bring out forms and images; of greater importance is that it is reflective. "What is expression?" asks the work of art. At first blush expression seems self-assertive: to make known outside what is inside. But in going to the outside, consciousness also admits to the magnetic power of external reality. Thus anyone who bothers to *say* he is a solipsist refutes himself on the spot because speaking admits to sending forth words to a place outside the mind. I speak because my thoughts are not found in the world and moreover need the world to become real. Thus we pour ourselves out into the world because we wait on its validation. Creatures that are blissfully fulfilled have no need for expressive languages. Language is for those who are outwardly turned, those whom nature has created to live in thirst and curiosity, incompletion and love, separation and wish for reunion. We express ourselves because we are in need of the world.

In truth, expression is less an act of consciousness than the *source* of consciousness. It is that by which consciousness is relational, why it is *of* anything at all.

Our way of being conscious harbors the wish not merely to live in and navigate the world, but also to become acquainted with it. Human consciousness goes out to things. Because it is viscerally expressive, consciousness seeks beyond perception and hankers for contact. At the expressive heart of consciousness is the mind's prayer to be relieved of its own emptiness. I venture into the world because alone I am nothing. And expression is the means by which consciousness fulfills the wish to become concrete, to escape the world of unreality and mental phantomhood that is the self.

Only perhaps in art is this knowledge of one's emptiness truly free of the instinct of clutching and acquiring. Artistic expression is content with the distance between self and reality. This is why it is often said that art is illusion and drifts away from real life. But it is a mistaken view that holds art to dodge reality. Art consents to the distance from actual things because only in distance do we avoid the taint of possession. To possess is to dominate and therefore to humiliate. It is probably impossible to possess a thing, let alone a being, and love it at the same time. Art maintains enough distance from reality so that here expression is free from the corruptive touch of possession. On the one hand, artistic expression requires the passionate commitment of one's whole being. Orpheus does need to submit body and soul to the gauntlet of

experience. On the other hand, however, art also calls for suspending willful habits of interfering. The experience of creating art needs the steadying hand of contemplation. Orpheus loses his beloved out of excessive attachment, because, in looking back at Eurydice, he gives in to possessiveness. He does not let his song work its magic. Active in him are, in spite of all, the old habit of control and dominion. To the contrary, genuine artistic expression agrees to the distance between the song and reality. The pinch of longing in great artworks, even joyful ones, comes from this acceptance of separation between subjectivity and the external world. To this separation art owes existence. A compact, homogenous world would leave no room for expression to wedge in. Expression acts on a vacuum. Thus at no point in time or space will the portrait by Rembrandt ever join the sitter. And this is just the acknowledgment of such a duality that lends expressiveness to the image. This is especially true of great portraitists like Rembrandt or Raphael, or landscape painters like Corot or Constable, or genre painters like Lorrain—their works display a heartrending affection and longing for the reality to which they bear witness yet can never successfully enter. Not, however, that the duality between expression and reality is outright divorce. For it is by letting reality be that the portrait stands in loving relation to it. In a sense, painting enacts the common truth that things appear only when we back away from them. Thus does all perception bear the stamp of separation but, since perception hurries out to things, also of our love for them. Of all living creatures we seem to be the one species blessed with the ability to *see* the world. The Fall from Eden, our stumble out of unconscious oneness, is also the sign of our election because it fathers our rare ability to love the world and depict it in images whose innermost wish is to let it appear.

Art, in brief, is moved by a passion for the outsideness of things. Let us call it, in opposition to the Pygmalion theory of art, the Orphic theory of art. Like Orpheus, the song of art is death of personality and love for the world. Just as Orpheus walks through death, and the lifegiving charm of his song hangs on his unstinting surrender, so art is subjectivity singing itself out, literally singing to empty itself. Art arises when the pull of objectivity is felt with overwhelmingly greater force than the subjective life.

This, incidentally, dovetails nearly point for point with Nietzsche's description of the Dionysiac. "To us," he says, "the subjective artist is simply the bad artist . . . since we demand above all, in every genre and range of art, a triumph

over subjectivity, deliverance from the self, the silencing of every personal will and desire; since, in fact, we cannot imagine the smallest genuine art work lacking objectivity and disinterested contemplation" (*BT*, 37). A certain will to fragility, to self-renunciation, is necessary for the creation of art. "The subject," he writes again, "the striving individual bent on furthering egoistic purposes, can be thought of only as an enemy to art, never as its source" (*BT*, 41). Abdication of self-centeredness, the silencing of personal interests, breaking the stranglehold of individuation—what are these if not the trademarks of religious experience? Central to the main world religions is the heartfelt need to shift the center of meaningful experience from the self to the nonself, to reorient life so that not the ego, but other people, animals, the world and its sustaining Source become the magnetic center.

Now this religiousness in Nietzsche's aesthetics is especially striking because it contrasts sharply with his later philosophy, the Nietzsche of the will to power, the Nietzsche as founding father and grand priest of the church of modernism. The late aesthetic holds that art is the consummate form of power, of the drive to grow and coerce at will, to unleash subjectivity. In this scheme there is no more vital and essential desire than to bring our surroundings in line with this desire. We are the Pygmalions of being and art is consequently the purest expression of the will to power since the artistic personality is also the most fully liberated and controlling.

Every form of religious life, the late Nietzsche holds, requires the submission of the intellect to unverifiable dogmas, hence abnegation and self-curtailment, the emasculation of the will.[5] Since only free exercise of will power matters, whatever restricts this will is an outrage against human life. But this philosophy is detrimentally reductive: for one thing, it shoehorns the infinite variety of human experience into one psychological principle only, the will. Which leads it to condemn any psychological or social activity not proven to serve the individual will, and labels hypocritical any selfless act, any form of generosity, or any charitable impulse on the ground that they too are secretly self-serving (it is not of course the fact that selflessness is self-serving that rankles Nietzsche,

5. At his most Kantian, and accordingly when he was most phobic of external influence. See F. Nietzsche, *The Anti-Christ*, trans. R. J. Hollingdale (New York: Penguin Books, 1968), §54: "The need for a belief, of some unconditional Yes and No is a requirement of *weakness*. Every variety of belief is, in itself. The man of faith, the 'believer' does not belong to himself, he can be only a means, he has to be used, he needs someone who will use him. . . . Belief of any kind is itself an expression of selflessness, of self-alienation."

but the fact that it pretends not to be; nor is it the hypocrisy that bothers him, since according to Nietzschean logic, hypocrisy is a good so long as it serves self-interest, which in the case of religion it reportedly always does; what really annoys Nietzsche is that some people pretend not to be Nietzschean, a sin without appeal even if committed out of self-interest).

But the will of course is not our only psychological fixture. What satisfaction would there be to the knowledge that another person loves me only because I *will* him to? Or that an argument is correct simply because I really want it to be? Or that the Earth is a sphere just because my will commands this conclusion? There is a part of us autonomous from will and self-interest. It is the part that wishes the world and other people and facts to exist in their own right, even if this restricts our freedom to do as we wish. We need some of our connections with the world to be unforced. Absolute control over other people and our environment may satisfy the grabbing infant in each of us, but it does not fulfill the mature intellect that values mutuality and connection over mere satisfaction of hunger. I want other persons to love me because *they* chose to. Their love is valueless if it does not come from them but is imposed on them. What's in the feeling that I want other people's affection for me to flow freely? Simply that I do not wish to live in a world that rises and falls with my will. Such a world is unreal, illusory, and I do not fully inhabit it. Whereas my dearest wish is that the world be real and I a real denizen. I want to be connected to the world: this is why I prefer to have others love me independently of what I would wish them to do. It is their independence from me that makes me an inhabitant of the world. Their separateness at least guarantees that they exist (whereas their utter submission to my will would in some sense eradicate their distinction from me). The separateness of the world tells me that I am not alone. The desire to not be alone (i.e., the desire for *love*) is stronger than the will itself. The proof is that we would rather be unloved for real than loved in illusion. When unloved for real we at least are connected to an actual state of things, to an independent reality of beings, that is, to a situation where love may arise; whereas no love can occur, and complete solitude prevails, in a situation where my will is all and the world an extension of the self. The labor of achieving this condition—love—is, one may conclude, more central to the human personality than the will. Otherwise we would be satisfied with living in delusion: whether your spouse really loves you or not would make no difference so long as you fancy that he or she loves you. Few, except from the

infantile, would opt for this fool's paradise. In truth, the grown-up intellect tends to choose reality over will. How odd that in his philosophical career Nietzsche raced in the opposite direction from maturity to infancy—from the early Dionysiac surrender to reality to the Apollonian collaring of reality, from the embrace of communion to the paranoid tightening of control. *The Birth of Tragedy* rhapsodizes on virtues (surrender, quietist acceptance) that the later Nietzsche would brand sinful. Whereas the late Nietzsche prosaically imagines human affirmation only in terms of bullish expansion of the individual's sphere of action, the early Nietzsche is more sensitive to the subtle ways in which human experience may gain in richness and intensity *without* invading on or crushing other beings—indeed a way in which the self may gain more life by overcoming the insatiable, greedy, self-seeking will. Alive in *The Birth of Tragedy* is the insight that human experience can expand by forswearing self-assertion. This is the Nietzsche under the influence of Schopenhauer's Vedantic explorations or Richard Wagner's fantasias of self-immolation and transcendence.[6] In Schopenhauer, Nietzsche glimpses a way of life where self-will isn't the paragon of humanity but a comparatively crude and shallow pursuit. To this overcoming of the will Nietzsche gives the name of Dionysus but he could have equally given the name of some Vedic deity. It is the idea of *unio mystica*, of transcending the self, of breaking individuality, whose uncomely bulk Nietzsche is not shy to brand "the root of all evil" (*BT*, 67).

Now evil is quite a thunderous word from the mouth of a philosopher who urged us to dismiss moral restrictions and take the world by wile and muscle. But good and evil do belong in the Nietzschean order. Only they are not casuistic but vitalistic markers. Thus evil, unlike the great ringing "yes" of goodness, is the spirit of negation and reduction. It frowns and enfeebles; it is the wish to subtract and impoverish, to split and haggle with a stingy heart. This, in fact, is the sense in which Nietzsche declares individuation to be the root of evil: to suggest that life centered on the narrow gauge of ego curbs and starves

6. Written in 1872, *The Birth of Tragedy* was influenced by Schopenhauer, so far as its Far Eastern overtones are concerned. Later Nietzsche became more deeply acquainted with the Vedas and Buddhism through other books, as indicated by texts in his library, many with marginalia. Among them were P. Deussen, *Das System des Vedanta* (1883); J. Wackernagel, *Über den Ursprung des Brahmanismus* (1877); and A. Coomaraswamy's translation of the *Sutta-nipâta*. For a complete study of the influence of Eastern philosophy on Nietzsche, see F. Mistry, *Nietzsche and Buddhism* (New York: Walter de Gruyter, 1981).

the great flow of experience. Individual life is contraction. It is a by-product of fear, timidity, and recoil from circumstances. The spiritual task of human life is to overcome this fear, hence to drain the source of individuation. Religion is most commonly identified with this task; but so should art be, Nietzsche suggests, thereby laying down a cornerstone for the religion of art—finally understood here not as the maudlin cult of museum pieces, but as the insight that art practices the release from self and love of the world.

If individuation is evil, then art, which swears off personalism, leads to the good. And the good here is contact with the world beyond individuality, beyond the barren feud of subject and object. Indeed Beauty is the Good in Nietzsche on the same terms that the good is beautiful in religion: both involve subjective emptying and being drawn to the world solely by the auspicious wish to receive it as it is.

&❖3

Now obviously Nietzsche is aware that he must square this mystical aesthetics with the mundane evidence that, *volens nolens*, an artwork is an artifact soaked through with the artist's personality, time, and social circumstances. As it happens, reconciling this external infusion with the anonymity of artistic expression is the major challenge of his treatise. Here is how Nietzsche puts the problem: "How can the lyrical poet exist at all as artist—as he who, according to the experience of all times, always says 'I' and recites to us the entire chromatic scale of his passions and appetites" (*BT*, 37)? To state it otherwise, How can the "I" of artistic production exist alongside the genuine experience which, in Nietzsche's words, is "a triumph over subjectivity, deliverance from the self, the silencing of every personal will and desire" (*BT*, 37)? Here we are asked to match two conflicting pictures of the artist. The first is of the magisterial creator of worlds, the second of selfless servant to an impersonal process.

Nietzsche's solution is this: in the artistic activity, the "I" becomes objectified; it is an "I" estranged from itself, sunk in activity, possessed by the work, and thus purified of the dross of personal feelings and opinions and preferences. "The lyrical poet . . . becomes his images, his images are objectified versions of himself . . . his 'I' is not that of the actual waking man, but the 'I' dwelling, truly and eternally, in the ground of being" (*BT*, 39). The idea here is not, against common assumption, that the artist portrays himself in images but rather that his images rob him of identity. It is not that the work becomes him but that *he* becomes his images. A work of art, whether a sculpture, paint-

ing, poem, or piece of music, gives the impression of rising subjectivity. This, however, is a partial truth. For subjectivity really has to descend into stone, or paint, or language, or sound in order to give birth to artistic expression. The artist is no puppeteer; rather he is an actor, a participant, an entranced oracle. Were he merely to manipulate his materials from on high, the work would have the look of a trick more or less cleverly pulled off. We know plenty of instances of such second-rate quick and glib stuff. A true work of art shows the depth into which the artist was willing to descend, how willing he was to sacrifice his talent and know-how, even the knowledge he had of himself, in order to meet the material, the reality facing him as nakedly and honestly as possible. This descent requires the self to reckon with worldly materialness in a spirit of respect and obedience—or else the work of art is a mere courier, a mouthpiece go-between.

The descent into matter demands abnegation of thinking oneself a creator separate from the material. According to Jackson Pollock, "When I am *in* my painting, I am not aware of what I'm doing. . . . I have no fears about making changes, destroying the image, etc., because the painting has a life of its own. I try to let it come through. It is only when I lose contact with the painting that the result is a mess."[7] Note that, so far as the painter is concerned, the experience of creation is not expressive. The work does not come *from* him; rather he is *in* the painting, as a traveler is *in* the landscape or a player is *in* the game. He is immersed in what, from a third-party standpoint, he appears to make. Creation does not occur in the artist's mind, nor is it a scheme laid out before the deed. Otherwise the artwork is a thing contrived and executed, a product of artistic talent but not the outcome of a total experience, a commitment of subjectivity to the vagaries of material nature, the flowing union of action and reaction, of mind and matter. To draw near matter, the mind must surrender. For the artist at work, the world of facts, concrete objects, matter and color and sound—all loom larger than the inner voice of subjectivity.

Art is an attempt to let the world speak for itself, instead of reporting the speech of minds excited by their picture of the world. . . . Art will free itself from the needs and desires of men. We will no longer paint a forest or a horse as we please or as they seem to us, but *as they really are*. (Franz Marc, *AA*, 445)

7. In B. H. Friedman, *Jackson Pollock: Energy Made Visible* (New York: McGraw-Hill, 1974), 99.

This of course is a perplexing statement from a painter famous for painting indigo horses and airborne cows. Who can lift the veil of appearance and behold the object untainted by the act of beholding? Nevertheless, the statement speaks of the mood in which the great artist sets to work. This mood is humility. It consists in abdicating mental projection, wishful thinking, emotional solipsism, the habit of supposing that reality ripples circlelike around the self. It is less an ascetic destruction of subjectivity than an unsentimental assessment of its proper place. "The purpose of humility," Simone Weil says, "is to eliminate what is imaginary."[8]

8. S. Weil, *Gravity and Grace*, trans. Emma Craufurd (New York: Routledge, 1963), 47.

CHAPTER 17

Art and Imagination

———————— ⟪◊⟫ ————————

ISN'T IT A PARADOX, a bit of rococo logic, to suggest that a painting or poem entails eliminating what is imaginary? What, after all, is art if not the realm of imagination?

Making sense of this paradox requires a look deeper at imagination. Imagination is the mind's ability to reach beyond perception and cognition. "Imagination bodies forth the forms of things unknown," Shakespeare says. It is extension beyond the boundary of what is perceived and known. This is how the German romantics, from Kant to Hegel and Schiller and Schelling, drummed on the notion that imagination is free. By this they meant that imagination envisions beings and appearances and arrangements not found in nature, hence free from its laws. This is why imagination is necessary to scientific investigation. Faced with the reticence of facts, the scientist need to listen to the imp within, the "What if?" that sparks discovery. Imagination is initially a step back from reality which, in and of itself, is unforthcoming.

But just because imagination leaps beyond the sensorial date does not mean that it abandons reality. Imagination is not retreat into conceptual abstraction. In fact, imagination leaps beyond the facts at hand because facts are too often in the grip of conceptual understanding. Imagination is moved by the maverick spirit of venturing and risking, and this means going beyond assumptions of the mind as well. Imagination is the mind breaking free from ordinary understanding. When it twists reality, it really twists the mind that commonly straightens reality.

However, just as imagination opens our mind up to reality by challenging the comfort of known assumptions, so it can isolate us from reality. For imagination is after all denial: denial of what we perceive in favor of what we do not yet see (e.g., it took imagination to deny the testimony of our senses and declare that the Earth is not flat). Productive and intuitive as it is, this denial can also turn into the worst enemy of reality. Imagination is thus a dangerous ally of creative work. It can serve the daring intellect but can also minister to the fearful, neurotic, boastful, hermetic mind. In the latter case, imagination exudes bloat and vainglory, that is, fantasy. Fantasy feeds our tendency to keep our eyes shut—to retreat into a mental garden of ideal figures, wishful thinking, and narcissistic comfort. Fantasy produces works of imagination that are generally mercantile because their obvious aim is to pander—to mollycoddle and numb and put the soul to sleep. Their service is anaesthetic, that is, the opposite of aesthetic, whose role is to expose the mind to the senses. Fantasy art is not humble because it bolsters itself up against contact with reality.

There is therefore the kind of imagination that retreats into the mind; and there is another sort of imagination that, in fact, is wary and watchful of the mind's own laziness and complacency. Imagination can be used to escape, but it can also be used to penetrate deeper into reality. This is called imagining into the life of beings and things. It requires attentive perception but also intuition: picturing what, in a human face, for instance, speaks beyond what it shows, reveals an inner world, the spark of a thought, a secret desire, a longing. The following passage from Tolstoy's *Anna Karenin* describes the first meeting between Vronsky and the heroine. It offers an example of the imaginatively perceptive person and a sample of the sort of imaginative activity of artistic work—which is to lead by means of imagination into the intimate life of things.

Vronsky followed the guard to the carriage, and at the door of the compartment had to stop and make way for a lady who was getting out. His experience as a man of the world told him at a glance that she belonged to the best society. He begged her pardon and was about to enter the carriage but felt he must have another look at her—not because of her beauty, not on account of the elegance and unassuming grace of her whole figure, but because of something tender and caressing in her lovely face as she passed him. As he looked round, she too turned her head. Her brilliant grey eyes, shadowed by thick lashes, gave him a friendly, attentive look, as though she were recognizing him, and then turned to the approaching crowd as if in search of some-

one. In that brief glance, Vronsky had time to notice the suppressed animation which played over her face and flitted between her sparkling eyes and the slight smile curving her red lips. It was as though her nature were so brimming over with something that against her will it expressed itself now in a radiant look, now in a smile. She deliberately shrouded the light in her eyes but in spite of herself it gleamed in the faintly perceptible smile.[1]

The scene is of a brief chance meeting, a mere sighting. Of course, Vronsky notices Anna for her beauty; but he does not linger over her just because of it. His attention is detailed (brilliant gray sparkling eyes, thick lashes, red lips) yet does not idolize the physical. Vronsky exhibits the imaginative sensitivity of the artistic person, of Tolstoy's own perception. He is sensitive to what is not apparent, the suppressed animation, Anna's inner world that both wants and fears expression. Vronsky *imagines* into her life. To him, Anna's appearance is a mystery that needs tending and attending to. He uses his imagination not to transmogrify or idealize Anna, but to enter her world, hear her silence, feel into what is not stated or shown. In that moment, imagination lifts Vronsky above self-interested desire and helps him testify to the plea, inherent in every living thing, to be seen in its own right. For it takes imagination to see the reality of a person—it takes venturing into the unsaid, feeling one's way through the tender signs, following hunches. In short, it requires a great generosity of imagination. Of course, the imaginative disposition is never free of projection. What we too often see of an entity is what we put there. Then our imagination undermines life—indeed, it becomes a danger to our loved ones, to our friends, to the circumstances that we all mistake for our wishes. This is not the act of imagination that inspires Vronsky. He momentarily achieves a state of imaginative receptiveness—and for a good reason is this moment one of love because love is our sensitive tuning to the whisper of reality. Imagination is gentleness—otherwise it defaces, caricatures, and fantasizes. Indeed, Vronsky's moment of imaginative reception carries him into moral grace. Tolstoy exhibits the moral practice that is artistic description: not merely to copy the facts but to sense beyond the surface display; to trace the detail all the way to its conscious source; indeed, to give up objective description and practice sympathetic subscription. Vronsky *subscribes* to Anna's presence: he devotes his imaginary powers to enhancing her reality. This, one may say, is the moral

1. L. Tolstoy, *Anna Karenin*, trans. Rosemary Edmonds (New York: Penguin Books, 1954), 75.

practice of the artistic imagination. Let us call the source of this realization the moral light. And if morality thus stems from a deep mindfulness for what does not obviously meet the eye, then indeed art is of a piece with moral intelligence.[2]

<center>છ૭</center>

At its outermost reach, imagination must admit defeat. Imagination is the courage to venture beyond the mind's horizon. In the end, imagination leads to a place quite outside the mind—a place where not fancy, but *necessity* holds sway. Imagination at its crudest or most infantile is a denial of necessity (Peter Pan flaunts gravity, as do teacups and saucers, and rabbits spring out of hats). At its most mature, on the other hand, imagination reckons with the intractableness of reality. In the painter Piet Mondrian's words, "It is . . . wrong to think that the . . . artist creates through pre-intention. . . . That which is regarded as a system is nothing but constant obedience to the laws of pure plastics, to necessity, which art demands from him" (*AA*, 429). By "pre-intention" Mondrian means imaginative formal free-play. And he contends that this so-called creative license, this freewheeling subjectivity has nothing to do with art. Instead, art is encounter with *necessity*. The artistic method is dutifully empirical. It is imagination curbed by matter. "There is something in painting that cannot be explained," Pierre-Auguste Renoir said, "and that something is essential. You come to nature with your theories and she knocks them flat" (*AA*, 322). The making of art is no magic trick. The Greeks were right to call it *techné*, a word that savors of the workshop, discipline and apprenticeship. An artwork has laws of composition that bear on the artist no less stringently than the laws of physics weigh on the human body. These laws are not external to the particular work of art—in the way that driving laws precede and are independent of my driving to the grocery store. Henri-Georges Clouzot's movie *The Mystery of Picasso* documents the selfsame

2. "The practice of any art," Iris Murdoch explains, "is, of course, a moral discipline in that it involves a struggle against fantasy, against self-indulgence"; see I. Murdoch, *Existentialists and Mystics*, 255. This idea is developed also in her book *The Sovereignty of Good*. It is supported too by Martha Naussbaum in *Love's Knowledge: Essays on Philosophy and Literature* (New York: Oxford University Press, 1992). And it finds confirmation with the doyen of art historical studies himself, E. Gombrich, in *Meditations on a Hobby Horse* (New York: Phaidon, 1963), 26: "We are led to the conclusion that once more it is the submission of the part to the whole, the element of control, of bridled emotion rather than of disconnected symptoms, that is responsible for this intuition of 'honesty,' and that may make art analogous to a moral experience."

painter at work. The film shows that once the initial brush strokes are laid down, the painter seems to *obey* the painting. He is in dialogue with what happens on the canvas. Perhaps it is only when they are completed that works of art display an air of magesterial authority. As artists keep saying, however, making an artwork involves tireless negotiation with laws that, though invisible to the spectator, absolutely compel the artist's hand and mind. Watch how Picasso tests his way through the painting, chancing a line here and taking it back, adding and erasing, always trying out and submitting new designs and shapes that offset the composition elsewhere, throw the painting off until, steadying itself, it asks the painter to rectify here and modify there, smooth off a line or tone down a shade that ripples through the entire harmonic scale of the canvas. The painting has a life of its own, rules of growth and composition to which the artist is a watchful servant. He cannot do just as he pleases. Instead, he parleys with facts, the way a structural engineer negotiates with the unyielding reality of steel and mortar and the laws of physics. The difference is that, unlike the laws of science or architecture or engineering, the laws to which the artist is beholden emerge from the work of art and do not precede it. But this in fact makes them all the more imperious. Because, while a scientist knows beforehand what laws he must propitiate, the artist improvises and bargains with rules arising on the spot. This is another reason why his method, if there be one, is truly empirical—empirical to the point of emptying the artist's store of theoretical wisdom and trade knowledge. His is not a labor of expressive soliloquy but one of attentive dialogue. And when, as at the end of *The Mystery of Picasso*, a particular painting proves resistant, refuses to obey, chastens the artist's imagination, then Picasso lays down his brush and says simply "It's not working." He is no less the reject of objective forces than a technician stymied by facts.

Artists like Picasso, the critic Clement Greenberg avers, discovered "the nature of the picture plane . . . in its inviolable quality as a material object."[3] This materiality of canvas and paint became an analogy of nature. Traditionally nature in art was understood as either an object to be copied or a style, that is, a natural effortless manner of expression. So-called abstract art discovers nature in the materialness of the artistic object itself. The painting possesses a reality

3. C. Greenberg, "The Role of Nature in Modern Painting," in *The Collected Essays and Criticism*, vol. 2, ed. John O'Brian (Chicago: University of Chicago Press, 1995).

to reckon with no less observantly than the Renaissance masters of imitation watched the shape and color of objects. Why this acknowledgment of the materialness of the object? What is in fact the payoff for the artist to limit his own expressive potential by butting against this "nature"? Why approach matter with such pious regard?

Can the artist not do as he pleases? In an obvious sense, he can. Nothing stands in the way of saying and bringing absolutely anything into shape. But this would betray the spirit. What sets apart the first rate from the second rate in art is not the degree of skill, the technical mastery, or the choice of subject but the spirit in which the work is carried out. A work of art executed with arrogance, contempt, or neglect toward the piece itself is inconceivable. A work of art soars in proportion to how deeply the artist acknowledges its reality. But isn't this reality a projection of the artist's own difficulties rather than an actually existing object? After all, the artist contends with nothing other than his own inspiration and activity, hence his own artistic limitation. He creates his own difficulties. In a shallow sense, this is correct. The canvas, the paint, the oil, the marble, the notes—they are intractable only so far as the artist intends to do something with them. But this does not really capture the matter. Try telling Picasso as he lays down his brush and groans "It's not working"—try telling him that the dead end he is up against is only a psychic projection and that an act of will, a muscular surge of self-control, will enable him to break through. This would not help one jot. In fact, asking the artist to take control of the work and subjugate it is like asking him to stop making art. For artistic work is undertaken in a spirit of response and participation. It is a silly romantic idea that supposes artworks to be outpourings of creative energy, Rorschach blots of psychic explosions and unfettered expression. The image of the expressionist or abstract expressionist genius giving free form to his inner vision is only an image. In reality, expressionism is less the celebration of unhindered expressiveness than the realization of our subjective confinement. Here such artists as Munch, Schiele, or Nolde come to mind. Their works show that expressionism is not about reveling in the powers of expression but about recording the anguish of being trapped in them, unable to push through. The subjective life pictured by such expressionists is no occasion for Nietzschean cheers of self-assertion; instead it is a subjective life hemmed in and assailed by the pressure of matter. These artists were not giving free rein to their imagination; they recorded how imagination is bound by matter. Admit-

tedly, second-generation expressionists, especially American abstract expressionists, cast off this middle-European pall of solipsism. The American soul is expansive even when it meditates before walls (e.g., Rothko). But expansive or expressive though he may be, the abstract expressionist is no freewheeling wunderkind. Pollock at work, for instance, hardly seems a mastermind flinging paint whichever way genius tells him. On the contrary, he heeds dutifully a law of construction comparable to the laws of rhyme and meter in poetry. On this topic, Pollock talked about a process of "give and take" between himself and the painting.[4] There too is a labor of listening, as in a musical composition, the "logic" of growth native to the artwork.

Matter invites subjectivity as much as it opposes it. Faced with the reticence of matter, some artists respond with excitement—as though being stymied set a test of realness, of touching the very skin of things. "Even if you can't do [things] well, there is something terrific about the tenacity of the form that won't allow you to do it" (painter Franz Kline).[5] Other artists have contended with this same reticence by embracing a kind of mystical sacrifice. This is the case of primitivist or brutalist modern art. Blocks, raw materials, unmodified shapes, and natural objects, all the starkness and geometry of modern art, speak of a wish to melt back into nature, mute stuff, the self-repose and quietness of matter. "The rectangular picture-plane indicates the starting point of suprematism. . . . The forms of suprematist art live like all the living forms of nature. This is a new plastic realism" (Kasimir Malevich; *AA*, 452). A work of art need not be imitative of nature to be like nature. An ascetic drive, a self-punishing streak, in the modern artist leads him to embrace the concreteness of matter that had traditionally been expression's foil. Pygmalion gives up trying to breathe life into the stone; instead, he yearns to live the very life of stone.

This seems to open a new episode in the history of art's longing relationship with nature. But art's wish to fall silent is in actuality a pursuit older than the demonstrations of modern art.

4. P. Karmel, ed., *Jackson Pollock: Interviews, Articles, and Reviews* (New York: Museum of Modern Art, 1999), 18.

5. In D. Sylvester, *Interviews with American Artists* (New Haven, Conn.: Yale University Press, 2001), 65.

Art and Nature

LET US IMAGINE IF WE CAN—we cannot—a world seen from no particular viewpoint, with no particular affect or feeling or care to guide our attention, and no thought or concept to identify the trees in the valley, the nameless fish in the sea, the stars in the sky. To picture such a state of things certainly requires a vigorous jolt of imagination because we ask imagination to put itself out of commission. This is no easy feat. Yet such is a twist of human intelligence that it cannot help contemplating what life is like when no human being beholds it. To this kink of the psyche we owe the concept of nature—not nature herself of course, but the idea that, above and beyond our mental radar, it pristinely *is*, or, to put it otherwise, that there is a way it exists apart from our apprehending it. This will be the root meaning of "nature" in the following discussion. From this core sense arise the more familiar meanings of "nature": the stoic repose, serenity, self-evidence, and self-sufficiency of, for example, forests, rivers, oceans, cloudscapes, and stars—reserves of calm in the background of our civilized antics.

Now whether this idea comes down to us from the primitive religions of earth and sky or from certain parables about a primeval garden once our honeyed dwelling but now irretrievably lost, it is safe to suggest that it has fallen on hard times recently. Reason has shouldered out the sky-fearing, world-centered cosmology of yore and put a human-centered one in its stead, a long process described above as the rise and triumph of the religion of self.

My aim at present is to illustrate the thesis that, first, alongside this humanization of the cosmos, there runs a streak of the old world-oriented disposition; and second, that this streak has taken refuge not just in the churches, as might be expected, but at the heart of secular culture, in art.

Nature is a word that encapsulates our sundry intuitions that the world is one, above and beyond the chaos that meets the eye. It is said to inspire awe: it is infinite and not of our making. Instead we are its dependents: our bodies are made of nature and hang on nature for their survival. It is thus normal to fear nature because it is our master, a force and condition mightier than us. To domesticate nature, we can of course make bows and arrows, build dams, split the atom. But these are attempts at controlling *parts* of nature. So, is there a more general way in which we can deal with our awe for nature, a way that seeks less to act on or to cure the awe but, as it were, to acknowledge it? Art primitively answered this need. Paleolithic cave paintings brought the moving forms of the fields and forests into the hearth. Nature was stilled. No longer was it the thunder that roared or the rain that flooded or the sun that parched; it was an image, an altar, a window onto the world where previously there had been rock. Nature was transfigured; indeed, it became a thing, and we imagine the ancient troglodytes huddled around the rock and marveling at the mind's ability to hold things in thrall, to stop the world. There is jubilation in this, but also gratitude. The drawings at Altamira or Lascaux bespeak not only the wish to encompass the living but also to do it *well*, with patient, delicate attention. To lay hold of, for sure, but also to describe and, in so doing, to turn the attention entirely to the bison, deer, wild boars, or horses of the earth. To revel in restating the obvious and raise it to light: that a bison exists as this form precisely, that a horse should appear as it does. Beings and things gain infinitely from the tautology of marking their existence. Art has the lightest touch. It says "This exists" with a smile of acceptance, of refined awe: no longer the awe that is fear but the awe of admiration. The difference between fear and admiration is that between rejection and acceptance. Nature is no less mighty to the fearful and the admiring. The difference is that the former runs away from the greatness of nature (and there is no greater absurdity than to run away from nature), while the latter admits to and cultivates this same awesome mightiness.

Art is a wish to give unto the world what belongs to the world, to take it as it is, to dim the human glare. Hence the reason why artists and thinkers of all historical ages, persuasions, temperaments, styles—whether classical, roman-

tic, realistic or expressionist, impressionist or cubist, figurative or abstract—why, then, artists and aestheticians of every hue and stripe have pointed to nature as both the source and the destination of art. "It is not the language of painters but the language of nature which one should listen to.... The feeling for things themselves, for reality, is more important than the feeling for pictures" (Van Gogh).[1] Nature is art's magnetic pole. Discussions always turn back to it.

Nature is art's corrective, its chiding voice. It is the reminder that, however skillful, a work of art is always too skillful, too contrived, too drenched in human intention. Anything that is intentional or expressive admits to lacking something, a destination, a recipient. Hence anything that is expressed or intended (i.e., anything human-made) can never be fully authoritative. Only what seeks or strives for nothing is authoritative. And that is why only nature has authority. A mountain, an ocean, or a blade of grass wait on no validation. They are calm self-sufficience. Nature is a form of life that exists without having to express itself; it is existence without demonstration, appearance without strain. Nature is the opposite of art, wherein everything appears for show and expression. Nature is therefore art's longing for existence. It is probably the only destination truly fascinating to art, precisely because nothing is so distant from art than nature. Nature's self-contained peace, its existence without intention—that is what art covets. An artist seeks to render in language what nature needs no language to express. This is the passionate paradox that goads and torments the artist.

There are objections to the idea that art courts nature. For one thing, nature is a ragbag. What informative value can the word "nature" carry when in fact artists as dissimilar as da Vinci, Van Gogh, Michelangelo, Cellini, Cézanne, Rodin, Pollock, Ingres, Marc, Poussin, Rothko, Alberti, Hopper, Corot, and Klee (a representative, not an exhaustive, congress) individually swear by it? Indeed, there is a sense in which Plato says that art imitates nature that is *not* the way Aristotle or Alberti mean it. Plato meant his remark as a slight on art whereas Aristotle intended his to be laudatory. So what can a catch-all term like "nature" mean given the myriad contexts and idioms in which it appears and is expressed? Does this variety not give reason to the social critic who holds "nature" to point not to a transhistorical stable and objective order, but

1. V. Van Gogh, *The Letters of Vincent Van Gogh*, ed. Ronald de Leeuw, trans. Arnold Pomerans (New York: Penguin Books, 1996), 21 July 1882.

to the multitudinous styles and fashions in which whatever is "natural" has struck various people under various climes?

Given that both Poussin and Pollock claim to emulate and work after nature, it is difficult to gainsay the normative definition of the word *nature*. On such definition, nature in art (but this also extends to nature in science, anthropology, legal affairs, etc.) is only what we mean by it; it exists nowhere outside our individually creative perceptions, and, come to think of it, probably has no permanent features of its own apart from our ingenious ways of interpreting it. My suspicion is that this normative definition is correct within a narrow understanding of art. Outside this gauge, I offer to argue, there is a way in which "nature" in fact can be said to describe a common experience—a way in which, say, both Poussin and Pollock mean "nature" in the same way.

The constructivist idea that "nature" is a rhetorical byword, not an objective landmark, stems from the notion that art imitates reality. On the evidence that Poussin's image of reality looks nothing like Pollock's, the art historian feels justified declaring that nature exists nowhere apart from the beholder. We see but appearances and, because art traffics in appearances, it is heir to all the psychologically induced errors of human perception. So, at least, ran Plato's theory of art in *The Republic*. It argues that art is an imitation of things and therefore secondhand, a step down from reality, a corruption of the original. Since corruption is by definition wayward, it also comes in many forms, which accounts for the stylistic pandemonium we know art to be.

The other ancestor to the normative understanding of "nature" in art is idealist philosophy and German romanticism in particular. Kant cranked idealism into a heroic mode with his idea of the "In-Itself" or "noumenon"—that is, the idea that we are sealed off from nature, which our mind is too contrived or feeble or hidebound or aprioristic to ever glimpse. This idea occasioned two sets of response: one, exhibited in the romantic poetry of Wordsworth, Coleridge, Vigny, or Lamartine, was the postlapsarian feeling that man was cast off and adrift in the world, having lost the primal connection with being, the erstwhile "splendor in the grass and glory in the flower." The second response was less disconsolate and simply averred that, since nature in itself is out of reach, since we only ever touch but a reconstruction of it, then it behooves us to shape, twist, and invent it in as many fantastic and freewheeling ways as possible. Combined with a new taste for freedom, a positive spirit of triumphing over the boundaries of matter, the second attitude gave rise to a

voluntaristic brand of aesthetic philosophy which, in Kant, Schiller, Schelling, or Hegel, suggested that art was only superficially imitative but actually inventive through and through. In their views, nature was raw material for our demiurgic consciousness to transfigure with a view to enjoying our spiritual freedom. This is the aspect in which modern art criticism is vestigially romantic: in its denial of a nonsubjective nature and its insistence that art forms are systems of conventions that transform, read, interpret, screen, and codify a natural given unyieldingly out of our cognitive reach and accordingly left out of the picture.

In essence, romanticism suggested that art was free to wander as far away from nature as it pleased because, as Plato had said, all imitation was second-rate anyway. Note that, however rebellious, this new disposition still leaned on the old conventional notion that the link between art and nature was one of mimetic affinity, that is, that art imitates the aspect, look, feel, or sound of nature.

Schopenhauer, and Schlegel before him, was the first thinker in modern times finally to dust up the old link between art and nature. Schopenhauer saw that the bond between art and nature was less imitation than fusion, that there was actually no bond to speak of but a great welter of forces in which the artist is irrepressibly sunk. The Schopenhauerian archetype here was music which, free of mimicry, tapped directly into the energy, or movement, or "will" of nature itself—giving, as it were, an aural picture of the cosmic whirl. This was an interesting new understanding, and certainly provided relief from the old duality between self and world that gripped the mimetic theory of art. In reality, the Schopenhaurian idea dates back to Aristotle. "*He téchne mimeîtai tén physin,*" goes the famous sentence in *The Physics*, "Art imitates nature." In context, this meant to suggest not that art imitated the aspect of nature, but that both shared the same process.[2] Artistic activity follows the ripening whereby all things in nature aspire to their fullest growth. Just as a tree strives to grow into the consummate form of a tree, just as it becomes all that it *must* become, so a work of art seeks fruition and fulfillment. The idea also became Aquinas's: "Art imitates nature.... All nature is diverted to an end, and a work of nature has the character of a work of intelligence: it moves to its certain goal by determinate methods. Thus art imitates nature in its ac-

2. Aristotle, *Physics*, trans. Robin Waterfield (New York: Oxford University Press, 1999), 199a 2–19.

tivity."[3] Naturally, this vision was underwritten by a firm creationist outlook. To the Scholastics, it was indubitable that nature evinced divine intelligence, that it was a work of order, craft, and forethought. Seeking perfection and order in his own work, striving for the sort of harmony and exquisite fullness displayed in the God-made world, the artist thus emulated the divine hand. And this clearly is not what later romantics à la Schopenhauer or Nietzsche had in mind. Imitating the *movement* of nature was admittedly the gist of art; but to them nature was no proportioned order but a roiling torrent that swept and surged and raged through all things. The aim of art was to open consciousness up to this unbridled power. At worst, it consisted in letting oneself become as disheveled, feral, and irrepressible as nature itself; at best, it consisted in emulating some of nature's generosity, vitality, and lack of self-consciousness. This is probably the way in which a latter-day romantic like Pollock understood his kinship with nature. "I am nature" he says; "my concern is with the rhythms of nature . . . the way the ocean moves. . . . I work from the inside out, like nature."[4] Here again is the idea of tapping the flow of nature, of moving as freely as the sea, or a storm, or the seasons.

Clearly our problem is not one of deciding whether artistic imitation copies natural *forms* or the vital *process*. Both are verifiably true. A great deal of art, at any rate before the modern period, reproduces the aspect of scenes, places, objects, and beings found in waking life; and an artist copies the generative flow of life if only by sowing forms and phenomena where previously there were none. As the artist Poussin puts it, "[A]rt is not a different thing from nature, nor can it pass beyond nature's boundaries" (*AA*, 154). Art has both mimetic *and* embryonic affinities with nature. Whereas cognition abstracts from nature, art draws from nature's models but also uses its materials, pigments, and sounds, and expresses thoughts by making them tangible, indeed casting them back into the world of things from which the intellect lifted them. Da Vinci puts the idea thus: "Painting is born of nature; . . . all visible things have been brought forth by nature and it is among these that painting is born."[5] What else can art be born of if not reality? From where else does it draw its material?

3. Aquinas, *Commentary on Aristotle's Physics*, trans. Richard J. Blackwell (Dumb Ox Books, 1999), 2.4.6.

4. In B. H. Friedman, *Jackson Pollack: Energy Made Visible* (New York: McGraw-Hill, 1974), 228.

5. Leonardo da Vinci, *Leonardo on Painting*, ed. Martin Kemp (New Haven, Conn.: Yale Nota Bene, Yale University Press, 1989), 13.

However far-flung art's flights of fancy be, they dwell in matter, sense percep-
tions, the bodied forms that make up what exists. And great art, so these paint-
ers and theorists seem to suggest, never loses sight of this origin.

By means of art, we palliate our human alienation from nature. For although
wrought by human ingenuity, art aspires to the simplicity, self-evidence, uncon-
trived harmony, and plain thereness of natural landscapes. A great work of art,
Kant argued, does not seem to have been made.[6] "A picture is finished when
all trace of the means used to bring about the end has disappeared" (Whistler;
AA, 350). Its every element falls into place where it *must*. To the effect that no
human hand seems to have interfered with the process. There human agency
seems absolved of the sin of separation, of consciousness lording it over mat-
ter, of the evidence that even our most sensitive dealings with nature are never
quite free of coercion, of meddling, of forcing things to march to our tune.
Of course, it is fair to point out that this stain of separation did not seem so
damning when, prior to the modern age, societies still lived under the whim
of storms, droughts, and plagues. Art became a paean to nature after science
and technology tamed its fits and furies. Only then could we afford to feel
tenderly toward it.

Still, there is more to the kinship between art and nature than our uneasy
conscience about railroads, bulldozers, and smokestacks marring the land-
scapes. Long before the Industrial Revolution, indeed, long before science
trapped it in a box, nature already held a magnetic attraction for artists: not
as a reserve of subjects and forms but as a manner, a likeminded disposition,
a spiritual guide of sorts. "Painting is the offspring of nature," da Vinci says
(*AA*, 48). Similar statements are legion in the artistic Quattrocento, in Alber-
ti, Cennini, and Vasari, for instance. They are often understood to be caveats
against painterly affectation, against Scholastic mannerism, against allegory,
against stylistic inbreeding, indeed, against tradition. Nature to the Renais-
sance offered escape from the musty medievalism of illuminatorists who, like
our postmodern Schoolmen, were under the thrall of the history of art rather
than the evidence of their senses. By drawing attention to facts as they appear,
and less as they are transmitted, the Renaissance artist uncovered a brand-new
realm of experience, an untapped frontier of life, an Eldorado of enjoyment
and fascination: his own eyes.

<div align="center">❧</div>

6. I. Kant, *Critique of Judgment*.

Rightly is Alberti's *Della pittura* a watershed in Western aesthetics. It reminded artists to paint not with their knowledge of art, but after their own perception. See for yourself, not with your artistic prejudices; mark what is around you; learn to notice how the arm muscle ripples below the skin, how a foot falls, the equipoise of a hand forked over the hip. Alberti sought to call the attention outward to what exists, the tangible. He urged the painter to face the light of day.

The turn to nature thus emphasized perception. The Renaissance of course witnessed the rise of the empirical method in science, of optical science, and of perspective in representation. The overriding assumption was that nature is best known via the bridge that she and we have in common, that is, corporeal life. Take, for instance, paintings from before and after the advent of perspective. In the former, the relationship between objects was depicted not as it appeared, but as it ought to appear should reality conform to our hierarchy of values. In the latter, paintings imitate what the eye sees, and less what it thinks. Renaissance man accepted a far more embodied notion of reality—or at any rate an experience of reality in which the trip between *A* and *B* travels through measurable space, not through the ether of wishful thinking. And this is how painters began to trust their own eyes and in time to fall in love with perception. Alberti started a revolution when he said: "[T]he painter has nothing to do with things that are not visible. The painter is concerned solely with representing what can be seen."[7] Not how things should be but how they actually are is the artist's business. Love of perception, the passion for "things that are visible," is a plea for man to dwell in his body once more and yield to phenomena—indeed, to *superficialize* experience, to lift the mind up to the shivering surface where it touches the tangible.

Of course, Alberti also advocates time-tempered technique. But technique, so *Della pittura* insists, is not an end in itself; it is a device to free the mind from rambling. Technique allows the painter to trust his senses and be bold—in the way a seasoned acrobat lunges above the abyss. Sight of course benefited from this reorientation. All ancient natural philosophers from Plato onward agreed that the eye was man's noblest organ and vision the gateway to truth.[8] The praise, however, carried intellectual bias. Vision was deemed the highest

7. Alberti, *On Painting*, trans. John R. Spencer (New Haven, Conn.: Yale University Press, 1956), 43.

8. D. Lindberg, *Theories of Vision from Al-Kindi to Kepler* (Chicago: University of Chicago Press, 1976).

sense because it was most mindlike. It surveys, scans, analyses, and quite literally puts things in perspective. But a more sensualist overtone crept in with the Renaissance. The eye is not just the choice tool for conceptualizing; it is more than the shopworn "window of the soul," more than the mind's factotum. It gains a dignity of its own—a dignity derived from its sensual proximity to nature. Of course vision is, of all the senses, the most abstract and distancing. It allows us to reach objects without being reached in turn. But the eye also combats the inward recoil of mind and gives us the gift of this-worldliness, of reality's glory. Witness da Vinci:

The eye, in which the beauty of the world is mirrored for spectators, is of such excellence that whoever consents to its loss deprives himself of access to all the works of nature, the sight of which reconciles the soul to living in its body's prison, thanks to the eyes which show him the finite variety of creation: whoever loses them abandons his soul in a dark prison. (*LP*, 21)

Note how the eye here is not, as in the intellectualist construct, a means to map out the visible; it is an escape from the inner dungeon, solipsism, mindful things. The eye conveys the ever fresh realization that the world exists and that it is flesh. Nothing like vision gives us confirmation of external existence. Hearing somehow turns us inward, for sounds are, as it were, heard inside our head; taste and smell involve inner organs, and a lot of touching is really flinching—a reminder of our bodily sheath. Vision, on the other hand, pulls us outward. It carries beyond the corporeal shell. Smells and sounds come to us, whereas we experience vision as traveling toward the object. Erroneous though this may be from a scientific standpoint, the falsehood carries great psychological wisdom. The eyes open to the outside. They are messengers of reality. We believe when we see. We fall in love at first sight. The scales fall from our eyes when we glimpse the truth. There is a reason why smell or sound does not really show up in the phraseology of truth and revelation and reality.

The Renaissance artist expressed gratitude to the eye and sang its praises (Petrarch, Ronsard, Michelangelo) at a time when, historically, science and philosophy shed doctrine and embraced the empirical method, when, that is, knowledge by observation started trumping knowledge by conviction.

Of course, the intellectualist claim over vision never really went away. For every artist who celebrates the sensualist pleasures of vision, a rationalist comes along to lionize the eye's sun-like remoteness. The intellectual history of

perspective is, in this respect, a telling dramatization of the division between the celestial and the terrestrial, between the advocates of mind who, like Descartes, held the eye to be ultimately subordinate to the mind, and the empiricists who held the eye's virtue to transmit reality as it is.[9] On the first construal, perspective is an abstract arrangement; on the second, it is acknowledgment of the depth and distance and openness of reality. Opposite as they may be— one viewing perspective as a means of escape from embodied reality, the other as a way of renewing our bond to it—these interpretations at least concur on the one idea that perspective was nourished by a new spirit of visual awareness and of tuning consciousness to the fact of reality. To a personality like da Vinci, nonperspectival painting exposed contempt for life, a kind of stubborn self-absorption that smacked of Scholasticism. Perspective signaled the intrusion of scientific rationality into painting but, so the general feeling went, the better to honor our connection to the real.

The Renaissance gave Western culture a hunger for the sight, touch, and taste of concrete life. It was then that painting began to be talked about as the queen of all arts, toppling poetry at the top of the classical pantheon and, by the same token, overthrowing the Aristotelian nomenclature that favored the general, the linguistic, and the abstract over the particular and the contingent. In fact, even when painting, and then modernist art at large, broke with representation, it never quite turned its back on the grit and gleam of reality. Only the object of reality traveled from the thing to be copied to the canvas and material aspects of the medium itself. The reality coveted by the wrongly called abstractionists was in fact the physical reality of the work.

"The only thing is to see," Rodin said. "The artist has only to trust his eyes" (*AA*, 325). Trust your eyes: this means let them do the seeing for you; see as freely and unguardedly as possible; do not force your gaze, do not imagine; move in time with the accidents of form, bear witness to what is there. Vision is the gift of outsideness. So philosopher Merleau-Ponty passionately argued: "Seeing is not a mode of thought or presence to self; it is the means given me for being absent from myself, for being present from within at the fission of

9. On the rich topic of perspective, see M. Kubovy, *The Psychology of Perspective and Renaissance Art* (Cambridge, U.K.: Cambridge University Press, 1980); L. Wright, *Perspective in Perspective* (London: Routledge & Kegan Paul, 1983); H. Damisch, *The Origin of Perspective* (Cambridge, Mass.: MIT Press, 1994); and K. Harries, "Descartes, Perspective and the Angelic Eye," *Yale French Studies* 49 (1973): 28–42.

Being only at the end of which do I close up into myself."[10] The sentence is less crystalline than the epiphany it describes, but essentially says this: that perception, and seeing in particular, throws the self open to reality; it breaks up the inner monologue, calls us back to facts, pitches us into the world. To see is to be penetrated by the seen. Lovers have long since known it, but now science proves it true. Light photons flying toward us penetrate the optic nerve where, deep in the brain, chemical emulsion transforms them into neurons, thoughts, visions. The things we see live in us: it is their very particles that glow in the visual cortex. Look at infants and young children. Their aptitude for fascination is boundless; they *are* the things they see. In certain psychotropic states, Aldous Huxley writes, "the eye recovers some of the perceptual innocence of childhood, when the sensum was not immediately and automatically subordinated to the concept."[11] Artistic seeing reaches for this contemplative fusion of subject and object, for the profound sympathy between self and world. At some deep level, the artist trusts his eyes, listens to their wisdom, believes in a primeval kinship between the seeing and the seen. Psychological science may tell us that an object's appearance is dependent on the viewer's neurological makeup (e.g., the blue of the sky is so because chemical reactions in my brain say "blue," not because the sky is intrinsically blue); but to the artist it does not seem so. To him the color of things is a gift from the world, a wealth that no imagination could have dreamed up. Van Gogh's letters contain lovingly detailed descriptions of landscape, testifying to his being a great observer even before he became a great painter, to his consuming desire to paint it like it is. If only, he repeats, I could near this splendor, this gleam; if only I could dip my brush in the grey-green hue of this hedgerow, the clarion splash of summer wheat, the opal of a twilit meadow. "It is of the utmost importance to immerse oneself in reality, without any preconceived ideas, without any Parisian prejudice. . . . My ambition reaches no further than a few clods of earth, sprouting wheat, an olive grove, a cypress."[12] Though impossible to achieve, this lack of perceptual guile is nevertheless the demanding direction of art, a passion for openness, for what is. The painter Jasper Johns remarked: "I'm not interested in any particular mood. Mentally my preferences would be the mood of keep-

10. M. Merleau-Ponty, "Eye and Mind," in *The Merleau-Ponty Esthetics Reader*, ed. Galen A. Johnson (Evanston, Ill.: Northwestern University Press, 1993), 146.

11. A. Huxley, *The Doors of Perception* (New York: Harper & Row, 1954), 25.

12. V. Van Gogh, *The Letters*, 20 November 1889.

ing your eyes open and looking, without any focusing, without any constitut-
ed viewpoint."[13] Love of perception means practicing mental availability, si-
lencing the mind, letting phenomena arise. A poem, Paul Valéry says, is a child
of my silence. It is the fruit of a complete, expectant, religious availability.

Again, this turn to perception is really first heard in the Quattrocentro.
It rode the wave of naturalism in intellectual affairs, was congruent with the
rise of empirical method in scientific knowledge, with experimentation, with
the "Let's see what works" attitude that inspires Machiavelli's ruler or Francis
Bacon's man of learning. The artist, however, aims to take the process of natu-
ralization a length further than the scientist. There is a deeper way in which
nature penetrates the mind—further reaches to which the artist pursues the
love of perception: not in *what* to look at, but in *how* to look at it. And this is
for the artist to explore. Alberti's or da Vinci's or Cellini's model artist pays at-
tention to nature so that a little of nature seeps into the act of attention itself.
An easy manner, a fluent style, a *natural* hand—these are so many phrases to
signify that nature herself teaches us how to see her. Seeing naturally is unlike
our normal subject-centered purposeful way of being on the lookout. The art-
ist sees not aggressively, with an eye to rob nature of its mysteries, as the scien-
tist might do; nor does he scan with an eye prospecting for exploitation and
profit, as the merchant might do. The artist sees for the sake of seeing—to per-
ceive what is there in as quiet and limpid a light as possible. In art, perception
of nature is akin to meditation. The goal is to strip seeing of the intention to
see so that only seeing remains. Thus Cézanne: "What I am trying to explain
is more mysterious. It's tangled up in the very roots of existence, in the intan-
gible source of our sensations. . . . Color is the place where our brain meets the
universe."[14] Cézanne's idea of perception is sacramental. Perception is a wave
of being. Like religious feeling, cultivating perception strives to erase the sin of
separation. By bringing the whole of mental activity to the outer edge of per-
ception, at the threshold where perceiving makes contact with the world, the
artist no less than the saint allays the pain of existential isolation.

Of course, aesthetic theorists since Schelling have always said as much. Art
brings us in touch with sensate existence. Wishing to break us free from the
jail of nerdy studiousness, ratiocination, history, the written word, Nietzsche
offered to *aestheticize* nineteenth-century man—that is, to superficialize the

13. In D. Sylvester, *Interviews*, 165.
14. M. Doran, ed., *Conversations with Cézanne*, 113.

human animal once more. Return to the senses, surrender to impulse, laughter, shouting, visceral expression—these were the practical features of this organicist revolution. Let us be savages, he proposed; or, as Dewey added, let us be athletes, gymnasts, afficionados of the body. In the air was a thaw of the great Victorian freeze. And art lent a hand. It is then, in the second half of the nineteenth century, that artists marched out of the studio and planted their easels in the countryside, amid actual trees and meadows and under a real sky. Impressionism was a vitalist movement born of vaguely scientific ideas about optics and physical aesthetics. It called the painter back to his retina and aspired to let the physics of perception do the work. This return to the soma formalized an impulse as old as art. Take, for instance, the ancient story of Zeuxis, whose fame extends from Pliny to the Renaissance. The painter Zeuxis completed a picture of grapes so realistical that birds flew down to peck them. Now, this fable is often taken to laud the skill of verisimilitude. But does it not also praise the painter's natural perception? For, to fool the birds, Zeuxis had to see the way they do, to simplify and denude his vision of mental assumptions. His was an exercise in natural seeing, that is, an exercise in spiritual affinity. To see her as she sees herself; to behold as nakedly as the human eye can; to let perception overwhelm what the mind knows—these perhaps are the ascetic exercises of spiritual sympathy by which love of perception is borne to fruition.

<p style="text-align:center">❦</p>

Nature in the phraseology of the Renaissance and the Enlightenment in fact served as a byword for this self-overcoming. It was the term used to defend the virtue of a clear unaffected eye over the painterly tricks of the trade, shopworn reflexes, a vision obstructed by other paintings. Of course, the classical artist was tradition-bound through and through, a product of apprenticeship at schools and ateliers. Nevertheless, he sensed the blessing of technical naiveté, of wandering off the trodden ways. In a society that breathed tradition, the artist could not afford to launch an all-out assault on the old. This is how "nature" came to the rescue, indeed working the same sort of revolution in the arts that the Reformation had performed in religion. To elect nature as mentor, as the tuning fork of art, was a way of bypassing clergy-bound artistic conventions. To honor the work of God, better it was to look right at His works rather than to interpose the mannered, illuministic rhetoric of medieval masters (in a like manner the Reformation made God accessible to

the private individual without the opulent go-between of Mass). To be "the offspring of nature," da Vinci says, "I tell painters never to imitate other painters' manners because by doing so they will be called grandsons, and not sons of nature" (*AA*, 50). Of course no artist, even those most besotted by the idea of self-invention, can afford to totally disregard his predecessors. But no artist worth the name can merely tread the beaten path either. Here we touch upon the confusing evidence that even the most innovative, trailblazing artists are also immensely perceptive and knowing readers of past artists. Why must the artist know his classics if the goal is not to be like them? Because, quite simply, the classics teach him how to break free of trade and affectation. The artist indeed must "never imitate other painters' manners," lest the result be stale and slavish. But he must admire what is inimitable in them. Perhaps an artist looks at artworks in the same way he looks at nature. Not, of course, that the artist confuses what is human-made and what is not. In both, however, he perceives that poise of uncontrived, unafraid, generous necessity. A great work of art simply is. It has the serene self-evidence, the unprepossessing thereness, of a natural fact. It is naïve. And it is so because it does not hold nature as an object to be copied but as *a state of being* to work into. Nature does not imitate itself: a tree does not say "I want to resemble a tree" even though it looks like a tree. It comes to be itself by venture and obedience, by calmness and submission. The tree does not *intend* to be a tree. But to be a tree assumes the existence of some affirmation in every tree—a will to be rather than not be. Thus nature is active and it is passive. See how a tree grows, its every shoot and twig and leaf twisting toward the light, life coiling, reaching and struggling through every sinew, roots spreading out far and wide into the earth. There is invention and resourcefulness in the myriad ways a tree will grow to reach maximum nourishment from the earth and the sun. Yet this creativity is uncontrived. This double state of creation and equanimity is just what the artist admires. It is the state where he, the creator, master of his domain, nevertheless *has no choice*—in just the same way in which the tree grows from striving and obedience, so the verse or the painted stroke or the musical phrase should come. The artist does not imitate nature; the artist wants to create as nature creates. This is the spirit of naiveté and trust, the balance of creation and abnegation that artists have been chasing in the grail of "nature" or "the natural style" or "natural grace."

My suggestion, then, is that an artist is knowledgeable in the artistic tradi-

tion in the same sense he has learned how to look at nature. He does not wish to imitate the old masterpieces because what is admirable in them is in fact their self-repose, their inimitable way of being naïve. Paradoxically, he goes to the museum to unlearn art, to learn to be simple, silent, open-eyed.

"Nature," Cézanne says,

> doesn't waver; it passes neither too high nor too low. It is true, it is dense, it is full. . . . But if I have the least distraction, the slightest lapse, if I interpret too much one day, if today I get carried away with a theory that contradicts yesterday's, if I think while I am painting, if I intervene, then bang! All is lost; everything goes to hell. (*CC*, 111)

The artist approaches nature's style by discarding schemes and theorems. This labor of giving up will, purpose, ambition, indeed his entire commanding vision, is the artist's way into nature. Nature's style is egoless. It is creation by necessity, by unfolding of the inherent characteristics of a living thing— that chord of fabrication and renunciation, of passive creation, of venture and heedfulness into which the artist tunes by surrender. Artifice says "I." Art says "Here it is." This eradication of the instrumental, technically prepared self is nature's touch in human works.

<div align="center">⁂</div>

Spiritual sympathy, then, is the basis on which a good work of art achieves the self-evident, uncontrived, and necessary look of, as Kant says, natural things. It achieves this look less by slavish imitation of aspects than by a discipline of affiliation, of suspending acquisitive attention (the kind that looks in order to seize). What toil, what effort, however, it is to renounce one's personality! The point is not to wipe away the traces of labor and forethought that go into the work, the way a burglar rubs out his fingerprints on the way out. Abnegation of personality is not a last-minute glaze. It covers the entire discipline of making art. As Michelangelo says,

> [W]hat one must most toil and labor with hard work and study to attain in a painting is that, after much labor spent on it, it should seem to have been done almost rapidly and with no labor at all, although in fact it was not so. And this needs most excellent skill and art. (*AA*, 70–71)

The art, then, is not to conceal evidence of manufacture; rather, it is to work as though the work was effortless. The whole effort goes into ease. Utmost concentration goes to relaxing concentration. The toil is to forget that one is toiling. Whereas the second-rate artwork often advertises the sweat that went

into it, the good artist gives away his work the way gifts are given, by first re-moving the price tag. To make it look easy, obvious, almost self-made: this is how the artist aspires to his nonimportance.

Great artworks, it is said, are anonymous: they are a filter that skims off the residually personal, the incidentally subjective. A work of art should have the look of an algebraic problem pulled off: no fingerprints of personality there, every trace of muddling and waylaying and striving erased by the perfect poise of the final equation. A work of art, Jasper Johns explains, "has to be not a de-liberate statement but a helpless statement. It has to be what you can't avoid saying, not what you set out to say" (*AA*, 158). Making art consists, as it were, in falling under the authority of the object. In this sense, the process is less manufacturing than sending forth. It is expression taking over its expressive source. It is an experience of giving in to *necessity*.

Submission, Necessity, Death

MODERN ROMANTIC SENSITIVITY is bound to bristle at these terms. How can we possibly parallel the artwork, an offspring of imaginative freedom, with a work of *necessity*, such as a mathematical formula? What, after all, is art if not an invitation to break the yoke and set fancy free? Of course, it cannot be that a work of art is necessary in the same way a mathematical equation is necessary. In the former case, we appeal to a quality of dedication, a spirit of seriousness and lucidity; in the latter, we convey that the equation checks out right by reason and logic.

So the issue of necessity really dovetails into that of truth. Art, it is said, is fiction, imagination, creation. Only that which is necessary, that which happens because it must and will, is true. So, at any rate, says science. So art cannot be true—necessarily true—in the same way a scientific theorem is true. For there is no pregiven way a work of art has to be—unlike, say, Fermat's equation the solution of which is scripted by its constitutive elements. Nevertheless—and Kant was not the first to remark on this—completed artworks have a look of necessity. Everything in them stands as it should; every element falls into place as it must; we would not dream of shifting a detail without, as in a mathematical formula, sending the whole edifice clattering down. But how is this necessity achieved, knowing that no preexisting law forced the artist's hand? Necessity sui generis, a law invented on the spot, is no law at all, no necessity. Each work of art is a cosmos that creates the rules by which it holds together.

But this seems simply like saying that a work of art is fancy arbitrarily setting itself up as an ad-hoc law—less indeed than a fast and firm case of necessity.

Yet truthfulness does apply to art; and necessity is a valid concept when describing the individual work of art. Taken as a whole, the universe is not under any superior rule, though everything in it is ruled. The same goes for artworks. Artworks are efforts to mimic the whole universe: a totality that gives itself rules, and unanswerable to no higher necessity than its inner coherence. This is the impression of truthful necessity in great artists—why it makes sense to say of Klee, Turner, Chagall, Van Gogh, Rodin, Sargent, Corot, Raphael, Bellini, or Rembrandt that they are truthful, though their works be altogether dissimilar. They are true and necessary in a sense that another universe would be true next to our universe, though it may play by laws altogether inapplicable or unintelligible to ours. Truthfulness is given by inner integrity. Thus a work of art is false to the extent that it admits ready-made or halfway solutions, weakness, compromise, deus-ex-machina solutions; and it is true to the opposite extent to which the artist has followed the rigor and logic of its construction. Truthfulness is measured by the intensity at which the artist pitched his surrender to the momentum. The reverse of truthfulness in art is distraction, dilution of attention, halfheartedness, casualness, arrogance—a would-be artist using his medium as a vehicle for other objectives.

Submission is what is demanded of the artist. Then is he less a maker than a helping hand, a medium. An anectode illustrates this idea. It is told by Vollard and relates to the occasion of his portrait by Cézanne:

In my portrait there are two little spots of canvas on the hand which are not covered. I called Cézanne's attention to them. He replied: "[P]erhaps I will be able tomorrow to find the exact tone to cover up those spots. Don't you see, Monsieur Vollard, that if I put something there by whim, I might have to paint the whole canvas over, starting from that point."[1]

Here Cézanne suggests that the artist cannot commandeer the work. It has harmonic laws, rhythms of coalescence, in short, a rule of *necessity* that needs to be respected. Just as doing a mathematic problem requires that we suspend personal preferences (how we would like it to turn out), so creating a work of art asks the artist to renounce bullish interference, action by fiat, a high-

1. E. Loran, *Cézanne's Composition* (Berkeley and Los Angeles: University of California Press, 1943), 95.

handed approach. Instead, it recommends discipline and acceptance of necessity. How telling that Picasso brings up geometry to convey his idea of artistic excellence:

> If you want to draw a circle and claim to be original, don't try to give it a strange form which isn't exactly the form of a circle. Try to make the circle as best as you can. And since nobody before you has made a perfect circle, you can be sure that your circle will be completely your own. Only then will you have a chance to be original.[2]

We customarily do not imagine the artist beholden to external laws. Romanticism has trained us to regard the artist as a lawbreaker. But Picasso suggests here that the artist is bound by a sort of internal yardstick. Creation is not about putting out just any form. Nor is to break rules, to twist them, and to be bizarre. Rather it is to tune into one's inner rule, the direction in which one cannot help moving, the inner command that is as clear and absolute as a circle. One must be dutiful. Indeed, the artist is not a scientist. But no less than the scientist does he obey rigor. He is no less aware than the scientist of the laws of physical existence. Only he does not transcribe them into abstract formulas; instead, he endures them, delves into them. An artist agrees to suffer the force and authority of matter as much as a valley endures mass and gravity. Witness Cézanne's nearly geological feel for reality:

> In order to paint a landscape correctly, first I have to discover the geographic strata. Imagine that the history of the world dates from the day when two atoms met, when two whirlwinds, two chemical joined together.... Slowly geographical foundations appear, the layers, the major planes form themselves on my canvas. Mentally I compose the rocky skeleton. I can see the outcropping of stones under the water; the sky weighs on me. Everything falls into place.... Geometry measures the earth. A feeling of tenderness comes over me.... It's a kind of deliverance.... An airborne, colorful logic quickly replaces the somber, stubborn geography. Everything becomes organized: trees, fields, houses. I see. (*CC*, 114)

Not an act of seizing, nor of peeling the landscape off from its place and laying it flat on canvas: composing the picture requires feeling into the density of earth, the swell of the land, the roll of mass and matter, the deep presence— full, undeniable, geometrical, infinitely reposed—of what exists around us. The feeling of tenderness that overcomes Cézanne is that of being delivered from mental schemes and surrendering to the quiet necessity of the landscape. His mind sags with the heaviness of earth and sky—a heaviness that, once ac-

2. In D. Ashton, ed., *Picasso on Art* (New York: Da Capo Press, 1972), 45.

cepted, is no longer a burden, not the sin of embodiment, but a blessing, "an airborne logic," order and clarity. The artist here agrees "to be the valley of the universe," to quote Lao Tsu, the spot where acceptance of gravity, fact, and necessity is greatest.

This poise is achieved only if the artist welcomes necessity. Necessity is that by which nature is most deeply and humbly accepted. To reach this state, the artist needs to let the fact of things seep into his hand, paint, and canvas so that they too become *factual*. "My canvas is heavy, a heaviness weighs down my brushes. Everything drops. Everything falls toward the horizon. From my brain onto my canvas, from my canvas toward the earth," Cézanne says (*CC*, 115). Indeed, making art is no spiritual sleight-of-hand. It is mind becoming incarnate and mortal, weighed down with body and gravity. From nature the artist learns to be serious. He reenacts the Fall—this time, however, humanity falls not for waywardness, but out of love. The descent into matter is a rise into communion. "I stand before a landscape," says Cézanne, "to draw religion from it" (*CC*, 115).

This puts us very far from the idealist, Pygmalion theory of art. But let the actual working Pygmalion speak in his own words and we will hear stories not of spells and magic, not of reality transmogrified, but of reality respected and listened to. A sculptor, Rodin states, *heeds* the stone. Carving should bring out what the inner density demands.

Each profile is actually the outer evidence of the interior mass; each is the perceptible surface of a deep section, like the slices of a melon, so that if one is faithful to the accuracy of these profiles, the reality of the model, instead of being a superficial reproduction, seems to emanate from within. The solidity of the whole, the accuracy of plan, and the veritable life of a work of art, proceed therefrom. (*AA*, 324)

What appears on the outside emanates from the inside. Design that is merely imparted onto the stone yields a shallow, bumptious, and ultimately feeble form. To have depth and solidity, a work of art needs be in tune with its material—so much so indeed that it seems but the outer expression of inner necessity.

Hence it is that the moment of grace in great artworks is also the moment of greatest surrender, the trace left by the artist of his submission to the process at hand. Beauty rings out of a Bach sonata, for instance, when the notes arise from a seeming necessity of their own. On listening to Bach, Leibniz, his contemporary, spoke of "unconscious calculating," which conveys well the dual

impression of a necessary sequence brought off effortlessly, as though by following the drift of things, the way a river obeys the lay of the land. The magic of melody is in part that of depersonalization: that a chord or note occurring at the end of a musical phrase is called for, and derives tonal value from, the internal necessity that ties it to a cluster of notes played at the beginning; that once a melody is begun it unfurls a logic for which the musician is a conduit. In great art, the creator is possessed by his expression. He, not the work, is the *medium* of utterance—a fact that highlights the degree of confusion in today's art world where paint, sculpture, video, found objects are casually said to be the *media* of an artist full of ideas.

Love of necessity (of life as mass and matter and weight) explains in part the ubiquitous figure of the dead Christ in Western art. Of course there are social and liturgical reasons behind it. But the memento mori, the reminder to contemplate death, has a long artistic lineage that precedes and runs parallel to Christian themes. In fact, the imagery of the dead Christ in some sense co-opts this tradition. The point is not theological but artistic: the dead body in fact gives art the chance to illustrate its love of necessity and thereby embrace its own physical reality. Let us take Raphael's painting of the Entombment. Christ is carried by faithful followers. Christ's body is awfully present. It sags, droops, weighs on the disciples. Never, it seems, did a corpse weigh so heavily. The disciples seem to be carrying the weight of the world—that is, the weight of the world without God, of matter without spirit.

God has died, God is dead—this is the most frightful of all thoughts, that everything eternal and true *is not*, that negation itself is found in God. The deepest anguish, the feeling of complete irretrievability, the annulling of everything that is elevated, are bound up with this thought.[3]

The death of Christ, so Hegel imagines, destroys everything that is elevated. Spirit, transcendence, indeed the infinite seem wrecked. All that is left is weight, matter, mortal flesh. Did not the Messiah himself give up hope in the end? Did he not shout out, "My God, why hast thou forsaken me?" This thought must weigh like gravity itself on the disciples. This is a universe from which spirit has departed, a world without a netherworld, dreadfully finite. A world of implacable necessity.

3. G. W. F. Hegel, *Lectures on the Philosophy of Religion*, trans. R. F. Brown, J. M. Stewart, J. P. Fitzer, and H. S. Harris (Berkeley and Los Angeles: University of California Press, 1996), 465.

But, then, what becomes of images without transcendence? What is an image if not matter becoming expressive? From the first spit-painted petroglyph in Lascaux to Tiepolo's dizzingly swirling skies and angels, images have entertained the dream of transcendence, of taking off, of being *elsewhere*, "anywhere out of this world," as Baudelaire puts it. This is the world-fleeing movement of art. An image is and is not itself. It dwells on canvas but lives in spirit. The pigments are material but the image is, well, imagined.

In actuality, however, a truly artistic image does not shun its material husk. There is the world-seeking direction of art, that by which expression seeks manifestation in concrete forms. Unlike we who see in reality what we seek, the artist sees adventures in concrete existence. Where I see a jug of water to slake my thirst, Vermeer sees the wedding of earthenware with a gleam of window-filtered sunlight, the bluish bloom of morning, the polygamy of paint and light and pottery, of mind and reality in a humble corner of the universe. To the artist, worldly forms are not just springboards into fantasy. When they are treated as means only, things take on a synthetic, garish, heavily contoured appearance. This is, for instance, the case of surrealist art—and there is a good reason why surrealism failed to produce truly great works of art. Surrealism is the dogma of fantasy, the victory of mind over matter. And surrealist works of art (Dali, Tanguy, and Magritte come to mind) show what happens to reality under total mental dominion: it oozes out of shape, it melts, it is toylike, glossy, uncared for. Everything in a surrealist painting seems to be seen from a great distance. Surfaces are oleaginous, the depths look vertiginous and uninhabitable, even the near-at-hand seems a loveless backdrop. Reality that is strictly imagined repays the offense by offering no hold, charm, or taste. What is not heeded has no presence.

What earmarks an artwork from second-rate products is the degree to which it attends and indeed succumbs to the reality it depicts and the reality it is made of. What, then, happens when a great painter beholds the divine corpse in a spirit of participation? If the picture is truly to see the corpse of Christ, and not be a mere representation, it will embrace its death, which means it is ready to welcome the demise of spirit and the triumph of necessity. This means relinquishing intention, expression, will, transcendence. Thus art is asked to forgo its own expressive force. Paintings of the crucified Christ pose a great challenge for artists because here art must resist its innate tendency to rise above matter. The challenge is to dip one's brush into the wreckage of spir-

it, into a world that is nothing but gravity. Here art faces disenchantment, the renunciation of the very magic that consists in conjuring up images. It is, for art, as for humanity, the darkest hour.

Upon death, everything returns to matter. Expression falls: like the corpse, it hangs loose. "His face is so dead that it no longer expresses anything" (Dostoevsky).[4] A cadaver is like nature: it neither projects nor withholds expression. It does not strive to appear or disappear. Human appearance achieves the self-evidence of nature. Must the artist shed the will to express in order to convey that expressive demise? Must he give up his bag of tricks, his painterly know-how, his marvelous gift for *breathing life* into paint? Must the image become mute, imageless? This paradox explains in part why, for Alberti, corpses numbered among the most intractably difficult artistic subjects:

An *istoria* is praised in Rome in which Meleager, a dead man, weighs down those who carry him. In every one of his members he appears completely dead—everything hangs, hands, fingers and head; everything falls heavily. Anyone who tries to express a dead body—which is certainly very difficult—will be a good painter, if he knows how to make each member of the body flaccid. . . . The members of the dead should be dead to the very nails. (*OP*, 73)

Everything hangs, everything falls heavily. There is an ideal of aesthetic completion at work in Alberti's vision of the corpse—a paragon of integration and equability. Effortlessly it achieves the ideal aesthetic integration of parts into whole. The corpse, Alberti suggests, coincides with itself in every way. Death spreads through every limb and sinew. It makes the body whole. This wholeness, however, is just what thwarts representation because representation is tied to expression, and expression to the discord between rest and movement, calm and intensity, retention and explosion. Whereas in the corpse nature fills the human form and the human form with supreme indifference to intention. It is made perfect by the smoothing hand of necessity. In the Christic corpse, physical perfection is no longer triumphant, willful, Grecian; instead, it is boundlessly fragile, abandoned. Not the triumph of the will but its renunciation is the message of religion. And so the artistic mind too must shed intention and design, indeed jettison the drive to signify.

But what is the artist left with? What does necessity ask of him? One thing: obedience to matter, surrender to the artistic material. A painting of the De-

4. F. Dostoevsky, *The Insulted and Humiliated* (1861), trans. Constance Garnett (Gaithersburg, Md.: Victor Kamkin, 1976).

position by Rubens gives a glimpse of what surrender looks like. The slumping body of Christ cascades down the canvas. It is a flow of fleshy mud that meanders and spills, sags and sprawls out of sight, out of representation, almost melting back into a soup of oil and pigments. A typical baroque arabesque, one may suggest. Yet more than that. The baroque (El Greco or Bellini, for instance), typically proclaims efflorescence: forms quickened by life, a bubbling breath running through all things, luxuriance and exuberance. Joyful or sad, forms want to expand and stretch with disposable energy. By contrast, the Deposition by Rubens slumps for lack of force. There is not enough will to rib the forms. This spill of matter is not without danger. It takes a human dam of eight surrounding figures to keep the cadaver from running amorphously out of the picture. It looks as though the painting is afraid of its own material mass, the outbreak of quiddity in its midst.

This quiddity is the weight of materials before creativity electrifies it. To paint a corpse with sympathy requires the artist to go back to the infancy of painting, its poorest beginning, when expression has not yet awakened, where there is only matter, stuff, thickness. In practical terms, this means returning to the level of materials (paint, pigments, and canvas) before they are stirred into semblance. This Deposition is an adumbration of an *arte poverta* to come, an art of the barest expression that comes to a head in modernist minimalism, in so-called environmental art, an art of sticks and stones, of dirt and water carved out of the land itself and sometimes indistinguishable from it. These developments give free rein to art's fascination with what seems most opposite to it, that is, the expressionless, the quietly present, nature. In hindsight, Kant's recommendation that art "must not seem to be designed, i.e., that beautiful art must look like nature" seems to sanction art's perennial fascination for the unmade, the unfashioned, things free of the stigma of human contrivance—a natural composure most challenging to reach because here art struggles against the very ground of its existence, namely, the fact that it is made and, to this extent, expressive.[5] The ubiquitous corpse in Western art suggests that, long before concrete art, long before it gave up on the romantic expressive binge, art was already after the most humble and poorest of expression, the human voice muted, the silence of nature, *necessity*.

Necessity is the authority of great artworks. Everything in them stands as it should and our dearest wish is that it all remains so. Their form has the easy

5. I. Kant, *Critique of Judgment*, 149.

look of things that grow out of biological necessity. Therein is born the aura of stillness around masterpieces. A great work of art stands in a circle of silence. However rambunctious or trivial its subject matter, however controversial its thesis, a great work of art creates silence. Like a tree, a cloud, or a hill, its presence seems self-justifying. The scandal of new art, the sort of art that disturbs aesthetic customs, derives in no small part from this quiet authority. Duchamp's *Fountain* once distressed people because it stretched the ambit of art to include found or ready-made objects. Was it disturbing because it highjacked the venerable authority of art into the lowly service of urinals? Or was it disturbing because it forced the recognition that the authority of masterpieces was not unlike the quiet strength and tranquility of the humblest thing? The confidence of objects lies in their humility. Effortlessly they endure, below the threshold of our notice. But really they are the ground beneath our feet. Therein lies their authority. By displaying a urinal, Duchamp revealed that the spectrum of human attention is really a loop. The highest form of concentration (religion and art) consists in seeing *below*, not above, the threshold of our normal attention. It consists in perceiving the overlooked. When this happens we realize that the overlooked is the ground of existence. It is the oblivion in which we keep objects that feeds their strength. *They* are rocks of existence while *we* merely hover. And this serenity is indeed just what we admire in artworks. The authority of a masterpiece is not unlike the tranquil dignity of, for instance, a urinal, a shovel, or a table. The life of objects is a source of wisdom for us humans who maintain ourselves only by sweat and sacrifice. Being objects themselves, albeit of special notice, works of art speak on behalf of the objective world at large, the legions of things that are but do not seek to be. A work of art opens our eyes to the peace of thinghood. Proper to all things, thinghood nevertheless arises best in artworks, sacramental objects, or entities that compel attention.

At any rate, the readymade exhibited a parallel between mere thinghood and art that was no avant-garde gimmick but an expression of an old human wish to come home to reality. Says the painter Gerhart Richter on found objects: "The invention of the Readymade was the invention of reality. It was the crucial discovery that what counts is reality, not any world-view whatever. Since then, painting has never represented reality; it has been reality."[6] Duch-

6. G. Richter, *The Daily Practice of Painting: Writings 1962–1993* (Cambridge, Mass.: MIT Press, 1995), 156.

amp quipped that a readymade could be, for instance, the whole of the universe. If Zeuxis' grapes is the first kiss, the found object is the climax of art's love story with reality. In the readymade, the artist contemplates, with a near religious thrill, his vanishing. At last, intention is silent. At last, what is, is. "The true language of art is speechless" (Adorno).[7]

Artworks advertise their thingness. This is true whether we are dealing with Richard Stella's giant steel structures or a tiny nude by Watteau. In either case, the eye is drawn to appreciate the physicality of the illusion—as though indeed artworks somehow wished to prick the bubble of illusion. Of course, we love enjoying the illusion of, say, that little nude. But the little nude calls our mind to its paintedness. "Artistic" pieces are elegant failures. Like broken objects, they draw attention to the matter they are made of. Quiddity tends to arise when an object foils our use or habit. Nothing brings home the thingness of snow better than an avalanche; nothing reveals metal better than a broken elevator door; nothing makes air appear like lighting up a cigarette in a hospital room. Artworks too fall in the category of broken objects. We misunderstand them if we hang them for decoration or use them for message-mongering. In truth, their thick silence and uselessness is part of their message.

Art is an antidote to advertising and modern politics whose message is the penetration of communication into all aspects of existence. Marshall McLuhan's "the medium is the message" warned that being in communication now eclipses the contents of communication. Visibility is self-justifying. One imagines a mass medium of the future that will be all gregarious communication and no communiqué (the babble of talk radio and television). Art stands at the opposite end. It draws us into precincts of silence. The here-and-now of a physical object, not the there-and-everywhere of promiscuous chatter, governs the artistic experience. To this extent, a work of art, even when it is not a found object, has the appearance of one. A found object is dumb with self-evidence. It was not looked for or sought after. It was chanced upon; it stands there. Next to it, our most contemplative pose is bustle and noise. A Van Gogh, a Rembrandt, a Titian, a Picasso too in the end are silent. We are that we are, is their message. And this is so because they are the product of love and acceptance; they are at one with their necessity.

Silence is the gateway to nature. Art nears nature not by representational to-do, naturalistic styling, and chameleon exercises, but by settling in the qui-

7. T. Adorno, *Aesthetic Theory*, 164.

etness of reality. Of course, appreciation of how it was made, the difficulties overcome, the wisdom and skill expanded—all these are crucial to enjoying an artwork. However, a work of art is loved because, in the end, we prefer its calm appearance to all the reasons we give ourselves for liking it. In love, as in artistic appreciation, understanding comes in the form of acceptance. Above and beyond the causes that sustain our admiration, we are grateful to the work of art for being what it is and for making it absurd to wish that it were different.

The authority of masterpieces is akin to the composure of natural things. A sunrise, a tree, a rain shower, a person asleep—these are regal things, for they do not strive to be what they are not and want nothing to complete them. "To the artist, nature is always perfect, in storm and rain as well as when the sun shines" (Malevich).[8] No exertion sustains the light and the rain; no design guides them; no intention diminishes them. In truth, anything that is made de facto drops in authority. The manufactured bespeaks strain and artifice. This is why kings and queens, when they still ruled the earth, had to be born so. A person who appears to try too hard loses our good opinion. Unaffected grace, by contrast, typically earns a person the praise of being a "natural." Ultimately, however, only nature is free from the stain of manufacture. Artworks, of course, are made and therefore carry the stain. Yet, of all human artifacts, they are those which, while at the apex of human invention, somehow tip over into nonhuman tranquility, into kingly self-evidence. A work of art is a process of purification that sieves out the psychologically trivial, contingent, and personal dross of human design. In a sense, a great work of art is "a natural": though manufactured, its appearance wipes out the smudges of contrivance.

Of course our democratic sensibility warms to self-improvement, the odds beaten, the man on the make. Yet respect for the natural-born, for the aristocracy of things unstained by effort, still endures and decides where, in the end, we give our admiration. However much we elevate artists, whatever the cult of personality around painters, our admiration and love for artworks still derives from their anonymous force. Mistakenly we correlate the authority of an artwork with its signature. The Picasso name at the bottom corner transfigures a painting like no magic wand. But this is taking things at the wrong end. In fact, the Picasso prestige draws weight from the paintings themselves. Had these been weaklings and daubs, no signature could recommend them now. The signature symbolizes the collective authority of a whole opus, but it is dependent

8. K. Malevich, *The Non-Objective World* (Chicago: Paul Theobald and Company, 1959), 38.

on the works themselves for its panache. To run things in reverse is snobbery.

The idea that a work of art's authority rests with its anonymity or "found-ness" is bound up with the notion of grace. The word *grace* designates both natural elegance and supernatural elevation. In fact the two meanings fuse. What appears free from contrivance is elegant; and freedom from the blemish of toil is an escape from mortal conditions—for nothing that is human really ever transcends effort. Grace gives us the illusion that a dancer walks above the strife and weight of corporeal life. Whereas others carry the burden of deportment and carriage, of bearing and demeanor (all terms that rightly be-speak weight), the graceful person seems to dance through the walls that mat-ter places between us and freedom.

The subtle grace of objects likewise stems from their indifference to the task of *having* to be. The beauty of a landscape lies in this freedom from tra-vail which, though totally natural, verges on supernatural grace. In this letters, Van Gogh expresses his longing to approximate the effortless modesty of a cy-press tree. To near this grace, an artist needs to silence his very wish to attain it. For willfulness savors of weakness and envy. The grace in artworks consists in achieving the poise of reality, which is always positive, fulfilled, unwant-ing. Again Kant's idea that art "must not seem designed, i.e., that beautiful art must look like nature" comes back to mind. It is no recommendation that art-ists restrict their interest to brooks and meadows. Kant's point is about spiri-tual attunement: regardless of the represented scene, a representation must move in spiritual sympathy with the "is-ness" of the object. The element of nature in art is not one of appearance but of being. At the empirical level, no artwork nears this ideal closer than the readymade; at a more critical level, it is a different story because the appearance of the humdrum thing as a work of art depends on an act of demiurgic appointment. "Let this be art" proclaims the artist and art it becomes. This is more pontifical fiat than spiritual attunement. To achieve the latter, subjectivity must truly dive into the corporeal depth of reality. And this immersion, I want to suggest, is responsible for our admira-tion of beautiful art.

Indeed, we admire artworks because they issue from human work. (What interest would there be to, for example, Caravaggio's *Conversion of St. Paul* if it were paint splattered accidentally on a canvas?)[9] But true admiration arises when work wipes away the fingerprints. Artists who refer to their artworks in

9. A point expertly picked apart by A. Danto in *The Transfiguration of the Commonplace* (Cambridge, Mass.: Harvard University Press, 1981).

terms of "problems" are simply aping the pidgin of critics. "I do not search, I find" (Picasso). Art making is strenuous unforgiving labor, beset with tremendous failures that only fantastic determination conquers. Once the work is done, however, the artist bows out of the piece. His sacrifice is to make it all seem easy and self-evident. "When a picture looks labored and overworked, you can read in it: 'she did this, and then she did that.' There is something in it that has nothing to do with beautiful art" (Helen Frankenthaler).[10] Art that is "difficult" may be intellectually engaging; art that lectures about historical tradition, winks at precedents, or flatters our fluency with artistic codes surely may charm. But a shadow of narcissism, a hint of self-regard, mars its appearance. The work thus cuts itself off from the composure of being real; it undermines its own authority. Nature is open to a great many forms of anthropomorphic projection (it can be "angry" or "clement," "sullen" or "cheerful"). Never, however, is nature narcissistic. This is oxymoronic. For nature's authority is immanence, whereas narcissism is a kind of longing. A work of art that is perfectly real likewise attains reality by casting off narcissistic reserve. It gives and gives and arrives at nature through giving.

10. In D. Sylvester, *Interviews with American Artists* (New Haven, Conn.: Yale University Press, 2001), 102.

CHAPTER 20

Art and Sacrifice

LIKE ANY HUMAN WORK, art is an investment of personality; unlike common work, however, art sieves personality out of the finished product. There is a sort of dedication to the making of art that verges on sacrifice. This of course is a commonplace of long standing (dedication to the muse, the cult of avocation, the religious ecstasy of art, divine possession, etc.). Nevertheless, the cliché perhaps holds an old truth.

For this purpose, let us take the poem "Pietà" by R. M. Rilke.

> "Now is my misery full, and namelessly
> it fills me. I am stark, as the stone's
> inside is stark.
> Hard as I am, I know but one thing:
> You grew—
> ... and grew
> in order to stand forth
> as too great pain
> quite beyond my heart's grasping.
> Now you are lying straight across my lap,
> now I can no longer
> give you birth."[1]

1. Rilke, "Pietà," *The Life of the Virgin Mary*, in *Translations from the Poetry of Rainer Maria Rilke*, trans. Herter Norton (New York: Norton and Company, 1938), 221.

Mary is the voice of the poem. The poet wishes to speak in a mother's voice, she who gives birth and is now bereft of her offspring. This is an obvious parallel but so it goes: artistic creation is akin to a kind of mothering. It is feminine, it is Mother. Pygmalion is of course the other artistic archetype. But Pygmalion in the end rapes Galatea. His creative gesture proves an enemy of life. He is really driven by self-gratification: to engineer a superreal playmate with whom to have his way. By contrast, in the self-sacrificing mother we find a figure more congenial to artists in whom generosity eclipses power and glory.

Giving birth is to Mary what dying is to Christ, or solitude to Robinson Crusoe, or delusion to Quixote. Motherhood is what she does and is. In "Pietà," she laments over the corpse of her son, remembering the years over which he became ever more his own man and ever less her child. *You grew and grew in order to stand forth.* She holds his remains and mourns her own motherhood. *Now I can no longer give you birth.* She is robbed of the one thing that made her a mother. As Jesus dies, so does her motherhood. Now she is barren, desolate with the weight and sterility of stone. *My misery is full, and namelessly it fills me. I am stark, as the stone's inside is stark.* For she is of course a Pietà, a marble statue eternally cast in bereavement. Her child completed his destiny, he is now his own self, he *stands forth beyond [her] heart's grasping.* She, the creator, bends over him and, in nameless pain, feels utterly separated from him. Hers is a lamentation of birth and death. For separation rules between them. She has given and given and now she is exiled from her gift. Unlike Pygmalion, she lets go of her creation. She accepts the loss.

Rilke's poem records the pains of a poet producing the lyric and letting it go, a poem that *grew and grew* until the poet could no longer give it birth and the fount of inspiration faced stonelike loss.

By its title, however, the poem seeks associations with other artistic Pietàs. *Hard as I am . . . as the stone's inside is stark:* this is not only Mary speaking, but clearly a sculpture of Mary. In the spring of 1898, Rilke was traveling in Florence and admired the Pietà sculpted by Michelangelo for his own tomb (known as the *Florence Pietà*). Rilke also wrote a book of prose, titled *Stories of God*, where one of the tales ("Of One Who Listened to the Stones") presents Michelangelo sculpting the *Florence Pietà*.[2] Surely it takes nothing away from the purity of Rilke's Pietà to suggest that it orients our attention to Michelangelo's.

2. R. J. Clements, *The Peregrine Muse* (Chapel Hill: University of North Carolina Press, 1959), 27–42.

It is recorded that Michelangelo took angrily to criticism that he had given Mary too youthful an appearance in his *Florence Pietà*, indeed that she looked younger than her own son. Michelangelo scoffed, Don't you know virgins keep themselves young? But the fact remains: the afflicted mother does look terribly young, too young to mourn a thirty-three-year-old son. Psychologically, we may understand her youthfulness to be of a woman who, however old her dead child, always weeps as a young mother, the one who once gave him life. In one of his many drawings for the *Florence Pietà*, Michelangelo wedges the dead Christ between Mary's legs as though it were with the womb, with her young motherhood, that Mary mourns. Indeed, she mourns with her creativity.

Evidently the subject fascinated Michelangelo because he sculpted three separate Pietàs and spent the last months of his life trying to finish yet another. So who is the childless mother? Why does she appeal to the artist so?

In *Lives of the Artists*, Vasari notes that Michelangelo bestowed such love on the Saint Peter's *Pietà* that he did something quite unique in all of his works. "Michelangelo placed so much love and labor in this work that on it (something he did in no other work) he left his name written across a sash which girds Our Lady's breast."[3] An anecdote, Vasari says, explains this unusual autograph. It is said that Michelangelo entered the church where the sculpture stood and overheard a group of foreigners praising the work but wrongly crediting it to a Milanese artist. "Michelangelo," Vasari writes, "stood there silently, and it seemed somewhat *strange* to him that his labors were being attributed to someone else; one night he locked himself inside the church with a little light, and, having brought his chisels, he carved his name upon the statue" (*Vasari*, 425).

A case of jealous authorship, one might say—but also an indication of the artist's great love for his statue and the *strange* feeling of being robbed of his offspring, of no longer being the maker or, one might say, the mother of the work he loved most. This feeling of love and estrangement conspired to make him carve his name not on the statue's base or on its back, but right on Mary's mantle strap. Robbed of his love child, Michelangelo sought to become once more the mother he rightly was. And let us note that he left his signature not just on the mother, but *on our Lady's breast*, the motherliest part of her. Of

3. G. Vasari, *The Lives of the Artists*, trans. Julia Conaway Bondanella and Peter Bondanella (Oxford, U.K.: Oxford University Press, 1991), 425.

course, this is less an act of recapture than an admission of loss. He wished to become the mother in just the sense Mary is a mother: when he could no longer give birth to the fruit of his labor, when separation made him a barren, powerless stranger. Let us say, then, that Michelangelo shared Mary's sorrow. He too leaned over a work that *grew and grew in order to stand forth*, until when it is *lying across his lap, he can no longer give it birth*.

(Michelangelo, it must be added, stood in Mary's place when he carved the image of Christ. In the Rome *Pietà* in particular, Christ can be seen fully only from above, from Mary's standpoint. Hence to see him well is in a sense to see him with Mary's eyes. Michelangelo carved Christ through the eyes of the mother who gives birth in order to let go. Long after the Rome *Pietà*, Michelangelo sculpted a statuary of the *Deposition from the Cross*, sometimes known as the *Florence Pietà*. There, Michelangelo placed his own likeness alongside the two Marys. It is a portrait of the artist as a mourner, with Michelangelo gazing down upon the dead Christ with a mother's love and heavy heart.)

As Mary is to the child, so the artist is to his work. The artist gives for the sake of letting go. Creation is sacrifice, a kind of self-forgetting. Beyond its liturgical office, a Pietà expresses the spirit of creation. Selfless giving, creating for the sake of the created, producing with a view to offering rather than stocking, opening and not closing, giving and not taking—these earmark the religious, as well as the artistic, spirit.

Naturally, letting go applies to all types of work. Whether you are Velasquez or a day laborer digging a trench, the work eventually comes to an end and sends you into symbolic retirement. This is part of what finishing a work means. What Michelangelo and Rilke show, however, is that an artist creates in a spirit of letting go. The wish to release the work from one's creation sustains the energy of creation. In the end, this surrender is of a piece with the venturing and generosity that accompanies the artist's hand. "One doesn't know exactly what one wants to do or what the end result will be" (Helen Frankenthaler).[4] "I want to leave everything as it is. I therefore neither plan nor invent. I add nothing and omit nothing" (Gehardt Richter).[5] This common resolve not to prejudge the outcome requires reining in the impulse to design and

4. In D. Sylvester, *Interviews*, 103.

5. G. Richter, *The Daily Practice of Painting: Writings 1962–1993* (Cambridge, Mass: MIT Press, 1995), 34.

control and project one's personality on the work. It also assumes renouncing the economic spur of creation. Work done now is a purchase on the future. It is an investment. On the contrary, artistic creation toils in a spirit of letting go, of liberating. It creates for the sake of setting free. This runs against our deepest instinct. It is as absurd as a fox building a den he has no intention of using. This, however, is the economic absurdity of artistic work—it is nonsensical from the standpoint of nature and, to this extent, supernatural.

<p style="text-align:center">⁂</p>

The annals of art are full of tales of the self-sacrificing genius, the wide-eyed visionary who follows his muse into the maw of madness, poverty, shame, obscurity. This fate became rather a badge of honor during the romantic period and the self-sacrificing artist never quite recovered from it. Modernism became suspicious of sacrifice. Economic utilitarianism, whether in its classic form (which holds that no animal or human action contradicts the principle of maximization of self-interest) or its Freudian retooling (which holds that egocentric gratification controls the gamut of behavior), has also done a lot to tarnish the gilt of self-sacrifice. There is no circumventing the self-serving principle, says modern psychology. The saint of yesteryear, the nurse who sits up all night with a dying patient, the soup-kitchen volunteer, all do-gooders are really in it for themselves—by feeding the secret thrill of subservience, for example. Least of all can we credit the artist, that perennial attention-monger, with self-sacrifice. Genuine sacrifice craves anonymity whereas works of art seek the limelight. Is Michelangelo not famous today? Indeed, the case for artistic humility is a hard one to make.

But this is looking at things from the wrong end. In actuality we must look at the process, not the social outcome. And it is not the fame and attention received that fuels the labor of artistic creation. The famous artist we applaud in daylight worked in solitude the night before. Then he faced the reticent judges of his paint and canvas, his brush or pen or chisel; then it availed him nothing to wave his genius and fame. An artist cannot *order* his artistic form to get up and seek glory. The perfect poem or the beautiful work of art cannot be bossed around into being. Generally an artist who regards his medium as press-agentry is correspondingly third-rate. This is so because to get or keep fame by means of art is to hold back from it, to use it as a means, hence to resist partaking of the work. A real artist does not use but *is* used. All he wants is the work of art to reach the fullest span of its possibilities. Whatever prize comes

of this achievement will happen in its time; for now the artist is a worker, and a worker is immersed in the work.

The artist is not the only practitioner of complete passionate labor. Say a mathematician seeks glory and promotion. To do so, he attempts to tackle the hardest of mathematical riddles. Does he hit on the formula just when his ambition is most pressing? This is doubtful. More likely he reaches the solution, if he does, when his attention forgets everything but the cadence of his formulas. A divided attention yields a product equally split. Simone Weil wrote, "If a child is doing a sum and does it wrong, the mistake bears the stamp of his personality. If he does the sum exactly right, his personality does not enter it at all."[6] A work purified of personality is one in which all the attention went to assisting the process. Error, by comparison, usually betokens mental reserve, distraction, admixture of personal considerations. A mathematician driven only by ambition cannot concentrate; he holds back from his numbers because he wants something beyond them. And so he is not paying attention to them. The results will bare the sorry face of this distraction.

But can this ascetic ideal really apply to art, so ostensibly a personal and expressive form? Well, in some sense, art is no different than mathematics. A form appears and demands following; a melody arises and sets its own law; a novel grows and soon the artist cannot break its logical momentum without committing infanticide (imagine Emma Bovary finding Prince Charming a second before swallowing the rat poison or Humbert Humbert living happily ever after with a plump matron). A work of art that shows the nicks and scratches of its maker's despotic hand is weakened in proportion. As with a sum done exactly right, his personality should enter only in the quality of servant.

Examples of art's servants are plentiful (Van Gogh, Valéry, Rodin, Rothko, the pious ethos of the Renaissance workshop, Giacometti, Picasso—despite his plethoric output, Degas who describes a painting as a battle, Kafka who toiled over drafts that never were good enough, Wordsworth, apparently more perspiration than inspiration, Richard Wagner, the filmmaker Stanley Kubrick). Among these, let us consider Gustave Flaubert.

Flaubert notoriously forwent life's pleasures and dissipations in the service of his craft. He shut himself up in the countryside, worked unstintingly, was

6. S. Weil, "Human Personality," in *Simone Weil: An Anthology*, ed. Sian Miles (London: Weidenfeld & Nicolson, 1986), 55.

liable to sweat over a paragraph for weeks on end, slave to a sentence that demanded perfection. "Madame Bovary, c'est moi," Flaubert famously said. This is how much he committed himself to becoming and partaking of the stuff of his writing. Flaubert entered the life of every character he drew—even and particularly the unmemorable ones, the inarticulate, or dumb. Among them is the mulishly faithful and self-renouncing servant Félicité of "A Simple Heart." Hers is a figure of abnegation to match the writer's own dedication. "A Simple Heart" recounts the life story of a country servant. The tale is told with a lack of stylistic affectation equal to its character. Félicité is taken into domestic service at an early age and serves her mistress hand and foot until old age and death, till nothing is left her but her devotion and a mind dumb with age and disuse. She is the antithesis of a character—as so many of Flaubert's characters are wont to be: pictures of persons who think nothing, do little, parrot what they hear or see, and plod down expected paths; they are vehicles of the humdrum. They are indeed less individuals than quotations of social attitudes and truisms. Flaubert's fascination with the verbal social cliché is well known. His characters wade shoulder-deep in them (Emma Bovary), flounder when they wish to be sincere (Frederic Moreau), or revel in them with pedantic complacency (Bouvard and Pécuchet). Flaubert is the man who collated a *Dictionary of Accepted Ideas* and dreamt of writing a novel in which no single word would be his. This casts new light on his famous aspiration to write from the perspective of no one, as a kind of no-person or omniscient god. This wish has often been thought identical to the ideal of objective realism. It is and is not so. Writing impersonally is an effort, not just to let reality speak, but most of all in Flaubert's case, to let language do the speaking. Flaubert's earnest labor is to sink as deeply as possible into the material of his art, language. Flaubert is a herald of "the linguistic turn" in modern understanding, that is, our framing our sense of reality in terms of "language games" and discourse. Do we ever say what we mean to say? Or is what we mean to say so deeply in the thrall of language that we can never really know what we mean outside of how we say it? Flaubert was perhaps the first artist to spin this agonizing doubt into novelistic gold—to have accepted his helplessness in the face of the Leviathan of language. Rather than describe it, Flaubert shared his typical character's tongue-tied opacity and stock perception. To speak is to be in language—the size of the prison may vary with one's linguistic stock but it remains a prison nonetheless. This is why Flaubert felt no less hemmed in than his dramatis

personae. "Madame Bovary, c'est moi." This means not "She is me," but "I am her." He agreed to incarnate himself into his heroine. He, the omniscient god of realist fiction, descended into flesh, became mortal, and agreed to see with the eyes of the benighted. This in fact is consistent with his ideal of realist objectivity. For him, our objective situation is enslavement to words. When we speak we are limited to what language lets us express. Flaubert's sacrifice was to kill the myth of authorial distance; he surrendered to the prisonhouse of language—the substance and matter of his art.

As poignant as "A Simple Heart" is the next story in *Three Tales*, "The Legend of St. Julian Hospitalor." Julian is born to a king and queen in a fairyland castle whose name must be Cornucopia. It is chockfull of every imaginable thing and, as in a Rabelaisian utopia, no want is ever felt. But Julian is therefore born to a world that is *too* complete, overfulfilled. Symbolically, this stifling fullness is conveyed by his predestination. Soothsayers foretell his destiny and thus take his existence away from him. For a life that is fated is not lived. It is followed. There is no room for will or inspiration, no corner of life that is free of prediction, determination, language. What is Julian to do? He fights in despair. He tries to make room in the universe, slashing through the layers of things and words that cosset and smother him. To begin with, he kills every animal in sight. He goes on depopulating rampages through the castle, the seigneurial land, and the world at large, seemingly slaughtering every beast and fowl in creation. There are too many animals, the world is too full, he has come too late. Julian thrashes about on a page too black with words, a tradition chocked with idiom, a land overfilled with language. But killing animals always seems to bring on yet more animals to the page, droves of them, milling and churning around him. Of course this is because the more animals he kills, the more Flaubert writes them down on the page. And so the world becomes more crowded as Julian clears room in it. This is Flaubert fighting language over the white page. The more he battles his way out of language, out of tradition, the dictionary, the endless pileup of words, the more he brings words to the page. Flaubert's exertion to squeeze language out of his mind only commits him deeper to the labor of language. In the tale this maddening paradox borrows the Sophoclean twist. Julian fulfills his fate precisely by trying to escape it (he kills his parents while running away from the horrible prophecy that he is to kill them).

The tale of St. Julian is that of Flaubert's predicament. It understates the

matter to say that Flaubert was crippled by a sense of coming too late in a literary lineage crowded with geniuses (Cervantes, Rabelais, Racine, and Shakespeare are the giants he could neither best nor forget). Every thought and expression we possess, Flaubert knows, is a quotation of them. His life is as fated to artistic belatedness as Julian is fated to *follow* his. (This psychological sketch is drawn from Flaubert's abundant correspondence, the tireless topic of which is how, what, when, and why to write.) What, then, is the artist to do? Every step away from the language of tradition returns him to tradition. Hatred of language is expressed only in language. This is why Julian fulfills his fate by running away from it, just as an artist sinks in language the more he flounders to pull out of it.

The solution is sacrifice. After murdering his parents, Julian becomes a mendicant in a hair shirt, no more fighting against fate and belatedness. He devotes himself to helping others. His life is now a passion of self-sacrifice and giving. He is Félicité in monk's robes. One day a leper comes, asks for shelter, food, and water. Julian gives and gives. But the leper is old and cold and asks for warmth:

"My bones are like ice. Come here besides me! . . . Take off your clothes so that I may feel the warmth of your body!" Julian stripped, and then, naked as on the day he was born, he lay down on the bed again. . . . "Ah, I am dying! Come closer and warm me! No, not with your hands, with your whole body!" Julian stretched himself out of top of him, mouth to mouth, breast to breast.[7]

All his life had been a fight to squeeze the world out of himself. Now he lets the world in. He is *visited*. He wills his nothingness. He submits wholly to the demand of another, of the external world. He becomes Julian the Hospitalor, the host, the willing vessel. Then Julian meets his death in a swoon of delight and superhuman joy. At last he is released from his fate, from the desolate confines of matter.

His plight, we now understand, had been to deny the conditions of his birth. By birth we are placed into a world that is infinitely more powerful than us. Much of human life is spent carving out some illusory distance and shelter from this power. This is the dream of autonomy.

Flaubert's art was, like that of much of the romantic and postromantic generation, fueled by this dream of autonomy: to create one's own person, to

7. G. Flaubert, *Three Tales*, trans. Robert Baldick (New York: Penguin Classics, 1961), 86.

speak in one's pristine voice, to erase tradition, the mob, the accepted ways, the backdrop of life in which we are sewn by birth. Flaubert, one might venture, created in terror of not being original enough, in a state of rage against language and prevailing ideas and sedimented talk. He is said to have howled and bellowed his sentences while writing, as though vomiting them out of his mind. But this fury, in the end, was rage against human existence itself, which is historical, never a sui generis thing, but the flower of the compost of the ages. To overcome this rage was perhaps Flaubert's greatest achievement. Certainly it opened the way to his artistic realization. To face the evidence of one's infinitesimal place in the world is, in some sense, to accept one's birth, the event that situates us irreversibly. Upon his victory over the illusion of autonomy, Julian is "as naked as on the day he was born." Likewise Flaubert made himself naked for the sake of truth. He *received* Félicité, the old domestic with no idea in her head and no concern for personal gain. To become her was, in a sense, to accept the deafening force of language over him, which when all is told is the presence of other people in us. Flaubert thus broke with his youthful dream of romantic self-achievement. Without the sacrifice of his personality and ambition, without this complete surrender, Flaubert would have been a good writer but never a great one. For an artist's genius consists not in judging but in enacting, not in showing but in embodying. The essence of art, Nietzsche suggested, is acting. And no trick or recipe, only true complete commitment, leads to it.

<p style="text-align:center">⁂</p>

Nietzsche regarded the oracle, seer, or twirling dervish as the quintessential artist: the one consumed and turned inside out by the song. "To become one with his images," he says, the artist needs to be an "actor" (*BT*, 78). He who *acts* commits to the world of action and becoming. He does not just dangle figures for his own amusement. Swept into the process, the actor is host to the voice speaking through him. He is stage and action, artwork and maker in one, a lightning rod.

Now, the idea that art is action has a long ancestry. Plato himself essayed a theory of art based on the total experience of producing it. Thus in *Ion*:

God takes away the mind of those men [poets] and uses them as his ministers, along with soothsayers and godly seers, in order that we who hear them may know that it is not they who utter these words of great price, when they are out of their wits, but that it is God himself who speaks and addresses us through them. . . . These beautiful

poems are not human or the work of men, but divine and the work of gods, and the poets are nothing but interpreters of the gods, each one possessed by the divinity to whom he is in bondage."[8]

The Plato who speaks here is the selfsame rationalist who extols elsewhere the virtue of logical ideas, clear thinking, and reason. Thus it does not do to dismiss his theory of inspiration, or to chalk it up to Delphic superstition, just because it baffles our scientific age. It is in fact pregnant with the same spirit of truth seeking prevalent in Platonic thought. Reason is rightly considered to be the keystone of truth seeking because the logical laws of reason give us a glimpse of reality not as we want to see it, but as we *must* see it. This suspension of personality in apprehending facts is the achievement of ancient Greek thought (and, well before that, of Hindu and Buddhist philosophies). Now, Plato says, inspiration is no less instrumental than reason in bringing about his suspension of personality. Inspiration is vital to the pursuit of truth. Here is how.

The artist, Plato says, is out of his wits. He does not know what he will do or say. If he did, his perception would be clouded by personal or intellectual concerns. In this case he is likely to lay out ready-made stuff. Thus art would be no different than craft or industry, the making of things for a stated purpose on the basis of known design.

Of inspiration born, art is not use-bound or knowledge-bound. It flaunts the old, the known, the sedimented, the crudely subjective. It goes forward into the world as nakedly as possible. Divine speech means annihilation of personality. Plato holds as proof the example of one named Tynnichus of Chalcis, a wretched poet and a tawdry personality, who nevertheless authored the "loveliest of all lyrics" in the Greek language (*Ion* 534e). Since no utterance so adamantine could come out of a source so crass, it follows that the song issues from a fountainhead beyond and higher than poor Tynnichus. His case for a nonpsychological, nonpersonal source of artistic expression entails that we do on occasion break with our own personality. We can choose to put it down to the workings of a deity speaking through us or, in less metaphorical language, to a sudden clearing of ego-driven consciousness, a suspension of our habit of reducing the world to what appears to us through the subjective keyhole. Exercise of reason is just such a renunciation of the crudely personal

8. Plato, *Ion* 534b, e.

self (everytime I see that "if 3 exists then so does 2," the impersonal speaks through me and triumphs over the wheedling self-sunk ego). But Plato suggests that art also brings liberation. It seeks a glimpse of things unrestricted to the accidents of psychology. And when this glimpse finally shines through, so Plato goes, then reality speaks.

Escaping personality, however, means struggling against our biological bent, which steers us toward self-promotion. It is not easy to shed oneself. It calls for dedicated practice, effort, will, and, in short, *work*.

CHAPTER 21

Art and Work

——————⟨⟨⟩⟩——————

IF ART MAKING WERE REALLY SO SIMPLE as expressing oneself, then to be an artist would only require having an exceptional personality. But this is not how it is. Artists are outstanding personalities only when seen from afar, in the limelight of fame. When they speak in their own words, in letters or diaries, artists speak of work, of mind-breaking and backbreaking labor, of drudgery, of the humbling conflict between imagination and reality.

The illusion of ease in art comes, first, from the work of art itself which, if well executed, erases evidence of strain. More recently, however, the idea of art's easiness has been distorted by all kinds of psychological voodoo about artistic release and catharsis; about accessing the left side of the brain, or childhood states, or involuntary memory—notions that stem from romantic half-truths about artists being inexhaustible founts of creation; and from certain surrealist cookery concerning the unconscious, psychic dam breakings, automatic writing, and stream of consciousness. These, in retrospect, seem like a scientific restating of the old theory of inspiration and divine fury. Nevertheless, it is a mistaken view that holds that inspiration is easy, that the artist just waits and suddenly channels miraculous voices. Inspiration is the outcome of flushing one's personality from the work; but once this is rooted out, the hard work still remains to be done.

And work, indeed, is how reality makes itself felt. Work is the dictate of necessity, of matter, of physical laws upon our life. To live is work. It is to labor

at staying alive. Work is the reality of our embodiment. Work marks the distinction between fancy and ability, between imagination and action, between intention and realization. It is the wall of reality between wish and achievement. "Making beautiful things," Van Gogh writes, "costs trouble and disappointment and perseverance. . . . It is working through an invisible iron wall that seems to stand between what one *feels* and what one *can do*" (*Letters*, 178). Perhaps the recurrence of workers and field laborers in Van Gogh's paintings, of hands and faces and tools and fields broken and furrowed by toil, evokes the laborious struggle between intention and actuality in art making. Van Gogh found in these subjects a reflection of the manual wrangle between matter and form from which paintings are born. "Painting is something that wears me out" (*Letters*, 320). For the hand need be broken, and the mind humbled by failure, by patience and duty and practice, before subjectivity can seep into matter. "My method is to love working," Cézanne says simply (*CC*, 127). Work reminds subjectivity of the hard edges of reality, the density and weight and gravity of things. Only when this reminder is duly accepted does nature enter art. Love of work, the kind professed by Cézanne, is a way of approaching reality, of agreeing to the tutorship of what undeniably exists, the world of paint and color and form that will not bend to the will. The artist loves work because through work he trudges through the thick stuff of life. The opposite of work is fantasy, which is the recumbent state of consciousness. Second to work, Cézanne's other method is, he says, "to hate what is merely imagined" (*CC*, 127). Imagination is insular, autistic, self-seeking. It raids reality for raw material and, once the plunder done, spares no thought for its source. It eats at the table and leaves without thanks. Love of work, in contrast, tarries with the given. It abides where consciousness is curbed and stymied and taught by facts—this patch of purple paint, the tripping cadence of a verse, gravity sculpting the dancer's dance. Work honors the experience of contact and embodiment that shapes everyday life.

"Where do I get this power of creating and forming? I don't know. I have only one thought: work" (*PA*, 49). The origin of art, so Picasso suggests, is humble. It does not start with demiurgic schemes or overweening ambition. These are the trappings of imagination. The artist is content with thinking small. He purposely restricts his goal to the task at hand. He agrees to become a drudge and a toiler; he lets others speak of broad conception, of high concepts, of genius. If there must be an origin to art, then let it be this deliberate

curtailing of the imagination, of the high-handed intellect that holds court. The artist is a foot soldier, digging in the trenches of the real. And this is so because, seen from a bird's-eye view, reality is lovelessly flattened. To the supreme being, reality indeed is putty. But this supreme being is sadly bereft of reality. Although he knows everything about reality, he lacks the living knowledge of what it is like to be caught up in it. This lack robs the world of wonder and mystery. The absolute demiurge, should there be one, would be a bored creature. Genesis in fact testifies to our refusal to envision such a demiurge. "And God saw that *it was* good." God, as we remarked above, is awed by His creation. To think of something is nice enough, but to behold it is *good*. There is a surprise to the *fact* of existing for which the mere *potentiality* of existing does not prepare. Reality is not a feature added to the conception. It transforms the concept. Existence, Kant once argued, is not a predicate. It does not qualify or exemplify or illustrate an already standing object. Instead, existence is so tightly bundled up with the thing, it so pervades its every particle, that the thing itself and reality are one. Existence *is* in and owing to existing things. This is why any object exceeds the thinking or dreaming of it—why God notices the thing's goodness *after* it is created.

In a sense, God set out to work in an artistic spirit—the self-same spirit that guides Picasso's hand. Creation begins not with conception, but with dogged toil on the near at hand.

The idea of artistic demiurgic potency is probably the invention of people who talk about art, not its actual laborers. It seeps into the language of artists only when they agree to become the laureled wizards whom devotees and profiteers want them to be. Andy Warhol airily exaggerated the pose of the genius (as his sense of camp exaggerated everything else) by declaring he was no artist at all, indeed that he left the business of making his artworks to others. This most probably was a swipe at the romantic pomposity of the demiurgic artist—at the beetle-browed Herculism of, for instance, Pollock. It scored the important point that, though work is crucial to art, the work of art itself should not advertise its labor, nor should the artist boast of tortuous effort. This would deviously raise the artist in importance over his toil. Neither difficult nor easy, demanding neither titanic sacrifice nor legerdemain, art is simply work. A maestro of the disappearing act, Warhol understood this and found himself steering between the double reef of romantic solemnity (the artist-as-godlike-creator) and antiromantic solemnity (the artist-as-hardbitten-drudge).

In the end he was done in by the pose of the artist-as-no-artist; but his example shows that, in relation to work, the artist must be neither a victor nor a victim. The moral lesson of work is submission—and such a submission should never be a prelude to triumphant one-upmanship (the artist as master of matter) or self-glorifying victimhood (the artist broken by his genius). To submit to work is simply to do what one does as best one can.

Though initiated during the Renaissance, the poster-size image of the artist as Living Force, as Godlike Maker and Shaper, gained steam with romanticism. It is by and large the product of critics and philosophers—intellects whose material, that is, ideas, as far more malleable than the plastic arts. Art criticism projected its habit of free conceptual play on the practice of art itself. Romantic philosophy aestheticized thinking. Logic in Hegel's lexicon is not the hard-and-fast rules of analysis, noncontradiction, things we cannot help saying. Hegelian logic instead refers to the winding vagaries of thought, the snail trail of the intellect through time, history, moods, and moral states. Indeed, thinking took on rather creative overtones. It was deemed to be a form of making the world. This aesthetic ideal invaded philosophy to the point where the philosopher took on the figure of artist. Hegel's announcement that art was dead paradoxically suggested that every human activity was art, that all material life was absorbed by our creativity—that nothing, not a daub of paint, nor a chunk of marble, nor a paltry rhyme, could possibly stand in the way of Spirit's assimilation of reality.

Down in the workshops of art, meanwhile, the work went on as before. At Jena the Real may well have been the rational; for people everywhere, however, it still required coping with; and for artists in particular it required encountering. How ironic is the juxtaposition that, just when German idealism proclaimed that reality was enchantedly infused by spirit, actual poets and artists created first-rate works of art in which disenchantment, precisely, was a prologue to a renewed bond with reality. Perhaps no poem speaks to this experience better than Wordsworth's "Immortality Ode." The occasion of the poetic utterance in this poem is, as is well known, loss of vision.

> There was a time when meadow, grove, and stream,
> The earth, and every common sight,
> To me did seem
> Apparelled in celestial light,
> The glory and the freshness of a dream.
> It is not now as it hath been of yore;—

Turn wheresoe'er I may,
By night or day,
The things which I have seen I now can see no more.
. . . I know where'er I go,
That there hath past away a glory from the earth.

Some have regarded the ode as a valedictory to declining poetic power; others, like Lionel Trilling, as an affirmation of continuing poetic strength.[1] I incline to think it is a meditation on the preparatory stage of poetic work. This state is indigence, penury of vision, renunciation of magic. The artist must shed the rich vestments of imagination before he can begin to see truly. To be sure, childhood is a wondrous time. It laces perception with imagination, reality with fancy. The child lives as if in daydream where self and world have not parted ways. But just for this reason a child is not capable of a full-fledged artistic utterance. Poetry, so Wordsworth first laments, then celebrates, begins when self and world have grown estranged, that is, when self and world are capable of encountering each other. For no longing acknowledgment of separation, hence no encounter, is possible wherever the self incontinently suffuses the external world. It takes being in exile from the world to meet the world.

Now, this process of meeting the world, of homecoming, occupies the poet for the duration of the ode. It is the task of art. And work, precisely, is the means to bring this task to fruition. The world may be reentered not by galloping imagination, but by religiously adjusting perception to what is there. Since perception is entrenched in the mind, it requires the breaking hand of labor, the chastening rule of work, the extracting power of toil, to bring it into attunement with what it is not, that is, matter. Oneness with reality came easily to the child, Wordsworth suggests. For this reason, however, it was only an imperfect oneness, based on unselfconsciousness. Contrast this with the affinity between mind and world, such as the ode happily achieves in the final stanzas. From suffering the discord between self and reality, the poet discovers love—the sort of love that labor has infused with respect.

Though nothing can bring back the hour
Of splendour in the grass, of glory in the flower;
We will grieve not, rather find
Strength in what remains behind;
In the primal sympathy

1. L. Trilling, *The Liberal Imagination* (Garden City, N.Y.: Doubleday Anchor Books, 1957), 125–54.

Which having been must ever be;
In the soothing thoughts that spring
Out of human suffering;
In the faith that looks through death,
In years that bring the philosophic mind.

Work is the opposite of intoxication and ecstasy. Both bring easy feelings of union simply because the mind is too enthused, too self-enthralled to notice otherness. "To arrive where you are, to get from where you are not, / You must go by a way wherein there is no ecstasy," T. S. Eliot writes in *Four Quartets*.[2] Indeed, to step out of the world of thoughts and dreams, to pull back from the unreal where we are not, and reenter the present, the concrete, the here, the poet must fold in the wings of fancy. Imagination is the artist's trickiest temptation. For imagination is necessary to go beyond the world, which every work of art must dare overleap. Reality alone cannot make art. The Napoleonic Wars could not have spawned *War and Peace*. A sighting of naked women could not have produced Picasso's *Demoiselles d'Avignon*. It takes an act of imagination to travel beyond the given. But imagination without love for what is left behind cannot produce art. The wish to return to reality sets the great artwork apart from the hack job. Thus as imagination leaps forward, work reins it backward. As it lunges out for utopias, for cloud-cuckoo-land, for the not-yet-existing, the work of art bends itself back to what is lowliest and nearest: the thickness of oily pigments, the numbness of stone, the leadlike drops of musical notes, the stubbornness of words. These cannot be trifled with. Work is their language. And through work, the self speaks the idiom of things.

 "It is work, and hard work, disagreeable work," says the painter Thomas Eakins (*AA*, 355). Work is hard because it is unnatural for consciousness to want to limit itself; and it is aberrant for the will to seek its own taming. Yet through work we seek our chastening; it breaks our back and our will. And in the end the work is done and needs us no more. An artist works for the sake of working—lest the work of art be treated as a means. Thus the artist works and lets go of the fruit of his labor at one and the same time. But how to let go and create at once? How can the surrender be creative without being overactive? To do so requires striking the balance of Nature herself. It is, for instance, the equipoise of surrender and creation that carves the wave out of the sea, or sways the branch in the wind. Nature is equilibrium between striving and

2. T. S. Eliot, "East Coker," in *Four Quartets*.

obeying, between gathering and dissolving. A cloud is an effect of creation as much as of decreation. For without the forces that unravel it, the cloud would not hang in the sky. Creation in nature is a form of letting go. And letting go gives rise to new forms. The surging wave is made of the emptying of the surrounding waves. The ocean creates and uncreates itself at the same time, in no point clinging to itself, but everywhere rising and dying, given and taken away. All happening is a passing, all creation an undoing, and all undoing the shaping of a given.

The artist at work seeks to emulate the movement of nature, the balance of obedience and creation in all things. It is the "easy give and take" spoken of by Jackson Pollock. Artistic work—both holding up and letting go—imitates the movement of the universe.

The Comedy of Art

———— ❧ ————

NATURE SHOWS NO VANITY, NO PRIDE. It does not angle for exception or permanence. Nature is serenely untragic. Tragedy arises whenever there is resistance, indignation, pride, stateliness, a cling to permanence. Tragedy is self-regard writ large. Comedy by contrast happily tosses out self-concern. It is revel and song (Greek, *komos* + *aeidin*). Just as the cloud, or the wave, or the long grass in the wind gives in to the rhythm of necessity, so comedy surrenders to the natural sway of things. Comedy agrees to necessity as much as tragedy rears against it. Shakespeare gave the Fool a deeper affinity with the cosmic than the foremost of men, King Lear, who kicks and whimpers against the tide. The Fool sees that constitution and dissolution flow into one, whereas the tragic king, the individuated man, woefully tries to stop the world of creation and destruction.

The genuine artist is the Fool, even when he postures as a tragic king, even when chance, society, weakness, suicide, or failure drowns him in sorrow. Even then the artist remains comic because the artist is in tune with the music of nature, that is, with grace and obedience. For if the artist stops agreeing, if like the King he rails against fate, then the personal in him starts emoting. The comic root of art is cut off and the artistic work stands alone, waving to gain attention and admiration. Hamlet, for one, knows better. Though tragic, the spirit of reconciliation in him runs stronger than indignation. This is why he plays the fool; why, in the throes of fate, he has time to laugh at his own puppetry. With fierce joy, he understands that the making of his life is also its un-

making. The tragic in him wants to erect monuments, climb out of life, and cast a sorrowful eye upon creation. But the comic knows there is no way out of life, that death too belongs to life. "If it be now, 'tis not to come; if it be not to come, it will be now; if it be not now, yet it will come: the readiness is all: since no man has aught of what he leaves, what is't to leave betimes?" (5.2). In the end, the stoic smile of comedy wins out and the prince submits to silence with a quiet heart.

Comedy entails accepting death. Pratfalls, it is said, are the essence of the comic, the tumble from the high to the low, from the spirit to the flesh, from the ethereal to the ground of dirt and seed and ashes.[1] The knockabout stumble, the unwanted fall, gives consciousness an intimation of its demise. It is a reminder of the weight and authority of matter over spirit. To lose one's footing, to trip, to blunder into awkward places—these clownish intrusions of the physical into the psychical are also part of the artist's workday. For making art requires a willingness to go wrong, to botch and bumble. Attachment to the polished dooms an artist. A flawless exterior bespeaks timidity, playing it safe, oratorical incuriosity. It is art is petrified by the fear of causing displeasure. Shying away from risk, the second-rate artist misses out on the adventure of reality. He loves his brushes more than he loves reality. Not so with the courageous artist. Out of love for reality, the latter happily dons the fool's cap and agrees to go out and bungle and stray. He agrees to be the inept one. "I don't know how to write poems; I don't consider myself a poet," says poet Henri Michaux. "I must impress upon myself that I know nothing at all, for it is the only way to progress" (Degas).[2] Cézanne declared: "With my tube of paint, my brushes in my hand, I am nothing but a painter, the last of the painters, a child . . . I forget everything I know" (*CC*, 127). This is the artist's trial: to concede to being the least able of all artists, to forget his stock-in-trade, to be the untutored idiot.

"My kid could do this." And indeed foregoing the squeaky finish of classical art, the price-fetching look of meticulous labor, the masterly touch—to do this, the modern artist takes on the risk of ridicule. He accepts the academic shrug, the rude dismissal, the critic's smirk, the jibe that he finger-paints like a child or a madman, that his music sounds like a poultry slaughterhouse, or that he writes poems of so few words that they may as well not exist. Through

1. M. Bahktin, *Rabelais and His World*, trans. Helen Iswoskly (Bloomington: Indiana University Press, 1988).

2. In *Degas by Himself*, ed. Richard Kendall (Boston: Little, Brown & Company, 1988).

it all, the artist, especially the modern artist, faces the danger of falling short of expectations. This anticlimax is, of course, a well-tested spring of comedy. Is this all? A few seemingly slapdash drippings of paint, a urinal lifted from its rightful place and plopped down in an art gallery, four minutes and thirty-three seconds of silence, a granite square. The artist does not court laughter but he does not shrink from incurring it either. Indeed, he would sooner be a buffoon who irks and disappoints than a courtier who curtseys and flatters. Comedy is an irritant if only because it depicts things that go wrong. It thus pulls the veil off the pomposity and the humbug of social reality. At its best, art avoids the trap of taking its own debunking seriously. For beneath the mask of comedy is the stare into the vanity of all things, the emptiness of all attempts, including the work of poking fun itself.

Tragedy rebels against the contingency of existence. "The gods are being unfair to me," says the tragic hero. Deep down, he is unable to accept the randomness of life and would rather see himself as the butt of a cosmic plot, a sacrificial victim, than accept the stark objectivity of events. Not so comedy. The comic artist is happy to accept that what is random is meaningless. He does not seek to impose a scheme on life's vagaries; these are proof that he is alive, that the world is real, that things have a will of their own. The artist as comic character thus courts chance because he knows it leads to reality. "I'm often astonished to find how much better chance is than I am. . . . It introduces objectivity" (Gerhart Richter).[3] Chance is the opportunity to escape contrivance, the all-too-human. It is a tumble into reality. The better one falls flat on one's face the deeper the thrust into the real.

"The very ambition to compose a poem is enough to kill it," Michaux says. To *intend* a work of art is to protect oneself against the surprise of it. And there is no art without this sort of stumble. The artist must fall. Ultimately this fall is an acknowledgment of one's frailty, indeed of one's insignificance.

The tumblingly beautiful poem "Clown" by Michaux comes to mind. Like Shakespeare, Kafka, Beckett, or the Zen masters, Michaux understood the religious intelligence of comedy. In "Clown," the poetic self looks forward to the day when he becomes nothing. I will tumble from great heights, he says, like a fool; I will fall and fall until, crumpled and broken and useless, I am a stringless puppet, a laughable residue. But from this being no one, the most ungainly of humans, a new freedom will arise.

3. G. Richter, *Daily Practice of Painting*, 159.

A clown, grotesque amid ridicule and laughter and guffaw,
kicking down the notion that, against the light of evidence,
I entertained about my own importance,
I will dive down.
Unsparingly into the infinite spirit beneath, open to all,
And I, too, opening to a new
Incredible dew,
By sheer strength of being nothing,
And low . . .
And laughable . . .

Laughter degrades but also readjusts. Things return to their proper measure. The archduke catches his sword in the doorway and the mere man emerges out of the role. The comedy comes from the discrepancy between the inflated sense of human importance, of what looks so large when close at hand, and the indifference of nature. The comparison between man and the universe is always incongruous. Schopenhauer built his theory of laughter on the notion of discrepancy,[4] discrepancy between aim and result, intention and achievement, meaning and actuality. Incongruity is never so wide as when we set side by side the pretensions of human activity and the universe. This discrepancy is a source of laughter that rings now with tragic alarm, now with comic abandon. That Hamlet gleans insight of the great human incongruity in the orbs of Yorrick's skull, the dead jester, tells plenty about the comic color of wisdom. In the comedian was first vested the awareness that all is naught and naught is all, that the gods toss us around for their fun, hence that laughter is the background music of life. Wisdom consists in learning how to join in the cosmic guffaw.

Frivolity shadows art wherever it appears. This is not to be bemoaned. Laughter is a way of accepting the travails of living and, ultimately, the nonimportance of striving. Laughter is the smile of acceptance that follows the wince of resistance.

In objection, one could adduce a great many artworks that are resolutely uncomic—works riven with suffering and indignation. To spot a twinkle of mirth in Picasso's *Guernica* or Goya's *The Shootings of May Third, 1808* or Henryk Gorecki's *Third Symphony* would be obdurate and foolish. But the comedy of art is not a question of subject matter. The comic lies deeper; it is

4. A. Schopenhauer, *The World as Will and Representation*, trans. E. F. Payne (New York: Dover Publications, 1969), I, sect. 13.

bundled into the nature of images. Should Picasso have been wholly consumed by the bodily suffering, the rage, tears, and horror of the carpet-bombed Spanish town, no escape from reality to the image would have been possible. Art is an expression of uplift and survival, for only he who surmounts the drowning, to use Primo Levi's phrase, can begin to speak. While this is not exactly grounds for comedy, it is grounds for hope—and wherever hope casts a glimmer, joy may follow. Being imagelike, art has the effect of removing things to a distance—and distance shrinks them, sometimes dwarfs them, at any rate sets them before the larger *mysterium tremendum* of life itself. The upshot is a kind of "Vanitas vanitatis" that is no prelude for lament but for surrender, a bracing realignment of perspective, happy reconciliation with our smallness. This is also why, even from the howling depths of hell, Dante's masterpiece is still a "comedy."

Willfully naïve, awkward, given to pratfalls, the spirit of comedy inspires the refusal of technical perfection. An artist guarded by his know-how has lost the heart for art. At any rate, he has lost interest in adventure and this seals off the road to discovery. In truth, the good artist's rejection of technical expertise and proficiency goes further than shunning it. It also wills to undo technique. Listen to Van Gogh:

I am determined, *even* when I shall be much more master of the brush than I am now—to go on telling people methodically *that I cannot paint*. Do you understand? *Even when* I have achieved a solid manner of my own, more complete and concise than the present one. (*Letters*, 271)

He who is proficient has lost touch with reality, for reality is not a course of study. Reality must find us ready, but not knowing; eager but not jaded. The artist needs to be "slow of tongue and despised as such" (*Letters*, 270). The lover of reality never takes his beloved for granted. Reality is surprise: no two blades of grass or clouds or faces are ever the same. The artistic technique must keep up with this flowering of surprise. To do so, it must be ready to upset its own ways, to strip itself clean of assumptions, to be naïve, unguarded, fumbling.

Naiveté, primitivism, absence of stylistic affection—these are features of the modernist aesthetic expressed by the works of Gauguin, Picasso, Klee, Dubuffet, or Kalho. They are responsible for the often raw, rustic, rough-hewn look of twentieth-century artworks. This primitivism carried on the romantic campaign of liberating expression from polite conventions and yield-

ing instead to spontaneous, uncontrived originality.[5] Curiously, however, an opposite trend in the same period emphasized technical sophistication and rigor. Beginning with futurism, and then later in Russian constructionism, the Bauhaus School, the systematic aesthetic of absolutism and minimalism, or Schoenberg's pioneering of duodecaphonic music, the artistic soul aspired to give aesthetic composition the rigor of pure structural intelligence. "We must free ourselves from our attachment to the external," the painter Mondrian writes, "for only then do we transcend the tragic, and are enabled consciously to contemplate the repose which is within all things."[6] The tragic is, on this view, our indenture to nature. To find the inner structure of things, the necessary skeleton beneath the random appearance, amounts to liberation: from impression, illusion, attachment. To do so, the constructionist banishes fancy and casualness from his style. To be sure, the emphasis on technique pretty much precluded the stumble into comedy—since comedy is stumble—but neither did it signal a triumph of human agency and self-possession. In fact, quite the opposite. Stern obedience to technique is as successful in rooting out the crudely subjective as, at the other extreme, total rejection of technique. Thus Seurat would take umbrage at admirers who praised the poetry and heart of his paintings. "I merely apply the system," came his cool rejoinder. There is a thirst for depersonalization in the all-out pursuit of technique. The modernist ideal of a machinelike work of art that makes itself, fascination with unmanned devices such as the camera or recording tape or radio sets, self-fulfilling process music, hyperrealism—all these are distant, perchance perverse, heirs to art's love for nature, for producing an expression unwrinkled by human noise. "Each picture has to evolve out of a painterly or visual logic: it has to emerge as if inevitably. And by not planning the outcome, I hope to achieve the same coherence and objectivity that a random slice of Nature . . . possesses" (Gerhart Richter).[7] Technique is thus a practice of self-humbling. Nothing is more unfunny than technique—for laughter requires that things go wrong. Nevertheless, technique, like comedy, is a practice of acknowledging our conditioning by forces that overpower our mastery. In the end, artistic technique seeks the same union with nature, with "the repose which is within all things" that comedy recommends.

5. C. Rhodes, *Primitivism and Modern Art* (New York: Thames & Hudson, 1994).

6. D. Sylvester, *About Modern Art: Critical Essays, 1948–1997* (Boston: Henry Holt & Company, 1997).

7. G. Richter, *Daily Practice of Painting*, 216.

The Religion in Art

—— ❧ ——

THERE ARE THUS VARIOUS WAYS in which art nears nature—none of which are emphatically imitative. These are, to sum up: love of perception, love of necessity, love of work, the love of comedy, and renunciation of technique or, to the same effect, all-out embrace of technique. With the love of perception, the artist does justice to the side of mind that leans on the external world; he learns to dwell on the cutaneous edge of consciousness where world and self interweave; he surrenders to the outward-facing side of mindful existence. With the love of necessity, the artist learns to accept the imposing reality of actual things; no longer the humiliating straightjacket of blind nature, necessity now seems the wise adjustment of force and counterforce, the give-and-take behind all things, and human attunement to this cosmic balance. Necessity reminds the artist of his physical connection to things. Just as the lay of the land heaves and rolls under the pull of mechanical necessity, so the artist's hand learns to feel the gravity in visible things, in his materials. With the love of work, the artist accepts being weaned from fantasy. At grips with the thingness of paint, marble, or words, he learns to jettison dreams of mental omnipotence and spiritism. Labor is a token of his earnest acknowledgment of material reality. With love of comedy, art becomes infused with bodily life and mortality. Comedy gives the artist the nerve to falter—for every misstep from the planned itinerary is a step into the wilderness of unexpected things, the unthought of, the untouched, the real. Forsaking technical savvy, the naïve

artist steps up to the work free of prejudice—with the same freedom from arbitrary meddling also afforded, strangely enough, by strapping oneself to technique.

Underpinning all five forms of love is the renunciation of ego. Ultimately the artist is thunderstruck by the accidental nature of his personality. Overcome also is the pathetic fallacy, our habit of smudging our feelings and moods all over the external world. And as it grows, the artwork too acquires reality, an independent nature, hence making it worthy of freedom from subjective encroachment. The artist learns to respect his work. Finally he sees that it is not his.

Presently the artwork overcomes the birthmark of manufactured things, of our normally slapdash, loveless, contemptuous handling of things. Though human-made, it is not a whim of the will but the will curbed and humbled. Perhaps indeed art is precious in the way sacrifice grows precious in proportion to how dear the gift is to the giver. And the gift here is subjectivity, our proud autonomy and separation. Herein lies perhaps a reason why nature seems awesome to the beholder: because ultimately, through birth, health, aging, and disease and death, nature holds us captive. In which case it is our own helplessness we gaze at in nature—a feeling that Kant was too timid to ascribe to the beautiful (man-made art) and instead gave to the sublime (nature). He should have trusted his own insight that beautiful works do not seem made, and thus understand that the beauty of art too turns on the retreat of subjectivity—that art, like nature, can elicit a kind of holy terror, the terror felt by subjectivity on the brink of self-release.

In summary, art enshrines the old sense of reality marginalized by overweening rationalism, scientific inquiry, philosophic subjectivism, and triumph of the human-made world. Civilization is the victory of thought over nature. What might does the river really possess when a mightier dam can block its flow? What residue of reality can an atom possibly hold when it too is liable to tweaking, when the genetic constituents of life are pried open to design? Rightly is it said that reality holds no enchantment for us moderns and Westerners—that its mysteries are magic spells no more but algorithmic riddles awaiting formulation. Religion, wherever it survives on the margins of science, still enshrines the old wondrous sense of reality; the sense that life ultimately is fantastic and inscrutable; that it is a sum of which we were mere parts. But religion has by and large lost much of its former authority. While it

still holds sway over the inner life, over matters commonly described as "spiritual," it rarely meddles with science's monopoly over the business of framing and explaining external reality. God is removed from the run of social and intellectual life, and people who still suppose the universe to be an intelligent person that takes interest in us are, to the philosopher, the cause of bemusement or nostalgia.

Reality has followed religion into the disappearing spiral. From Descartes's grounding of metaphysical inquiry in the thinking subject to postmodernism's mantra that all is text, reality has gone into constant downward reassessments. Science has made it undignified and passive and postmodernism sees only a dream dreamt by language. Thus we are said to live in a disenchanted world made up of mathematical laws and words.

But this, in fact, is a misconception. More to the point is it to say that we have traded one kind of enchantment for another. For a world in which everything is thought to be human-made, a world that is an exitless stage where all is made up of our artifacts, projections, dreams, and creation—this, then, is really a spellbound world. It is in the thrall not of gods, but of humans. Spirit has not deserted it. But it is the spirit of human intelligence colonizing reality down to its smallest reach.

Art has the power to lead us out of human-centeredness. Like religion, it restores dignity to reality. Of course, it is a fact that religion has not always dealt generously with reality. Take, for instance, the streak of world renunciation at the heart of Christian dogma. Whether this stems from the Platonic distrust of phenomena, Roman stoicism, or the influence of Augustine, Christianity has often shown disgust for and rejection of physical reality. It is a veil of illusion, the Veil of Maya, say the ancient Vedas. It is a prison-house of attachment and pain, of Samsara, says the Buddhist. Clearly, world renunciation is one pillar of religion.

But religion does not stand on one pillar; it certainly cannot stand on disgust and negation alone. The other pillar of religion is, as befits strong structures, symmetrically opposite. It dedicates itself to maintaining intense attention to the reality of beings and objects outside the mind. The religious life is born when the nonself is perceived with the same degree of attention and respect as those things that belong to the self. To describe how reality can win ascendancy over the mental, some religious traditions personalize reality; they suppose that a god inhabits it or that it is God. Other traditions, among them Buddhism, emphasize the godliness of reality—by which is meant not that

God lives therein, but that to see reality with the utmost quietness and clarity is near to seeing the universe as the universe sees itself. It is a transcendence of the ego and therefore a kind of godliness. Whichever the tradition, religion requires a reorientation from the self to the nonself. "Do unto others as you would have them do unto you," says the Golden Rule. This means give external existence the same degree of respect and attention as you give yourself. Religion means broadening our mindfulness, hushing our solipsistic soliloquy, and, through prayer or devotional act, allowing reality to shine into the mustiest reaches of thought.

Now art, whether the practice or appreciation of it, operates through a similar effect. Art retails in the perceptible, and the perceptible implies presence. The eyes and ears are wide-awake to the concrete features of the art piece, its volume and nuances and tonality and movement. The mind delves in the particular, the irreplaceable, the unduplicatable. It matters not whether the object in fact is a duplicate, such as a photograph or a serial object. Some have supposed that mass duplication has killed art's aura of presence. This is a partial view, for aura is a property not of the object alone, but also of the quality and intensity of our attention. If one's awareness of the photograph is serious and passionate, if the serial object is the focus of one's entire being, then it is inconsequential whether ten thousand copies of the same object are extant. For the mind strikes an encounter and encounter occurs in a unique intersection of place and time. If we truly give ourselves over to the piece, if the climate of our mind turns blue from the blue of Bellini's sky, if then reality returns the compliment and breaks through the mist that dulls our everyday perceptions, then we are in the presence of vibrant existence. Now we say "you" to reality for it is not something about which we talk or extract knowledge; rather, it is a presence *to* which we address ourselves. And this experience, finally, is just the nerve of the religious insight.

Art, then, is a practice of religious attention. This of course upends the modernist construal that subordinates religion to art. The subjectivist cast of modern thinking holds that religion, science, politics, philosophy, and culture in general are intrinsically aesthetic because their truths and values are human-made, hence artifactual, and therefore artistic.[1] The argument of this book urges the opposite and presents art as one way in which the religious

1. This common idea informs even quite profound inquiries into the connection between art and religion, such as T. R. Martland, *Religion as Art: An Interpretation* (Albany: State University of New York Press, 1981).

disposition expresses itself. Of course, as a scholar of art and religion writes, "There can be and there is art wholly unrelated to any religious end."[2] Obviously many works, such as, say, Manet's *Olympia* or Claes Oldenburg's giant *Clothespin*, show little evidence of religious feeling. But if the work of art is genuine, if the artist's dedication to the work and the reality unfolding before his eyes is complete, then the outcome is religious in spite of its subject matter, indeed in spite of the artist himself. The subject matter need not be evidently religious. Religion is a quality of attention, a degree of kindness and receptiveness. This is why, for instance, the quiet moments of domestic life in Vermeer are forms of religious thanksgiving. The serene dutiful absorption of the milkmaid pouring milk from the earthen jar is an image of the artist pouring his care upon her, dedicating his careful skill to testify to her reality. Religion is present wherever generous attention holds sway, wherever seriousness trumps glibness, and wherever absorbing work outweighs sensationalism. The poet Rilke thought Baudelaire's "Une Charogne" (notoriously about a swarming carcass) was a religious poem because of its attention to that most abject reality.[3] How much love, how much care and regard, went into that small etching of that hare by Dürer. Great art occurs when the reality of the depicted eventually overruns the artist's intention to hone his skill at the object's expense, or when the reality of the work overtakes the artist's purpose. This is why a sacramental aura shines out of modern secular masterpieces, why the silence of reflection, of reality respected, of beings and objects duly seen pervades, to list at random, Serra's sculptural installations, Rothko's meditation pieces, but also Warhol's portraits (a risky flirt with idolatry), or the works of Kline, Klee, Matisse, Rodin, or Hopper.

Hobbes remarked sardonically that any object, however trivial or ridiculous, can become and indeed has at some point in history become the object of religious devotion—to mean that the divine really dwells with the projecting mind rather than with the recipient. "The Heaven, the Ocean, the Planets, the Fire, the Earth, the Winds, were so many Gods. Men, Women, a Bird, a Crocodile, a Calf, a Dogge, a Snake, an Onion, a Leeke, Deified."[4] Of course, Hobbes is factually correct. To worship an onion or a crocodile is self-worship because man simply reveres his own power of elevating objects above everyday

2. E. Gilson, *The Arts of the Beautiful* (New York: Scribner's, 1965), 171.
3. R. M. Rilke, *Letters on Cézanne*, trans. Joel Agee (New York: Fromm, 1985), 68.
4. T. Hobbes, *Leviathan*, part 1, chap. 12.

life. But to worship an onion is not always to lend it personal features. It means to perceive it for its own sake, for the sake of letting it become present. Then it gains an aura of uniqueness, of rare existence, of preciousness that is indeed personal. This is no anthropomorphism, for the object need not be assumed to have an intelligent presence. Rather, it is the birth of an individual connection. For whereas an onion is indisputably not a person, no other onion can be this onion in the way this precise one is. The religious mind does not so much deify objects as open itself to their heart-stopping presence. Hence the miracle of Cézanne's apples, of Van Gogh's sunflower, of a shadow on Rembrandt's cheek in one of his many self-portraits. It is reported that some Native Americans pray by sitting together with eyes open and naming every object in sight.[5] There is not any question of deifying or anthropomorphizing or spiritualizing things; the point is to dust off everything that is casual and instrumental and slapdash in our attitude toward them; and instead to pause on the coincidence of our presence in time and place with them as the tremendous occurrence that it is, a moment as great as infinity because, like infinity, it is unlike anything outside itself. "We must dare to believe that what is, is" (Van Gogh).[6] Noticing objects with complete dedication, not just with the timid feelers of psychology, but with all of one's sense of self; not just through the keyhole of the profit-bent mind, but infused with the realization that this is our life and that it is happening: these are actions by which the so-called object-worshipping primal religions give testimony of the identity of artistic attention and religious attention. Here lives the truth that religious concentration is artistic, and that artistic attention is love of the world.

5. H. Smith, *The World's Religions* (New York: HarperCollins, 1991), 371.

6. V. Van Gogh, *Letters of Vincent Van Gogh*, ed. Ronald de Leeuw, trans. Arnold Pomerans (New York: Penguin Books, 1996), December 1888, 424.

CHAPTER 24

Art and Love

————— ❧ —————

The great secret of morals is love, or a going out of our nature,
and the identification of ourselves with the beautiful which exists
in thought, action, or person not our own.

<div align="right">P. B. Shelley</div>

THE ASPECTS OF THE ARTISTIC TEMPER so far surveyed shear off a pole of the artistic dynamic that art simply cannot do without: to wit, the subjective.

What, after all, is art if not personalities expressing themselves and imparting human design upon matter? Monet may have wanted to paint merely what the retina mirrored; still, in the end, he painted like no other before him, and an undeniable infusion of the Monet personality pervades his canvases. Likewise there is a Titian "take" on reality that is not Rubens's, a Constable way of painting gray watery skies that is not Corot's, or again a Twombly way of rendering the four seasons that is nothing like Vivaldi's. No two artists have transposed the same landscape or object in exactly the same hues and forms. This, then, should be where art's commitment to reality expires—on the evidence that no two artworks have ever been able to agree on the same terms for what reality looks like.

Likewise, the notion of art as work, sacrifice, technique, blessed ignorance, fragility, and love of nature in the end sits ill with art's affirmative character. If

art truly is to be lifelike or life loving, then how can it demand the sacrifice of one of the terms of reality, the subject? To the subjectivist we must grant this point, that reality bereft of the human viewpoint is a bony abstraction. The human element must be worked into reality if truly the claim of telling reality like it is holds any weight. "Reality is one part; feeling completes it" (Corot; *AA*, 241). "Everything which we call nature, in the last analysis, is a figment of the imagination" (Malevich).[1] Reality is reality perceived, and reality perceived entails a perceiver. This, at any rate, is basic.

Subjectivism is correct to point out that bracketing personality yields a picture of reality negatively tinctured by the self—if only because the self's withdrawal leaves a ripple on the perceived. Even when we strive for objectivity, we still dye reality with the brush of our subjective mood—even if it be the mood of self-abnegation.

In general we should be wary of the self-mortifying streak of impersonality in art. In fact, erasing the self has been a fashionable critical hobbyhorse ever since Parisian structuralists heralded "the death of the author," the advent of the anonymous "Text," and the reign of the even frostier "différance," all harbingers of a jubilant surrender to a machine aesthetic. These heady days now seem on the wane but they have left a powerful taboo in their wake, one that prohibits appreciating the work of art with anything remotely savoring of biographical interest. A poem, a painting, or a piece of music is a transformation of personality, an alambic into which the artist's life is distilled, transfigured, elementally cleansed of biographical dross.

This of course is true enough—within limits. Beyond them, our appreciation of art becomes blindly technical. Some works are inseparable from their biographical context. It does not deflect from the *Divine Comedy* to have some awareness of its author's embroilment in Florentine politics. Oscar Wilde's *De Profundis* without the background of the author's emprisonment at the Reading Goal is an eviscerated read. Paul Celan's poems are elegant riddles, not strangled cries, if abstracted from the poet's experience of the Shoa. To be sure, a great work of art is strong enough to stand alone, but its meaning can never be wholly self-contained. Only the universe as a whole is self-contained, which is why it is meaningless. Anything less than the universe has meaning by virtue of relating to other things.

A work of art is made by *someone*. To take a painting or poem as just a sys-

1. Malevich, *The Non-Objective World* (Chicago: Paul Theobald and Company, 1959), 20.

tematic or random or nonintentional assemblage stems from orthodoxy. It requires as abnormal an attitude as that of picturing oneself having a conversation not with a friend, but with a friend's words. Many an ineptitude would be avoided if the critic kept in mind that a far-fetched or theoretically forced reading sins not only against a piece, but against a person. Critics who, in the style of Stanley Fish, decree that a work's meaning is strictly what the critic can persuade us to believe commit the moral offense of plagiarism or wrongful attribution. For if the work of art speaks now, it is because a human once spoke through it. To twist his words out of recognition is no better than to bully the person, to rob him of humanity—the same way we strip others of humanity when we impound their ability to speak for themselves.

A person is present in the work of art. Rembrandt looks at us from out of his self-portraits with a nakedness and honesty of which he was perhaps incapable in life. If anything, a work of art often purifies subjectivity of the fidgeting and posturing of social life. Of course, the effort is never free of window dressing and self-vindication. Even the warts-and-all pose pioneered by Rousseau sugars the truth; an excess of honesty can be a boast of superhuman immunity; a voice undeniably gets entangled in the vagaries of textuality and sometimes ends up unknowingly recanting itself. But in the end these phenomena are interesting on account of their human drama. It is because subjectivity toils at its own erasure that the subtleties of desubjectification capture our imagination. The deconstructionist who gloats over words that break away from their author's intention still thrills at the *human* comedy of it. Even the most skeletal artwork proclaims subjectivity, if only in the wish of hiding or withholding it.

Now, this said, the upshot is not that the striving for clear vision is moot and that we should write ourselves an all-relative, reality-is-what-you-make-of-it blank check. Giving up on the will to transcend rank personality means packing off not just art, but also justice and morality. Whenever we give up self-overcoming, injustice sets into human affairs, bestial aggression or cowering edges out morality, idolatry invades religion, and sentimental or pretentious trash replaces art. Our last chapter will seek to establish which, of all human dispositions, is best suited to join self and reality, to let subject and object stand in equal partnership. The answer is love.

<div align="center">⚜</div>

Our world is shot through with wishful thinking. By nature, the mind recoils from the unpleasant and the eerie, and indulges in the soothing and ha-

bitual. It is as unnatural for the mind to seek the chastening edge of reality as for the flesh to seek pain. We have art lest we should die from the truth, Nietzsche once said. The statement is, in my view, wrongheaded, but let us understand it as saying, in part, that we have consciousness to shield us from reality. To pierce through our mental padding, a sharp painful jolt is sometimes necessary. A wife leaves her husband and he realizes that his lazy domestic peace masked her utter boredom. My dreams of superiority at chess or tennis are crushed by ringing defeats. Inner expectations are laughed at by facts. These are everyday occurrences in which reality is rightly said to "check" and often checkmate us.

Such interventions, however, are suffered by the mind but are not of the mind's devising. They come to us. So the question really is to find out whether the mind can of its own accord seek reality at the risk of rebuke and humiliation, whether, that is, the mind is capable of disabusing itself without being forced to. Are we always coaxed, charmed, or cowed into facing reality? Or can the mind open freely?

The answer is that it can—this, in the last instance, is the good tidings of religion and philosophy, to wit, the news that the mind possesses the means to go beyond itself. Simone Weil puts the matter thus:

The mind is not forced to believe in the existence of anything. . . . That is why the only organ of contact with existence is acceptance, love. That is why beauty and reality are identical. (*G&G*, 56–57)

The philosophic background is Cartesian skepticism. Wrapped up in itself, the mind is segregated from reality. What we know, we obviously select and everything we near is coated with the resin of our awareness. "What is the essence of our consciousness?—The inability to apprehend reality" (Malevich).[2] Now, given that the mind cannot reach reality by nonmental means, and given also that these nonmental means, should they be successful, would not be a human achievement (What worth would there be to fusing with reality without being aware of it?), the goal is to identify the mental state that is freest from subjectivity. This exceptional state, Weil suggests, is love.

Now, obviously, these means cannot be intellectual. Ideas are representations and representation leads away from reality. We take it from the mouth of the archrationalist himself, Socrates: reason alone does not purvey passage to reality. A more complete state of being is needed, a complete giving of the

2. Malevich, *Non-Objective World*, 20.

self to the truth. The Socratic weaving of truth and love in *The Republic* and *The Symposium* finally suggests this: that the brightest, most disciplined intellect remains blind so long as it is ruled by ideas. For a well-ordered mind is not necessarily a lucid one. What lucidity requires is a passion for reality. To want reality, the mind must admit being short of it, hence in some sense inadequate. "Let us then acknowledge our range: we are something, and we are not everything . . . The scant being that we have hides from us the sight of infinity" (Blaise Pascal).[3] The spirit of love inspires this admission. A creature thoroughly inured to love basks in self-satisfaction. For nowhere in it is there room for doubting that its perception of reality falls short of reality. The notion that we are mentally limited arises because love for reality is more powerful in us than the regard for inner mental coherence. In truth, nothing forces us to acknowledge our limitation. The animal way of being is solipsistic: a beast does not reflect beyond his perception. The whole universe boils down to his immediate sensitivity. He shows no sign of intuiting a reality outside his hunger, or fear, or satisfaction. This is because a beast lacks love (though he may know devotion). Love is the state of awareness that grasps the discrepancy between mind and world; it is that by which we are able to say that reason is finite. (And this no doubt means that, as constructionist, subjectivist philosophy says, reason, or text, or language is infinite, it shuts itself out from the inspiration of love. Hence the reason why little is spoken nowadays about the kinship between love and philosophy.)

Though an externalizing force, love of course is produced in the mind. There lies the difference between love and lust. Lust tugs at the body. We succumb to an external attraction, we surrender, we "fall." Our emotion hangs on externalities; it rises and falls with them. So lust only lasts as long as desire lasts—and there is no friend more fickle than desire satisfied. We are the plaything of a moment that delivers us back to ourselves hardly changed, only bewildered.

To achieve a more lasting condition, the passion for reality must not be passive and dependent on circumstances. It must be an achievement, produced freely, and not, as in romantic love, chanced upon. In the words of Eric Fromm:

3. B. Pascal, *Pensées*, trans. Honor Levi (New York: Oxford University Press), 69.

Love is an action, the practice of a human power, which can be practiced only in freedom and never as the result of a compulsion. Love is an activity, not a passive effect; it is a "standing in," not a "falling for." In the most general way, the active character of love can be described by stating that love is primarily *giving*, not receiving.[4]

Now the goal is to understand, first, just what special features gives love access to reality and, second, how art plies the passage to reality.

❧

Though it requires intentionality, love does not altogether answer to the will. Indeed, if it did, it would be indistinguishable from allegiance. It is a good thing for a person to stand by and act on his love; nevertheless, a love that is only *willed* proportionately drops in value. We do not want others to love us out of obligation, effort, or concentration. Then their love is suspected of strain and calculation. This is why love is said to be a kind of falling. It involves surrendering to another being, to circumstances, to the unexpected. Indeed, love pulls us out of ourselves, throws us into vibrant contact with the facts of reality, with the physical presence of a being. The metaphor of falling in love demands a literal reading. To fall is to experience the pull of physical reality. We then submit to gravity, matter, weight, bodily existence. A person who falls is caught the thingness of his body. On the contrary, pure mental activity is tied to metaphors of flight, etherealness, and rising. Thought is abstract and leads away from the particular. Now, love is a kind of falling because it calls us back to the tangible. Love is a connection with the particular and the unique: a face, a person, a body, a moment, a gesture. A Christian heart may be full of universal love for the whole creation; this love, however, is incomplete or abstract if it cannot completely connect with the preciousness and rarity of one person. As Montaigne said of his loving friendship with La Boetie, "If you press me to say why I loved him, I feel that it cannot be expressed except by replying: 'Because it was him, because it was me.'"[5] Why we love a person is, in this sense, unaccountable because explanations tie an object to externals and conditions whereas love is the discovery of what is unique and unrelated and irreplaceable about one being.

Now, inasmuch as love is the state of being in which the unique absolutely matters, it connects us to the physical. It is spirit falling into the flesh. The wisdom in the Song of Solomon, in Christ's Incarnation, in Rabelais, Chau-

4. E. Fromm, *The Art of Loving* (New York: HarperCollins, 2000), 21.
5. M. de Montaigne, *The Complete Essays*, 212.

cer, Shakespeare, and Nietzsche is that physical existence too is sacramental, a source of joy and understanding; that in the end the particular is no less worthy than the universal; and that the sensorial is no less noble than the intellectual. Love is physical and sensuous, it needs to touch and embrace not just for the sake of biological reproduction. In fact, we spontaneously want to touch beings or objects to which we have no libidinal disposition: a friend, a parent, a child, a pet, a beautiful thing. This is because love is the joyful realization of being made of flesh. *This* flesh.

Hence the kinship with art. For art is the celebration of tangible life, the concrete form, the particular shape or sound or movement. As Hegel emphasized, art is concrete. Artworks are mental expressions cast in "sensuous form and shape" that is "individual, in itself completely concrete and single."[6] Art revels in the sensual, the phenomenal, the particular. It does not shy away from the thick and the messy; indeed, it sometimes seeks it, through ribaldry, comedy, modernist dissonance, the impasto that sticks to one's shoes. In fact, art honors material reality because it divorces our appreciation of it from appetitive interest. Our casual connections to the material world are guided by our physical needs: food, sexuality, comfort, safety. Art, however, opens us to an experience of the tangible where biological interests play a minor role. In a work of art, we appreciate the substance of reality for its own sake. A beautiful painting will not satisfy my hunger, my sexual appetite, my need to be sheltered, and yet I am *physically* interested in it. It is a quiet, unhurried appreciation and celebration of the material world. As such it practices love, because love is respectful sacramental veneration of the concrete.

Art appreciation teaches how to attend to reality—its forms, colors, and scents. A painting teaches us to see and be mindful of the minute aspects of physical life. Any art lover recalls the tender shock of noticing the overlooked detail in a painting, of seeing how a small line, a discreet shade of color, a tiny stroke balances the entire work—how indeed it absolutely matters. Seeing art makes us devotees of the reality that is ignored and synthesized by our everyday bustle. Thus lovers of the concrete, we become practitioners of love itself—because love, as we understand it, is really the call of reality—reality's triumph over the abstraction of mind.

Love is different from idolatry. Likewise, art dwells in the physical but

6. G. W. F. Hegel, *Aesthetics: Lectures on Fine Art*, trans. T. M. Knox (London: Oxford University Press, 1975), 70.

points beyond it. The artistic delight we take in the physical is not merely physical, if only because it responds to no specific biological need. Hegel usefully contrasts the physicality of nature, which is "naively self-enclosed," with the physicality of an artwork which is "essentially a question, an address to the responsive breast, a call to mind and the spirit" (*A*, 71). Indeed, artistic matter is expressive. Shaped by human hands, it has a voice, an intention, a will to communicate. Of course, art embraces the physical; in the last instance, however, sensual stimuli are not enjoyed in the senses themselves but in the mind. So—this is basic enough—art is really *spiritual* appreciation of concrete existence. Only, if we are going to use the word "spiritual," we must be ready to follow where it leads.

"Spiritual" is not just synonymous with "mental." The word denotes an exertion of consciousness trying to reach beyond the mental.[7] Art, as we have seen, dwells in physical existence but it is matter expressively calling to the mind. Once received by the mind in the form of images, however, the physicalness of existence does not give up its claim. Images of concrete life are enjoyed in consciousness but concrete life of course is more than an image. To forget this means to fall into the trap of intellectualism that shuts out reality. Art is matter calling to the mind in the form of images; but it is also mind striving to go beyond the images it receives of matter. It is mind trying to unmind itself, trying to let in the reality of what is. In brief, art teaches us that we need to go beyond the image.

Toward the end of his life, the critic Roland Barthes wrote a beautiful short book on photography, *Camera Lucida*. Parts of it predictably defend the structuralist mantra of absorption of Reality by Text. But Barthes also discovers that a photograph is not just textual construction; a reality from the past—a person, a face, a moment—can always come piercing through the image and tear us out of our aesthetic contemplation; in this moment a being is released from the image. This breakthrough is not subject to theorizing and generalizing. It issues less from a state of mind than from a readiness of the heart. Only "love, extreme love [can] erase the weight of the image. . . . The suspension of images must be the very space of love."[8] Barthes is referring here

7. For a meditation of what the word *spiritual* can still mean to the secular thinking person, see Robert C. Solomon's *Spirituality for the Skeptic: The Thoughtful Love of Life* (New York: Oxford University Press, 2002).

8. R. Barthes, *Camera Lucida*, trans. Richard Howard (New York: Noonday Press, 1982), 12.

to a picture of his mother as a young woman. By means of this photograph, he witnesses her before she was a mother; when, that is, she was a person in her own right, unrelated to Barthes's life. He sees her apart from his need for her. Of course, the photograph does not make her present. But neither does the physical presence of other people make them humanly, subjectively present. In real life too we need to break through the sheen of the image to restore the person. This act requires spiritual generosity, acknowledgment, and accepting the separateness of other beings. It means suspending one's perception, which is an inveterate objectifier, to understand that a being does not just appear to us, but *exists* at the thither edge of his or her appearance. Then we are transported by love.

The blazing actuality of an artistic object, unique and beautiful, reminds us to put our perception in the service of reality. Everyday perception is use-bound: we draw information from the object, we notice only what fits our preestablished schemes of interest. Casual perception is in the service of the human agent. In contrast, the mindful perception elicited by art encourages us to suspend our judgment, and reception of the object so that it alone matters—so that, at any rate, it matters more than our perception of it. This disposition is *spiritual* because it requires us to go beyond sensual stimuli *and* intellectual understanding. It requires hushing the senses and the mind.

English painter Edward Wadsworth says: "In the best periods, the painter does not paint what he sees but what he knows *is*. A reality must be evoked—not an illusion" (*AA*, 458). Illusion afflicts the senses (Plato, Descartes), but it also plagues concepts and thoughts that, however cogent, invariably fall short of what they are about. What power or organ will then lead us to reality, to what we know *is*? Let us reflect on what the painter means by this "knowing" of what is. We *know* reality in the emphatic sense not because we have information about it, nor because we have sound logical proof of its existence. Instead we *know* reality with a preintellectual force that amazes the intellect. It is embryonic and instinctive knowledge—an intuition so basic that it seems of a piece with the reality it knows. It knows not *of* or *about* reality; it *knows* reality, in the sense that it is married to it, comes from it, shares its substance (and indeed how can we deny that our organ of knowing, the brain, is made of the stuff of reality itself?).

How can we express this affinity, this marriage between knower and the known? Simply the way that true marriages are expressed: through love, that

is, through a generous kinship. Love says that our connection to other people and things is basic, organic; that separation is an illusion; hence that intellectual considerations about the existence of the world come too late, for they already assume the existence of being. What reality, of which we are a part, requires us to do is to act the role of a part. Love is the disposition of being related, of being present to others. It is inaccurate to say that love connects what is separate. Love is the realization that nothing is separate. This is why love breaks through images, for images are tokens of separation and representation. Love seeks presence, not images.

Likewise art. At first glance, art seems to be concerned with making images and representations. This is only an impression. In actuality, art is concerned with participation. It seeks less to represent the world than to convey the exhilaration and miracle of our being in it. Of course, objects and persons are represented in artworks; if, however, those works are artistic (and not merely artful), they are imbued with the spirit of participation and love, with the wish to melt separation to nothing so that only the being arises in spite of, indeed, in victory over, its appearance. Only love, says Barthes, can break the spell of images. The amount of love in an image, that is, the extent to which an image strives to reach beyond the film of appearance, in the end decides whether it is art or not. This is why love is the most persistently named virtue of artists in Vasari's *Lives of the Artists*; why, also, Cennino Cennini claims it to be the item of first importance in a painter's box;[9] why the Renaissance could always spot a skillful artist but praised above all the artist who works out of love. The former makes nice pictures, but only the latter achieves grace.

In answer to the perennial question of what makes art, let me venture the following axiom: an image is art to the extent that love runs through it.

· ❦ ·

In this intuition I am preceded by a thunderbolt of a little book that rattled the European aesthetic tradition. At the close of the nineteenth century, Leo Tolstoy's *What Is Art?* looked over the modern discourse on art and found it wanting. Whether under the name of Baumgarten, Winckelmann, Kant, Fichte, Hegel, Schopenhauer, Schiller, indeed of the entire romantic generation, a general assumption had it that art is synonymous with, primarily, pleasure: pleasure taken in the senses; delight in exercise of the mental faculties;

9. C. Cennini, *Il libro dell' arte*, trans. Daniel V. Thompson (New York: Dover Publications, 1978).

enjoyment of one's intellectual freedom; satisfaction in the spectacle of nature tamed and orderered; pleasure in contemplation; and so on. This hedonistic assumption, Tolstoy suggested, is a great mistake.

Here is why. Eighteenth-century thought basically defined art in terms of beauty. Whatever else an artwork may be, it must cause admiration, amazement, delight in form and understanding, the pleasant feeling that occurs when a harmonious object mirrors the order of reason and taste. The overall tendency really is to assimilate beauty with the feeling it gives. Plainly put, art is beauty and beauty is what pleases. As Tolstoy puts it, "[N]otions of beauty come down to a certain sort of pleasure that we receive, meaning that we recognize as beauty that which pleases us without awakening our lust."[10]

This is just what Tolstoy wants to debunk—the urbane pleasure, the prim hedonism, the salon sampling of the fruits of civilization so appealing to the modern self in quest of self-cultivation and self-fashioning. It is consistent with the nascent ethos of the customer-comes-first variety. In the monarchic age, it would have been dangerously impious to declare that God's or the king's excellence, objective though it seemed, dwelt actually in the courtier's appreciation. Not so in the age of leveled hierarchies. As objective values go into eclipse, the individual has no foothold other than his personal experience to appraise things around him. Thus beauty is subjective pleasure and pleasure is, well, essentially, enjoyment of one's free subjectivity.

For Tolstoy, this subjectivist aesthetic is responsible for the modern muddle over art. For pleasure can in no reliable way provide a yardstick to measure an object's excellence. Otherwise the most popular work would always be the most certainly beautiful; or a work would cease being beautiful if, unlike yesterday, it happens to afford me no pleasure today; and no ground for argument could be found between your experience of beauty and mine, if like capers or sardines, beauty is lodged in a person's taste buds. Aesthetics would in fact collapse because there is really no point in discussing the worth of an object if one is only voicing one's gustatory impression. And lastly it would become illogical to redirect a neophyte's attention away from the third-rate daub if he happens to find it altogether to his pleasure.

Tolstoy's solution, it appears, is to cut beauty off root and branch from artistic discussion. (What he proposed instead I am not going to discuss at

10. L. Tolstoy, *What is Art?*, trans. Richard Pevear and Larissa Volokhonsky (New York: Penguin Books, 1995), 34.

length because it is flawed. Briefly put, Tolstoy banned pleasure and appointed social responsibility in its stead: art must put forth ideas and examples that give hope and purpose to life, improve humankind, and generally work for charity and understanding among people. A proof that art wears badly under such social good works is given by Tolstoy's own late fiction, novels like *Resurrection* that toil under their philanthropic burden. This, of course, does not mean that a work of art cannot have a message—only that it had better not be indentured to it.) Tolstoy's banning of beauty surely is a draconian measure. Nevertheless, it rests on a valid point. Perhaps he foresaw where all the talk about beauty led—that is, to hedonism, the biological reduction of art to tickling, entertainment, and therapy—the sort of private boudoir pleasure enjoyed by the decadent aesthete and his modern avatar, the consumer. Entertain me, says the modern consumer. And once we consumers grow confident enough, once the pampering attention gives us an inordinate sense of our entitlement, of *deserving* it (in the gassy lingo of advertising), and once we become a *public*, hard to please and more dangerous to displease, then we can afford the luxury of thinking ourselves not just the waited-upon beneficiaries of art but also its ruling patrons: this is the theory that we, recipients of art, are also its makers, since *we*, not artworks, constructively imagine into *them* whatever artistry they are thought to display. Indeed, the idea that artworks are subjectively constructed as art by public reception is no less than the old tyrannous system of princely patronage retooled for democratic use. Then the prince or pope sanctified art through his authority; now every person can feel entitled to create artistic value just by mental projection.

This is what's so crude about modern art appreciation, indeed, the assumption that art is only there to be appreciated. It revolves around the predictable center, chief customer, and beneficiary of modern life: the individual self. And whenever there is only one thing, one person, one principle, there can be no love. For love is conversation. It is relation.

This, in the end, explains why Tolstoy's *What Is Art?* makes *communication* the very nerve of art. An artwork is, whatever its form, genre, or nature, a human being addressing other human beings. "We cannot fail to see that art is a means of communion among people" (*WA*, 37). Art is intersubjective and social in the primordial sense. It is about human encounter. Neither objective nor subjective, neither just the object nor just the self, art is movement, a kind of Hermes that brings human beings together in a way that social life

or politics cannot approximate. Why not? Because social life puts people in touch with a view to purposes other than being together. In art, on the contrary, communicating is practiced for the sake of communication. It is not just an instrument to get things done. It is appreciated in itself. This is why the essence of art is not expression, in which case the necessity of conveying a message would reduce the artwork to being a means. No, the essence of art is *conversation*. It is a way for humans to take delight in language, communication, relatedness.

<center>�808</center>

In contrast Tolstoy wishes to make the transaction of art centerless. Communication implies plurality. To speak is to acknowledge that one's own words stand in need of understanding. Otherwise I should never bother to say anything. Nor do we speak always, or even essentially, to transfer information. What sort of information is conveyed in a conversation among friends, lovers, or strangers discussing the weather? Far more often than we care to notice, the ritual of communication eclipses the purported message. Then exchanges are sacraments of acknowledging and being acknowledged. The goal of communication is its enactment. And what is enacted is the membership in a common form of life and a shared existence.

Art cultivates and marvels at the sacrament of communication. What's communicated in a portrait by Rembrandt? Of course, snatches of information slip through: the age, sex, social status, trade, or personality of the sitter. But these, really, are not given objects but emanations of Rembrandt's spiritual conversation with them. They exist nowhere outside of being seen by the artist. Hence they are suffused with the spirit of encounter. In general, a portrait testifies that a person was *seen*, a landscape that it was responded to, a form that it was waited upon with care. A work of art is like a conversation made visible. As in a conversation among friends, the exchange imbues the communicated with radiance. A work of art says that contact was made. And contact involves a broadening, indeed, an opening, of the first person singular.

How, in practical terms, does an artwork enact human relatedness? How does it cultivate love? Let us take the example of Van Gogh's *Portrait of a Peasant* (1888). Everything about the peasant—his age, sex, social status, trade— belonged to the peasant of course. But these features are really not independent objects. So far as the painting is concerned, they exist nowhere outside of being seen by Van Gogh. They are the product of his engagement with the

peasant. Every element in a painting is shot through with the artist's witnessing. What, however, is witnessing? To begin with, let us consider what it is not. To witness is not just to find oneself in the same place with someone else. Physical proximity is a condition for witnessing, but not its equivalent. One must also be willing to encounter the witnessed. How does one become present? First of all by dropping "aboutness" from our worldly attention. To let our attention be *about* a person or thing is to allow knowledge to slip in between us and the living. It converts a person into a mental item. And mental facts are objectlike possessions, whereas encounter occurs between two subjective forces.

The great artist, as the painter John Singer Sargent remarked, will "paint something alive" and make the person "live."[11] Another way to put the matter is that an artist is able to transfer a subjectivity into an objective image with little or no deadening effect. Art is thus a kind of moral achievement—morality being understood as our effort to preserve and honor the subjectivity of other beings. The artist seems to achieve with oil and pigments the sacred respect that religion and moral philosophy want to enact through, respectively, good works and logical argumentation. But how does the artist perform this miraculous nonobjectifying presentation of a subjectivity?

Let us, first of all, be assured that this achievement does not rest with accurate resemblance. If photography offers any lesson, it is that lifelikeness does not rest with a degree of correct imitation. A photograph of Jane evinces mirrorlike resemblance to Jane yet dwells infinitely below the threshold of Jane's subjectivity. This is because photography is a mechanical device and can entertain no disposition (welcome or rejection) toward its topic. It simply snaps, absorbs, and regurgitates. Of course, the photographer himself is driven by intention and emotion. His medium, however, is indifferent. Thus, while human intentionality defines what is being photographed, within what angle, focus, and framework, the job of likeness making is actually done by a mechanism: to wit, the photosensitive emulsion plate on one side and incoming light beams on the other. This explains why, in every respect like Jane, a photograph of Jane nevertheless underreports her subjectivity because the camera itself never *saw* Jane. At most all it did was stare at her. Jane is captured but not seen. For subjectivity cannot be captured. Subjectivity is like the fairytale talisman that can

11. In C. Ratcliff, *John Singer Sargent* (New York: Abbeville Press, 1982), 247.

be touched only by the pure at heart but dissolves into ashes when grabbed by the thief or interloper. To grab hold of subjectivity is to reduce it to object. Likewise, if driven by conquest or gumption, resemblance may well turn out accurate but it will have the perfunctory, dull, reluctant look of cheap portraiture. The appearance is there but it is objectlike, leaden, thickened by its own precision. Encounter did not take place.

It is the spirit of encounter that lifts Van Gogh's *Portrait of a Peasant* into the realm of great portraiture. This painting is not *of* or *about* the worn-out, gaunt, old peasant. It does not imitate the peasant by duplicating his sensorial appearance; it imitates him by sharing *his* world. The portrait tells us less about what the peasant looks like than what it is like to be him. Van Gogh's gnarly brushwork shares the travails of a face that years of field labor have dug and weathered and exhausted. The portrait endures the history of a face, it reconstitutes its creation, falls under its command and influence. The portrait is an achievement of human sympathy, of loving sensibility to the experience of another person. To open up in this manner requires time, patience, dedication. It happens through labor and effort. If the work is easy, then it is entered casually. No sacrifice takes place. And without sacrifice the artist's personality crowds out the reality that needs encountering. Work is a good teacher of reality because it makes us dedicate our energy and attention to an object or being outside ourselves. It forces us to reckon with the pull and heft of reality, its intractable density, its weight. Van Gogh's paintings bear testimony of having been labored through, plowed into, entered with complete dedication. In the course of this total process, the reality of the work and the reality of the sitter take over the painter's attention. The artist is penetrated by his subject until it becomes more central and immediate to his own self than his own stream of thought. In effect, the artist becomes a witness. He does not observe; rather, he dedicates his own existence to testify to another person's life. It is less technical achievement than a gift: a labor of moral generosity.

We must imagine Van Gogh facing the peasant not as an object of study, but as a center of subjectivity. How is subjectivity rendered? Through the sacrifice by which the artist acquiesces to the sitter's magnetic force. Indeed, the subjectivity of another person arises when one allows oneself to be seen by him. Then encounter takes place. The paradox is that a portrait achieves encounter when the artist lets himself be actualized by the sitter. As in love, artistic portraiture requires perceiving one's own self as an emanation of another

person's presence. This is what lifts the sitter's face from the realm of matter where it objectively dwells, into the realm of expression from which it really looks at us. A work of art testifies to the experience of what it was like to be in the presence of that person or landscape, to be actualized and seen by them. A work of art is conversation made visible.

This, at any rate, is the reasoning behind Tolstoy's notion that art is primarily relief from the ego and permeation by the plurality of human lives:

> The effect of the true work of art is to abolish in the consciousness of the perceiver the distinction between himself and the artist, and not only between himself and the artist, but also between himself and all who perceive the same work of art. It is the liberation of the person from his isolation from others, from his loneliness, this merging of the person with others, that constitutes the chief attractive force and property of art. (*WA*, 121)

Cultivating communication for its own enjoyment is to honor the shared nature of human experience. Communication implies a common language, which in turn implies an understanding greater than the communicants taken singly. Whenever I am understood, it must be that my message transcends my private understanding—or else my words would sound like squawking to others. To utter words is, to this extent, to speak in the other person's language—at least to share a public form of life, a democracy of understanding beyond any single person's monopoly. Communication entails a loosening of the egocentric life. Art cultivates this loosening: its greatness depends less on the subject matter than on whether it is penetrated by the spirit of conversation. Indeed, it depends on how deeply the work of art entered the community of language.

How does Van Gogh succeed in conveying not just the appearance, however miraculously rendered, but the very presence of a person? By first "listening" to the face in front of him. To him, the subject's appearance is not an object, not visual data, but a message: the human plea to be seen, to communicate, indeed, to transcend our own image and make a connection. Van Gogh's works are portraits of loneliness seen and transcended. They go beyond the image in exactly the sense every human being yearns to be more than an image in other people's minds. Thus his portraits are not of appearances but of persons touched by the love of communication which, in fact, is the purest love we are capable of, because it is love of love itself. The human face is intrinsically a call to see and be seen. It cannot help talking, even silently, to other selves. In

depicting persons, an artist sanctifies the communication in the human figure with the love of communication that is art.

The mission of art (but also of religion and the moral life) consists in extending the circle of our relation to the thinnest reaches of our attention, to those beings and objects too distant or humble to elicit relationships: a chair (Van Gogh), a silver goblet (Chardin), the morning fog (Turner, who made us love what previously had been deemed a nuisance to sight), street urchins (Goya), or a society lady (Sargent). As to Sargent's question about how an artist paints "something alive" and made his subjects "live," it is now clear that the solution does not turn on a technical trick but on spiritual disposition, a labor of moral attunement, a practice of self-emptying. An artist wills himself to become fragile, exposed, naked. Instead of going at the visible with the weapon of his will and talent and thirst for conquest, an artist succeeds in seeing more reality in the person than in his awareness of him or her. This is the miracle of Rembrandt's *Bearded Man in a Wide-Brimmed Hat* or of Vermeer's *Girl with the Pearl Earring*. They are miracles not of expression, but of friendship.

Here, finally, is the painter Philip Gaston on the mystery of what makes a painting alive:

What Rembrandt has done is to eliminate any plane—anything between that image and you. The Van Dyck painting hasn't. It says: I'm a painting. The Rembrandt says: I am not a painting, I am a real man. But he is not a real man either. What is it, then, that you're looking at?[12]

The answer is: a portrait of love. Only love wields the force to break through images.

Artworks speak for the love of conversation, that is, for the love of love. They submit a picture of the world held together by encounters. That the artwork springs out of encounter means it is created by, never an "I," but an "I-and-You." When an artist says "you" to a landscape, he is ready for art; when he perceives his own "I" as a "You" whispered by the landscape, then art enters him. Art suggests that reality is whole and not broken; that life is conversation, response, exposure; that to see is to be seen; that to touch is to be touched; that to know is to be known.

"For now we see through a glass, darkly; but then face to face; now I know in part; but then shall I know even as also I am known" (1 Corinthians 13):

12. In D. Sylvester, *Interviews*, 97.

Paul thus evoked Christian love. But these verses really depict the triumph of *all* love. Paul sets up a difference between then and now, between fallen nature and grace, between mechanical life and spiritual realization. In the *now* of darkness, the "I" sees only one-directionally. This one-directionality muddies up the glass. The view is darkened because seeing runs from subject to object and thus petrifies, degrades, what it falls upon. The opposite of seeing darkly is of course seeing clearly and wholly. But the verse puts the matter more practically: to see clearly is to be face to face. Grace will not give us vision sub specie aeternitatis; instead it will land us in communication, which is to see *and* to be seen at once. Likewise the opposite of knowing in part, of earthly limited knowledge, is not supernatural omniscience; instead it is love: *then shall I know even as also I am known.* No knower and known do we find in the state of grace. Every action is interaction and every doing is a being done to.

It is said, rightly, that art casts thoughts into tangible forms. This incarnational process goes deeper than translating intentions into sensible aspects. True embodiment occurs not only when one is given a body, but when one's embodiment connects one to the presence of other people and beings. To be a body is to be vulnerable to joy and illness, gentleness and violence. This is a fall we gladly take. Incarnating ourselves, we become inhabitants of the world. Art makes good on this newfound citizenship by practicing looking at the world with one's body, naked and vulnerable, *knowing as also we are known.*[13]

Because art assumes human beings to be citizens, not overlords, of the Earth, it prompts us to share. As art is a dedicated practice of communication, it is attuned to justice, which is the acceptance of being parts and not the whole. This realization urges tolerance and a conversational approach to reality. Where reality is inhabited, it is inhabited by the many. I see a tree outside the window. My seeing it is only one perspective; it does not exhaust the tree as such. This is how embodied seeing, of the type cultivated by art, promotes justice.[14] It reminds us that vision is partial, local, relative to other viewpoints and subjectivities. Indeed, it reminds us that the world is woven through by conversation, reciprocity, interaction. The world is the balance and agreement of all that is seeing and being seen in it. When we seek justice, we resume our

13. The book to read is M. Merleau-Ponty's *Eye and Spirit*, in *The Merleau-Ponty Esthetics Reader*, ed. Galen A. Johnson (Evanston, Ill.: Northwestern University Press, 1993).
14. The book to read is Elaine Scarry, *On Beauty and Being Just* (Princeton, N.J.: Princeton University Press, 2001).

place in the democracy of viewpoints. And this democracy can occur only when we accept our physical place in the plural world, when we accept, that is, being parts and not the whole. Art is in the end nothing but the gentle, sad, amazed, breathless, exuberant, wistful, wise, quiet, or furious, though always dedicated, cultivation of being a part.

In truth, a work of art does not need to advertise its commitment to justice and conversation. It does not need to preach, because the virtues of justice and conversation are inherent in its making. At most we can say that art is especially suited to decry the mutilation of human life. Physical and psychic assault against the conversation of being also strikes art to the quick. The violence that lacerates beings by the same token lacerates art. Let's turn again to Picasso's *Guernica*. We see writhing ends of human bodies, Hieronymus Bosch's Hell updated to the century of napalm and carpet bombing. It is the same agony, the same suffering, but those mouths howl to a godless sky. Only a mockery of divine judgment stares back in the form of a light bulb, harsher than shrapnel. Thrusting out of the carnage is a horse's head torn open, a spike where his tongue should be. The language of pain, we understand, is steel-cold and speechless. Violence maims, mangles, humiliates, and reduces persons to meat. It denies the victims language and self-expression. It punctures the human conversation that holds us above animality. And so the painting too suffers the destruction of language and expression. Its eloquence is choked and pierced through by the coldness and indifference of metal and fire, by the storm of matter that drowns humanity. Like so much of twentieth-century art (the art of razor wire and ashes, of Beckett, Celan, Giacometti, the composer Ligeti, etc.), *Guernica* conveys communication's maiming.[15] The painting is a screech because language is dead. And when language dies, when communication is ripped out of our throats, then matter wins out, and violence is supreme, and silence rules. The greatness of *Guernica* is that, better than showing this compounded horror, it incarnated it. It is a picture of communication's, and therefore humanity's, martyrdom.

Art is communion, Tolstoy concludes. Is it so strange that museums became like churches and temples round about the late nineteenth century? Many now think the religion of art as risible a relic as coat tails and prepran-

15. The books to read are J. Ortega y Gasset, *The Dehumanization of Art* (Princeton, N.J.: Princeton University Press, 1968), and P. Celan, *Selected Poems and Prose of Paul Celan* (New York: W. W. Norton & Company, 2000).

dial sherry. That it became a cult in an age when the thinking person turned away from the church is nevertheless telling. The need to express reverence for life does not disappear because people stop attending Sunday mass. Art, like praying and worshipping, is a quiet experience of the love of listening. What do we find in museums? Objects that gesture to us. What do they ask for? That we pay attention to them, that we rest awhile with their quiet presence, so humble next to the razzmatazz of modern life. Museums are temples of the silent conversation. We go to them to see that reality is being seen and loved; that there is more to us than users of nature; that we are capable of gentleness and attention. It is impossible to feel alone in the presence of artworks, among these acts of solipsism overcome. Perhaps we (the distracted, careless, hurried we) rarely do better than look at them; they, by contrast, always *see* us. They teach us to take care; to pause; to heed; to orient our attention away from egotist concerns; to attend to the other; to enter into a relation; to participate; to see as also we are seen. They are moral lessons, lessons in gentleness and sensitivity, in compassion and listening. That Titian can dedicate so much loving attention to rendering the velvet gleam of a coat (*Man with the Red Hat*), that Vermeer can expand such precious care on the mystery of the sketch of a smile (*The Girl with the Pearl Earring*), that Mary Cassatt can devote such thoughtfulness to a small dog asleep (*Portrait of a Little Girl*), that artists can thus offer their purest quality of attention, skill, and effort to the smallest, humblest, most overlooked things: this really is an invitation that we can awaken to the actuality of beings and things, open our consciousness to them, become inhabitants, and not thin-blooded passers-by, of reality—an invitation that in the end encapsulates the best of moral and religious teaching.

Postscript on Art and Religion

To show that art partakes of the religious does not suggest that art encompasses religion, or can substitute for it. To the extent that art resembles religion, it is also distinct from it. The failure of the nineteenth-century religion of art (of the aestheticism that tried to raise art to a devotional cult) is often attributed to the decay of religiousness in modern society. Regard for the religious aura of art, for the hope that it would lift us up into a clear, clean realm of experience above the material world—all this frothing aesthetic passion died down because, it is thought, belief in the transcendental died.

In fact, this is half the explanation. It could just as reasonably be argued that the belief in art's religious power expired because it failed to measure up to religion—because on the whole the promise of art proved to be less than the works achieved by religious belief. Art did not replace religion, nor did it become a religion of its own, because there is yet a power proper to the religious experience that transcends art.

This experience is the power that comes from merging the self into a life force infinitely greater and mightier than the self. It is the power that comes from feeling encompassed and accepted, the paradoxical power of surrender. The believer does not seek to understand God; he does not try to make the universe fit into his mind. God is where explanations give out. "I am that I am" says the Whirlwind. Wittgenstein once wrote that theological statements do not signify in the ordinary sense because they point to a state of being beyond

the ambit of observable or explainable things. Ultimately, the true language of religion is silent—the silence of prayer, meditation, the complete generosity of the loving act. The believer *receives* God (Grace): this means that God is not elucidated. He is not reached for or dragged into the net of understanding. He shows himself when the mind quiets itself and gives up straining and striving for sense; when existence as a pure fact is received; when the mind accepts. Acceptance reorients the self from feeling like the center to feeling like an infused part. For by declining to understand, the self eschews anthropomorphism, that is, the reduction of the whole to one of its parts. To understand is to translate into human scale. It is a shrinking of reality. Whereas complete acceptance (Faith) widens intelligence by, paradoxically, muting it.

In art, the mind also commits to a discipline of self-restraint, on the one hand, and loving attention to reality, on the other, but it does not wholly practice acceptance. This would imply a blank art, an art of silence, of nonexpression. Art speaks—this is what it cannot help doing. It signifies. It draws pictures. It expresses. The subject is the emitting center of the communication. Whereas in religion, the subject silently listens. He does not understand what he hears, he does not translate the silence into words. He only knows that that silence is the very voice of God—the harmonic note that fuses all the sounds in the universe. Art cannot resign itself to silence. For while its expression stretches itself beyond the self-centeredness of practical reason, it nevertheless remains a language: this is both its glory (the valiant effort of reaching beyond human limitation) and its ruin (since it ultimately speaks too much). Art is a gift proffered by the self; but it is not the gift of the self as performed by a life given to prayer, to serving, to love, to helping others.

The artist never goes as far as the saint in his love for reality. The former speaks to reality; the latter listens and acts without putting himself forward. "God, make me an instrument of thy peace," says the saint. This entails no less than becoming a humble channel. To be sure, the good artist humbles himself (even when he shouts out his style and inner world), but he does not escape human language. He cannot stop making sense. And sense is of human stamp.

This, one would say, is the metaphysical explanation for why art cannot supplant religion. But there also exist practical reasons.

Religion is not only a way of opening the mind to the totality of the universe, it is also a source of spiritual comfort. To contemplate the honeyed crust

of the loaf of bread in Vermeer's *Milkmaid*, to bathe the mind in its gently white wall, to linger over the dandelion-colored fuzz of the corset, to melt with tenderness before the milkmaid's lovely care as she tilts the milk into the earthen jar, indeed, to absorb a bit of her loveliness—all this fills me with the miracle of being; it makes me feel grateful for being alive; it opens my eyes to the radiance in all things. In the end, however, the work of art does not reach beyond the world. It shows us how miraculous the world is, and of course God suffuses all things (He is in the small as well as in the cosmically large). But religion is not limited to the perceived. It also points beyond it. It relates human life to the totality of life *such as it cannot be individually seen, or felt, or known*. It tells us that what seemed frighteningly outside human experience, and therefore foreign, like death, in fact belongs inside the totality of the universe of which we are a part. Death is fearsome only to the individual; to the religious person, that is, to the person who does not stake his self-sense on the limited ego, death is as much a part of life as he himself is a part of it. This is why religion has the power to reconcile us with death, indeed, and teach us to stop fearing and start loving it. It assures us that death belongs to life—that our nonbeing is an aspect of being; that we are absolutely safe, even unto death. By contrast art at best only makes us love this life. It cannot conquer death because it is riveted to the things of this world.

Another reason for art's incapacity to replace religion lies in its relative lack of authority. Though art asks for dedication, it nevertheless pertains to the nature of *appreciation*. It cannot altogether break off its kinship to pleasure and entertainment, to the notion that it is there to please. For this reason it cannot be a compelling source of moral guidance. Its ethical power consists in refining one's sensibility; but moral behavior, as we well know, requires a support stronger than sensibility. To be steadfast, morality must lean on some intellectual authority: the power of conviction.

This conviction is anchored in one realization: belonging to an order of things requires heeding this order. It requires attuning one's behavior to the nature of what is. Thus religions vary, as individuals vary, but a common moral bedrock unites the great religious traditions (at least the great religions traditions born in antiquity: Hinduism, Judaism, Christianity, Buddhism, and Islam). This common bedrock consists in doing justice, being truthful, and avoiding the infliction of wanton suffering. These insights are shared because they stem from observing the same, one reality: a universe stronger than death (or else it would occasionally sink into nonbeing); a universe that is true (it

never pretends but is what it is); and one that never *intends* to do harm. It gives life, sustains life, and when it seems to mete out death, it is so because we mistake a fragment of the cycle for all (a star that dies is just energy being transferred elsewhere; so it goes with the death of a person). It is by opening to the widest scope of apprehending the universe that man models his right conduct. It is no incidental conduct but the overall mode of being of the universe which, as Genesis says, *is* good. To attune one's conduct to the universal harmonic base of being, one cannot but follow the good. For instance, "Thou shall not kill." This moral precept does not issue just from social interest in keeping the peace. It follows also from an ontological realization that consists in knowing that being is not our possession; that it precedes us, makes us, and outlasts us; which entails the conclusion that we have no authority over it. This realization about the precedence of being over us is the root of the moral authority of religious wisdom.

This moral authority, unlike in art, recommends practical moral actions: to share, to bring succor, to make peace, to help the afflicted. The churches and temples and mosques are places of worship only if they are also centers of good works. Obviously art does not achieve that level of active philanthropy. It does not feed the hungry, does not help the sick, does not shelter the homeless. Art does make us feel related but, most often, this relatedness carries no commanding word. Art inspires us to admire and look up to the beautiful. But in the end aesthetic beauty woos rather than commands; it seduces rather than compels. It arouses the devotion of Eros and not the devotion of self-surrender. One generally goes to the museum to receive, whereas one goes to the mosque, church, or temple to give praise. The aesthete remains, notwithstanding his fervor, a customer.

To be sure, art often speaks for the afflicted and against injustice. But this sentiment is inspired by sensibility and inclination, rather than by a responsibility to serve. There is a difference between doing good because one feels like it and doing good because this is what one must do—between, that is, feeling like a good person and being the instrument of divine work. The former is liable to contingent moods, the latter is the striving of an entire life. Art refines our sensibility to the existence of other beings, to the beauty and preciousness of life, but it does not tie these realizations to practical works of charity. A religion made up only of aesthetic sentiment would surely be gentle and sensitive but not necessarily dutiful and charitable.

In the end, we must recognize art to be only a kindred companion to reli-

gion—which in fact it has been since its dim beginnings—but not its substitute. It may direct our intelligence to a religious apprehension of reality. But this "may" is too loose a basis to set the lives of individuals on the path toward the good. Religion is the basis on which a particular sensibility rests. Art is an expression of sensibility and sensibility comes too late for religion, which is not a feeling (as the Buddhist well knows) but a ground older than the self. Only a self can know this, but simply in the same sense that it takes a self to reach beyond selfhood.

Bibliography

Abrams, M. H. The Mirror and the Lamp: Romantic Theory and the Critical Tradition. New York: Oxford University Press, 1971.

Adorno, Theodor. Aesthetic Theory. Translated by Robert Hullot-Kentor. Minneapolis: University of Minnesota Press, 1998.

Adorno, Theodor, and Max Horkheimer. The Dialectic of Enlightenment. Translated by John Cumming. New York: Continuum Books, 1976.

———. Soziologische Exkurse. Francfort del Mero: Europäische Verlanganstalt, 1969.

Alberti. On Painting. Translated by John R. Spencer. New Haven, Conn.: Yale University Press, 1956. (Original work published in 1435.)

Aquinas, Thomas. Commentary on Aristotle's Physics. Translated by Richard J. Blackwell. South Bend, Ind.: Dumb Ox Books, 1999.

———. Summa Theologica. Translated by the Fathers of the English Dominican Province. Thomas More Publishing, 1981.

Arendt, Hannah. The Life of the Mind. New York: Harvest Books, 1981.

———. The Origins of Totalitarianism. New York: Harcourt, 1948.

Aristotle. Physics. Translated by Robin Waterfield. New York: Oxford University Press, 1999.

———. Politics. Translated by T. A. Sinclair. New York: Penguin Books, 1992.

Ashton, Dore, ed. Picasso on Art. New York: Da Capo Press, 1972.

Augustine. Confessions. Translated by John K. Ryan. New York: Doubleday, 1960.

Ayer, A. J. Language, Truth, and Logic. New York: Dover Publications, 1952.

Bahktin, Michael. Rabelais and His World. Translated by Helen Iswoskly. Bloomington: Indiana University Press, 1988. (Originally work published in 1965.)

Barth, John. Lost in the Funhouse. New York: Anchor Books, 1988.

Barthes, Roland. Camera Lucida. Translated by Richard Howard. New York: Noonday Press, 1982.

———. The Pleasure of the Text. Translated by Richard Miller. New York: Hill & Wang, 1975.

Barzun, Jacques. The House of Intellect. New York: Perennial Classics, 2002.

———. Romanticism and the Modern Ego. Boston: Little, Brown, 1946.

Bataille, Georges. Erotism: Death and Sexuality. Translated by Mary Dalwood. San Francisco: City Lights Publishers, 1986.

———. Inner Experience. Translated by Leslie Ann Boldt. Albany: State University of New York Press, 1988.

———. Visions of Excess. Translated by Allan Stoekl. Minneapolis: University of Minnesota Press, 1985.

Baudelaire, Charles. The Painter of Modern Life and Other Essays. Edited by Jonathan Mayne. New York: Phaidon Press, 1995.

Berger, John. The Sense of Sight. New York: Vintage Books, 1985.

Berkeley, George. A Treatise Concerning the Principles of Human Knowledge. (Original work published in 1710.)

Berlin, Isaiah. The Roots of Romanticism. Princeton, N.J.: Princeton University Press, 1999.

———. The Sense of Reality. New York: Farrar, Straus & Giroux, 1996.

Bloom, Harold, ed. Romanticism and Consciousness. New York: W. W. Norton and Company, 1970.

Bourdieu, Pierre, and Lewis Wacquant. An Invitation to Reflexive Sociology. Chicago: University of Chicago Press, 1992.

Buber, Martin. I and Thou. Translated by Ronald Gregor Smith. New York: Scribner's, 1958.

Canetti, Elias. Crowds and Power. Translated by Carol Stewart. New York: Viking Press, 1963.

Cavell, Stanley. The Claim of Reason: Wittgenstein, Skepticism, Morality, and Tragedy. 1979. Reprint, New York: Oxford University Press, 1999.

———. In Quest of the Ordinary: Lines of Skepticism and Romanticism. Chicago: University of Chicago Press, 1994.

Celan, Paul. Selected Poems and Prose of Paul Celan. Translated by John Felstiner. New York: W. W. Norton & Company, 2000.

Cennini, Cennino. Il libro dell' arte. Translated by Daniel V. Thompson. New York: Dover Publications, 1978. (Original work published in 1432.)

Clements, R. J. The Peregrine Muse. Chapel Hill: University of North Carolina Press, 1959.

Confucius. The Analects. Translated by Arthur Waley. New York: Vintage Books, 1989.

Conrad, Joseph. Heart of Darkness. New York: Penguin Books, 1995.

Damisch, Hubert. The Origin of Perspective. Cambridge, Mass.: MIT Press, 1994.

Dante, Alighieri. Divine Comedy. Translated by Mark Musa. New York: Penguin Books, 1995.

Danto, Arthur Coleman. Transfiguration of the Commonplace. Cambridge, Mass.: Harvard University Press, 1981.

da Vinci, Leonardo. Leonardo on Painting. Edited by Martin Kemp. New Haven, Conn.: Nota Bene, Yale University Press, 1989.

Deleuze, Gilles, and Felix Guattari. Anti-Oedipus: Capitalism and Schizophrenia. Translated by Brian Massumi. Minneapolis: University of Minnesota Press, 1983.

———. A Thousand Plateaus. Translated by Brian Massumi. Minneapolis: University of Minnesota Press, 1987.

Derrida, Jacques. Of Grammatology. Translated by G. C. Spivak. 1967. Reprint, Baltimore: Johns Hopkins University Press, 1998.

———. Speech and Phenomena. Translated by D. Allison. Chicago: Northwestern University Press, 1973.

Descartes, René. Descartes: Philosophical Letters. Translated by Anthony Kenny. New York: Oxford University Press, 1970.

———. "Discourse on Method" and "The Meditations." Translated by F. E. Sutcliffe. New York: Penguin Books, 1968. (Original works published in 1637 and 1640.)

———. Meditations on First Philosophy. Edited and translated by John Cottingham. Cambridge, U.K.: Cambridge University Press, 1996. (Original work published in 1640.)

Dewey, John. Art as Experience. New York: Perigree, 1980.

Dickie, George. Art and Value. New York: Blackwell, 2001.

———. Art Circle: A Theory of Art. Chicago: Spectrum Press, 1997.

Doran, Michael, ed. Conversations with Cézanne. Berkeley and Los Angeles: University of California Press, 2001.

Dostoyevsky, Fyodor. The Insulted and Humiliated. Translated by Constance Garnett. Gaithesburg, Md.: Victor Kamkim, 1976. (Original work published in 1861.)

Eagleton, Terry. Ideology of the Aesthetic. New York: Blackwell, 1990.

Eldridge, Richard. The Persistence of Romanticism. New York: Cambridge University Press, 2001.

Elias, Norbert. The Society of Individuals. New York: Continuum, 2001.

Eliot, T. S. Four Quartets. New York: Harcourt, 1943.

Emerson, Ralph Waldo. The Essential Writings. Edited by Brooks Atkinson. New York: Modern Library, 2000.

Ferry, Luc, and André Renaut. French Philosophy in the Sixties: An Essay on Anti-Humanism. Amherst: University of Massachusetts Press, 1990.

Fichte, J. G. The Science of Knowledge. Translated by P. Heath and J. Lachs. New York: Cambridge University Press, 2003. (Original work published in 1794–1795.)

Flaubert, Gustave. Three Tales. Translated by Robert Baldick. New York: Penguin Classics, 1961. (Original work published in 1877.)

Foucault, Michel. Discipline and Punish: The Birth of the Prison. Translated by Alan Sheridan. New York: Vintage Reprints, 1995.

———. Power/Knowledge: Selected Interviews and Other Writings, 1972–1977. Edited by Colin Gordon. New York: Pantheon Books, 1980.

Freud, Sigmund. Psychologische Schriften. Edited by Alexander Mitscherlich, Angela Richards, and James Strachey. Frankfurt, Germany: Fischer, 1989.

Friedman, Bernard H. Jackson Pollock: Energy Made Visible. New York: McGraw-Hill, 1974.

Fromm, Eric. The Art of Loving. New York: HarperCollins, 2000.

Gaita, Raymond. A Common Humanity: Thinking about Love and Truth and Justice. New York: Routledge, 1998.

Goldwater, Robert, and Marco Treves, eds. Artists on Art from the XIV to the XX Century. New York: Pantheon Books, 1945.

Gombrich, Ernst. Meditations on a Hobby Horse. New York: Phaidon, 1963.

Goodman, Nelson. Languages of Art. New York: Hackett, 1976.

Greenberg, Clement. Art and Culture. Boston: Beacon Press, 1961.

———. The Collected Essays and Criticism. Vol. 2. Edited by John O'Brian. Chicago: University of Chicago Press, 1995.

Hegel, G. W. F. Aesthetics: Lectures on Fine Arts. Translated by T. M. Knox. London: Oxford University Press, 1975. (Original work published in 1835.)

————. Lectures on the Philosophy of Religion. Translated by R. F. Brown, J. M. Stewart, J. P. Fitzer, and H. S. Harris. Berkeley and Los Angeles: University of California Press, 1996. (Original work published in 1832.)

————. The Phenomenology of Mind. Translated by J. B. Baillie. New York: Dover Publications, 2003. (Original work published in 1807.)

Heidegger, Martin. Being and Time. Translated by John Macquarrie and Edward Robinson. New York: Harper & Row, 1962. (Original work published in 1927.)

————. Nietzsche. Vol. 3. Translated by Joan Stambaugh, David Farrell, and Frank Capuzzi. San Fransisco: Harper & Row, 1981.

————. On the Way to Language. Translated by Peter D. Hertz. New York: Harper & Collins, 1971.

————. Pathmarks. Edited by William MacNeil. New York: Cambridge University Press, 1998.

————. Poetry, Language, Thought. Translated by Albert Hofstadter. New York: Perennial Books, 1985.

————. The Question Concerning Technology and Other Essays. Translated by William Lovitt. New York: HarperCollins, 1982.

Hobbes, Thomas. The Leviathan. New York: Penguin Classics, 1982. (Original work published in 1651.)

Hoffmann, E. T. A. Tales of Hoffmann. Translated by R. J. Hollingdale. New York: Penguin Books, 1982. (Original work published in 1815.)

Horkheimer, Max. Critique of Instrumental Reason. Translated by Matthew J. O'Connell and others. New York: Continuum, 1994.

————. Eclipse of Reason. New York: Continuum, 1974.

Husserl, Edmund. "Inaugural Lecture at Freiburg in Breisgau." In Husserl: Shorter Works, translated by Robert Welsh Jordon. South Bend, Ind.: University of Notre Dame Press, 1981.

Huxley, Aldous. The Doors of Perception. New York: Harper & Row, 1954.

James, Henry. The American. New York: Thomas Crowell, 1972.

James, William. The Varieties of Religious Experience. New York: Modern Library, 1999.

Kafka, Franz. The Trial. Translated by Willa Muir and Edwin Muir. New York: Schocken Books, 1956.

Kandinsky, Wassily. Concerning the Spiritual in Art. Translated by M. T. H. Sadler. New York: Dover Publications, 1977.

Kant, Immanuel. Critique of Judgment. Translated by J. H. Bernard. New York: Hafner Press, 1951. (Original work published in 1790.)

————. Critique of Practical Reason. Translated by T. K. Abbott. New York: Prometheus Books, 1996. (Original work published in 1788.)

————. Critique of Pure Reason. Edited and translated by Paul Guyer. New York: Cambridge University Press, 1999. (Original work published in 1781.)

————. The One Possible Basis for the Demonstration of the Existence of God. Translated by Gordon Treash. Lincoln: University of Nebraska Press, 1994. (Original work published in 1763.)

Kantorowicz, Ernst. The King's Two Bodies: A Study in Mediaeval Political Theology. Princeton, N.J.: Princeton University Press, 1957.

Karmel, Pepe. Jackson Pollock: Interviews, Articles, and Reviews. New York: Museum of Modern Art, 1999.

Kendall, Richard, ed. Degas by Himself. Boston: Little, Brown & Company, 1988.

Kierkegaard, Soren. Concluding Unscientific Postscript. Translated by D. F. Swensen. Princeton, N.J.: Princeton University Press, 1941.

Kosuth, Joseph. Art after Philosophy and After: Collected Writings, 1966–1990. Cambridge, Mass.: MIT Press, 1993.

Kubovy, Michael. The Psychology of Perspective and Renaissance Art. Cambridge, U.K.: Cambridge University Press, 1980.

Lindberg, David. Theories of Vision from Al-Kindi to Kepler. Chicago: University of Chicago Press, 1976.

Locke, John. An Essay Concerning Human Understanding. New York: Prometheus Books, 1994. (Original work published in 1690).

———. Two Treatises of Government. New York: Cambridge University Press, 1988. (Original work published in 1690).

Loran, Edward. Cézanne's Composition. Berkeley and Los Angeles: University of California Press, 1943.

McIntyre, Alasdair. After Virtue: A Study in Moral Theory. London: Duckworth, 1981.

Malevich, Kasimir. The Non-Objective World. Chicago: Paul Theobald and Company, 1959.

Malraux, André. The Voices of Silence. Translated by Stuart Gilbert. Princeton, N.J.: Princeton University Press, 1968.

Marion, Jean-Luc. Cartesian Questions: Method and Metaphysics. Foreword by Daniel Garber. Chicago: University of Chicago Press, 1999.

Martland, Thomas R. Religion as Art: An Interpretation. Albany: State University of New York Press, 1981.

Marx, Karl, and Frederich Engels. The Communist Manifesto. New York: Oxford University Press, 1992.

Mathewson, Robert. The Positive Hero in Russian Literature. Stanford, Calif.: Stanford University Press, 1975.

Merleau-Ponty, Maurice. The Merleau-Ponty Esthetics Reader. Translated by Richard B. Smith. Edited by Galen A. Johnson. Evanston, Ill.: Northwestern University Press, 1993.

Mill, John Stuart. An Examination of Sir William Hamilton's Philosophy. London: Longmans, 1889.

Mistry, Frederick. Nietzsche and Buddhism. New York: Walter de Gruyter, 1981.

Montaigne, Michel de. The Complete Essays. Translated by M. A. Screech. New York: Penguin Books, 1987. (Original work published in 1575.)

Moore, George. Nietzsche, Biology, and Metaphor. New York: Cambridge University Press, 2002.

Mosse, Gerald. Nazi Culture: Intellectual, Cultural and Social Life in the Third Reich. Madison: University of Wisconsin Press, 2003.

Müller-Lauter, Walter. Nietzsche: His Philosophy of Contradictions and the Contradictions of His Philosophy. Translated by David Parent. Urbana: University of Illinois Press, 1999.

Murdoch, Iris. Existentialists and Mystics: Writings on Philosophy and Literature. Edited by Peter Conradi. New York: Penguin Books, 1997.

———. The Sovereignty of Good. New York: Routledge, 1985.

Nagel, Thomas. The View from Nowhere. New York: Oxford University Press, 1986.

Naussbaum, Martha. Love's Knowledge: Essays on Philosophy and Literature. New York: Oxford University Press, 1992.

Nietzsche, Friedrich. The AntiChrist. Translated by R. J. Hollingdale. New York: Penguin Books, 1968. (Original work published in 1888.)

———. Beyond Good and Evil. Translated by Walter Kaufmann. New York: Random House, 1966. (Original work published in 1885.)

———. The Birth of Tragedy. Translated by Francis Golffing. New York: Doubleday, 1956. (Original work published in 1871.)

———. The Genealogy of Morals. Translated by Walter Kaufman and R. J. Hollingdale. New York: Vintage Books, 1989. (Original work published in 1887.)

———. Thus Spoke Zarathustra. Translated by R. J. Hollingdale. New York: Penguin Books, 1961. (Original work published in 1891.)

———. The Will to Power. Translated by Walter Kaufman and R. J. Hollingdale. New York: Vintage Books, 1968. (Original work published in 1901.)

Nozick, Robert. Socratic Puzzles. Cambridge, Mass.: Harvard University Press, 1999.

Ortega y Gasset, José. The Dehumanization of Art. Translated by Helene Weyl. Princeton, N.J.: Princeton University Press, 1968.

Orwell, George. 1984. New York: Harcourt Brace and Company, 1949.

Pagels, Elaine. The Origin of Satan. New York: Vintage Books, 1995.

Pascal, Blaise. Pensées. Translated by Honor Levi. New York: Oxford University Press Classics, 1995. (Original work published in 1660.)

Pessoa, Fernando. Selected Poems. Translated by R. Zenith. New York: Grove Press, 1999.

Plato, Gorgias. Translated by Walter Hamilton. New York: Penguin Books, 1960.

———. The Republic. Translated by Desmond Lee. New York: Penguin Books, 1955.

———. The Symposium. Translated by Walter Hamilton. New York: Penguin Books, 1951.

Putnam, Hillary. Realism with a Human Face. Cambridge, Mass.: Harvard University Press, 1992.

Ratcliff, Clement. John Singer Sargent. New York: Abbeville Press, 1982.

Rhodes, Colin. Primitivism and Modern Art. New York: Thames & Hudson, 1994.

Richter, Gerhard. The Daily Practice of Painting: Writings 1962–1993. Cambridge, Mass.: MIT Press, 1995.

Rilke, R. M. Letters on Cézanne. Translated by Joel Agee. New York: Fromm, 1985.

———. Translations from the Poetry of Rainer Maria Rilke. Translated by Herter Norton. New York: Norton and Company, 1938.

Ross, Stephen David, ed. Art and Its Significance. Albany: State University of New York Press, 1994.

Rousseau, Jean-Jacques. Confessions. Translated by Angela Scholar. New York: Oxford Classics, 2000. (Original work published in 1782.)

Ruskin, John. Modern Painters. New York: Knopf, 1988.

Sartre, Jean-Paul. Existentialism. Translated by Bernard Frechtman. New York: Philosophical Library, 1947.

———. Psychology of the Imagination. Translated by Hazel Barnes. New York: Philosophical Library, 1948.

Scarry, Elaine. On Beauty and Being Just. Princeton, N.J.: Princeton University Press, 2001.

Schenk, H. G. The Mind of the European Romantics. Garden City, N.Y.: Doubleday, 1969.

Schmidt, James, ed. Eighteenth-Century Answers and Twentieth-Century Questions. Berkeley and Los Angeles: University of California Press, 1996.

Schock, Peter. Romantic Satanism. New York: Palgrave MacMillan, 2003.

Schopenhauer, Arthur. The World as Will and Representation. Translated by E. F. Payne. New York: Dover Publications, 1969. (Original work published in 1818.)

Smith, Huston. The World's Religions. New York: HarperCollins, 1991.

Solomon, Robert. Spirituality for the Skeptic: The Thoughtful Love of Life. New York: Oxford University Press, 2002.

The Song of God: Bhagavad Gita. Translated by Swami Prabhavananda and Christopher Isherwood. New York: Mentor Books, 1954.

Spinoza, Benedict de. Ethics. Translated by G. H. R. Parkinson. New York: Oxford University Press, 2000. (Original work published in 1677.)

Steiner, George. Language and Silence. New Haven, Conn.: Yale University Press, 1998.

Sylvester, David. About Modern Art: Critical Essays, 1948–1997. Boston: Henry Holt & Company, 1997.

———. Interviews with American Artists. New Haven, Conn.: Yale University Press, 2001.

Taylor, Charles. Sources of the Self: The Making of Modern Identity. Cambridge, Mass.: Harvard University Press, 1992.

Tocqueville, Alexis de. Democracy in America. Translated by George Lawrence. New York: Harper & Row, 1969. (Original work published 1835–1840.)

Tolstoy, Leo. Anna Karenin. Translated by Rosemary Edmonds. New York: Penguin Books, 1954. (Original work published in 1875.)

———. What Is Art? Translated by Richard Pevear and Larissa Volokhonsky. New York: Penguin Books, 1995.

Trilling, Lionel. The Liberal Imagination. Garden City, N.Y.: Doubleday Anchor Books, 1957.

Van Gogh, Vincent. The Letters of Vincent Van Gogh. Edited by Ronald de Leeuw. Translated by Arnold Pomerans. New York: Penguin Books, 1996.

Vasari, Giorgio. The Lives of the Artists. Translated by Julia Conaway Bondanella and Peter Bondanella. Oxford, U.K.: Oxford University Press, 1991. (Original work published in 1658.)

Weil, Simone. Gravity and Grace. Translated by Emma Craufurd. New York: Routledge, 1963.

———. Simone Weil: An Anthology. Edited by Sian Miles. New York: Grove Press, 1986.

Willoughby, L. A. The Romantic Movement in Germany. 2nd ed. New York: Russell & Russell, 1966.

Wittgenstein, Ludwig. On Certainty. Edited and translated by G. E. M. Anscombe and G. H. Von Wright. New York: HarperCollins, 1996. (Original work published in 1955.)

———. Philosophical Investigations. Translated by G. E. M. Anscombe. Malden, Mass.: Blackwell, 1953.

Woolf, Virginia. A Room of One's Own. New York: Harcourt Brace Jovanovich, 1929.

Wright, Lawrence. Perspective in Perspective. London: Routledge & Kegan Paul, 1983.

Index